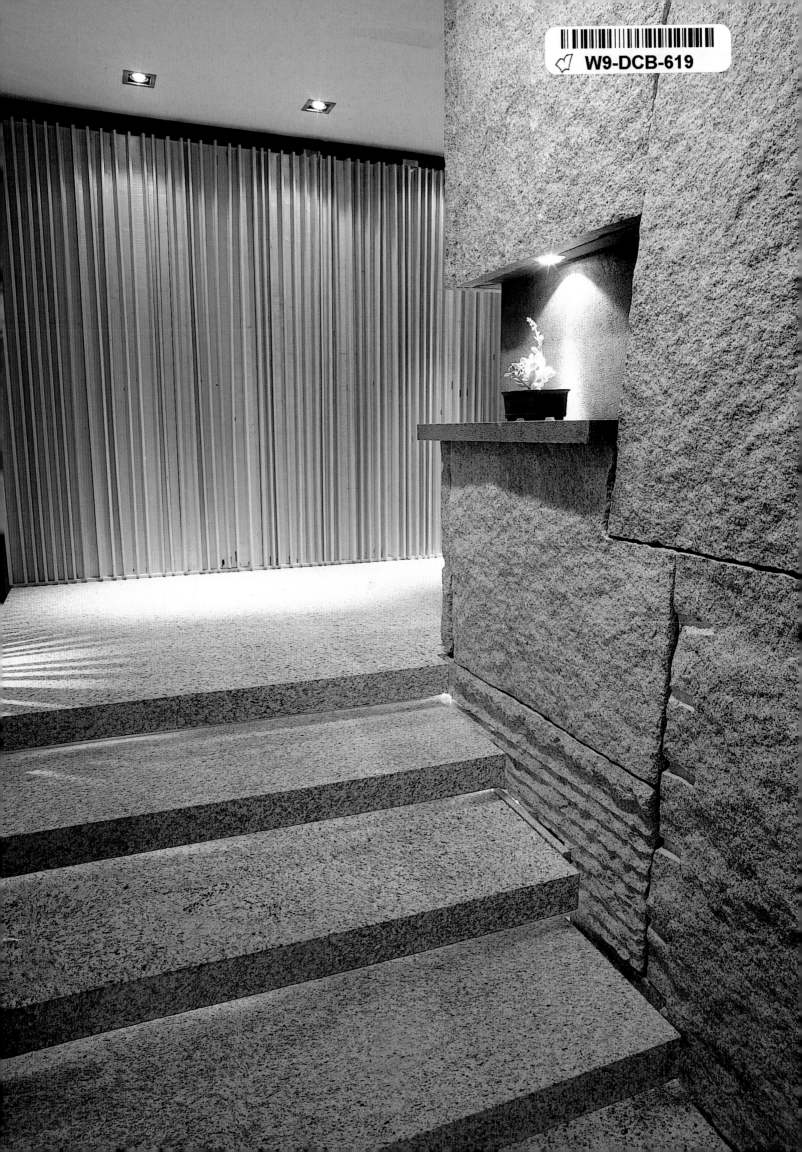

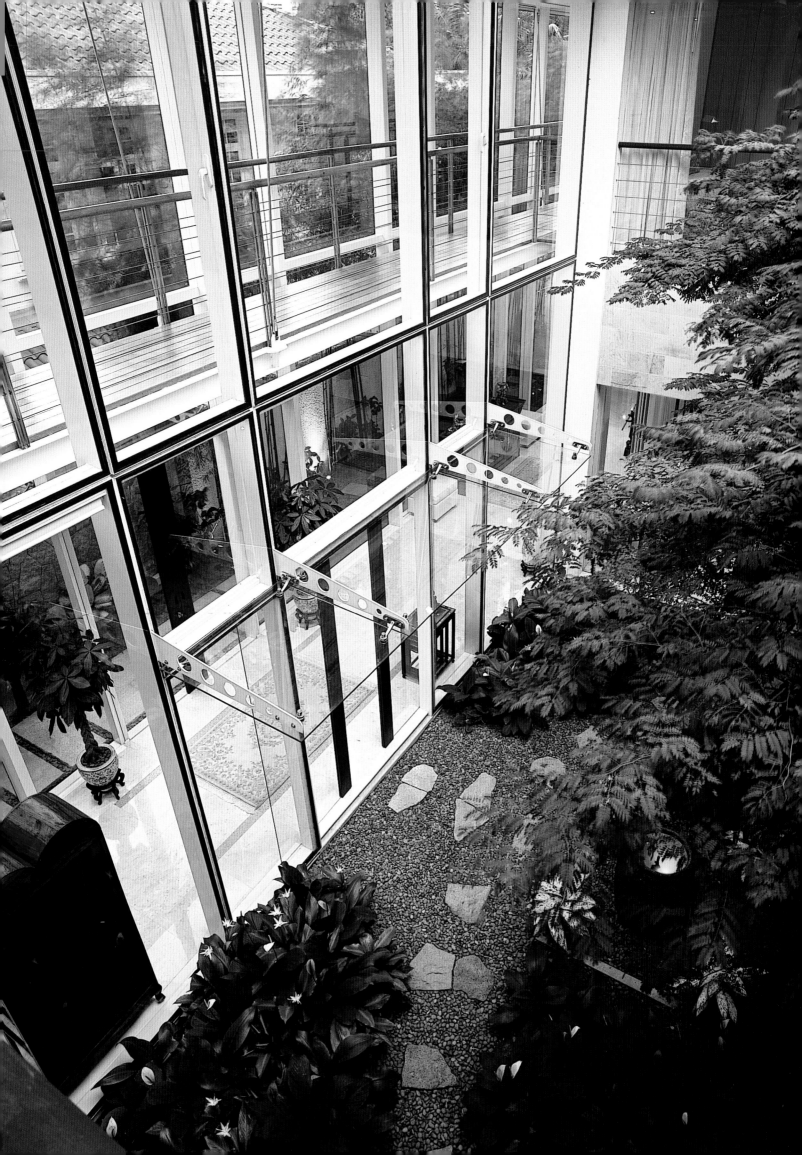

25 Tropical Houses
in Singapore & Malaysia

PAUL McGILLICK
photographs by PATRICK BINGHAM-HALL

TUTTLE Publishing

Tokyo | Rutland, Vermont | Singapore

Published by Tuttle Publishing, an imprint of
Periplus Editions (HK) Ltd

www.tuttlepublishing.com

Text © 2006 Paul McGillick & Pesaro Publishing
Photographs © 2006 Patrick Bingham-Hall

ISBN 978-0-7946-0528-5 Hc
ISBN 978-0-8048-4445-1 Pb

Distributed by:
North America, Latin America & Europe
Tuttle Publishing
364 Innovation Drive
North Clarendon, VT 05759-9436 U.S.A.
Tel: 1 (802) 773-8930
Fax: 1 (802) 773-6993
info@tuttlepublishing.com
www.tuttlepublishing.com

Japan
Tuttle Publishing
Yaekari Building, 3rd Floor
5-4-12 Osaki
Shinagawa-ku, Tokyo 141-0032.
Tel: (81) 3 5437-0171
Fax: (81) 3 5437-0755
sales@tuttle.co.jp
www.tuttle.co.jp

Asia Pacific
Berkeley Books Pte. Ltd.
61 Tai Seng Avenue, #02-12
Singapore 534167
Tel: (65) 6280-1330
Fax: (65) 6280-6290
inquiries@periplus.com.sg
www.periplus.com

Printed in Malaysia 1405TW

Hc 12 11 10 8 7 6 5 4 3
Pb 16 15 14 8 7 6 5 4 3 2 1

Page 1 Sunset Vale House, Singapore.
Architect WOW Architects.

Page 2 Jalan Ampang House, Singapore.
Architect Guz Architects.

Pages 4-5 Cassia Drive House, Singapore.
Architect SCDA.

Pages 6–7 Sunset Vale House, Singapore.
Architect—WOW Architects; Cairnhill Road
Shophouse, Singapore. Architect Bedmar &
Shi; Sinurambi House, Kota Kinabalu, Sabah,
Malaysia. Architect Fahshing.

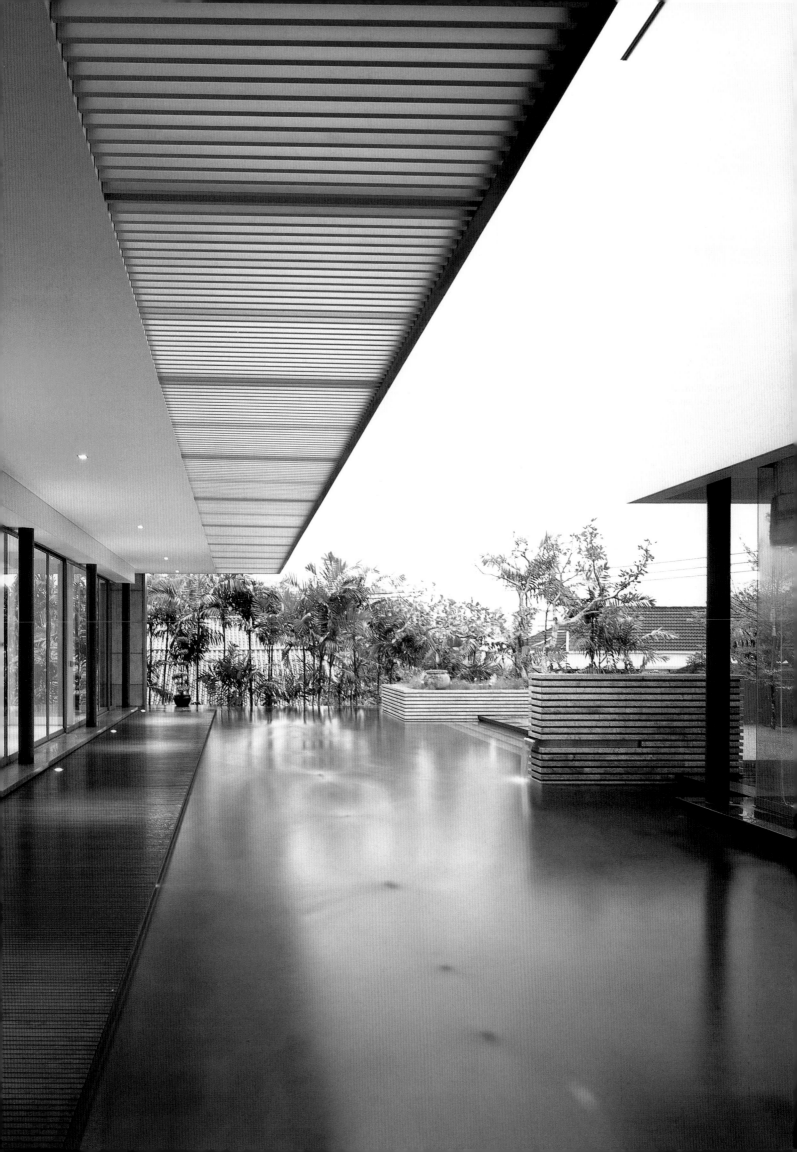

contents

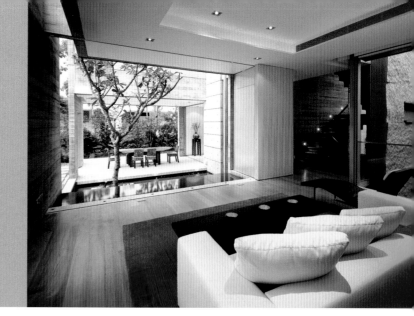

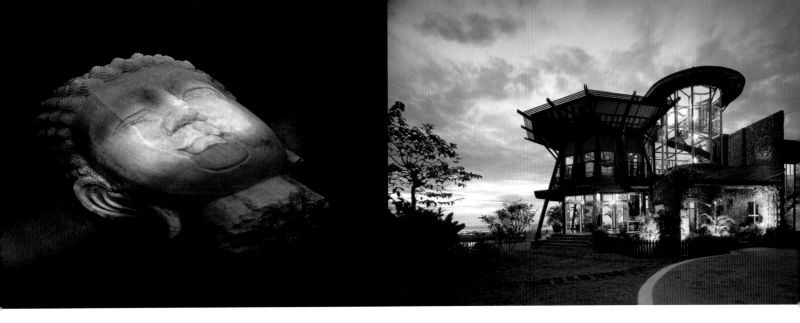

"Architecture must facilitate man's homecoming"

ALDO VAN EYCK

houses and homes

This book is titled "25 Tropical Houses in Singapore and Malaysia", but it could just as well refer to "25 homes", because the residential buildings illustrated share a common spirit: they are not just buildings, but *homes* – with all that the word implies.

Witold Rybczynski points out that the home is the result of historical evolution. It is tied to the growth of urban living with its accompanying industrial and technological innovations, which have in turn resulted in profound changes as to what we understand a family to be. Intimacy and privacy, according to Rybczynski, are key features of the modern idea of home. He is careful to say that it "would be dangerous to claim that there was a single place where the modern idea of the family home first entered the human consciousness. There was, after all, no identifiable moment of discovery, no individual inventor who can be credited with the intuition, no theory or treatise on the subject." [1] But in Europe, there was what he calls the "exemplary" development of the bourgeois interior in the Netherlands in the 17th century - significant because it was here that the modern "social dictatorship of the merchant class" first emerged as part of an evolving capitalism, urbanism and democracy.

In other words, the modern idea of a home with its functional differentiation of spaces, the separation of utility and ceremony, the separation from the public domain, the provision of private spaces to members of the family and the creation of intimacy is linked to social, economic and technological changes. Since the latter part of the 20th century, such changes have taken on a 'global' character. The world is now linked financially, commercially and technologically to an unprecedented degree, such that there is a rapidly advancing surface uniformity in urban life all over the world, apparently regardless of culture. But the extent of this uniformity is debatable, as culture continues to mediate the homogenizing effect of globalization. Even in Europe, the imposition of greater uniformity by the European Union has provoked a countervailing 'regionalism', as individual parts of Europe respond by accentuating their regional, cultural and linguistic character, instinctively alert to the threat of losing their identity.

In Asia, reasserting cultural identity has been an even larger issue, due to the post-colonial legacy. Having to endure a kind of cultural schizophrenia, where a colonial culture was imposed on top of the indigenous culture, many parts of that geographic region casually referred to as

Right Sadeesh House
Subang Jaya, Malaysia
Bedmar & Shi

1 Witold Rybczynski (1988), *Home – A Short History of an Idea*. London: Heinemann. p.52

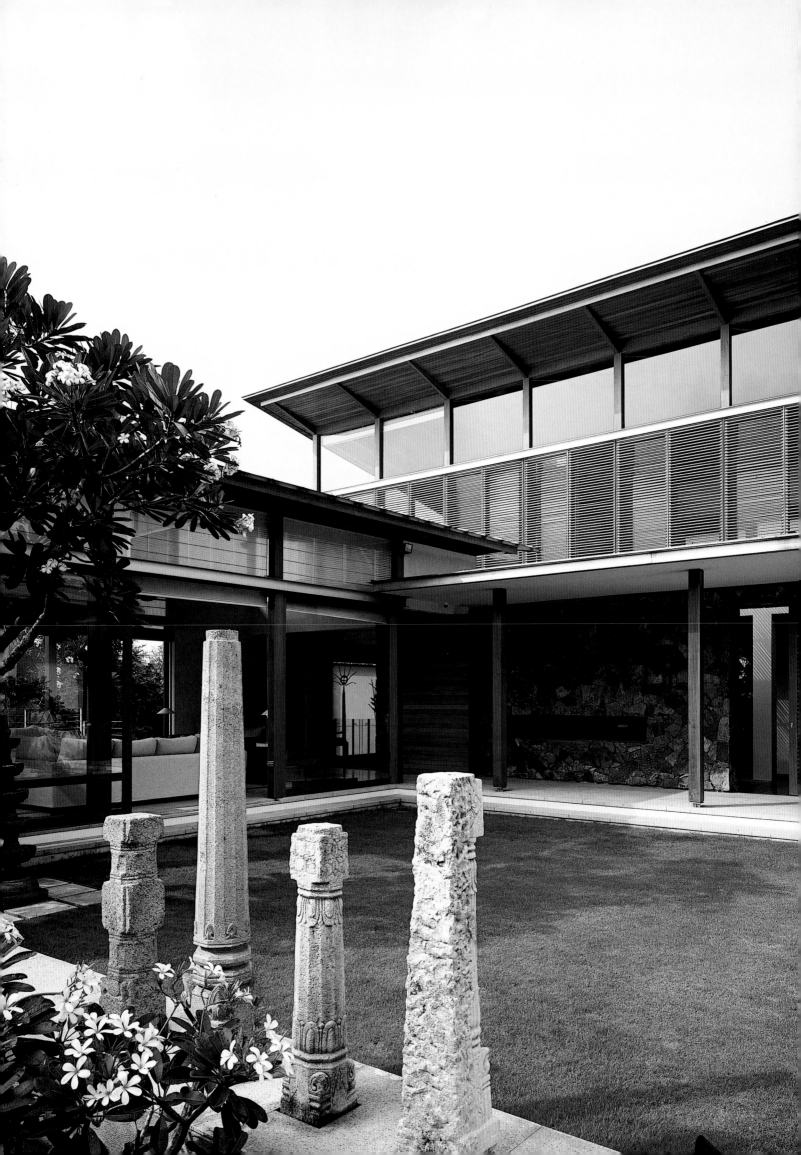

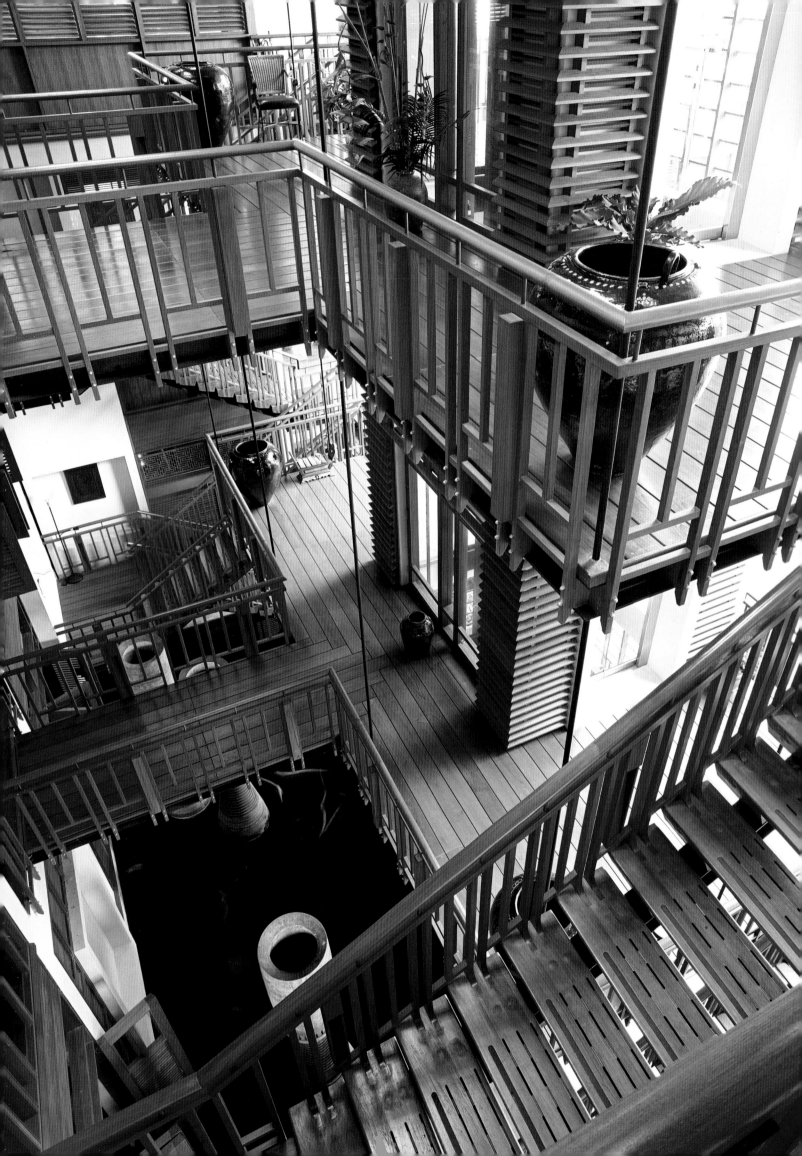

Left Timber Joinery House
John Heah

'Asia' are determined not to experience a re-invented colonialism disguised within a global economy, which is still driven, to a great extent, by the USA and Europe. Nonetheless, the notion of taking from the West what is useful and rejecting the rest whilst conserving a unique culture is not simply a colonial by-product. The idea has had a long history in China and arguably remains the dominant strategy in China's relations with the West to this day. Thailand, too, had its own version of the idea and successfully resisted colonial compromise throughout the 19th century.

This is part of the context of an important theme which emerges in the houses published here - the idea of home. On the one hand, it is a universal idea linked to modernity and the growth of urban communities. But, on the other hand, it is an idea mediated by local culture and climate. As we shall see, this interaction has resulted in a distinctive architecture, which simultaneously celebrates both its time and its particular place, in what can often be a sublime resolution of universal and culturally specific values.

Before moving on to specific recent residential design in Singapore and Malaysia, it is important dwell for a moment on some more universal issues to do with house and home.

A house is not always a home, but a home is always a house.[2] Grant Hildebrand argues[3] that bio-cultural and ecological imperatives underpin our aesthetic choices in the home. In so doing, he goes back to some very basic principles behind the idea of a house. A house is a refuge from a world that we cannot fully control and a world that is always potentially threatening. It is a place of concealment and protection, but at the most primitive level, we also need to store food and water in safety. So we need access to a place from where we can hunt and forage, a place that offers views over long distances and a place that is brightly lit. In other words, it offers prospect. "From the refuge," says Hildebrand, "we must be able to survey the prospect; from that prospect we must be able to retreat to the refuge." The possibility of retreat is communicated by elements of penetrability – windows, alcoves, recesses, balconies and overhanging eaves – which signal ways into the refuge. On the other hand, generous openings, balconies and terraces offer prospect: views out over the landscape.

The house, therefore, offers refuge and prospect, but there is a duality to this concept: the house is a refuge offering external prospect, but it can also offer internal refuge and prospect. "Interior prospect," says Hildebrand, "depends on opposite characteristics: relatively generous plan dimensions, a significantly raised ceiling plane, significantly increased light levels and generous expanses of transparent surface. When one space is significantly opened to another, the extended vista will contribute to a sense of interior prospect. Vistas through hallways that open to more distant windowed spaces conjoin interior and exterior prospect." The more successfully it can serve this dual program of external and internal refuge and prospect, the more the house becomes a home.

Of course, there continue to be real threats to our security in the modern urban environment, and gated communities have emerged as a response to these threats and provide refuges from rising levels of criminal activity. But before it is a refuge from crime, the modern urban house is a refuge from the climate and the hectic, debilitating pace of contemporary urban living. The house of the northern hemisphere is primarily concerned with taking refuge from the cold winters, but the tropical house must find ways of offering refuge from heat, humidity and heavy, often horizontal, rain. At the same time, however, both northern and tropical houses need to offer refuge from an increasingly demanding urban environment: the pace of life, professional demands, noise, air pollution and over-crowding.

2 It is an interesting debate as to whether an apartment can ever really be a true home, but one which is at least partially resolved by the cluster housing and multi-residential projects in this book, which have been chosen precisely because they deliver so many of the features we associate with a home, despite their density.
3 Grant Hildebrand (1999). *Origins of Architectural Pleasure*. Berkeley: University of California Press.

Having moved on from a preoccupation with vernacular typologies, the most interesting recent houses in Singapore and Malaysia have internalized the lessons in natural climate control which vernacular forms presented, and now aspire to a seamless marriage of the 'vernacular' and the 'modernist' at both the functional and the aesthetic levels. It is now less an issue of 'coping' with the climate, and more a case of creating pleasure from the climate: of working with the climate and the landscape to generate architectural pleasure.

In many cases, the houses in this book present an anonymous, even bland face to the street. This helps to bluff would-be burglars and so serves to create refuge from criminal threat, but it also provides the opportunity to create a ceremonial sequence, whereby one leaves the public domain and moves through a transitional space, before the prospect of an intimate, private and tranquil refuge is opened up. Like all pleasure, architectural pleasure is enhanced when it is delayed.

Identity and Modernity

Singapore, an island state, has consistently shown a remarkable ability to regularly (if not, continually) re-invent itself. Economically, this has been the secret of its success: lacking raw materials, Singapore has been repeatedly challenged to identify what it can do better than anyone else, and invariably, this has meant turning to its own human resources. Despite a reputation for being politically and socially rigid, Singapore has in fact demonstrated flexibility, imagination and creativity in its responses to recurring challenges. What has often been perceived in the West as a lack of flexibility tied to authoritarian governance, is clearly seen in Singapore as a necessary social and political discipline.

Beneath the surface of perceived blandness and intolerance, a passionate debate has long been taking place, which has been largely concerned with identity: an issue highlighted by the collision of modernity with cultural plurality and Asian traditionalism. In Singapore, despite its cultural plurality, the dominant ethic has been Confucianism (more than 75% of the population is Chinese), prioritizing the family and the collective over the individual: which is an ethic echoed throughout Southeast Asia, including its largely Muslim neighbor, Malaysia.

In the late 1980s, this debate found expression in the flowering of the performing arts in Singapore. While overt political dissent was largely discouraged, practically anything else was permitted. Hence, for example, issues of gender identity and sexuality started to be widely canvassed, often as seeming metaphors for political and social concerns. For example, the contradiction between a traditional and an aspirational technocratic society, leading to a sense of *anomie*, was often played out as a conflict between generations or as a conflict between individual sexual and social needs and conforming to family expectations. At the same time, performing arts companies like Theatreworks were exploring the potential of traditional performance modes within a global, modernist context. It is important to realize that this exploration was not a sentimental, backward-looking indulgence, but a disciplined investigation of the capacity for that tradition to interact productively with modern international performance traditions to create a new and distinctive indigenous performance culture for a contemporary Singaporean audience.

From the late 1980s onward, Singaporeans increasingly gave themselves license to be creative, to let their imaginations off the leash: aware of indigenous, regional and global precedents, but without feeling tied exclusively to any one of them. This was part of what Rem Koolhaas and Bruce Mau somewhat acidly refer to as "the transition from a hyper-efficient garrison state to a

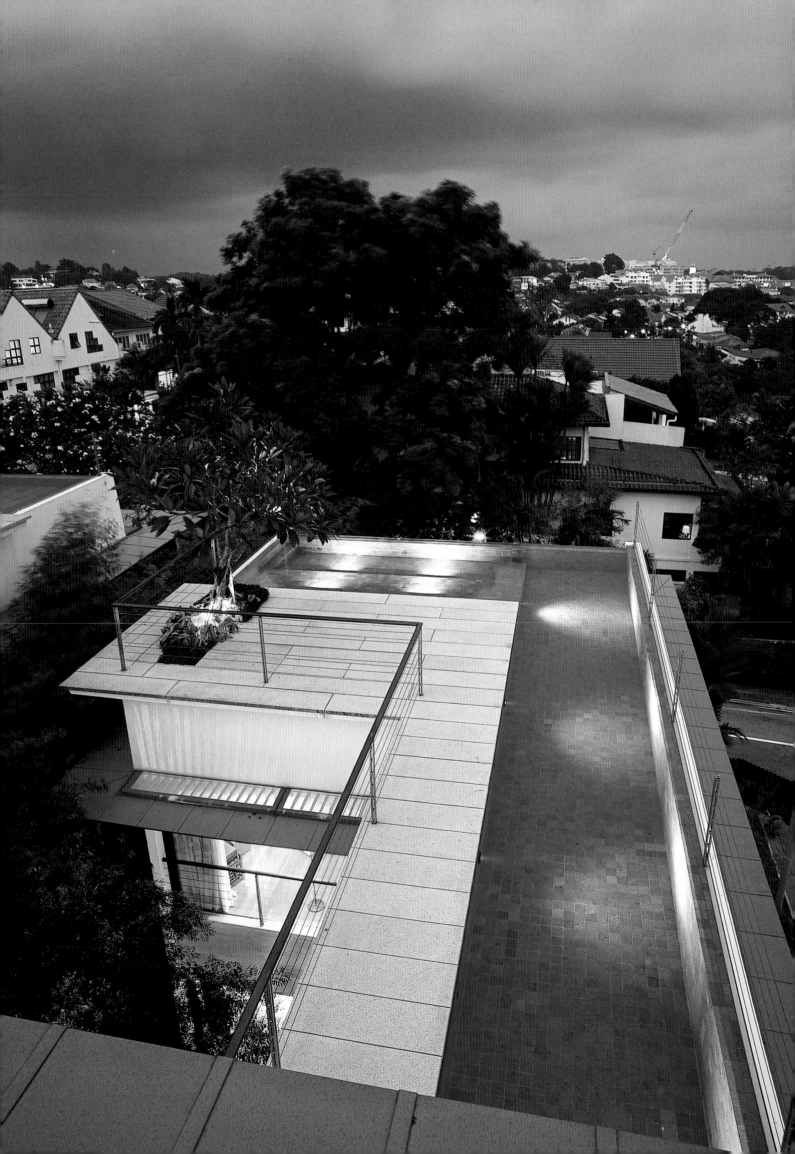

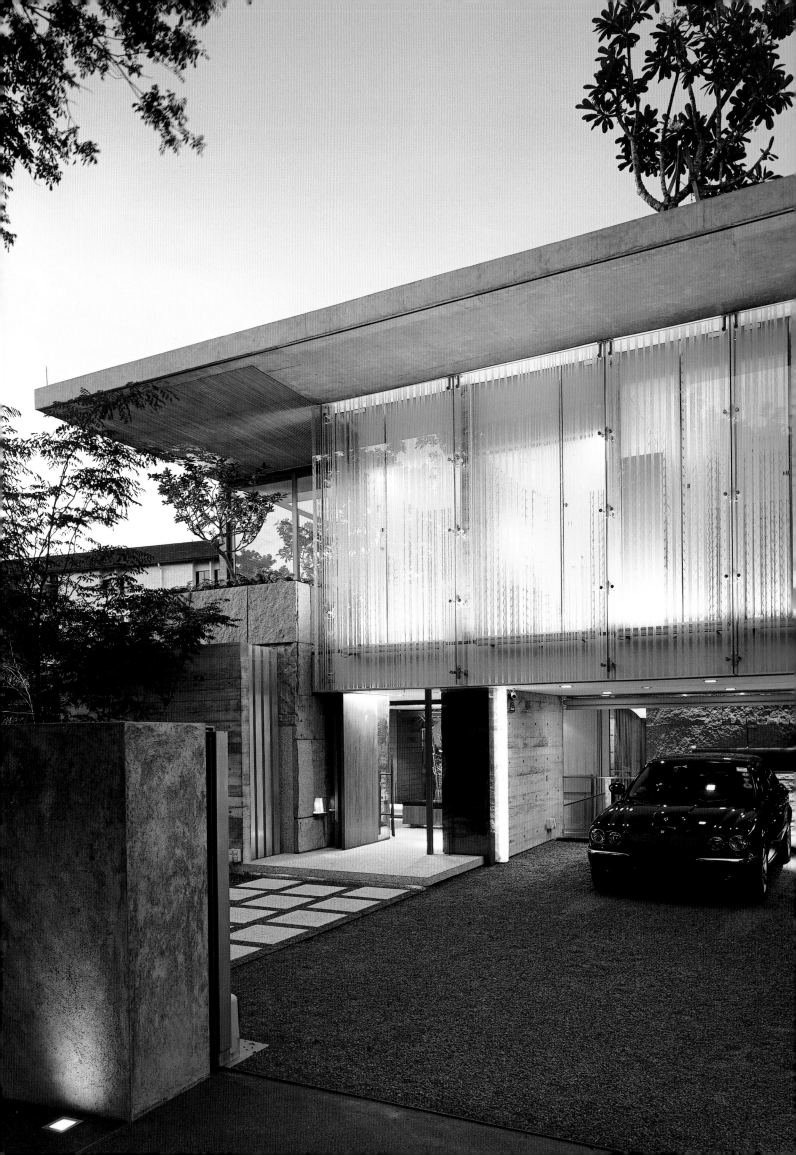

Left Sunset Vale House
Singapore
WOW Architects

more relaxed version of Sparta."[4] After urbanization, say Koolhaas and Mau, comes 'leisurization'. And they offer two quotes to convey the spirit of the times: "Singaporeans now aspire to the finer things in life – to the arts, culture, and sports", from a statement on the accession of Goh Chok Tong to the Prime Ministership in 1990; and "It may seem odd, but we have to pursue the subject of fun very seriously if we want to stay competitive in the 21st century", from the Minister for Information and the Arts.

Western views of Singapore as a post-colonial society frequently miss the point: Singapore is now a 'post-post-colonial' society. In other words, it sees itself as an autonomous society, which no longer feels any need to define itself in opposition to a colonial past. It may be positioned in Southeast Asia, but Singapore lives with a global consciousness informed by a thoroughly modern sensibility, and mediated by an inherited culture and sense of place.

Koolhaas and Mau comment in a postscript to their essay that Singapore is "now poised to metastasize across Asia". In other words, it is being used a model for rapid and intense urbanization elsewhere: "The sparkle of its organization, the glamour of its successful uprooting, the success of its human transformation, the laundering of its past, its manipulation of vernacular cultures present an irresistible model for those facing the task of imagining – and building – new urban conditions for the even more countless millions."

They have China specifically in mind, but a closer example might be Malaysia. Despite the often prickly relations between the two neighbors, dating back to their failed post-colonial union (1959-65), Malaysia can often seem to be emulating Singapore, if lagging about ten years behind. The last decade has seen strong, sustained economic growth in Malaysia and a comparable will has emerged to radically re-cast the urban landscape (indeed, urbanize the rural landscape in the form of dormitory towns and grand schemes such as Putrajaya) in order to accommodate the 'brave new world' offered by an affluent, technocratic society. As in Singapore, tensions exist as a result of the apparent conflict between traditional values and the implied deconstruction of such values as part of the new global economy. Both Singapore and Malaysia are pluralist (or multi-cultural) societies and they share a tradition rooted in the landscape, climate and mercantile history of their common region. And both are dominated ideologically by a supra-regional value system: Malaysia by Islam, and Singapore by the secular and ethically-based Confucian tradition.

Both societies are preoccupied with maintaining links to tradition while simultaneously re-building from the ground up. Kuala Lumpur, for example, has been effectively re-built over the last decade, but unlike Singapore, it is not a city-state: it is a conurbation with a hinterland that remains highly rural. In that sense, Malaysia's 'tradition' is quite tangible, whereas Singapore's exists as a cultural inheritance - a memory - since the buildings and market gardens of old Singapore were largely razed during the 1970s in the push for re-development. Hence, when we look at the re-investigation of vernacular building forms undertaken by architects in Singapore and Malaysia, there are important qualitative differences. Arguably, there is today a situation where the best Singapore architecture has moved on from an explicit interest in the 'vernacular', whereas (broadly speaking, at least) that interest remains quite strong in Malaysia.

The example of the performing arts in Singapore is reflected in the recent history of architecture in the island state, where we have not so much a re-invention of the 'vernacular' with an updating of traditional tactics for climate control, as an adaptive modernism. This is not quite the same as the notion of 'critical regionalism',[5] which describes an essentially universal, modernist architecture inflected by regional cultural characteristics. In 'New Directions in

4 Rem Koolhaas and Bruce Mau (1995). *Small, medium, large, extra-large: Office for Metropolitan Architecture*. Rotterdam: 010 Publishers. pp. 1008-1087. This article is concerned mainly with urban planning in Singapore. It is a highly critical, but insightful discussion of the degree to which Singapore was treated as a 'tabula rasa' and whether, in the rush to develop it as a modern technocratic state, it had lost any sense of the identity it once had – especially as embodied in its built form.

5 The notion of critical regionalism was originally proposed by Alexander Tzonis and Liane Lefaivre in "The Grid and the Pathway: An Introduction to the Work of Dimitris and Susana Antonakakis", in *Architecture in Greece* 15 (1981), pp. 164-78. It was further developed by Kenneth Frampton, notably in "Towards a Critical Regionalism: Six Points for an Architecture of Resistance", in *The Anti-Aesthetic: Essays on Post-Modern Culture*, ed. Hal Foster (1983), pp. 16-30.

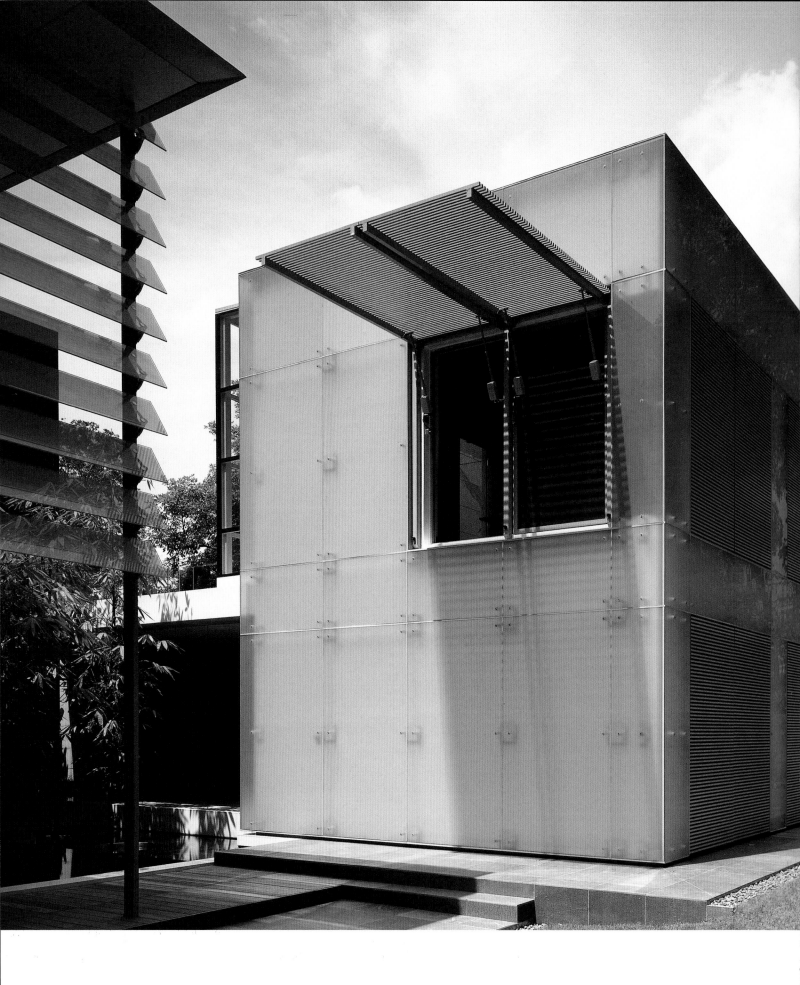

Left White House Park House
Singapore
Hans Brouwer

Tropical Asian Architecture', Philip Goad cites Jiat-Hwee Chang's idea of "hybrid modernities, instances where exchange, negotiation, translation and reinterpretation are more instructive terms than emulation or subservience to canonical models."[6] Goad elaborates by saying that the "aims no longer embody the reforming zeal of the 1950s (when modernism was an expression of a national independence and a symbol of progress), nor the ambitious social/urban programs of Design Partnership in the 1970s, but in many respects, signal a return to first principles, to beginning again. This next generation has moved beyond the attractive, formal signs of a so-called regional architecture, to a re-thinking of the fundamental issues of space, material practice, tropicality, sustainability, urbanity and place…"

Implied in Goad's remarks is the need to distinguish between what has been called Tropical Regionalism – a more or less surface reiteration of vernacular forms – and a more comprehensive understanding of the term 'vernacular' to include not just traditional building materials and technologies, and responses to climate, but also social and cultural issues. As many of the architects represented in this book put it, we are seeing here a contemporary application of traditional forms and tactics. Not surprisingly, many of those architects belong to a newly matured generation who were educated overseas before returning home with a strongly cosmopolitan orientation.

When looking at these new tropical homes, we need to bear in mind that in Singapore, for example, almost 90% of the population now live in high-rise, high-density apartment towers: either in towers built by the Housing and Development Board or, for upwardly mobile middle class people, privately developed medium-rise condominiums. With land in short supply, the opportunity to live in free-standing houses or even low-rise, multi-residential cluster housing (townhouses) is restricted to the very affluent (although over 80% of Singaporeans now live in their own homes). This situation is not so marked in Malaysia where land supply ensures that plots remain more affordable. It also suggests a stronger *suburban* character to Greater Kuala Lumpur than can be found in the universally *urban* nature of Singapore. Nonetheless, in the broadest sense, both cities offer their inhabitants a choice between two very different urban experiences: one in relatively small areas of free-standing or low-rise medium-density housing, the other in high-rise, high-density apartment blocks. To talk about home, therefore, is to talk about two very different experiences. One is about the entire city with its parks, public amenities and multi-functional shopping malls as an extension of home, the other is about a private, intimate space with its own internal landscape and which turns its back on the contemporary, tropical megalopolis.

What the two have in common is an evolving and unique response to modern life in a tropical context. As Anoma Pieris points out:[7] "As modern Asian people blend strong filial connections and meaningful cultural traditions with economic aspirations and cosmopolitan desires, they will produce a material culture quite unlike that found anywhere else." Both experiences demand study, but this book is concerned with the latter.

Tropical Urban Homemaking

Some of the most concentrated explorations of prospect and refuge in urban tropical homemaking are found in the adaptive re-use of the row or terrace house, known locally as a shophouse. In Singapore, especially, the adapted shophouse brings into focus a number of issues in the development of new housing types. These issues include how to achieve density in inner-city

6 In Patrick Bingham-Hall (Ed.) *New Directions in Tropical Asian Architecture.* Singapore: Periplus Editions (2005). P.17.
7 In Bingham-Hall (2005), p. 32.

Right Cairnhill Road Shophouse
Singapore
Bedmar & Shi

locations using low-rise buildings that offer privacy, space, light and connection with nature. At the same time, they are almost ready-made 'theatres' for playing out the contesting values of contemporary Asian urban life: tradition versus modernity; reconciling the private and the public; accommodating the individual and the family; mediating engagement and withdrawal; and sustaining contact with light, air and nature without losing touch with the energy of urban life.

By the mid-1980s, even the Singaporean government conceded that valuable heritage had been lost in the relentless process of urban renewal.[8] In 1986, the Singapore Heritage Society was established and, in 1988, the Ministry of National Development designated four conservation areas, while Rent De-control was introduced in the four areas to encourage conservation.[9] In 1991 the Urban Redevelopment Authority Concept Plan outlined a new approach to land development, housing, transport, industry, leisure and cultural facilities for the next 25 years. This involved a shift away from high rise/high density residential development to low/medium density housing, decentralization (the creation of four regional centres, a new business district at Marina Bay and two high technology corridors consisting of 18 business parks), an extension of the MRT and expressways, new golf courses and marinas, 300 hectares of natural landscape and the preservation of architectural heritage.

Shophouses specifically benefited from the new appreciation of architectural heritage, and they are now heritage-listed with strict controls on what can be done to the street-facing exterior. Architects, however, may re-model the interiors as long as the scale of the building conforms with the other buildings in the row. The shophouse is typically urban, and in Singapore architects have discovered that by radically re-casting the interior spaces it can be adapted to make an extremely comfortable home in, or close to, the city centre whilst achieving a high degree of density. The shophouse typically has a ground floor and an upper floor contained within a long rectangular 'railway carriage' form, with a central air well.

Bedmar and Shi's makeover of the Cairnhill Road Shophouse (situated on a busy city road) moves beyond collective and cultural preoccupations into a very private domain of contemplation and meditation. In the strictly architectural sense, the Cairnhill Road Shophouse forms part of what is almost a contemporary tradition, due to such precedents as Chan Soo Khian's (SCDA) Goei House (1997) in Singapore, his Heeren Shophouse (2002) in Melaka, Malaysia and Richard Ho's Everton Road House (1995) in Singapore.[10] All of these adaptations focus on converting the air-well into a light-well or glass-topped atrium, not just to draw light into the deep interior of the house, but also to expose an enhanced verticality of the house. All three architects make the central atrium an 'ambiguous' space,[11] which creates the illusion of being simultaneously inside and outside, public and private, a gathering place and yet a place of silent contemplation: as with the Cairnhill Road Shophouse's reflection pool and the mysterious Buddha head lying in the water.

Strategies of prospect and refuge have created all the spatial pleasure and moments of intimacy and tranquility we expect from a home. The Cairnhill Road Shophouse, for example, is a contemporary home, but one with a strong sense of connection to the traditional home it once was, most explicitly expressed in the counterpoint between the still strongly traditional entry and ante-room off the street, and the elegant minimalism of the atrium-dining area with which it connects. In this way, it offers a sense of belonging *in time*, of sharing an enduring cultural legacy, of belonging to an historical continuum. By definition, the home embodies identity and protects

8 Figures such as William Lim and Tay Kheng Soon had from the mid-1960s argued that issues such as history, context and community should become part of a broad debate about the direction of urban renewal in Singapore. In 1965, they formed the Singapore Planning and Urban Research Group which, until 1975 lobbied the Housing Development Board, but with only limited success.
9 Robert Powell (2003), *Singapore Architecture – A Short History*. Singapore: Periplus Editions. p.108.
10 See Robert Powell (1998), *The Urban Asian House – Living in Tropical Cities*. London: Thames & Hudson. Also Patrick Bingham-Hall (Ed.) (2005). *New Directions in Tropical Asian Architecture*. Singapore: Periplus Editions. p. 96-101 (Heeren Shophouse).
11 Cf. Robert Powell, 1998. p. 22.

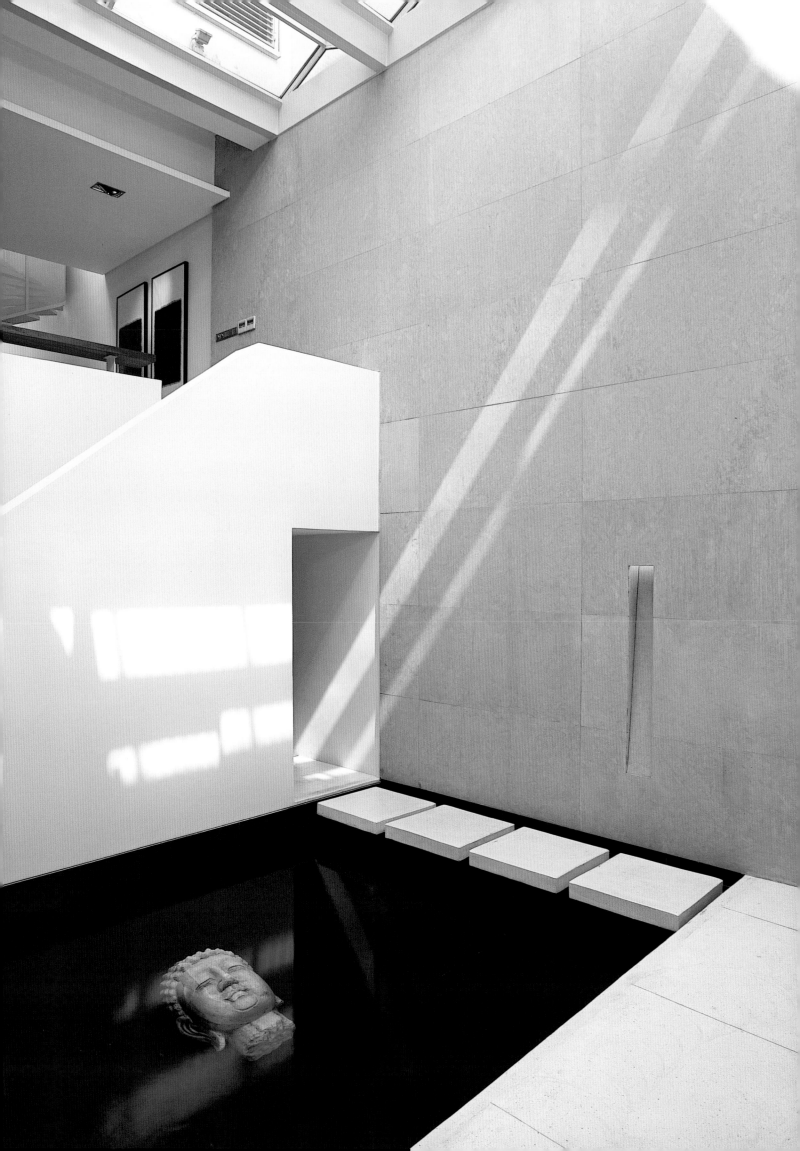

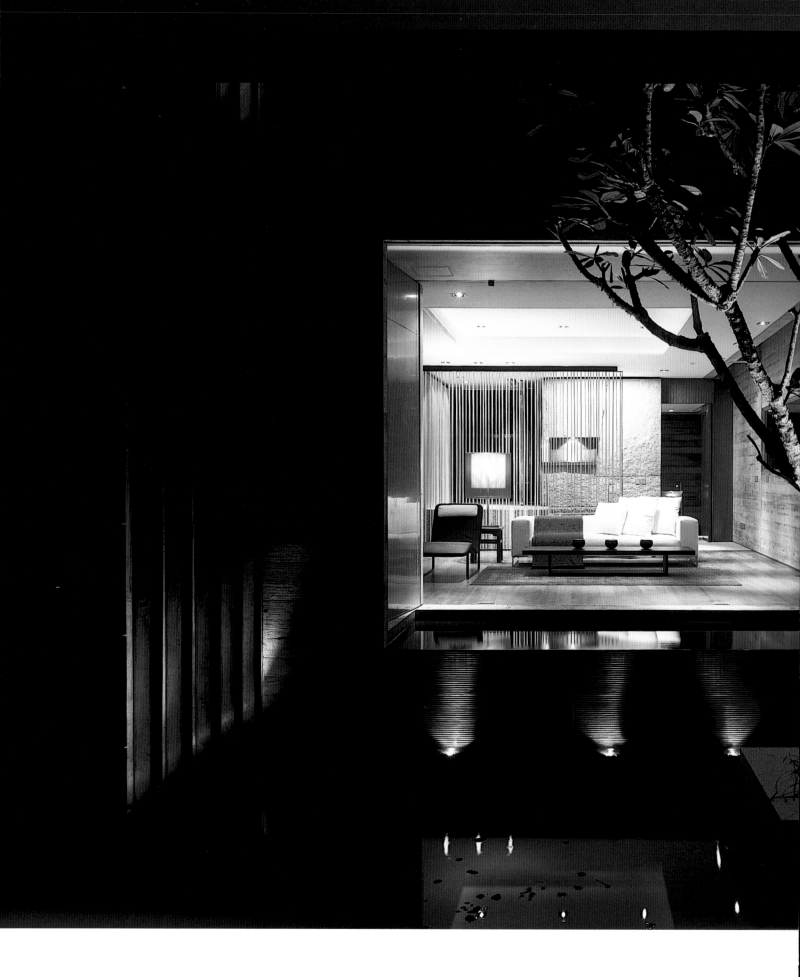

its inhabitants from *anomie*. The Cairnhill Road Shophouse is a contemporary home right in the middle of post-modern Singapore with all its identity-threatening contradictions, conflicts and entrepreneurial mania. But by its use of water, light, strategies of connection and subtly embodied cultural memory, this house provides the opportunity for re-affirmation of self and identity.

Similar strategies are employed by the Malaysian-born, American-trained Chan Soo Khian (of SCDA) in his renovations and additions to a Black-and-White house: the Dalvey Estate House. But this is a case not of adaptation, but of restoration, with subtle modifications ensuring a contemporary functionality and a bold and thoroughly modern addition. At the same time, this historical Black-and-White house engages in a provocative argument with a neighboring house in Dalvey Estate, also by SCDA, about what constitutes an appropriate contemporary Singaporean house: a dialectic continued in SCDA's Cassia Drive House. Chan's solutions are non-prescriptive in the sense that he prefers to respond to a specific site and program rather than impose pre-conceived 'regional' or 'vernacular' solutions. In the words of Robert Powell, "he is committed to refining a modern architectural language and simultaneously re-thinking typologies."[12]

Unlike an apartment, which is entered directly from a communal corridor, the house-as-home offers the opportunity for a ritual of extended transition from public world to private sanctuary. Invariably this involves a sequence of arrival, implying the gradual shedding of the emotional and visual detritus of the outside world, before entering the home proper. Once inside, an internal prospect reveals itself, offering a series of choices with varying degrees of refuge. This sequence of arrival at a discreet entry, followed by ceremonial penetration into the refuge of the home before the magical – sometimes grand – revelation of the interior sanctuary is a recurring theme, especially in the houses of Ernesto Bedmar (of Bedmar & Shi). On the other hand, the explicit historic character of the shophouses and Black-and-White houses is, of course, absent from the completely new houses. Instead, historical and vernacular elements remain implied, and historical connections become a sub-text.

Each of the houses illustrated in this book could be seen as a variation of a number of common themes. But one thing most of them have explicitly in common – sometimes still, sometimes flowing – is water, traditionally a symbol of life, but also a cooling agent and a generator of tranquility. Rarely can we talk of a 'lap pool', because these pools always go well beyond the simple utility of staying fit. They are partly decorative and partly objects of contemplation, often extending beyond the customary rectangular form into broad and sometimes irregular expanses of water with trees and lilies. In the case of Bedmar & Shi's Caldecott House and IP:LI Design's Linden Drive House, the guest pavilions are given a privileged aspect on to the pool, with their own privacy and prospect affording traditional honour to the guests. These are essentially modern houses, whose character is inflected by deft juxtapositions of materials, the use of devices such as timber louvres and screens, and the exposure of interior spaces to the open air, thus drawing connections with vernacular forms and traditional climatic strategies. Just as strongly implied is the concept of *feng-shui*, so directly concerned with prospect and embedded in Chinese culture – determining the aspect of a house to achieve harmony in the lives of the people for whom it is a home.

This cultural sub-text is also evident in the way tradition and modernity are accommodated by planning for an extended family (as in WOHA's House at Rochalie Drive), or affording individual spaces for parents and children, while still articulating the house around a common

12 Robert Powell (2004). *SCDA Architects – Selected and Current Works*. Melbourne: Images. p.13.

Right 67 Tempinis Satu
Kuala Lumpur, Malaysia
SekSan design

area, as with K2LD's Nassim Road House. Chan Sau Yan (of CSYA), with the Coronation Road West Houses, addresses the cross-generational tension between the family and growing individualism not through a single building, but by a compound of three pavilions. It is this concept of a compound rather than any vernacular gestures – since the three pavilions are elegantly modernist – which gives the project the subtlest of context, hinting at a traditional village with all the communal values that go with it. Otherwise, the pavilions of the parents, son and daughter are linked by a common architectural language and by the landscaping, whilst retaining the privacy of their individual domains.

Most of the Singapore houses we look at are relatively large in scale, but one exception is K2LD's artful and modest take on Richard Neutra with the Khai House. Although even here the beautifully articulated and highly transparent ground floor is a deliberately public space for entertaining friends and business associates. Another exception is the Sunset Vale House by WOW Architects, a compact home which utilizes almost every centimetre of its small plot to create a wonderfully intimate home for a young family. It maximizes the use of natural light and ventilation, and by the use of reflection ponds and deft landscaping creates a feeling of space and tranquility despite the constraints of the site. Smaller scale projects such as these imply a critique both of the over-scaled houses, which became fashionable in Singapore during the 1980s, and of the simplistic stand-off between a regionalist ideology (based either on traditional forms and/or climatic responses) and a modernist position (which often simply ignores the climatic imperative, instead relying on air-conditioning). This critique takes on considerable sophistication in the work of two Malaysian architects, Kevin Low and Ng Sek San.

Like most architects of his generation in Malaysia and Singapore, Kevin Low was educated abroad and returned home with a cosmopolitan outlook, but focused on exploring what could make an appropriate residential architecture in his home country. Based in Kuala Lumpur, he designs what he calls 'garden houses' – houses where the inside and the outside are extensions of one another. He is critical of what he terms "the post-colonial quest for credibility and legitimacy" and advocates a "contextual" approach, which is less concerned with traditional forms and more with an immediate response to the context of site and climate, as well as the needs and character of the people who will live in the house. He resolutely adheres to a commitment to affordability and to the use of local materials. Low's understanding of the principles of Modernism (as distinct from its stylistic habits) has enabled him to produce a body of highly distinctive, even idiosyncratic, work.[13] From Modernism he takes the principles of clarity of structural expression, truth to materials and attention to detail, while he possibly also owes a debt to such 'critical regionalists' such as Jørn Utzon for the priority he places on a response to site, climate and the program of his client.

The work of Low's fellow Malaysian, Ng Sek San has an equally sharp dialectical edge: raising issues of affordability, context, sustainability, commitment to local materials and artists (10% of his company's profits go to supporting local artists), and an all-encompassing notion of simplicity, including the use of 'poor' materials (re-cycled materials and found objects and materials used in innovative ways).[14] Sek San is a structural engineer and landscape architect, which add an extra dimension to the way in which he addresses these issues. As with Low, Sek San is interested in creating a house which is never really finished, but which continues to transform and accrete. His 67 Tempinis Satu in Bangsar, Kuala Lumpur, is also a model for the 'poor' house: affordable, unostentatious, and delighting in re-cycling simple materials and objects

13 For a full discussion of Low's work see Anoma Pieris' chapter on him in *New Directions in Tropical Asian Architecture*.
14 Two of Ng Sek San's houses are published in *Houses for the 21st Century*, Geoffrey London (Ed.), Singapore: Periplus Editions, 2003.

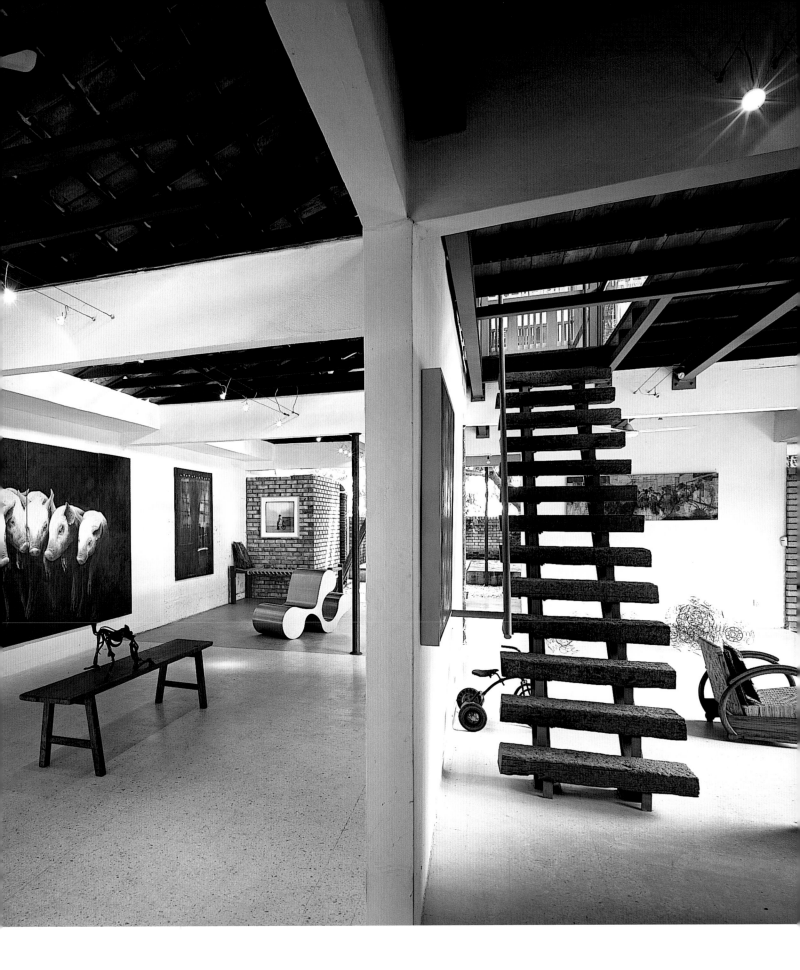

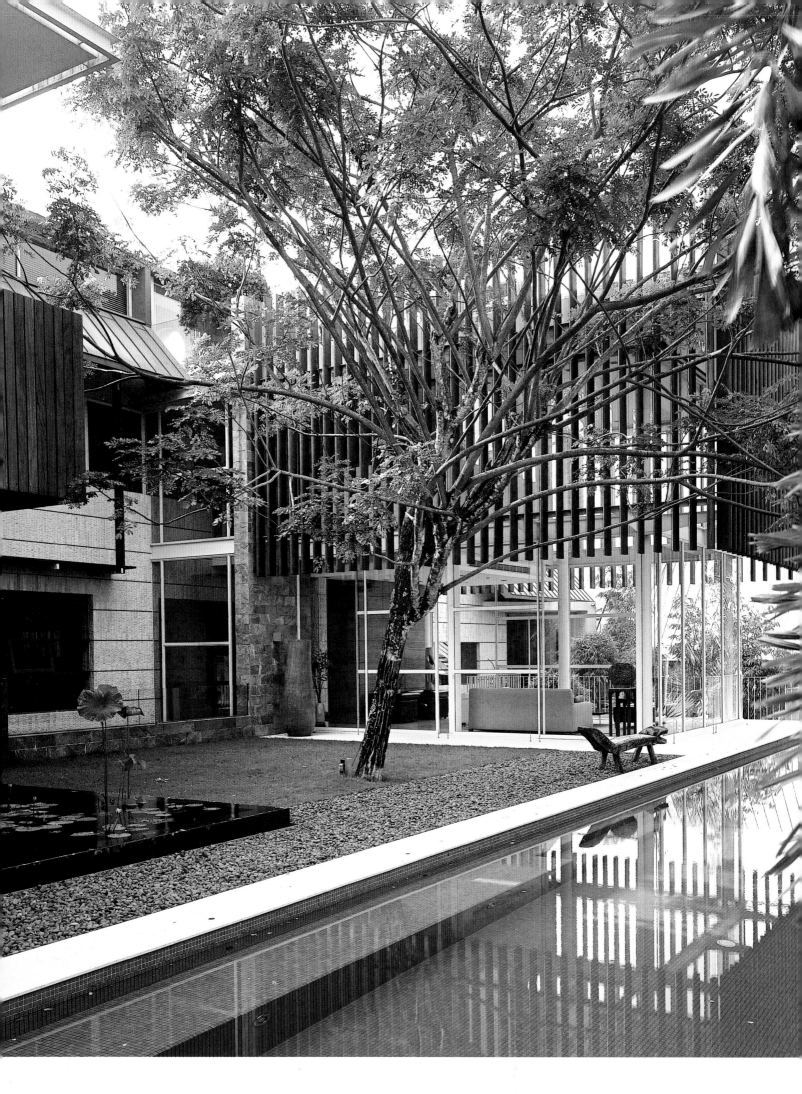

by giving them a new context and a fresh function. The house's functional areas are not defined by fixed elements, but by the play of light during the course of the day. It was inspired by the simplicity of traditional village houses, and its subtext is an argument for a return to a simple way of life based on respect for the environment and modest consumption.

The work of Sek San and Kevin Low highlights the contrast between the urbanity of Singaporean architecture and the more environmentally engaged projects of Malaysia's most interesting architects. To an extent, this reflects the more expansive sites, the sense of space and the proximity to the natural environment of Malaysia. Fahshing Ling's work and philosophy may not be exactly anti-urban, but it is certainly a powerful critique of urban development. His Sinurambi House, near Kota Kinabalu, is set on the edge of the jungle, and while it provides all the amenities of a contemporary home, it is also a bravura architectural essay: it demonstrates how a modern home can grow out of the principles of vernacular architecture in close harmony with the natural world. Wooi Lok Kuang's own home in Shah Alam, on the other hand, is in an urban setting that it basically ignores: it is a virtuoso exercise in the juxtaposition of forms, materials and spaces. While it does not occupy a particularly large site, its grandiloquent soaring roof and interior volumes generate their own sense of limitless space, just as the exquisite detailing and imaginative internal planning create a private world. The house may as well be out in the countryside.

From Conformity to Difference

Looking at this selection of free standing, semi-detached and row houses, together with some examples of medium-density multi-residential developments, it is clear that there have been significant shifts in approach to recent residential design in Singapore and Malaysia. During the 1980s, new freestanding houses were typically of the 'wedding cake' variety, occupying the centre of a block of land, heavily embellished, with an under-developed landscape and (with the availability of air-conditioning) oblivious to the climate. They were status symbols: a case of doing the same thing as everyone else, but more impressively. Today, however, the best of the new housing reveals a critical change – away from conformity and towards difference, accompanied by an assertion of individuality. There is a younger, more affluent generation: widely traveled and open to new ideas. Where clients would once have wanted a status home by a recognized architect, they are now more likely to want a unique home, very possibly by an up-and-coming architect.

The result is a new wave of highly distinctive architecture. Architects have more license to play with ideas, and landscape has become central to design, as have issues of climatic responsiveness, resulting in less dependence on air-conditioning, a greater interest in cross-ventilation, and the use of water, plantings, sunscreens and extended eaves. If houses remain as status symbols, they are more discreetly so, and there is a strong inclination to turn away from the street and create an inner sanctuary, which is far more concerned with making a home, than with advertising success and affluence in the form of an ostentatious house. And, if anything, there is an even stronger interest in maintaining cultural connection. But where this was once expressed through the revival or imitation of vernacular forms – often in a quite literal and picturesque way – the 'vernacular' is now likely to be a metaphorical presence, derived from an appreciation of the principles of vernacular design, rather than a celebration of its surface forms.

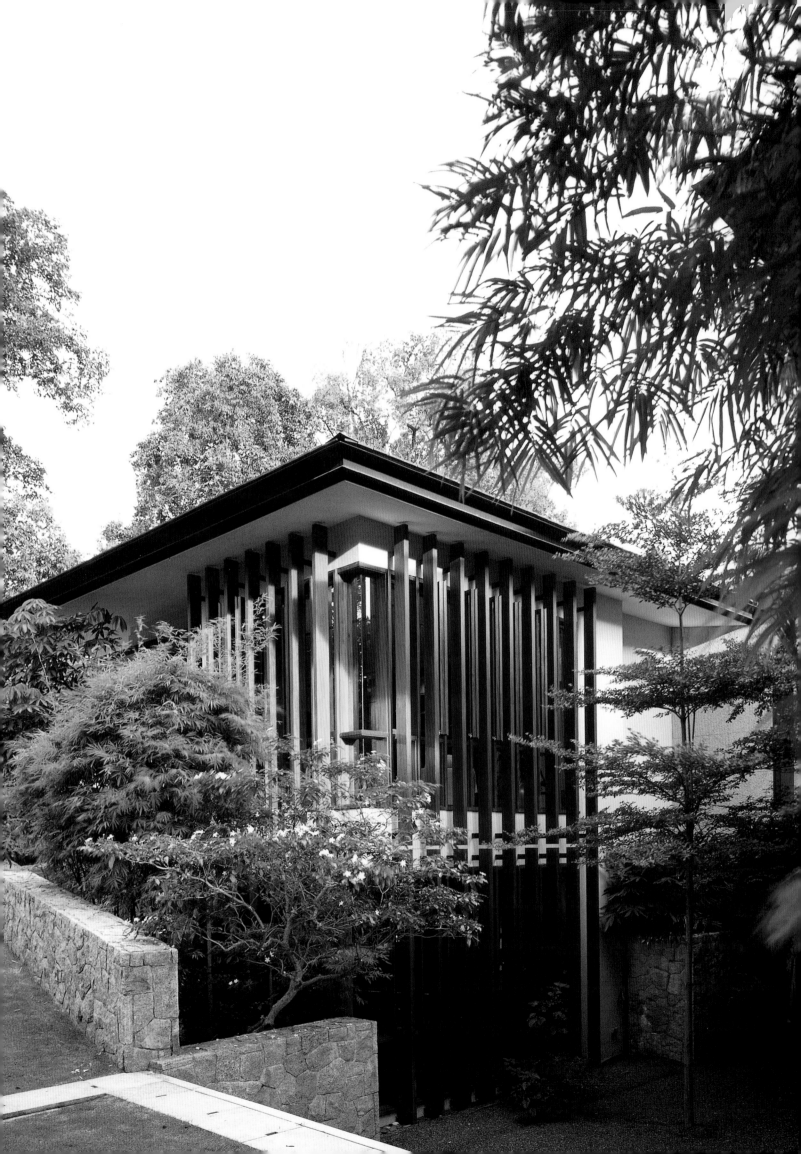

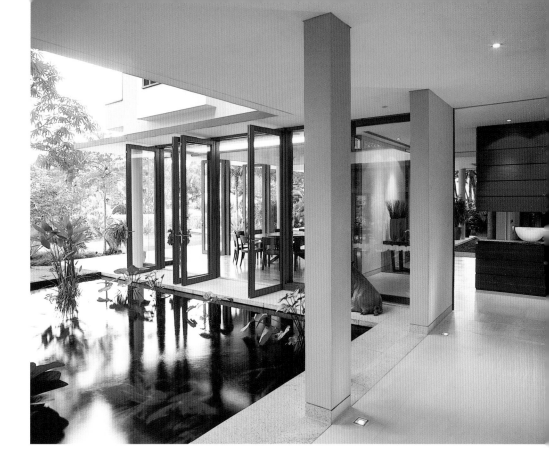

Opposite The northern elevation of the house appears as a reclusive and demure tropical residence with elegant timber sunscreens.

Right The entertainment and dining pavilions are linked by a ceremonial colonnaded gallery. The idea of a modernized plantation house is signaled here by this view over the water garden.

Following pages The bedroom wings cantilever out over the garden with expansive overhangs to provide shade and protection from rain.

nassim road house

Sitting circumspectly on a low hill, the Nassim Road House generates a powerful sense of expectation with glimpses of its low-pitched tiled roof from below. The ascent to the house feels like a pilgrimage... and the house itself seems more like a temple, closer to the sky than to the world below.

NASSIM ROAD HOUSE

SINGAPORE

ARCHITECT K2LD

The impression of approaching a temple, rather than a house, is reinforced by the grand *porte cochère* with a massive cantilevered canopy. A ceremonial stairway leads up to the house, turning back on itself to further extend the journey of arrival, which culminates before two huge timber-studded, bronze-handled doors, inspired by traditional Chinese doors. But next to the doorway an exterior pond connects visually with another pond in the entry court, setting up the expectation of a series of unfolding interior spaces.

Once in the large reception hall, the house reveals itself to be more domestic than the initial distant views suggested. The client had wanted a 'tropical' house, with adult and children's areas separated in different wings. The result is a kind of modernized 'plantation' house open to an expansive garden and pool area, and designed for cross-ventilation with a mix of large timber-framed glass sliding doors and vertical timber-framed windows, reminiscent of traditional hook-and-latch windows, but twice as high.

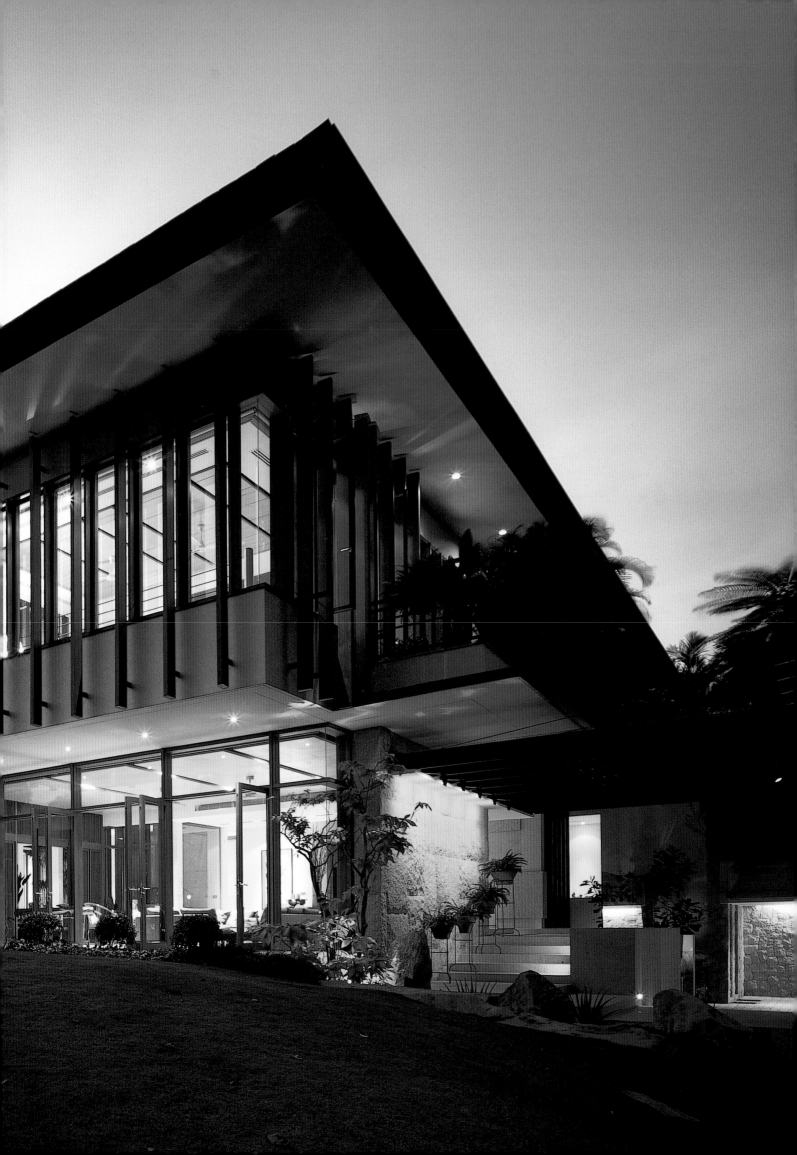

Site plan

Opposite The small powder room off the main entry is an exquisite space with Chinese lacquer box joinery and direct exposure to the external environment.

Below Upon arrival at the house, a sense of ritual is created by a grand *porte cochère* and ceremonial steps leading to the entry terrace and front door.

Section

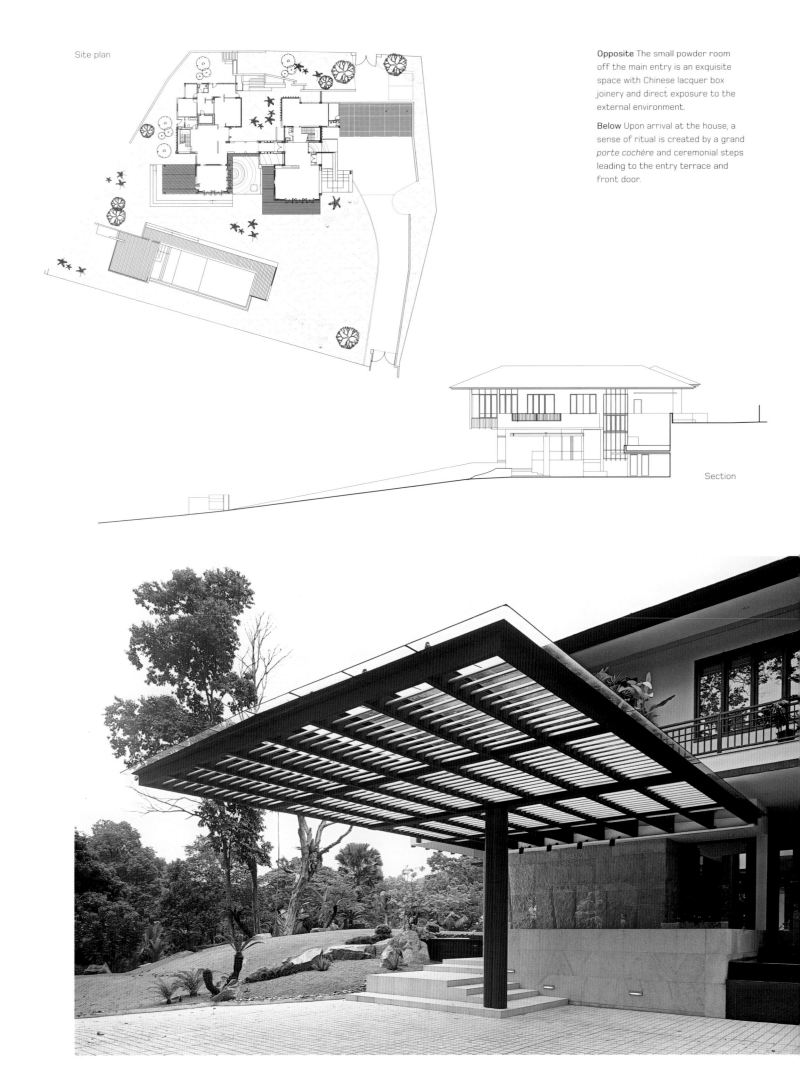

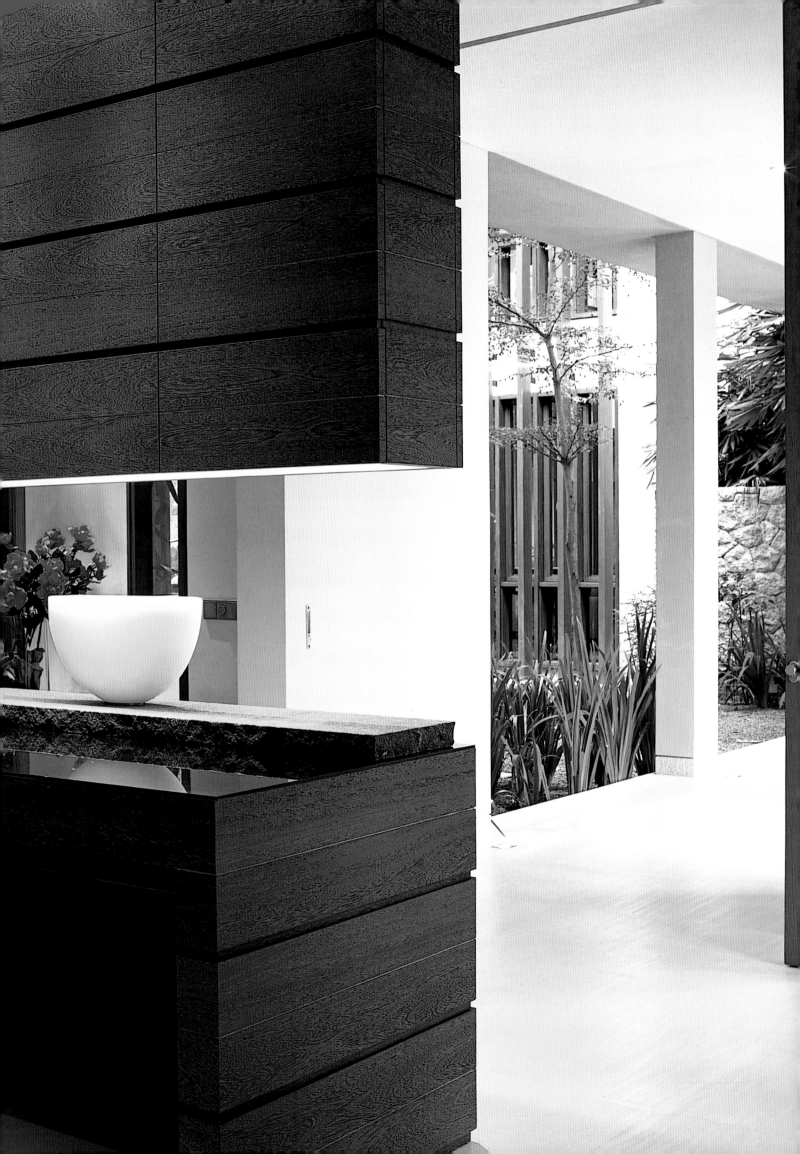

On the ground floor, two pavilions are linked by an open gallery with views across the internal pond to the garden. In the first (eastern) pavilion a large fully glazed living area is off to the left, and an entertainment room is to the right with views across the entry court to the pond and garden. The powder room is itself an exquisite space… entered through a solid walnut door, folding glass doors open out to an intimate bamboo garden courtyard. The concealed timber details simulate a Chinese lacquer box opening up to a red, colour-backed glass lining. The second (western) pavilion contains a formal dining room on the garden side and an informal dining area, which is an extension of the link gallery, but screened by a beautiful piece of sculptural joinery topped by a sculptural light fixture. This area leads on to a terrace and tropical outdoor dining pavilion. The kitchen off the informal dining area is not a typical Asian kitchen, in that it does not have separate wet and dry areas. Like the entertainment room, it looks out on to the rear courtyard through pivoting, vertical timber-framed windows.

Upstairs, two bedroom wings cantilever out towards the garden with generous overhangs. The linking corridor leads into a larger space, and the two come together to make up the heart of the house, as it is here that the family relaxes with a sitting area, a games room and computer work stations.

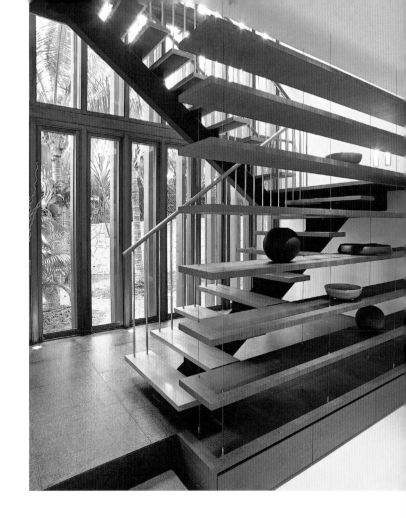

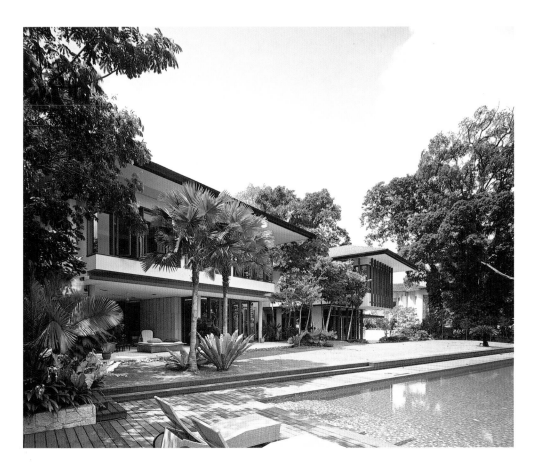

Above The suspended stairway linking the ground floor to the bedroom level maintains connection between the internal and external spaces. A finely crafted exercise in joinery has resulted in a combination of stairway and ornamental shelving.

Left The view looking back from the swimming pool and expansive lawn reveals a truly tropical house embedded in a lush garden.

Opposite The informal dining area looks back through opulent open joinery and an internal gallery to the rear courtyard.

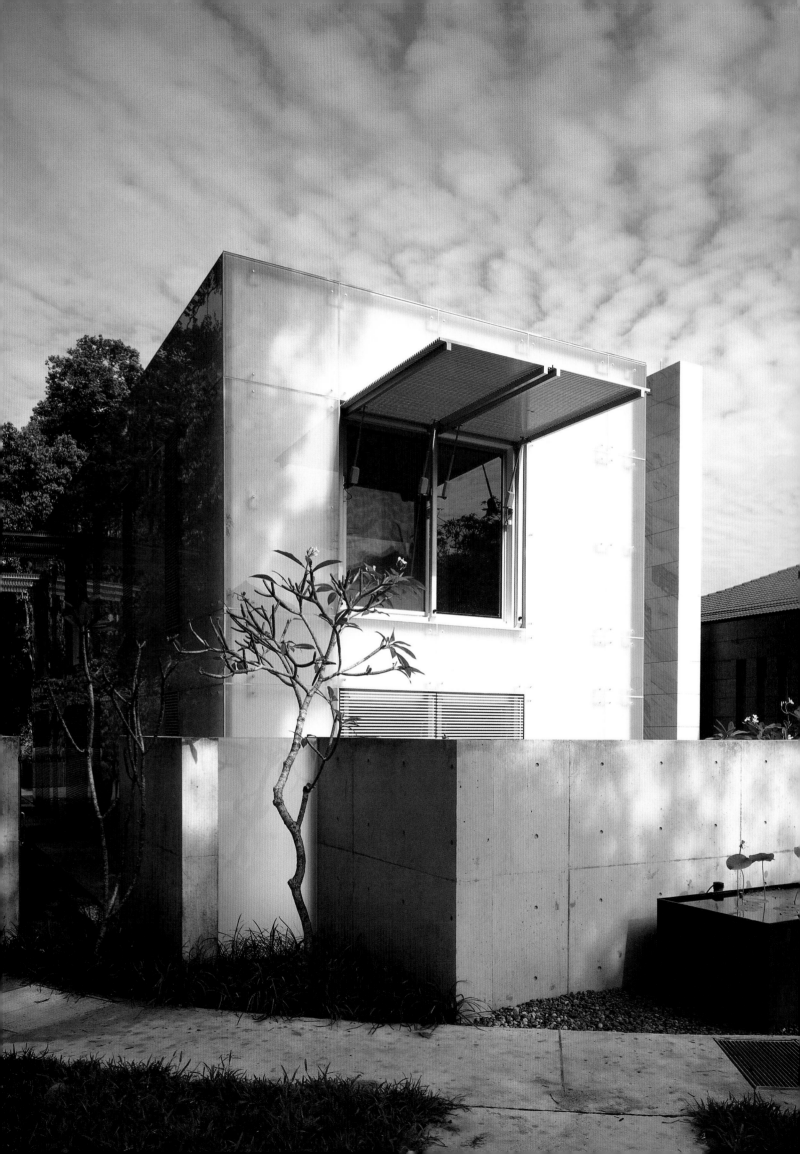

Left As viewed from the street, the softly coloured bedroom pavilion can be seen as a homage to traditional bungalow living, clearly expressed in the simplicity of its form.

Right This boldly contemporary house also offers moments of traditional tropical living, especially in the landscaping. The external courtyard between the two main pavilions comprises a shallow pool, whose water flows gently into circular plantings of bamboo.

white house park house

This is a house that can be almost anything one wants it to be. It offers a variety of different journeys, different spaces and different ways of living. In other words... it is not just one world, but a kind of mini-universe containing a host of alternative worlds.

WHITE HOUSE PARK HOUSE

SINGAPORE

ARCHITECT HANS BROUWER

According to the architect, the house has three narratives. It certainly possesses a multitude of ideas, and the journey through the house is a constant unfolding of these ideas, which are eventually woven into a single, coherent- albeit variegated - experience. At its simplest, the house consists of two connected pavilions – bedrooms and living - set on a curving corner site, with the living pavilion oriented to borrow the view opposite of an attractive, hilly and forested block of state land.

The first of the narratives is a clear delineation of served and servant spaces. The second derives from the clients' love of bungalow living… that is, living on one floor. Hence, the bedrooms are contained in one pavilion, distinctively clad in silk-screened frosted glass punctuated by a series of narrow grille windows, while the family living area is on the ground floor of the second pavilion.

Above Slender fritted glass louvres substitute for balustrades to the living room stairway, adding a distinctive and elegant decorative feature.

Right above A monumental Cor Ten rusted steel wall is an emphatic gesture, which defines the house's relationship to its corner site. A doorway cut through the wall deliberately frames the trees in a neighboring garden.

Right below The second floor family room has a surprising intimacy, created by the Cor Ten wall, which ensures privacy from the street and neighbours.

Following pages The living and entertainment pavilion floats out over the pool, a vista dramatized by the huge Cor Ten wall thrusting through the house. The bedroom pavilion glows softly in the background.

The upstairs is reserved for entertaining. The third narrative is of contrasting spaces - inward and outward-looking spaces - and contrasting materials. In this respect, the most dramatic element is the massive rusted Cor Ten wall, which begins as a sharply faceted blade wall on the outside of the living pavilion near the pool, cutting through the building to form the rear wall of the living pavilion to emerge on the other side. From the street, this dark backdrop gives definition to the fully glazed volume of the interior.

Entry to the house is through a dedicated pedestrian walkway into a transitional water garden court, which is clad in expressive Volaksas marble from Greece. This leads to an intersection point, where a choice is made as to which pavilion to enter. Entering the bedroom pavilion is through a narrow corridor with a double-height slot window and cantilevered timber stairway. Responding to its street exposure, the master bedroom uses aluminium

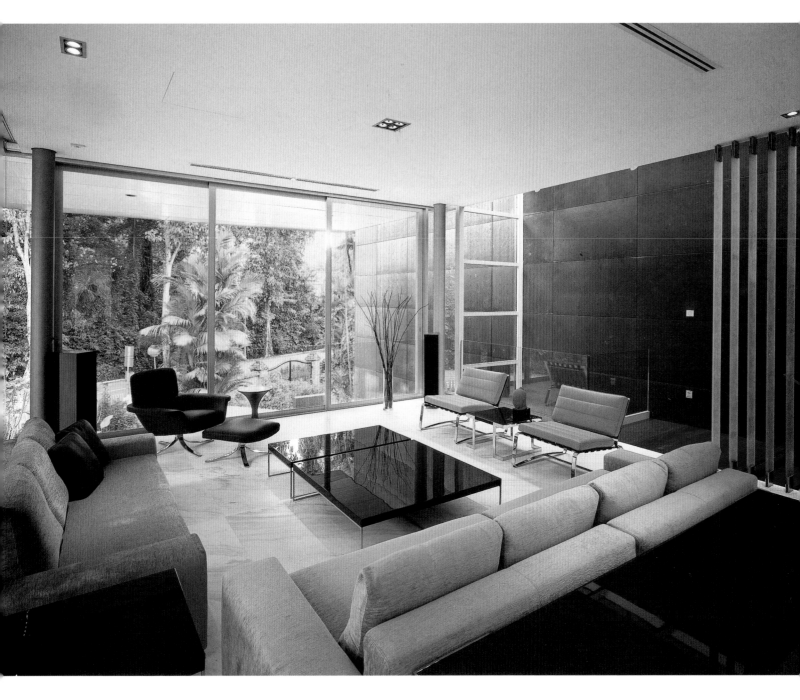

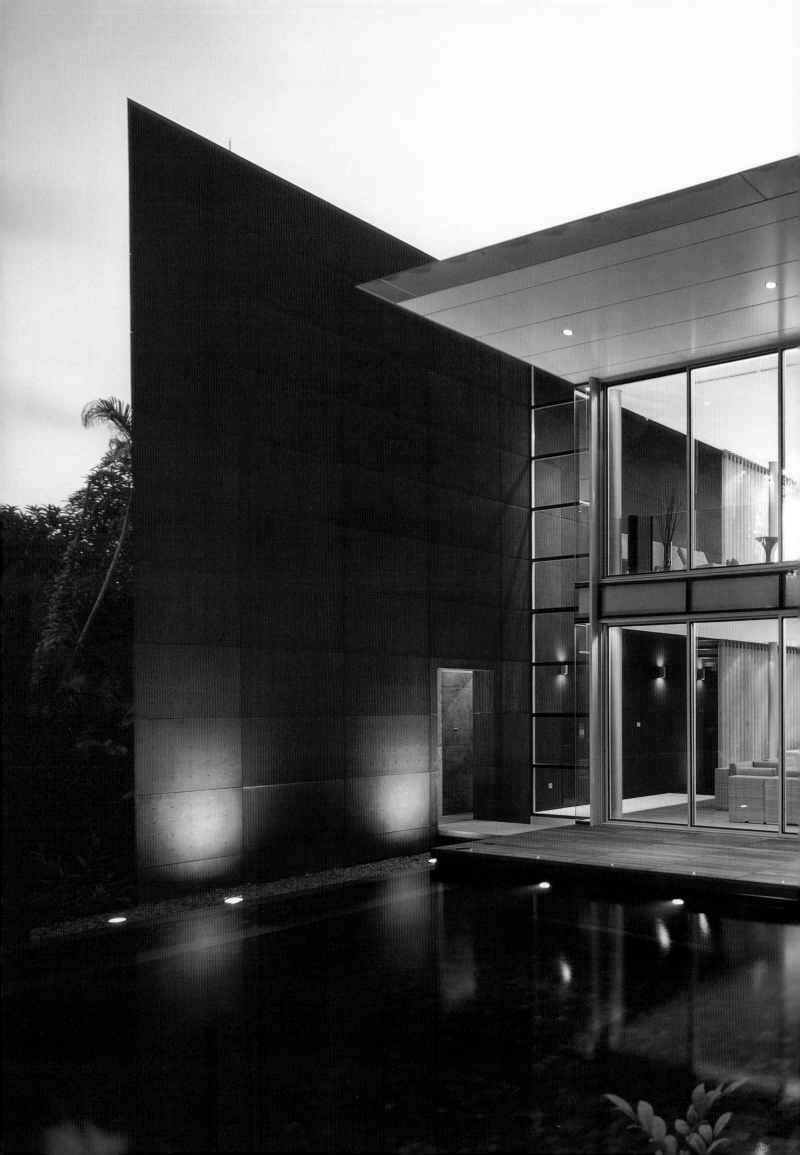

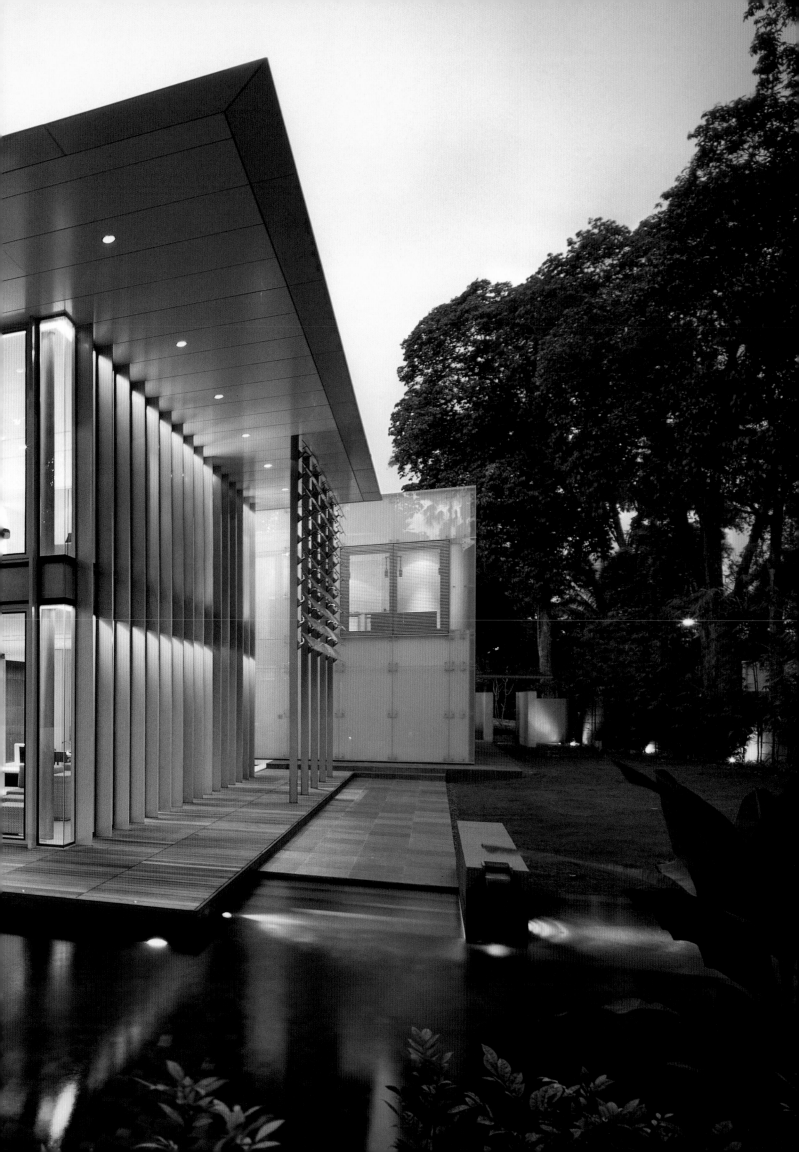

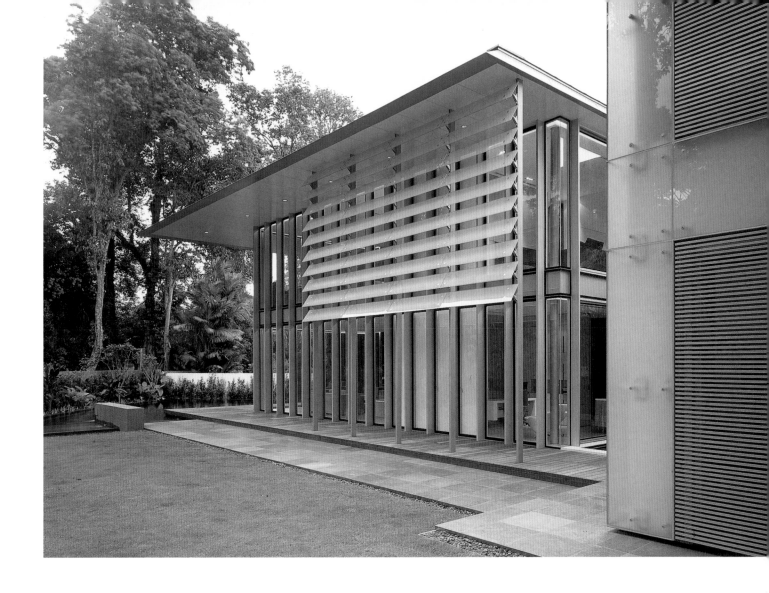

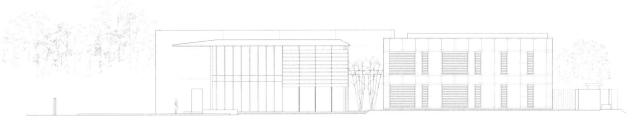

Left and above The living pavilion is screened from the southern sun by intricate louvres of translucent glass. The supporting framework introduces a beautifully detailed high-tech element to the pavilion's overall composition.

privacy screens, which are motorized to act as sunscreens. On the upper level there is a rooftop terrace and a link to the entertaining area.

The journey of contrasting materials is continued by fritted glass louvres, which screen the living pavilion stairway, by Indonesian slate for the swimming pool walling, and by China granite for the street wall. The kitchen is on a mid-level at the rear of the living pavilion, clearly separating it from the other spaces. The pool wraps itself around the corner of the house as a circular segment, with a gym and sauna behind the Cor Ten blade wall. Downstairs, in the basement entertainment area (soundproofed for music and parties), the pool is visible through a large, below-the-surface viewing window.

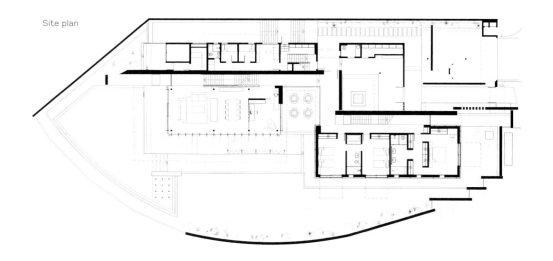

Site plan

Below The entry court, with a soothing water garden surrounded by marble-clad walls, is a transitional space before entering the house itself.

Right above Fritted glass louvres partially screen the suspended stairway in the living pavilion.

Right below In the living pavilion, a fabulous underground entertainment room has a horizontal slot window looking into the swimming pool.

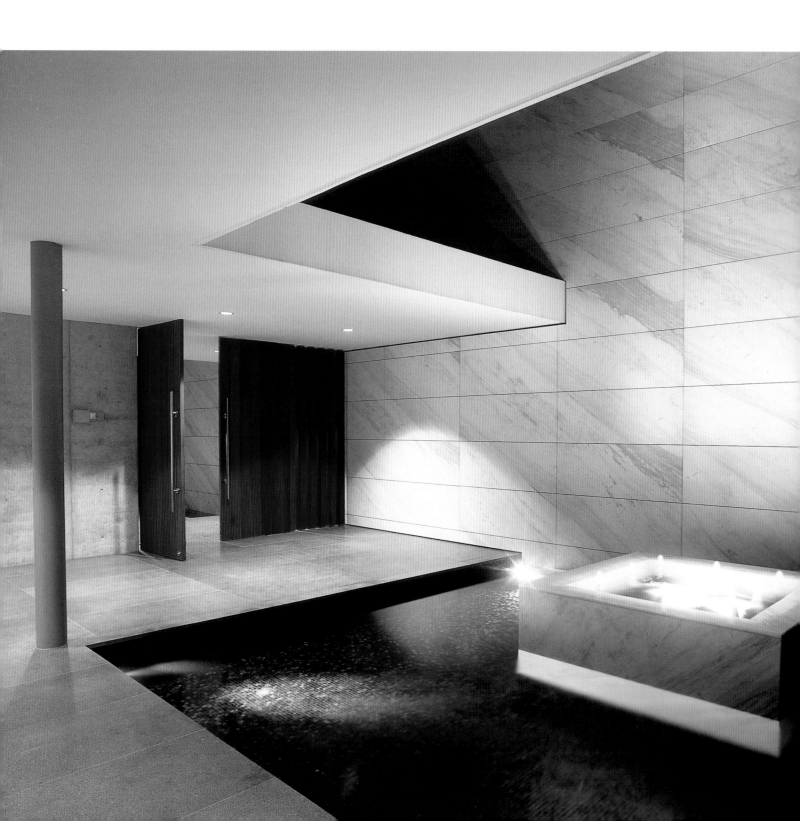

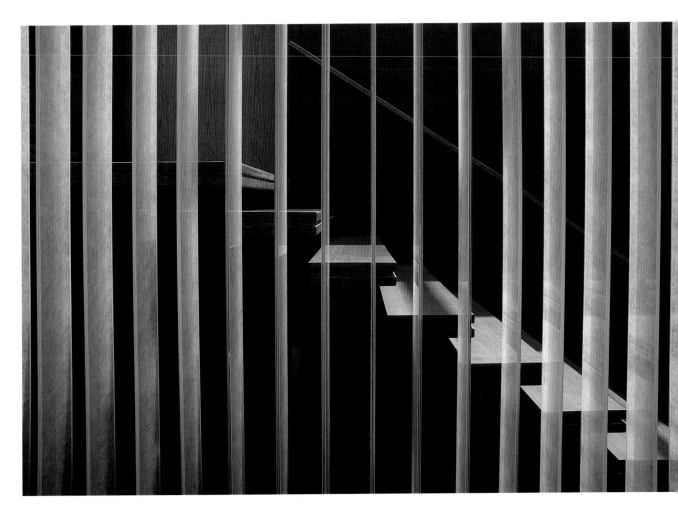

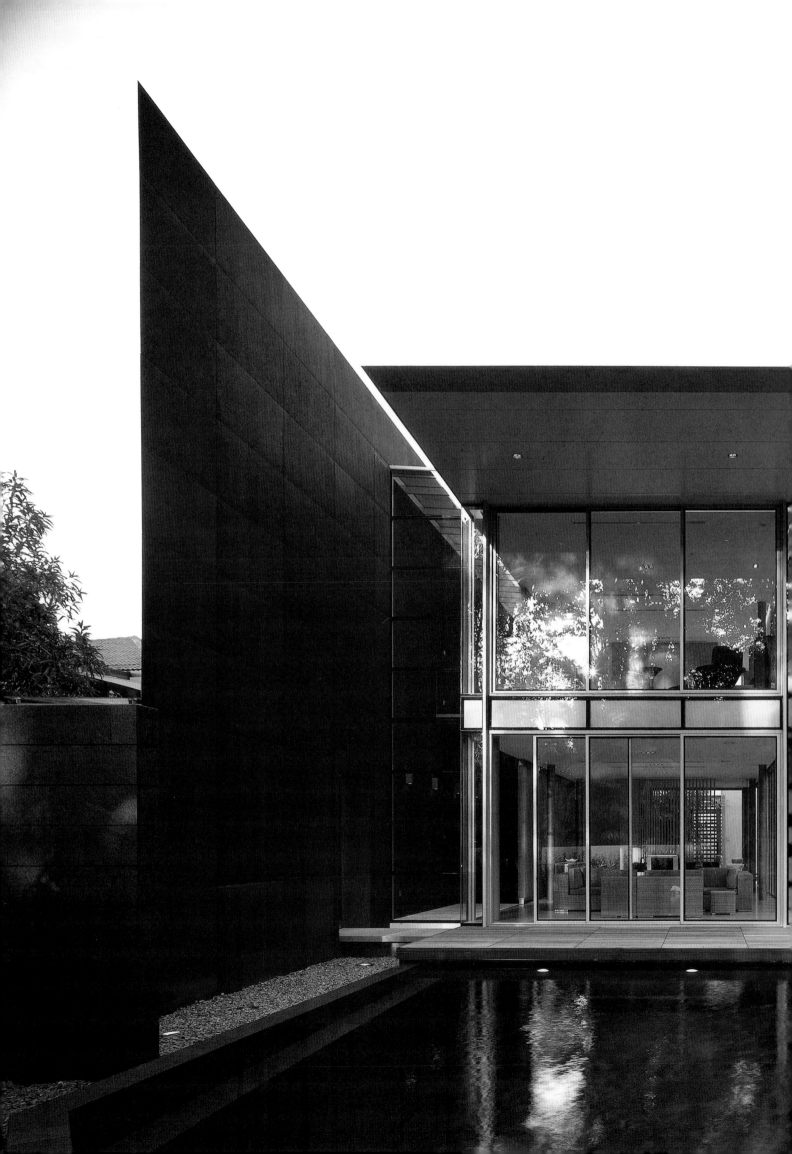

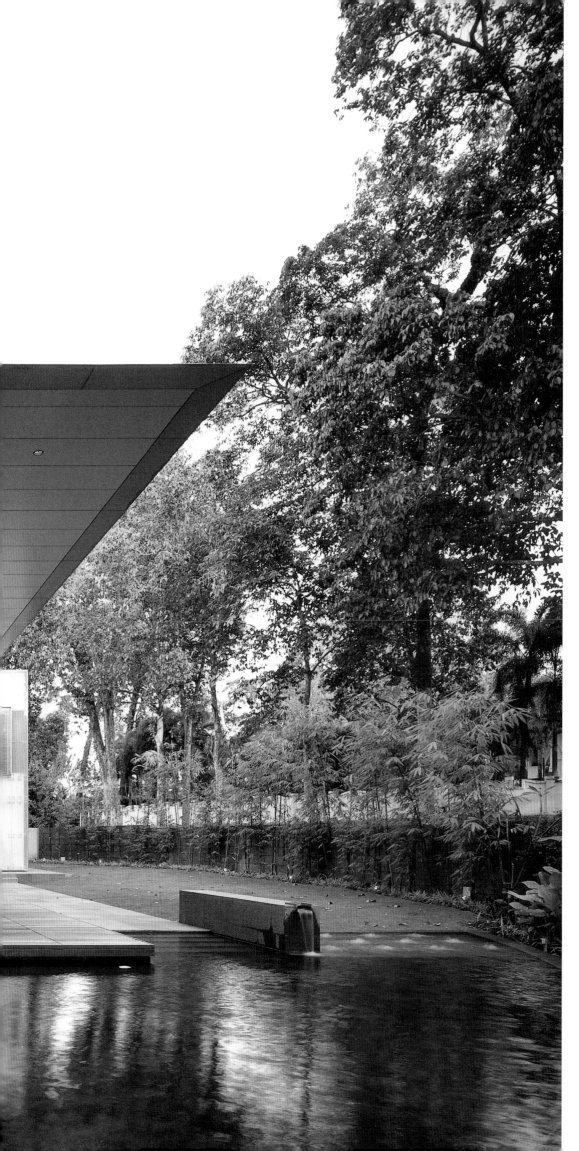

The dynamic sculptural composition of the house is clearly expressed when seen from the west. The razor-sharp profiles of the Cor Ten wall and the massive eaves have created a residential landmark.

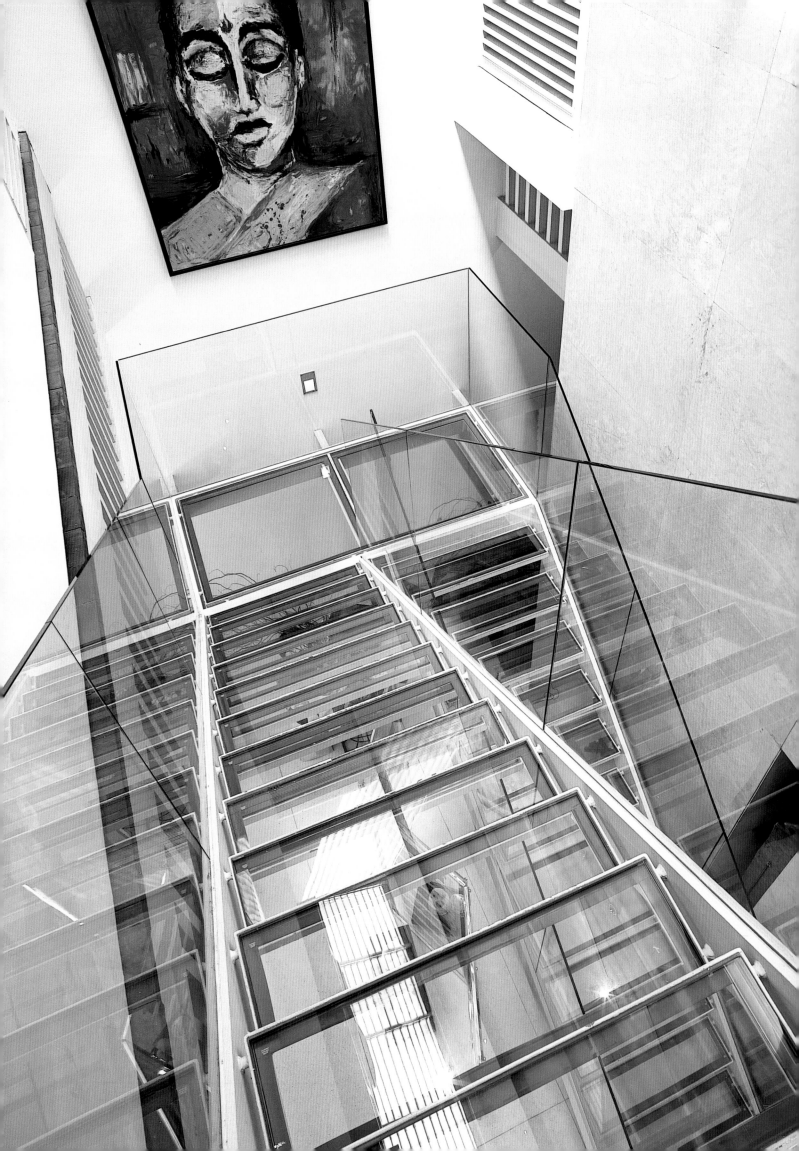

Left Transparency is literally taken to another level with a glass stair-case, balustrades and floors, which draw light down into the heart of the house.

Right In a typical gesture, Ernesto Bedmar has placed a Buddha's head face up in the central reflection pond, reinforcing the contemplative calm of the living areas in the shophouse.

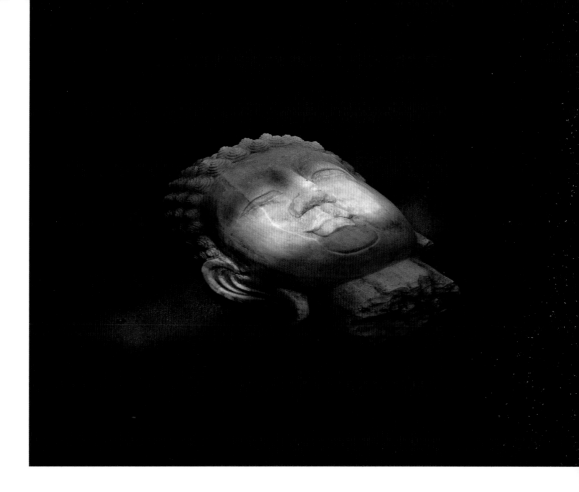

cairnhill road shophouse

From the busy street outside, the Cairnhill Road Shophouse appears simply as a well-preserved Peranakan shophouse. Inside, however, it is an oasis of tranquility and reflection, and a seamless marriage of contemporary living and a traditional home... it delivers the reassurance of belonging to a enduring culture and of all the benefits of modern living close to the heart of the city.

CAIRNHILL ROAD SHOPHOUSE

SINGAPORE

ARCHITECT BEDMAR & SHI

The Peranakan shophouse is a traditional form of row housing, consisting of a long and narrow sequence of spaces between two party walls with an air well in the middle. In this case it is entered through a small forecourt off the street into the front room, which was traditionally used for business and screened off from the domestic spaces beyond. The front façade has been restored by the architect to conform with heritage regulations, but he has added an addition at the rear where a lush hill provides a sense of sanctuary and a ready-made garden.

This conversion by Ernesto Bedmar (an Argentinian who established a partnership in Singapore with Patti Shi in 1984) is unapologetically modern; for example, the use of metal doors and shutters rather than timber shutters, except for the new family room at the rear, which has moveable timber louvre panels. But this sets up an intriguing conversation between the original elements and the

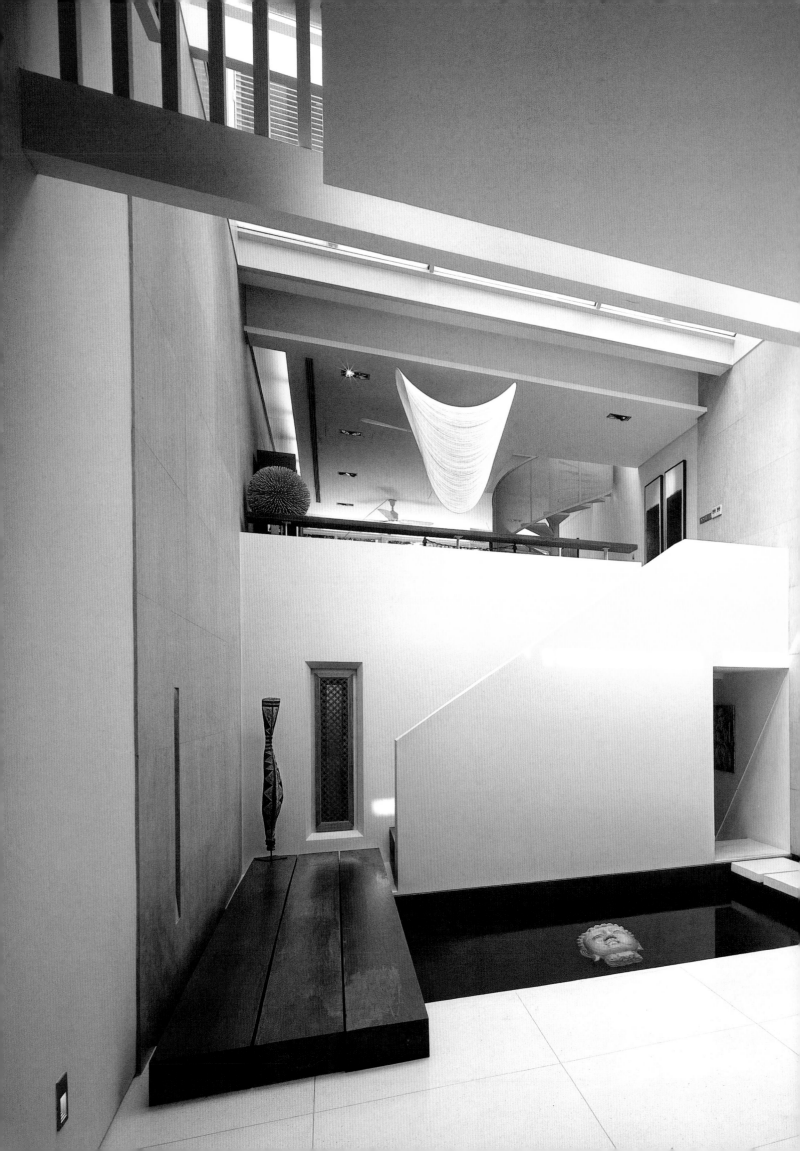

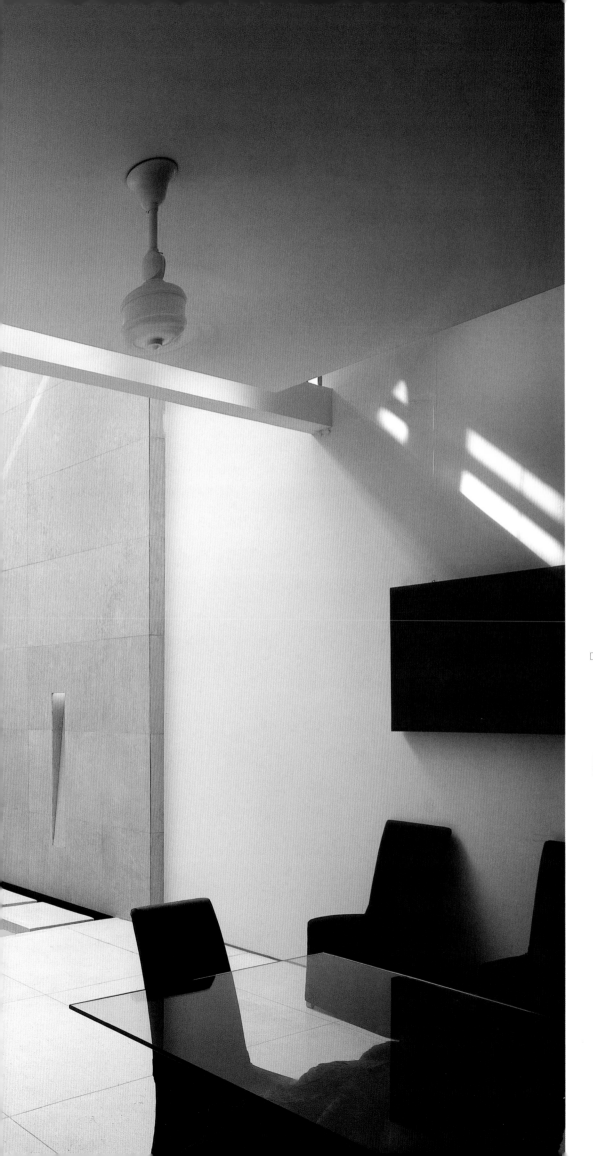

Ground floor plan

A soft light suffuses the central atrium from a skylight above, and from the generous glazing of the new addition.

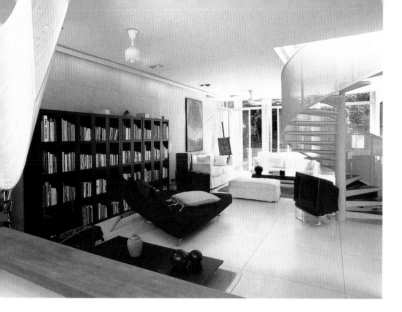

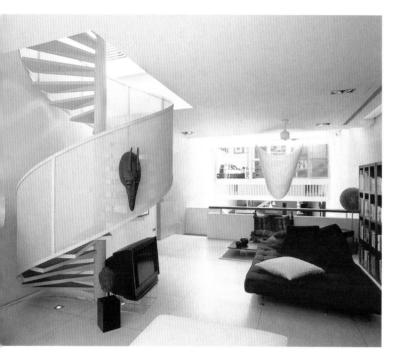

new, between past and present, enhanced by a rich texture of internal cross-views. These cross-views result from the creation of split-levels for both the front and rear 'blocks', which connect visually with one another across the radiant glass-topped central atrium, through which daylight pours in. Light also pours in from the skylight above the front block, washing down into the master bedroom, then filtering through the transparent perforated ceiling into bathroom below and into the baby's room below that. A skylight in the rear block has the same effect.

The heart and soul of the house, though, is the atrium… a sublime space, which seems to be simultaneously inside and outside, a public and a private space, and a gathering place. It is an extension of the dining area, and a place of quiet contemplation with its silent reflection pool and mysterious Buddha's head lying inscrutably on its side in the water.

The new interior is kept very simple, with a straightforward articulation of space and a restrained palette: the emphasis is on creating a contemplative refuge illuminated by soft natural light. The meditative atrium space maintains a connection with the inner world, just as the new family room at the rear is connected by generous windows to the borrowed garden outside: all forming a contemporary adaptation to a long cultural history.

Above The family room in the new addition at the rear enjoys the 'borrowed' external garden with total privacy, and looks back across the atrium to the original shophouse building, connected to it by a shared transparency.

Right Looking down into the central atrium space, which possesses a purity of geometrical form, tempered by the use of warm, tactile materials.

Opposite The atrium, defined by a shallow reflecting pool, has a serene temple-like quality, enhanced by the rays of sunlight whose angles change during the course of the day.

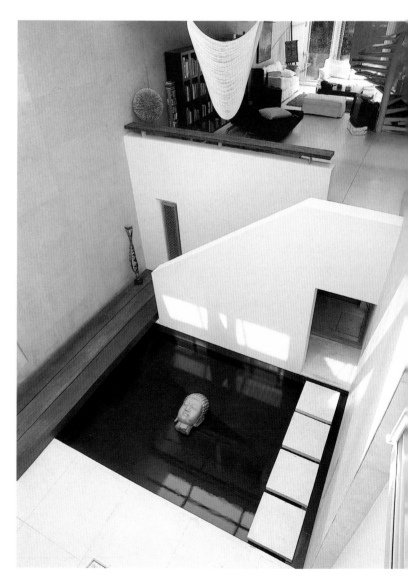

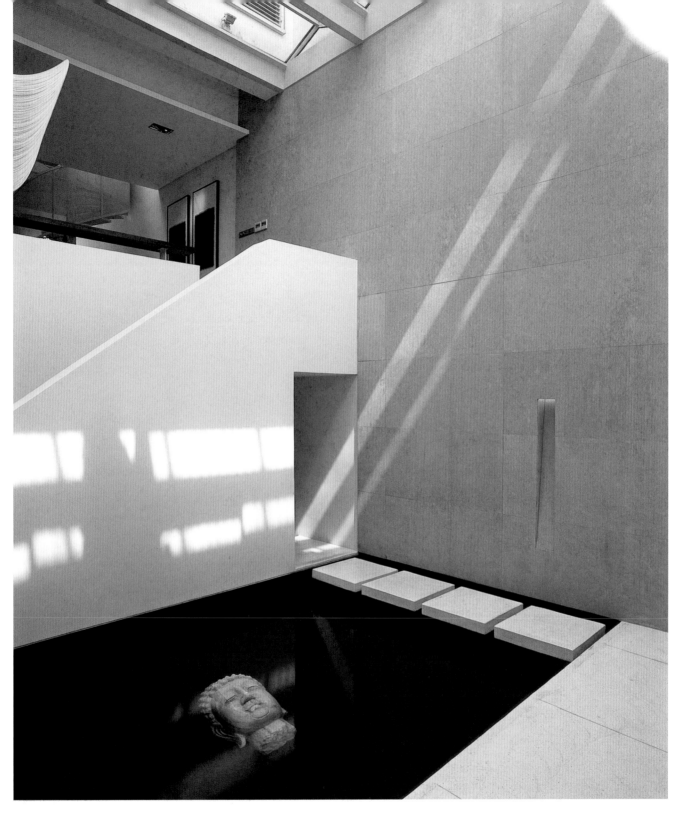

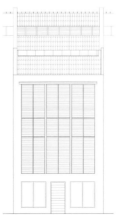
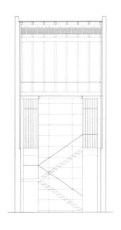

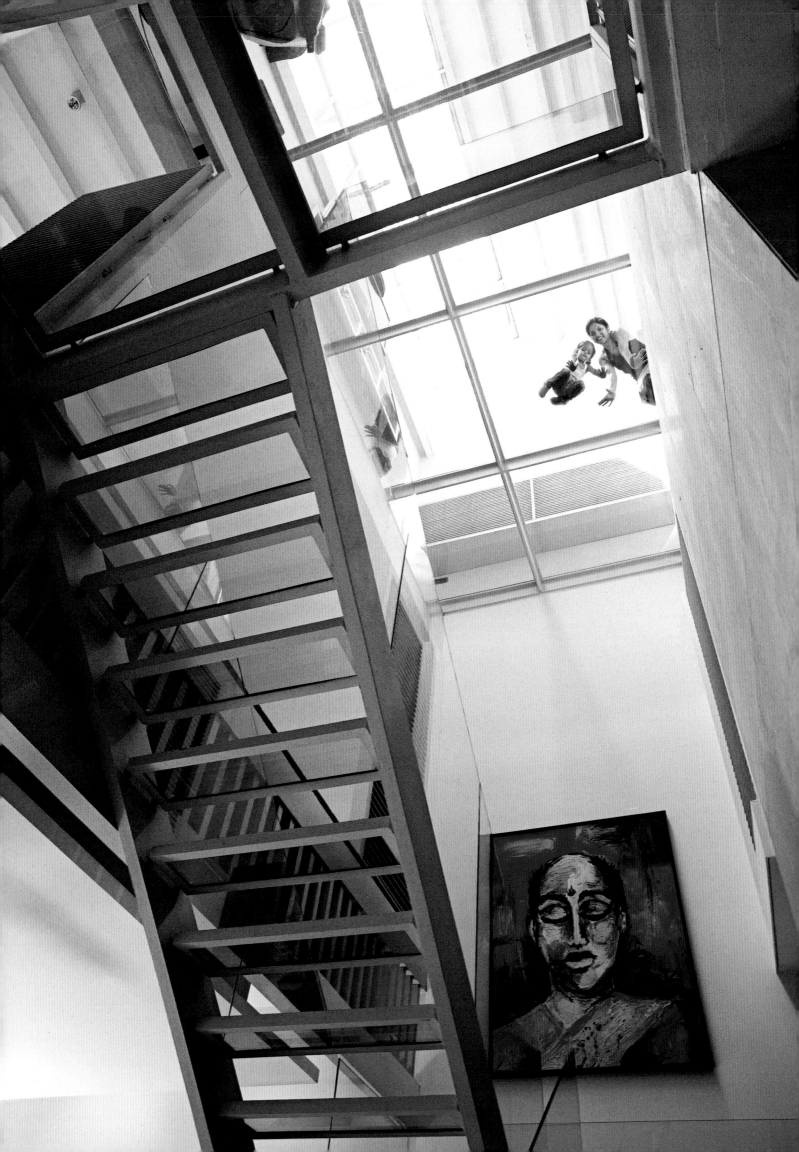

Section

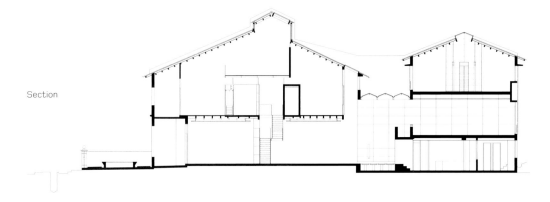

Left Ernesto Bedmar has illuminated the dark interior of the original shophouse by the bold and constantly entertaining use of transparent glass floors.

Right The master bedroom in the attic space of the original building has a clear glass floor, which forms the ceiling of the bathroom below.

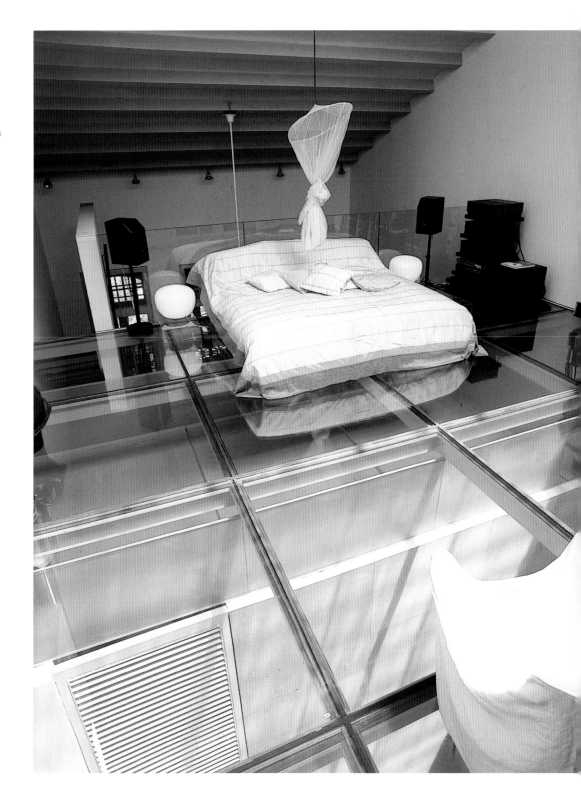

khai house

The Khai House is a restrained, though beautiful, resolution of house and site, form and function... and reflects the perfect fit of a client and an architect who agreed from the start that composition would take priority over function, and that the design should evolve as part of a continuing conversation between the client and the architect.

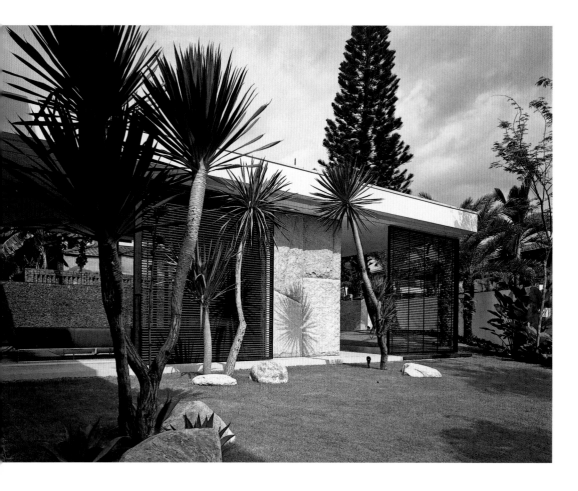

Left Seen from the carport entry to the house, the living pavilion is completely transparent, with views through to the sloping grass wall and swimming pool on the eastern side.

Right The two pavilions form a perfect fusion... intersecting planes and internal spaces flow seamlessly into one another.

Following pages The luminous living pavilion is defined by a faux chimney at the near end and a wall of massive granite blocks at the other, repeated on the exterior where the poolside bathroom is entered through a monumental granite door hidden in the wall.

KHAI HOUSE

SINGAPORE

ARCHITECT K2LD

The house also enjoys a perfect fit with its western-oriented, triangular corner site. There are two entry points from the street, at either end of the triangle's base. One is the carport, where three timber fins signal arrival and provide partial screening of the garden. These fins also disguise structural columns supporting the cantilevered upstairs bedroom level. The other entry is intended to be the real arrival point for guests... from its elevated position, it reveals at a glance the elegant composition – two pavilions forming an off-centre T-shape – of the house. The 'stem' is the living pavilion, which appears to slide perfectly under the upper level of the cross-bar. Glazed on its east and west sides, it is otherwise clad in granite, roughly hewn at one end and forming what seems to be a residual chimney at the other end, which is more finely honed and

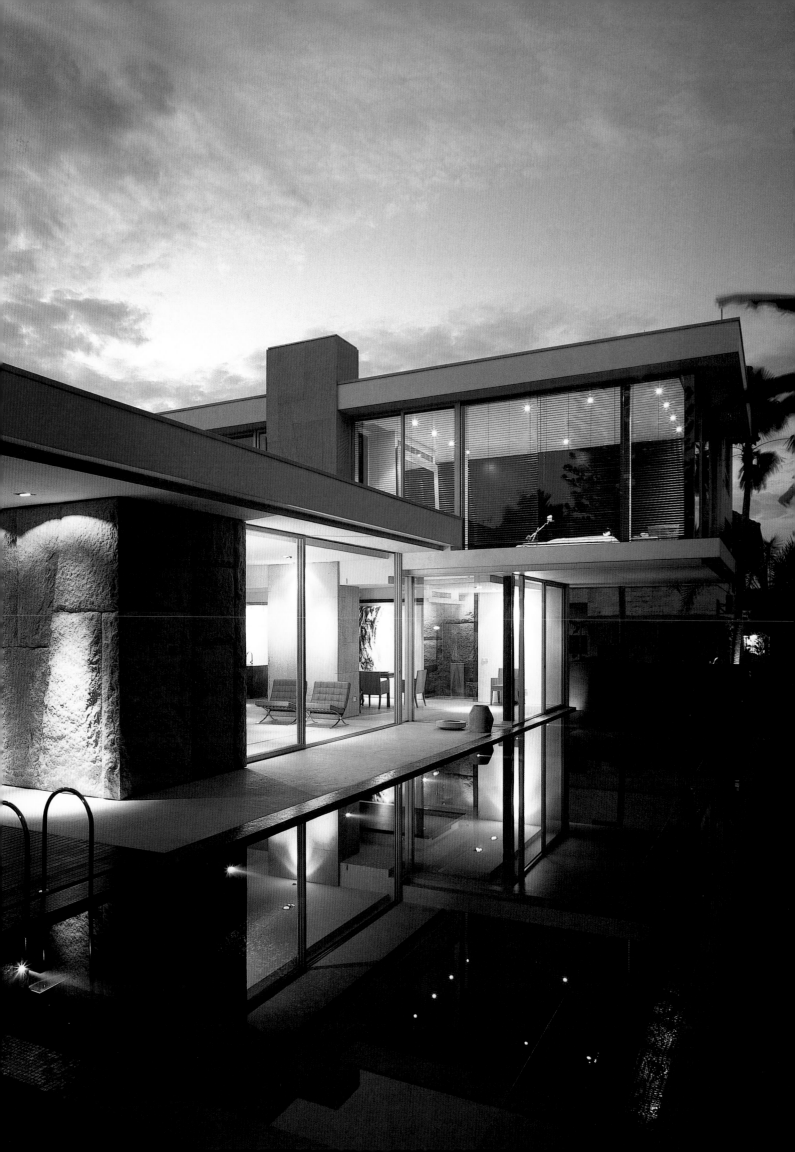

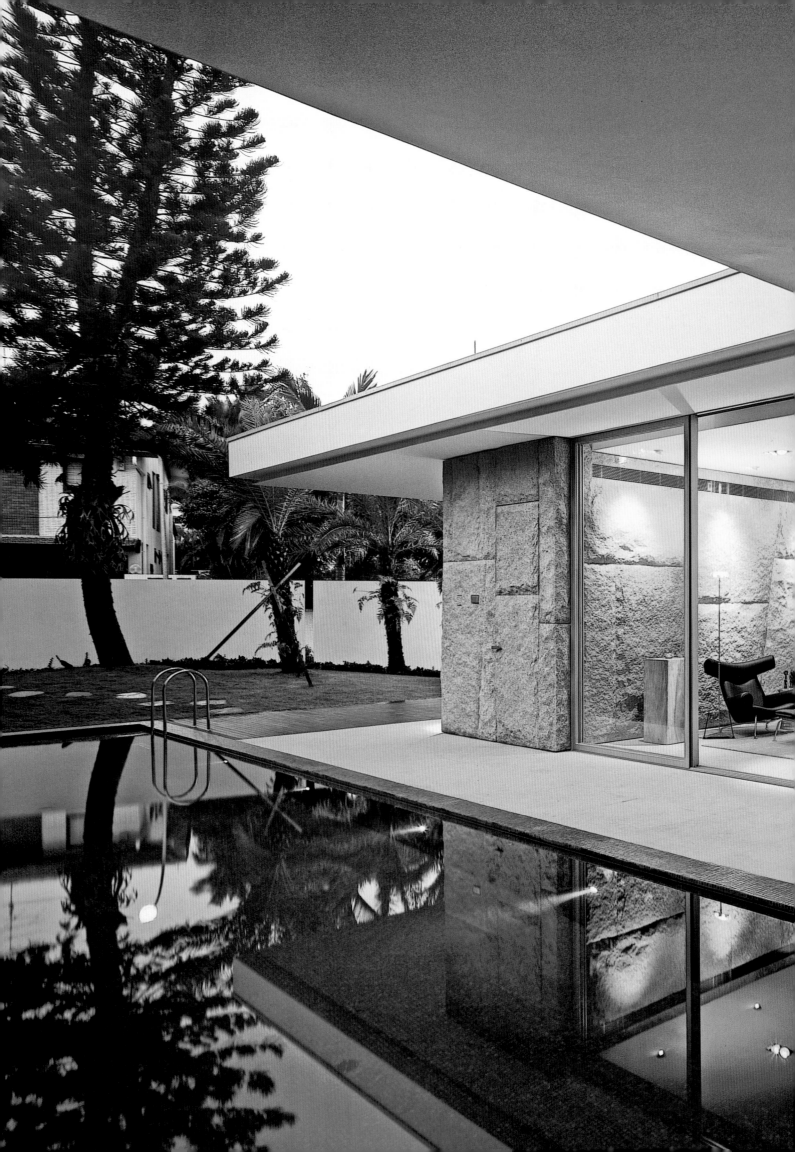

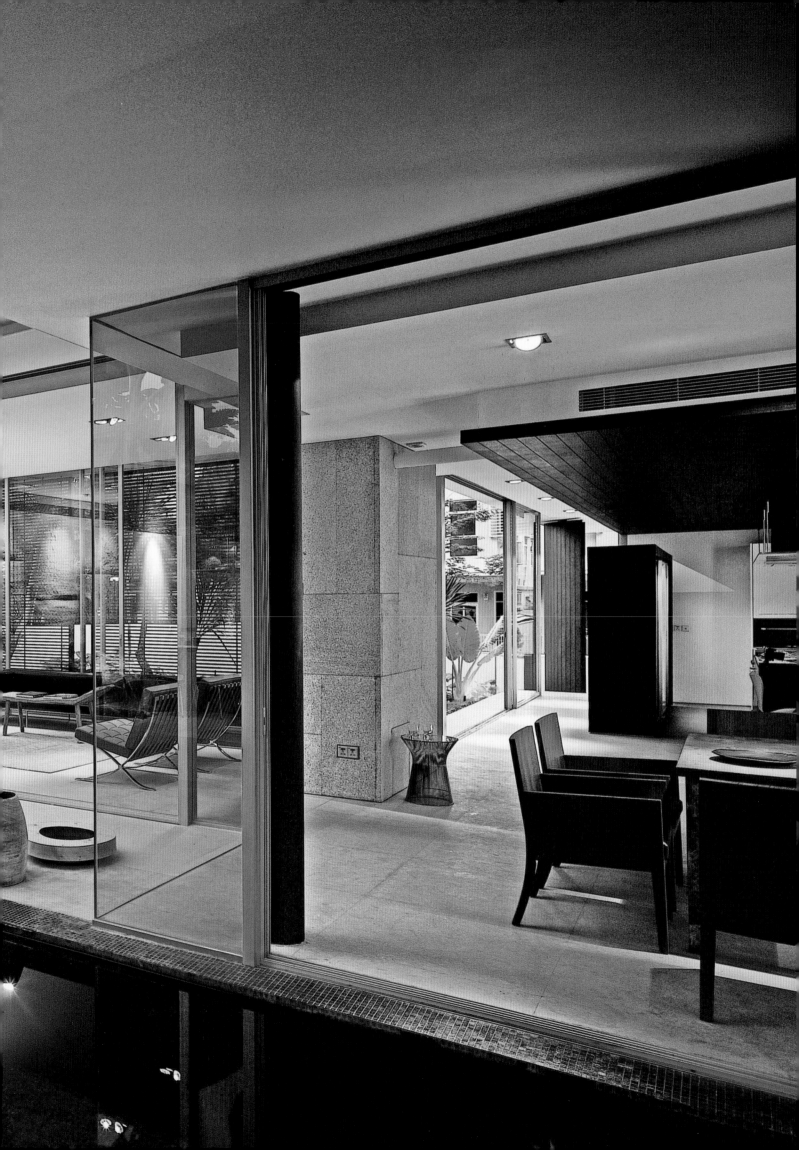

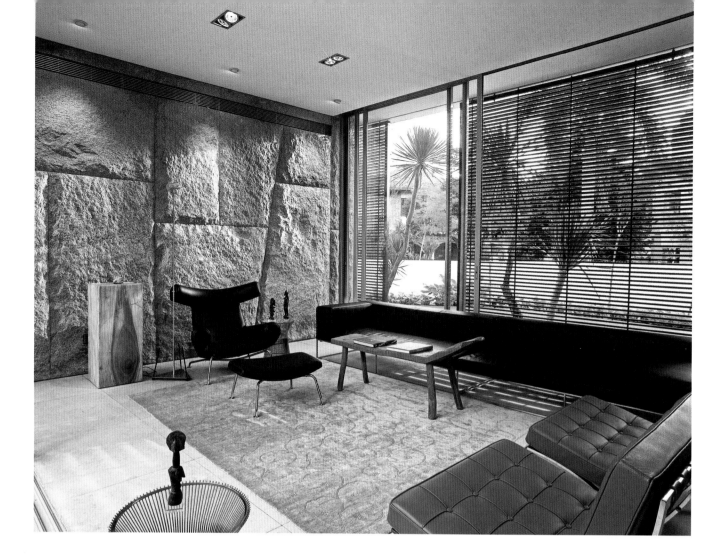

Section

Above The living room is a bold and rich arrangement of materials and shapes... a granite wall contrasts with a limestone floor.

serves to divide the living area from the dining area.

The ground floor of the main pavilion is a single open space, fully transparent, with the kitchen and services clustered at the western end and partially screened from the garden by a frosted glass kitchen storage unit. The dining area looks over the pool, which runs through to the rear of the pavilion before cascading gently down the wall into the lower court. This is the basement area, which contains an external drying area, a study, a bedroom and the maid's quarters. Bedrooms occupy the upper level of the main pavilion, which cantilevers out at either end. The connecting spine along the northern side of the building also acts

as a gallery for the client's art collection.

The beautiful composition of intersecting forms is repeated in the equally refined use of contrasting materials. The natural materials – granite cladding inside and out, Spanish limestone flooring downstairs, the lowered Wenge ceiling in the kitchen/dining area, Patagonian Walnut joinery upstairs – soften and warm what could have been an austere exercise. Similarly, the geometry of the building is is held in counterpoint by such expressive gestures as the randomly fitted ceiling lights in the living pavilion, the open plan of the kitchen/dining area and the creation of a grass wall on the eastern side of the pool.

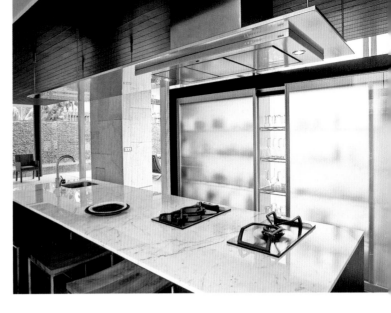

Site plan

Above A frosted glass storage unit acts as a wall on the garden side of the kitchen, allowing natural light to penetrate.

Below The bedroom wing cantilevers out towards the street to form the carport, supported by three timber fins.

Following pages The main bedroom cantilevers out over the pool, a floating transparent box set at a right angle to the similarly orthogonal open living pavilion below.

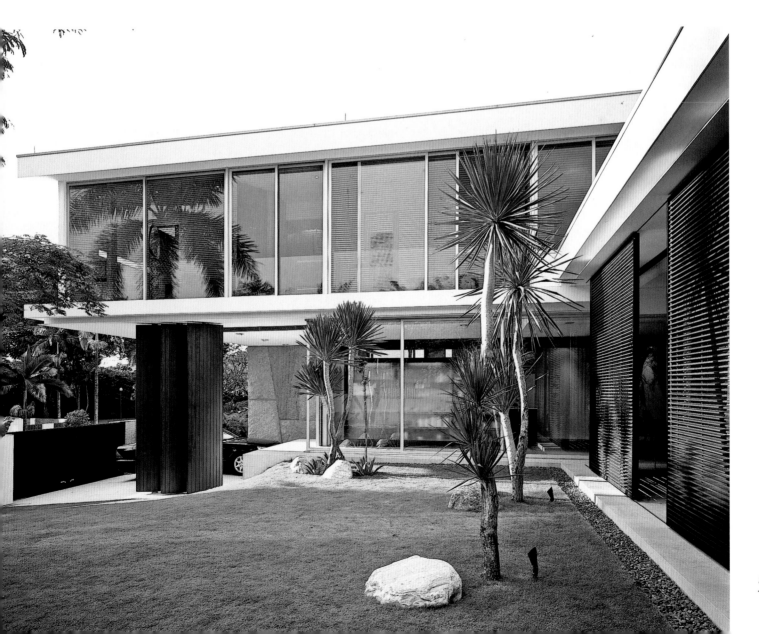

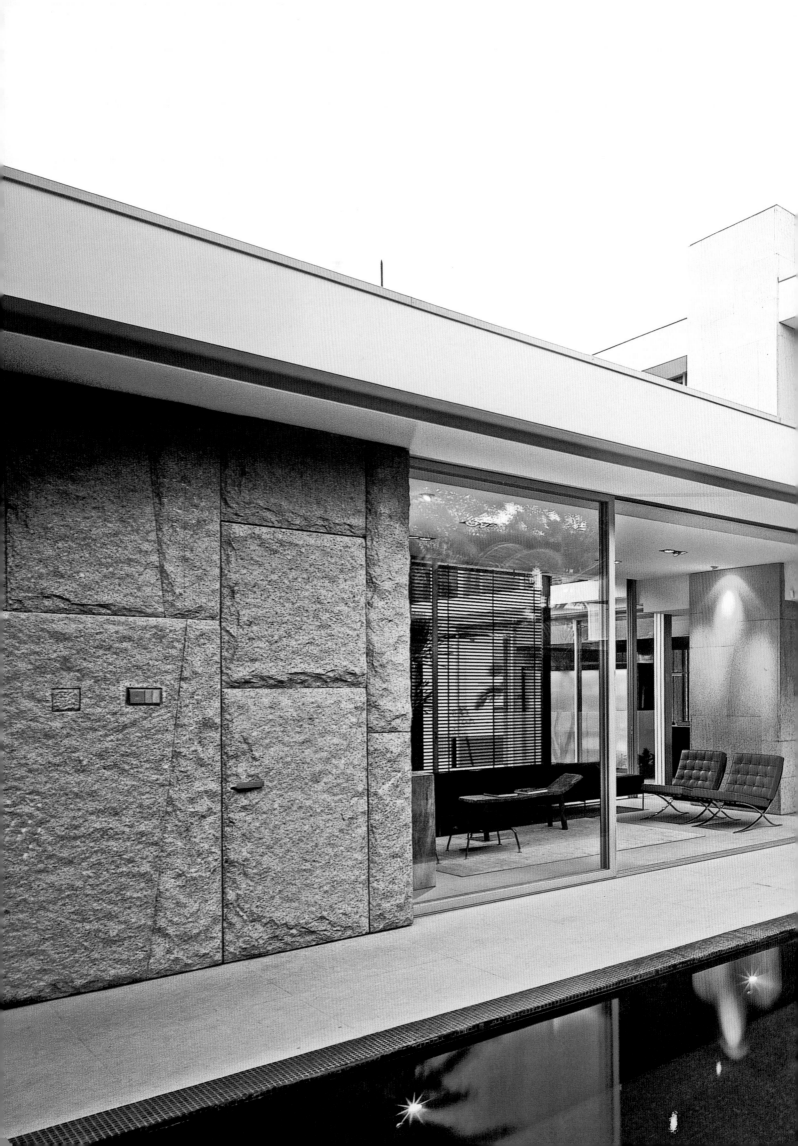

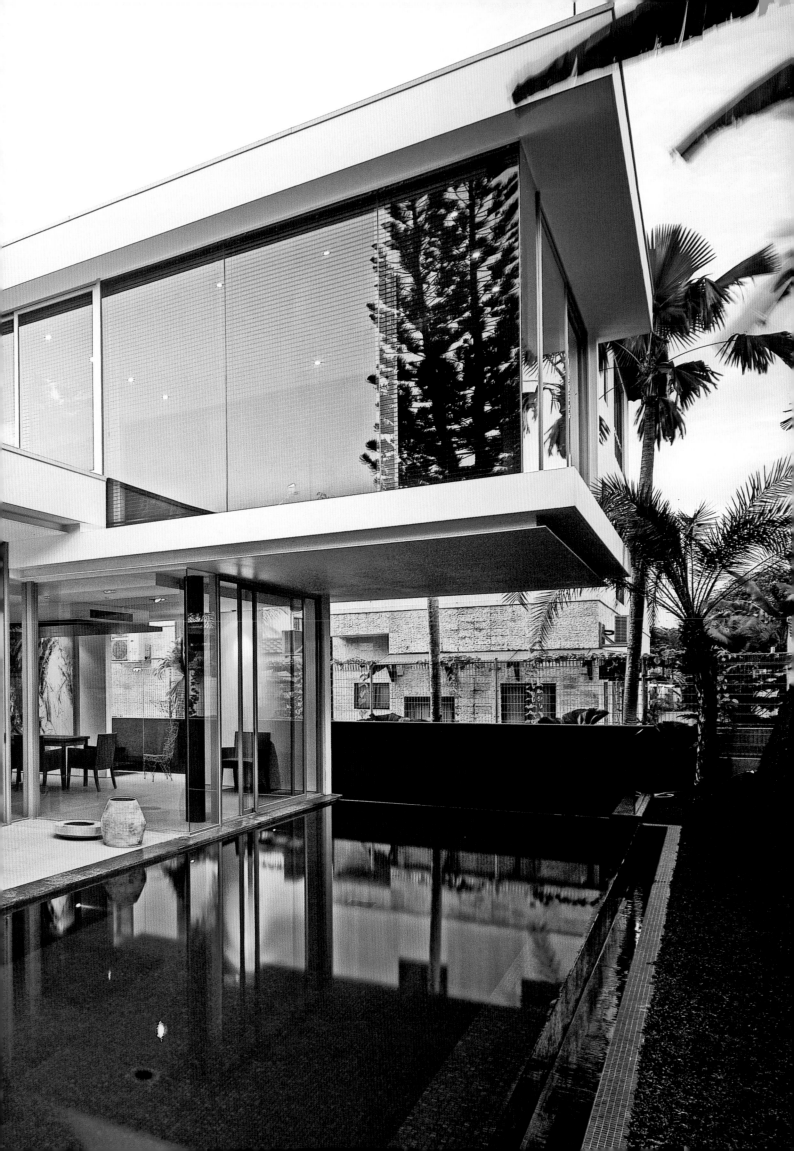

sunset vale house

This is a simple, self-contained house of flowing spaces, closely connected to its garden and surprisingly replete with private places. High levels of transparency and internal cross-views create a sense of space which belies the actual size of the house.

SUNSET VALE HOUSE

SINGAPORE

ARCHITECT WOW ARCHITECTS

At 6,000 square feet, the site for the Sunset Vale House is relatively small and the footprint of house occupies nearly all of it. But there is nothing claustrophobic about this exquisite house… the internal prospect of the house – through views and cross-views - is such that the individual spaces simply merge into a beautiful flowing whole. A key to this is the architect's strategy to bring the garden into the house, and this is crucial to creating a sense of continuous space. At the same time, it supports another strategy - to accommodate the tropical context within a modernist program.

The distinction between inside and outside is blurred immediately by the ground floor powder room, tucked away just behind the entry stairs… it is open to the sky, with a river pebble pond and a bold juxtaposition of granite, concrete and durian timber. The interior of the house responds to the way the site slopes down from the road: the compact living room looks out through folding glass doors

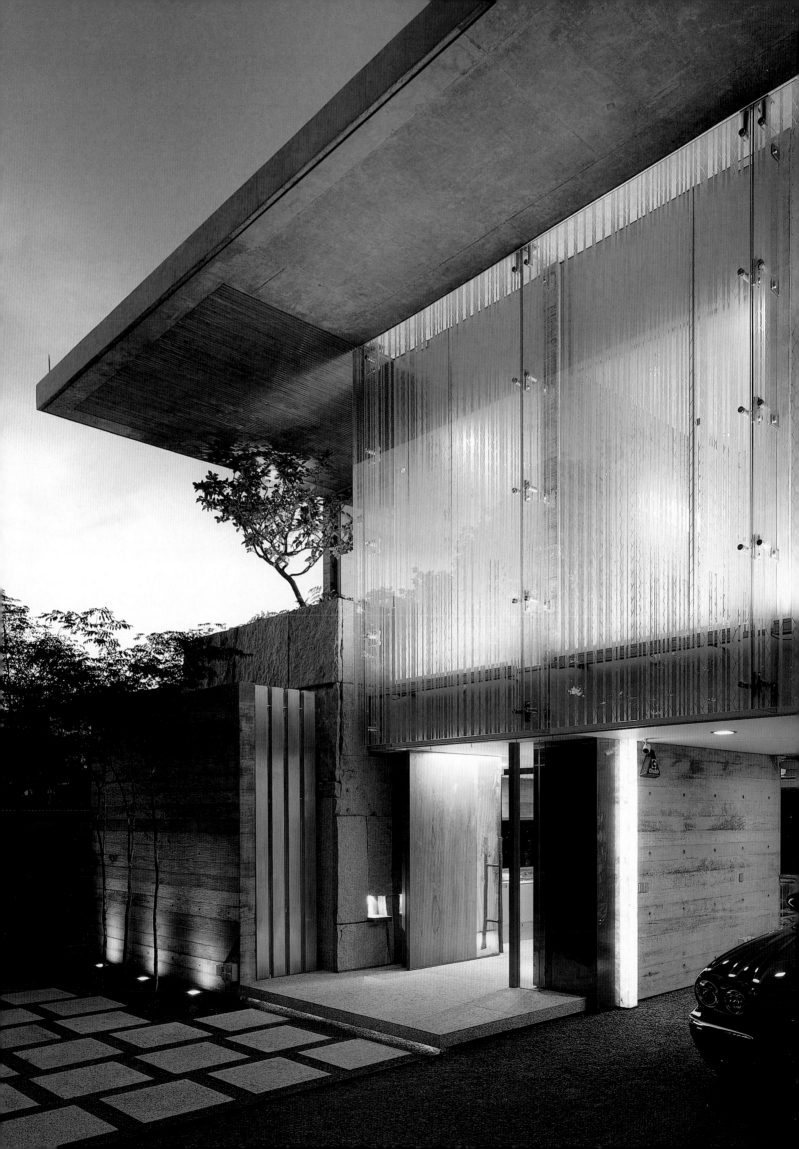

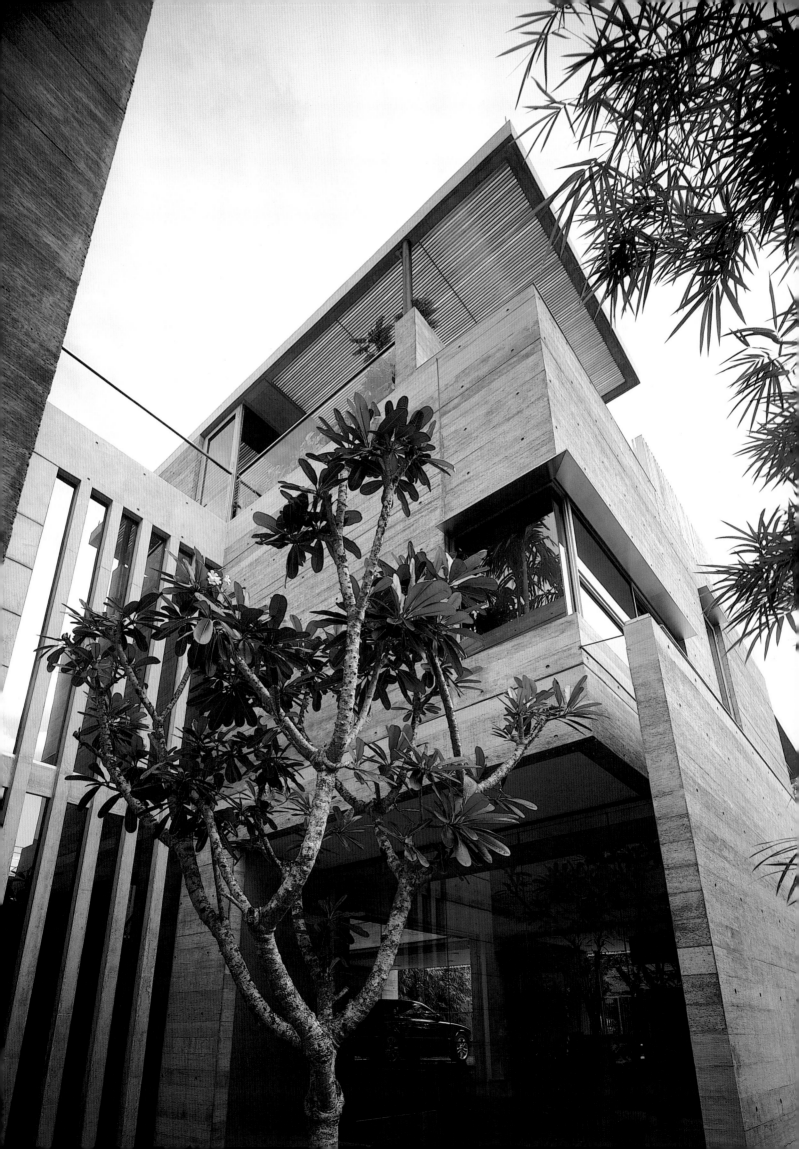

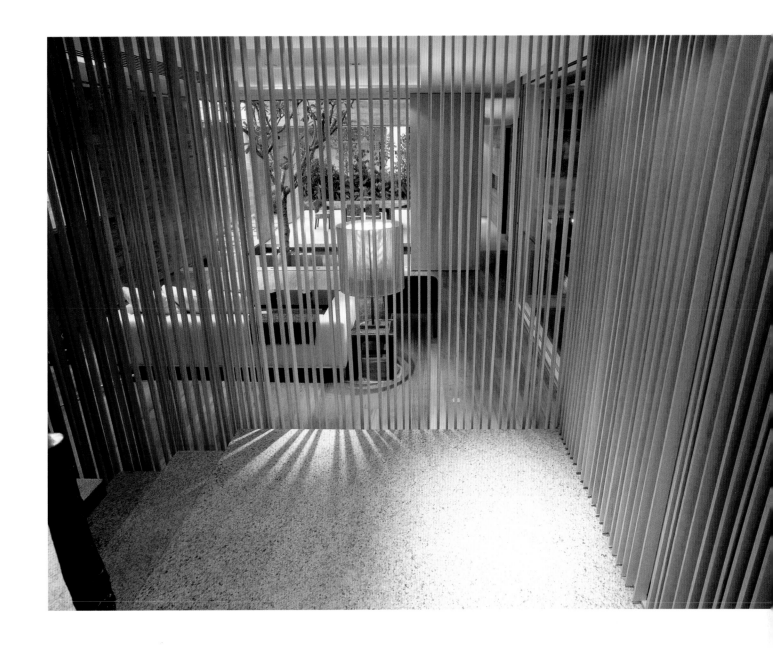

Left A frangipani tree rises from the central pond, marking a point of reflection in the journey through the house. The external cement surface has a soft fili-greed texture, giving the house a constant tactile personality.

Above A sequence of screened spaces between the front door and the living room extends the moment of arrival.

Section

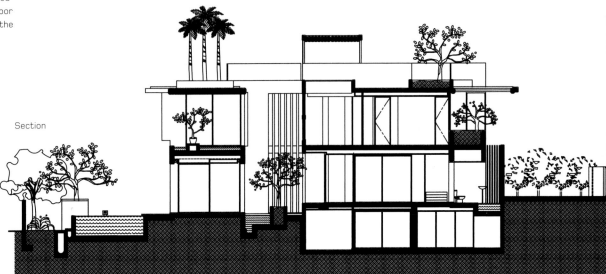

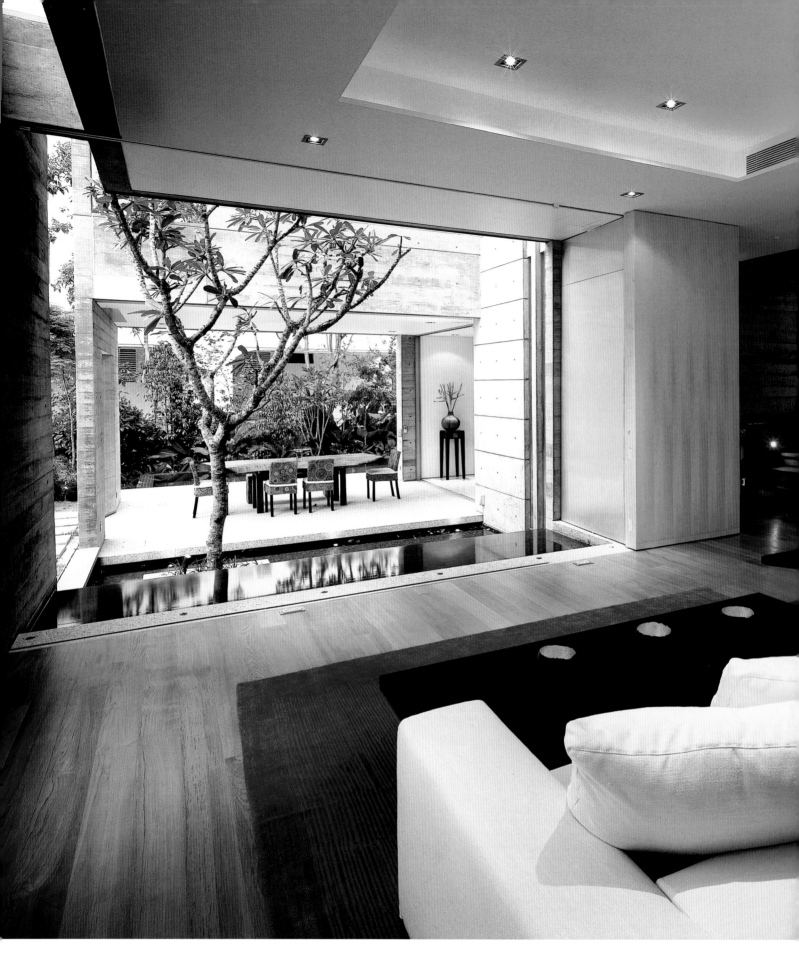

Above The openness of the house dispels any possible feeling of constraint within the relatively confined site, as well as providing a variety of visual and tactile experiences. This view from the entry displays the architect's ingenious sequencing and juxtaposition of internal spaces and external voids.

Above right The stairway connecting the three levels is suspended within an atrium, illuminated (and screened) by etched glazing.

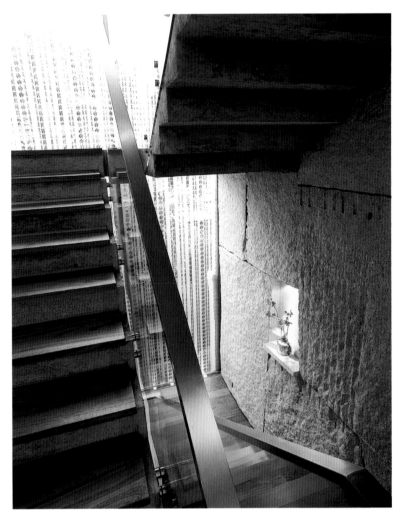

Ground floor plan

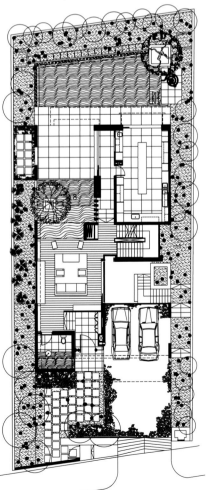

Second floor plan

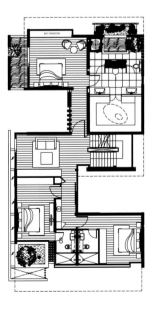

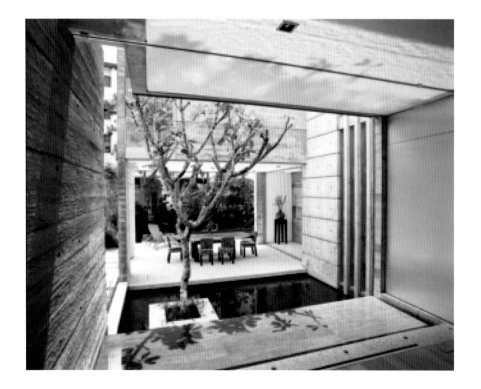

Above The powder room at the ground floor entry is open to the sky, and provides the first hint of an occasional and unexpected ambience of tropical indulgence.

Left Looking from the living room across the internal pond to the dining room and rear garden is a visual delight, as light plays across a variety of textures and materials.

Right The view back into the house from the rear dining room offers a series of layers of visual experiences.

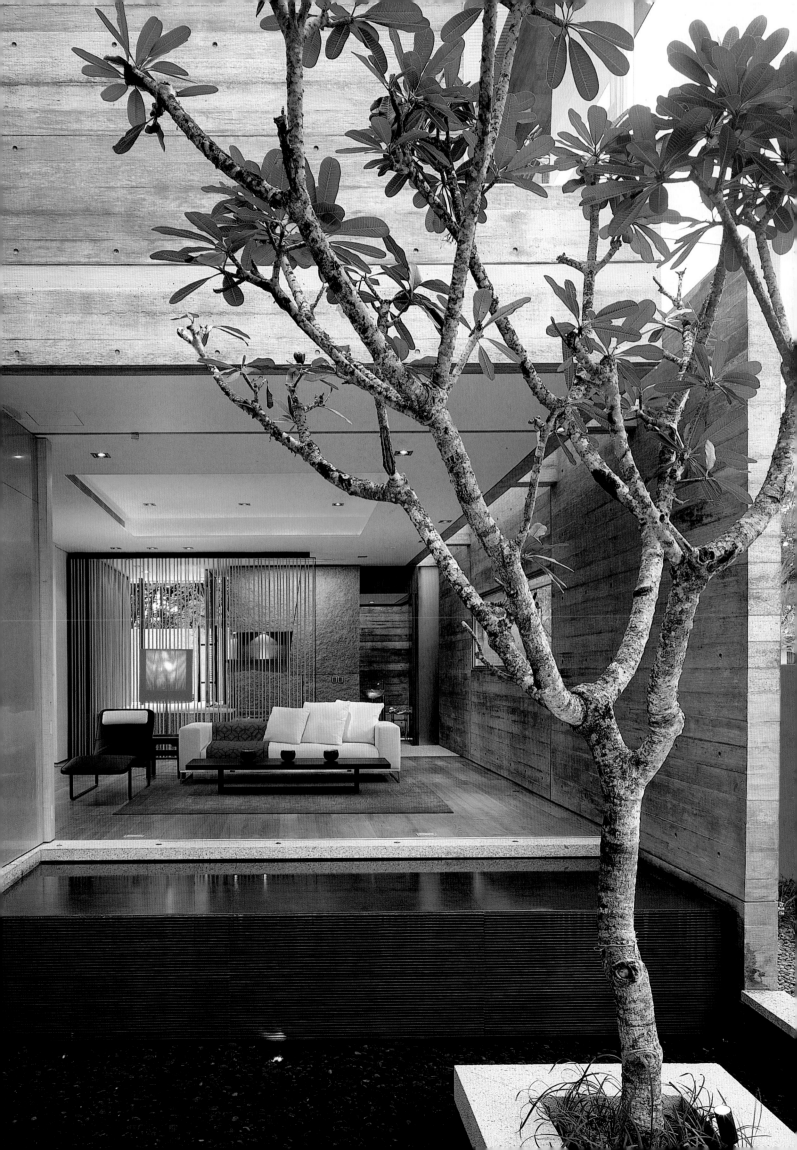

Below The internal ground floor corridor is a colonnade, which offers glimpses of the internal pond and clearly articulates the rhythm of progression through the house.

Right above The bathroom for the master bedroom is a transparent tropical world of its own, with an open air bathing area replete with vegetation.

Right below The water features are continued on the upper level, where the master bedroom enjoys the tranquility of its own reflection pond.

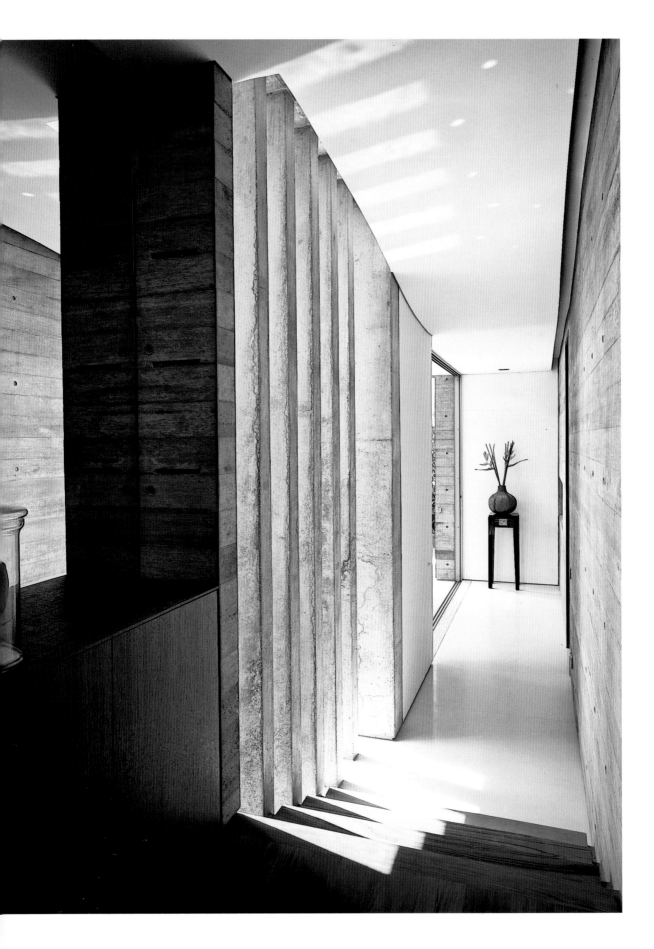

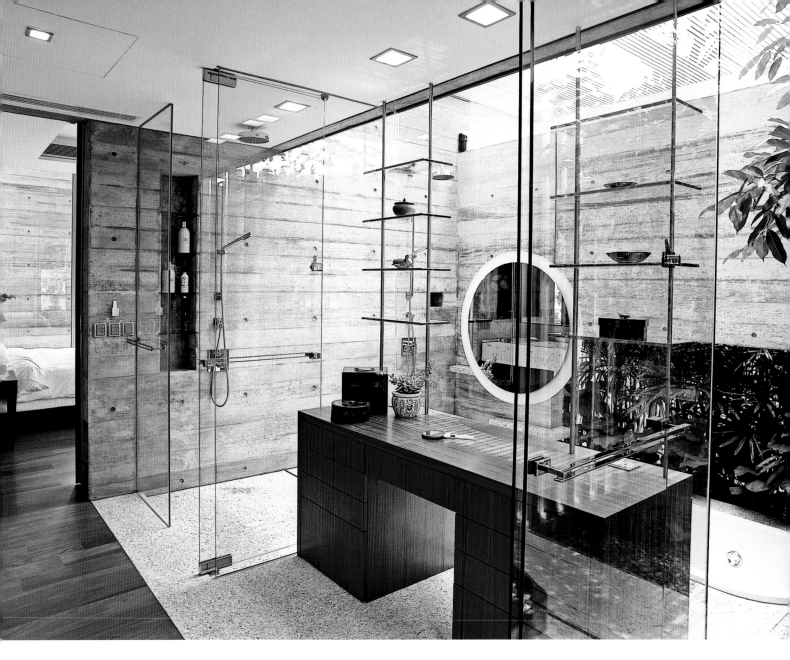

to a central pond and frangipani tree; the house then steps
down to an open dining pavilion and another pond which
defines the rear edge of property; and a large kitchen
connects to the rear garden and swimming pool through
sliding glass doors.

Another theme is the continuing conversation between
different materials and different textures… smooth and
rough, soft and hard. The stairwell is fully glazed with etched
glass (also used to form a double skin façade to the house)
and looks down to a garden court in the basement. The
guest bedroom looks directly on to this court through a
fully glazed wall, which contrasts with the teak flooring and
joinery. On the second floor, the master bedroom is located
at the rear of the house, adjoined by a bathroom featuring a
sunken bath and an exterior WC.

The conversation between materials and textures is
successfully engaged whilst simultaneously maximizing
space, both in plan and section. The house never feels claus-
trophobic or over-worked, and it also succeeds in achieving
remarkable privacy and tranquility, despite the close proxim-
ity of neighbours on three sides.

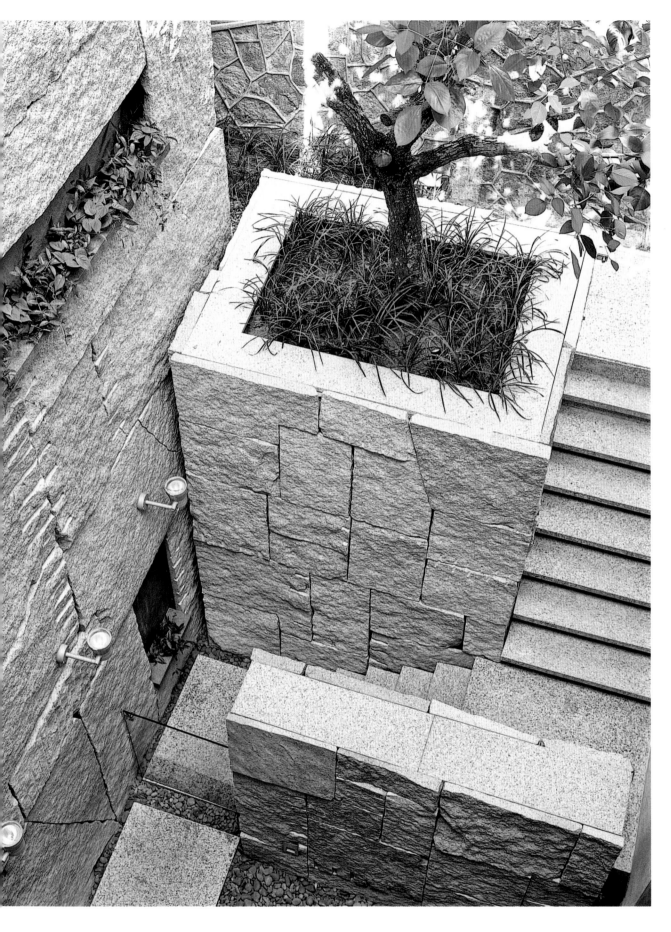

Above Roughly cut stonework, a planter box and a niche for plants create artful abstract compositions which emphasize the natural connections of the house.

Right The rooftop garden is an unexpected sculptural folly, with a lone frangipani marooned in a shallow pond surrounded by lawn.

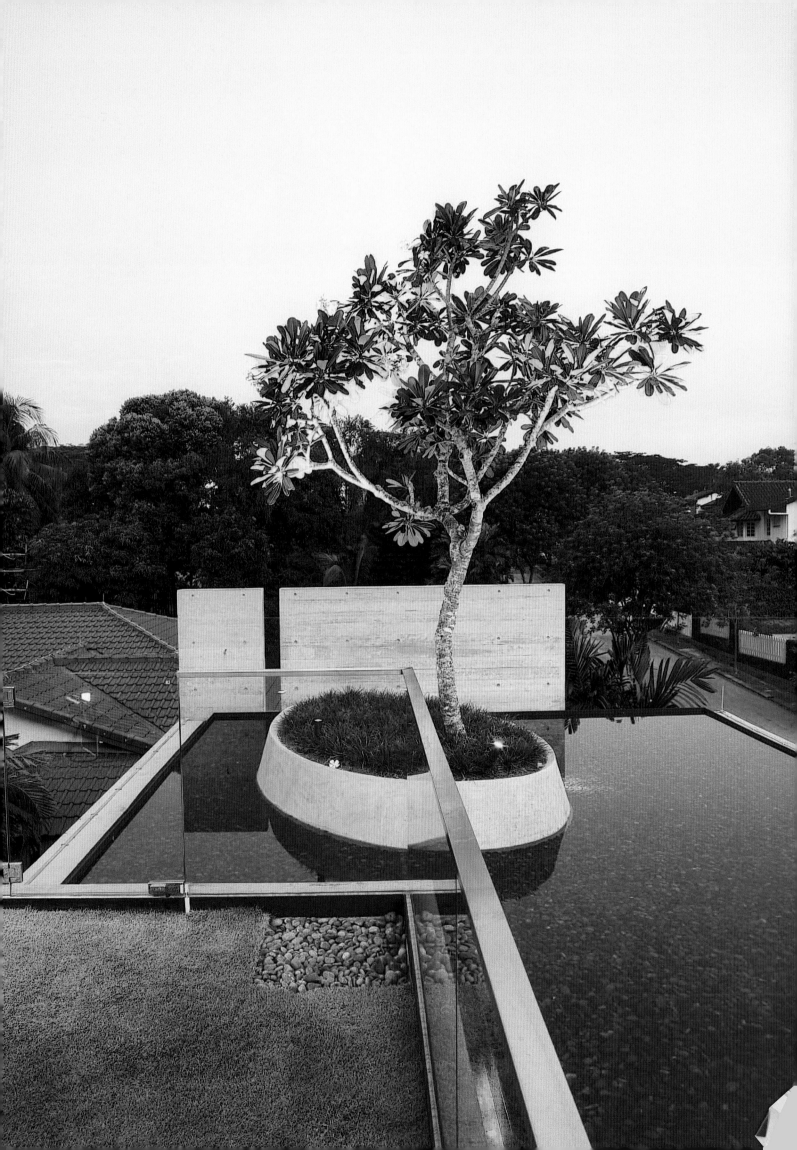

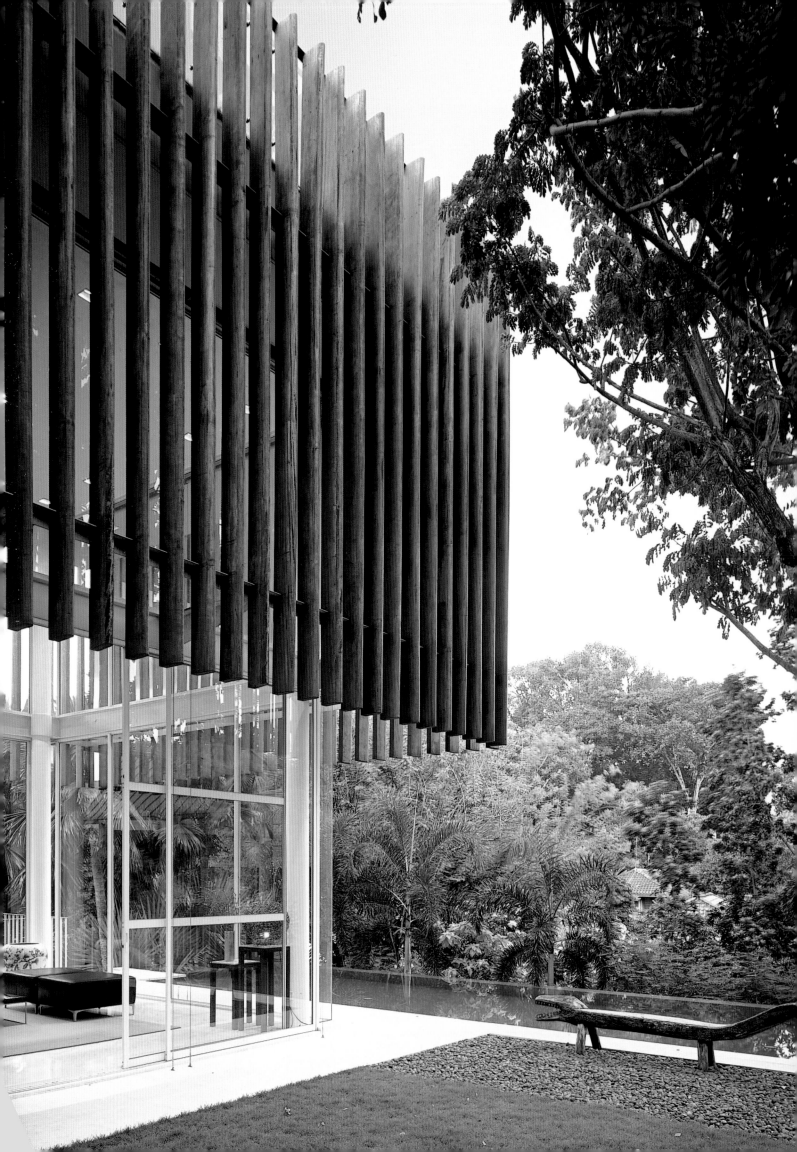

Left Elevated above the tree-line of the street below, the house appears as a temple, with the enormous glass void of the main living room projecting across the garden.

Right The southern approach to the house, as to a temple, is up a grand flight of steps and through two massive teak doors into a grand vestibule.

kheam hock house

The Kheam Hock House floats imperiously above the road in the manner of a Chinese temple on a terraced and richly vegetated hill. As with the traditional temple, this house seems more content to connect with the sky than with the suburban life below... it is fitting that the upward journey from the street should terminate on a splendidly private roof garden with just the sky for a roof.

The clients gave the architect a free hand, apart from instructions to preserve the multi-level site, and to provide a 25 metre pool and a separate, though connected, wing for their daughter. The result is a grand and complex cluster of spaces, all closely connected to the lush garden. Despite the house's scale and transparency, it is remarkably intimate. It comprises an intriguing counterpoint of levels, volumes and materials... featuring timber, titanium roofing and marble cladding. These elements are braced internally and externally by thin slivers of aluminium and stainless steel, which provide a horizontality to balance the vertically stepped volumes.

There are two points of arrival. One, from the garage, is a journey from the softly lit vestibule on the basement level - where the eye is drawn upwards by a sunken water garden open to the sky - to the ground floor, where one is greeted

KHEAM HOCK HOUSE

SINGAPORE

ARCHITECT AAMER TAHER

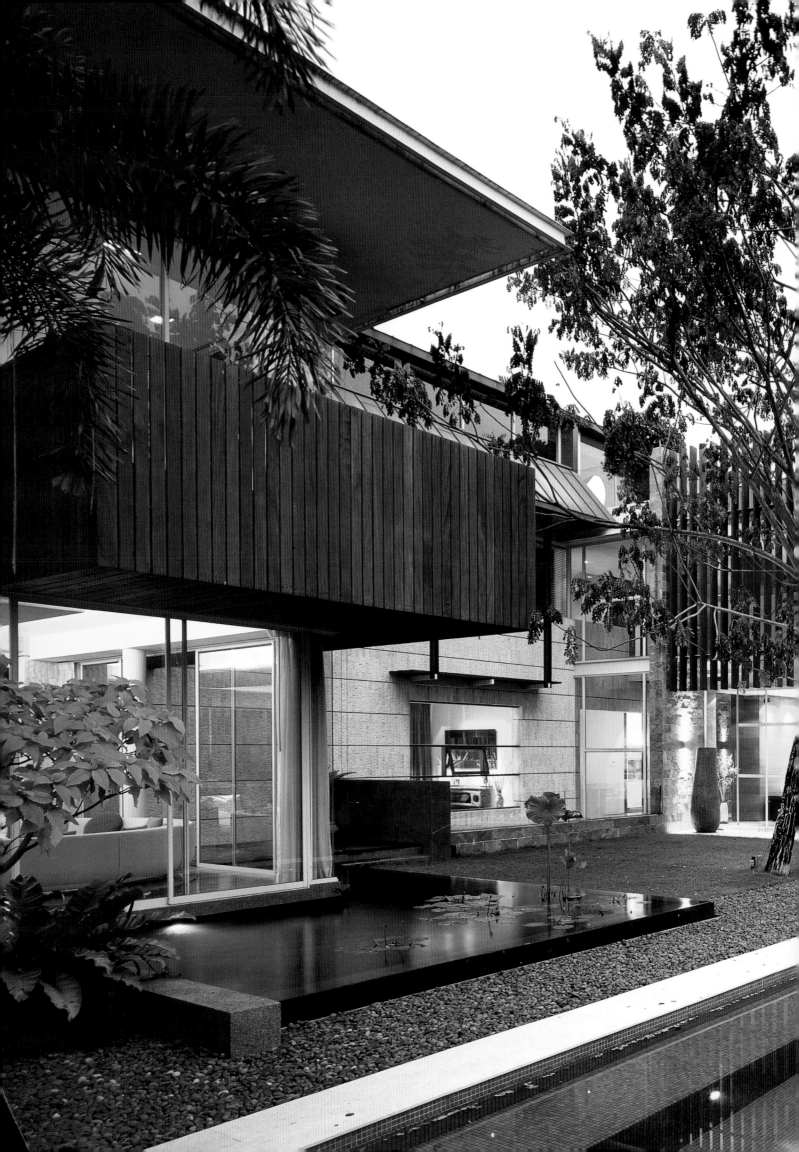

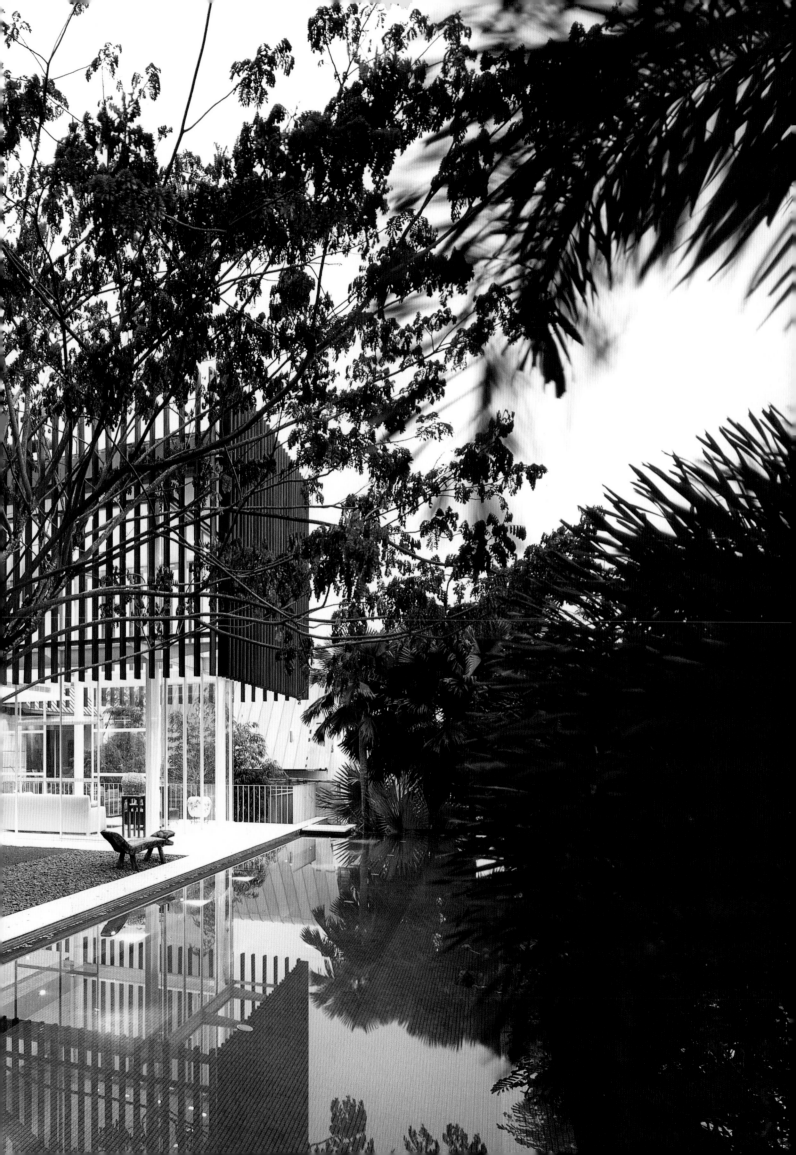

Previous pages The main living spaces form two pavilions projecting from the spine of the house, and engage completely with the lush tropical garden, the tranquil reflection pond and the pool.

Above Timber flooring on the second floor contrasts beautifully with the prevailing palette of stone. A timber bridge links the upper level gallery to a family room suspended above the large glazed living room.

Right A similar viewpoint on the ground floor shows the entry vestibule, with the double-height glazed living pavilion on the right.

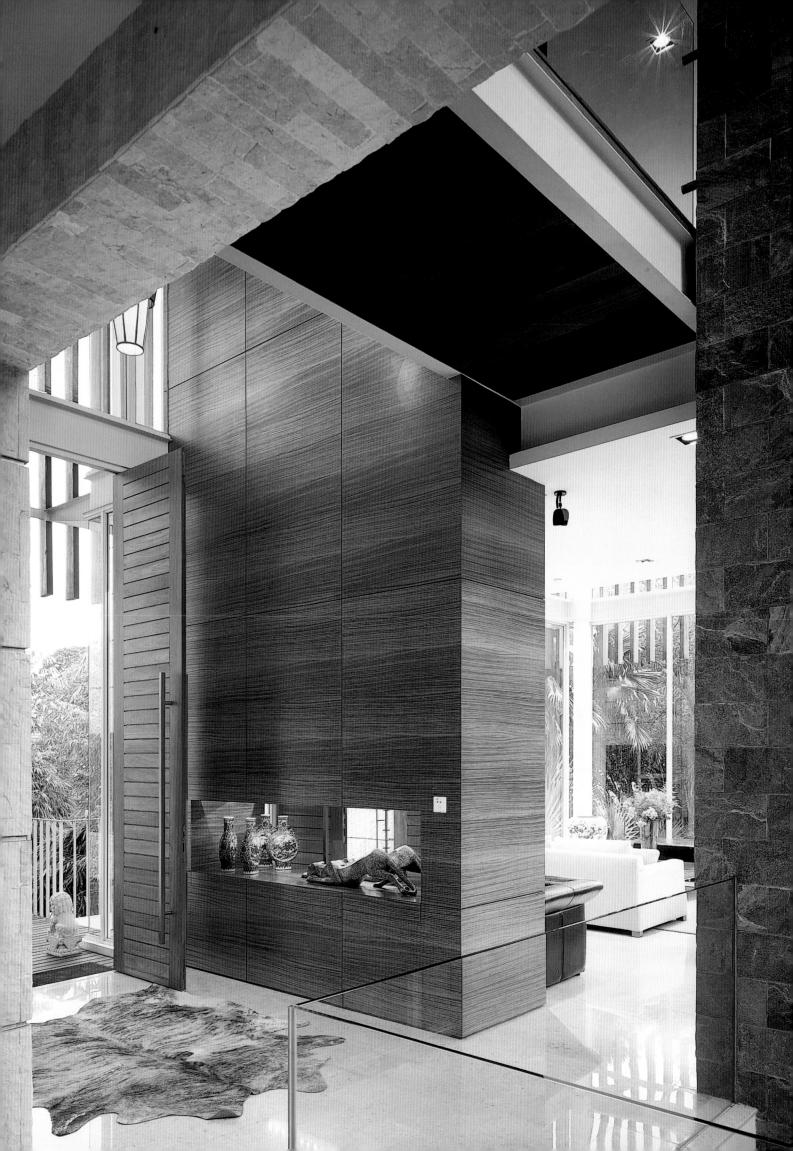

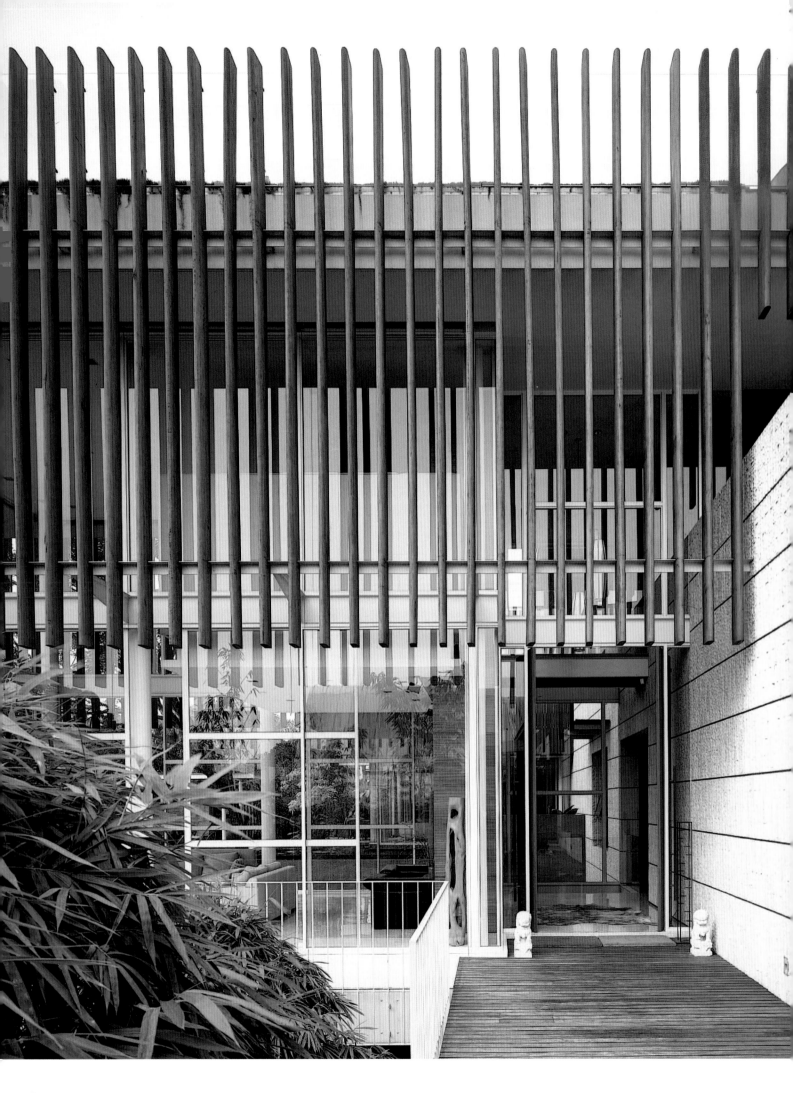

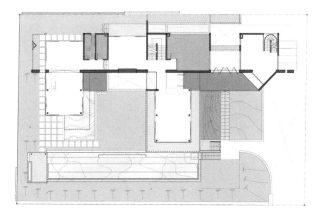

Ground floor plan

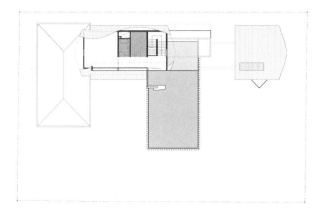

Third floor plan

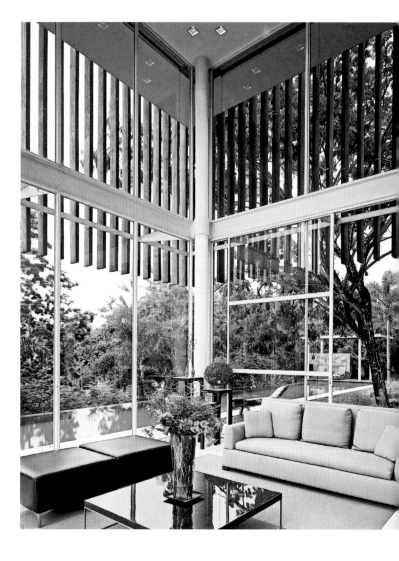

by the magisterial double-height, fully-glazed living pavilion extruding out into the garden. The other entry is at this level... after scaling a ceremonial stairway to the imposing double timber doors, one encounters a vista to the living pavilion and beyond to the terraced gardens, pool and reflection ponds.

On the ground floor, the sequence of spaces – a formal dining room, an entertainment room and a powder room with an external shower - unfolds easily without ever losing connection to the garden. The daughter's wing has its own separate entry, but can also be accessed from both levels of the main house, and on the ground floor this is through an informal, open breakfast area. Her bedroom is downstairs, with an internal courtyard and bath open to the sky. Upstairs, a study area connects to the main house by a bridge and a corridor which links the guest bedrooms and a family room looking down into the main living area below. A gallery space leads to the master bedroom - a double-sized space combining sitting area and bedroom, and featuring a geometrically patterned wall mural running from the outside into the bedroom, its patterning repeated on the bed-head. An attic level is quite different in character to the rest of the house... it consists of a bedroom, a teak-lined bathroom and a rooftop garden terrace.

Opposite The skeletal timber battens screening the living pavilion provide a distinctive and unforgettable profile to the house. This view shows the southern entry, approached by a flight of steps from the street below.

Above The entirely glazed double-height main living pavilion is protected from the western sun by the massive timber screen and retractable blinds.

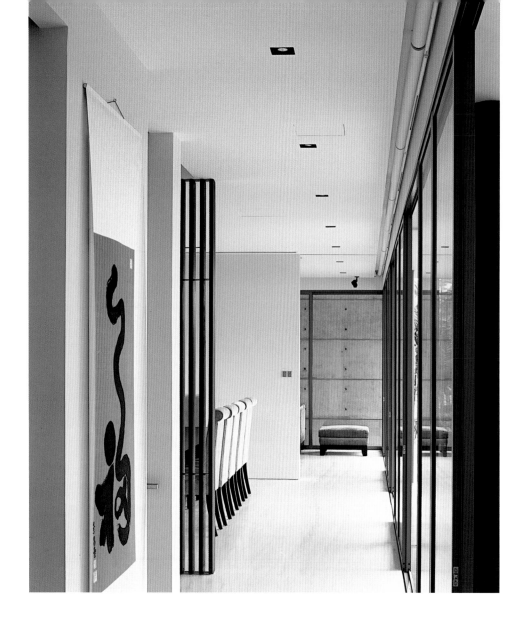

Left The broad corridor connecting the spaces of the living pavilion is effectively an elegant light-filled loggia opening out to the deck of the pool.

Right A series of transitional spaces unfold between the street entry and the house itself. The entry sequence is composed from striated granite walls, shallow pools and carefully placed large stone pots.

cassia drive house

From the street, the Cassia Drive House has an almost temple-like sense of anonymity… walls of horizontal granite slabs reveal nothing to the outside world. But step inside the gates, and there is an immediate sense of a transition to another world, with the expectation of sanctuary from hectic urban living.

CASSIA DRIVE HOUSE

SINGAPORE

ARCHITECT SCDA

Large stepping-stones lead to the ceremonial entry, flanked by a reflecting pool and a large, contemplative, earthenware pot. There are two ways to enter… one is through the formal ceremonial entry doors and vestibule, which delays the discovery of the rich world within, and the other is through a central full-height timber door, which swings open to immediately reveal a granite-lined swimming pool running the length of the house to an 'infinity' edge. Two transparent pavilions wrap around the pool with an enfilade of columns, which continue the ceremonial mood.

The southern pavilion contains a light-filled living space with the master bedroom above, which is connected to the northern pavilion by a glazed bridge. This northern

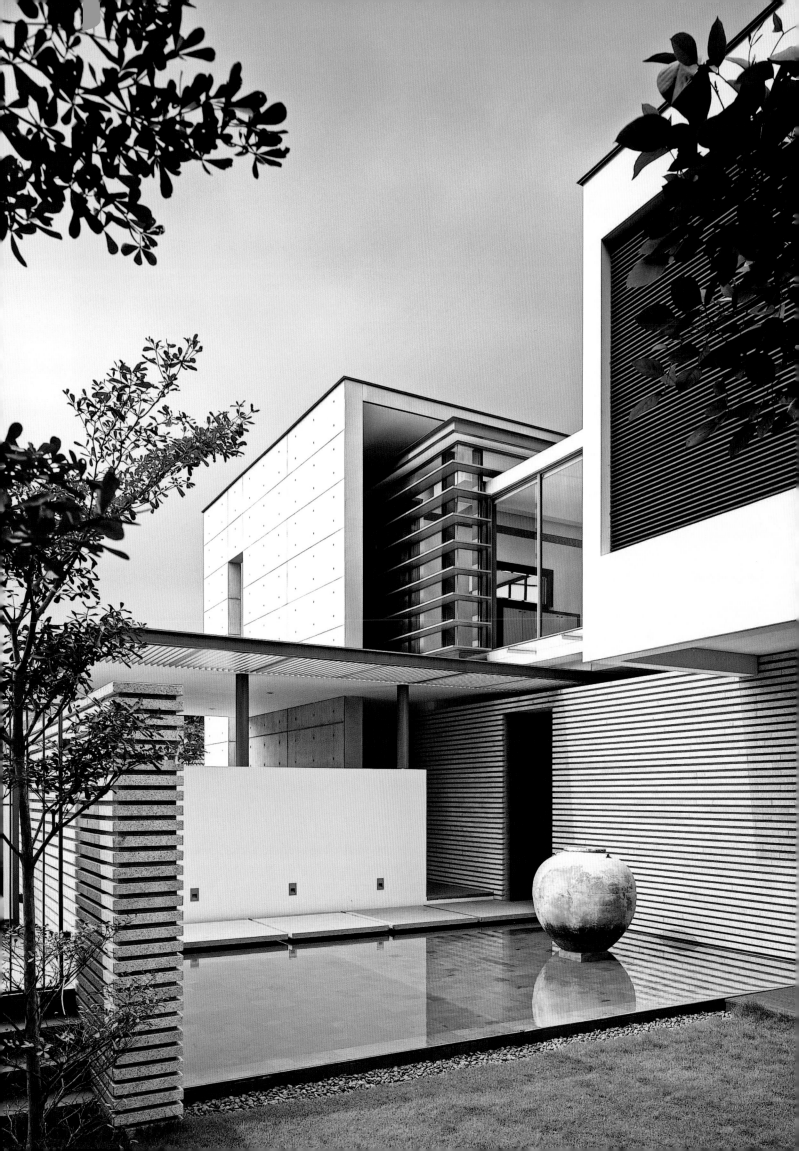

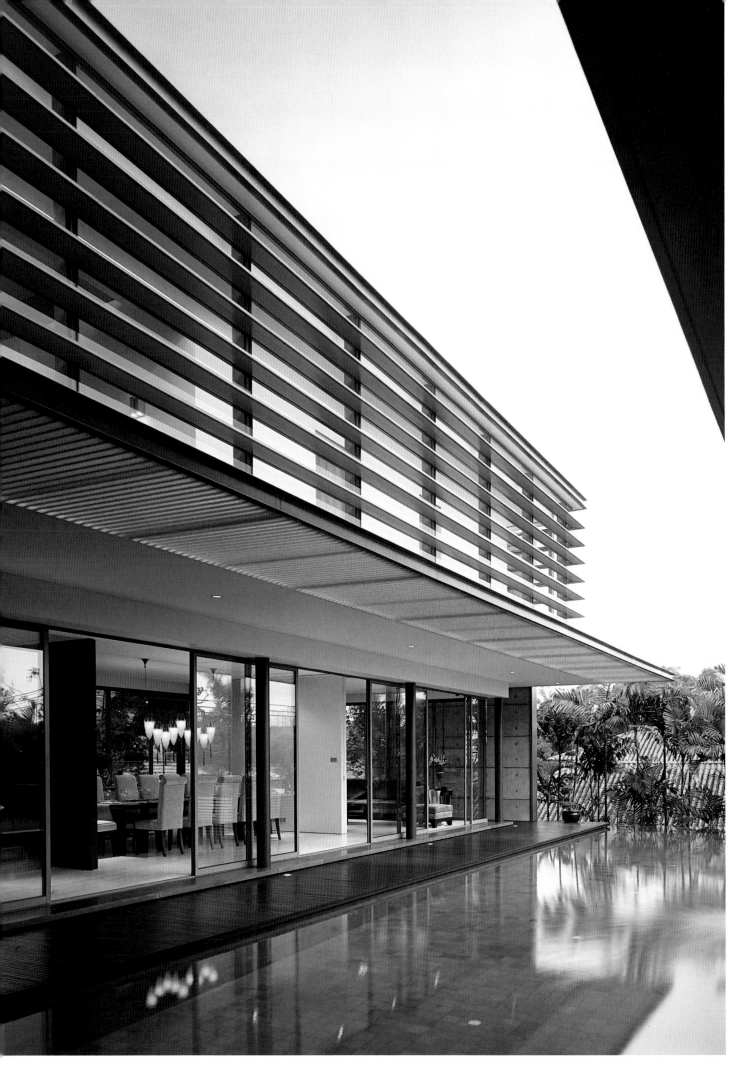

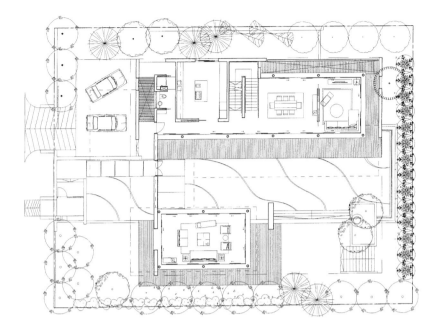

Opposite The generous timber battened overhang filters light into the ground floor of the living pavilion while sunscreens protect the upper bedroom level.

Below left Looking across the pool to the smaller pavilion, which contains the formal sitting room on the ground floor with the master bedroom above.

Below right A glimpse down the central stairway of the living pavilion to the cool presence of the pool and its understated landscaping.

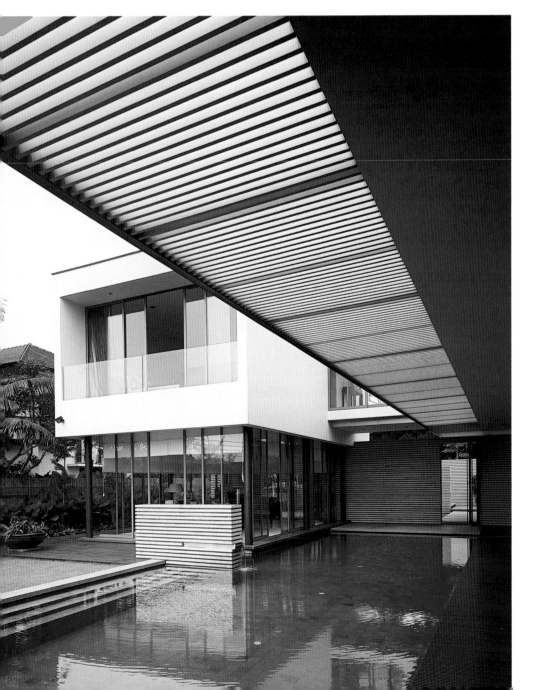

cassia drive house

West elevation

South elevation

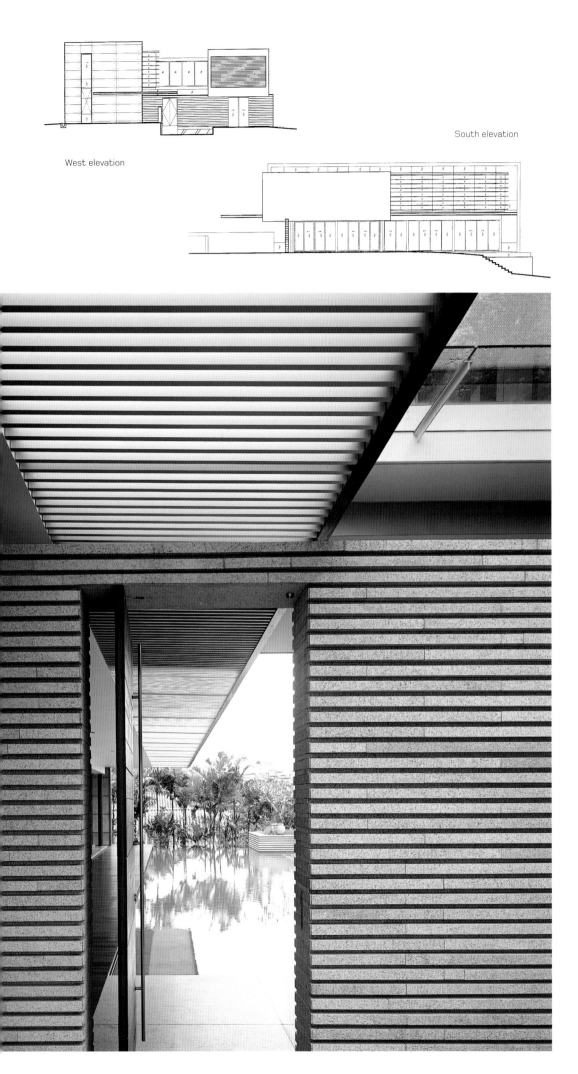

Left An alternate entry to the house, on an axis with the pool, opens to reveal a serene perspective along the pool deck, terminating with a screen of trees.

Above From the street the house presents an elegant composition of horizontal and vertical planes. The architect's signature striated deep reveals in the stone walls convey an impression of monumentality.

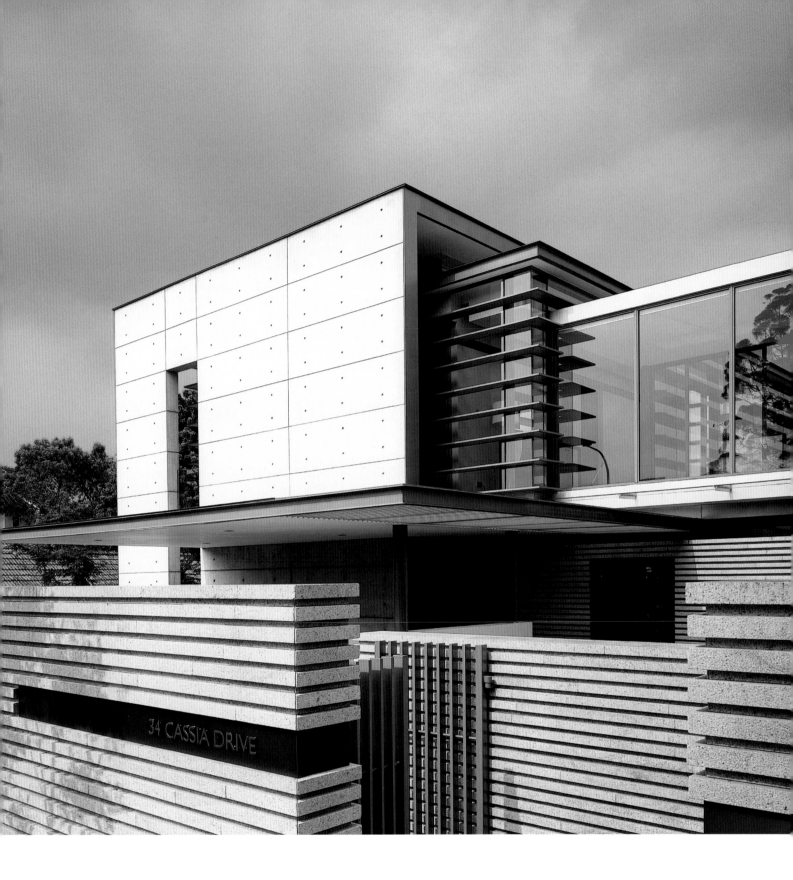

34 CASSIA DRIVE

pavilion comprises a series of spaces off a fully glazed corridor running down the length of the pool: wet and dry kitchens, a dining room and a fully glazed TV room, whose privacy from the neighbours is protected by an off-form concrete wall. A timber batten screen divides the dining room from the stairs to the upper level and down to the basement. The corridor spills out through sliding glass doors on to a timber deck and the pool, which are protected by an overhang and sunscreen. The horizontal lines of the exterior

are continued inside by the stonework, sun louvres and the basement stairs, which run the full height of the house down to an internal pond.

As with any temple, the exterior of this house only hints at what lies within. After the ceremonial transition, a new and private world of gentle contemplation reveals itself, with the two pavilions appearing to float on the pool... which seems to be less concerned with swimming than with being an object of contemplation.

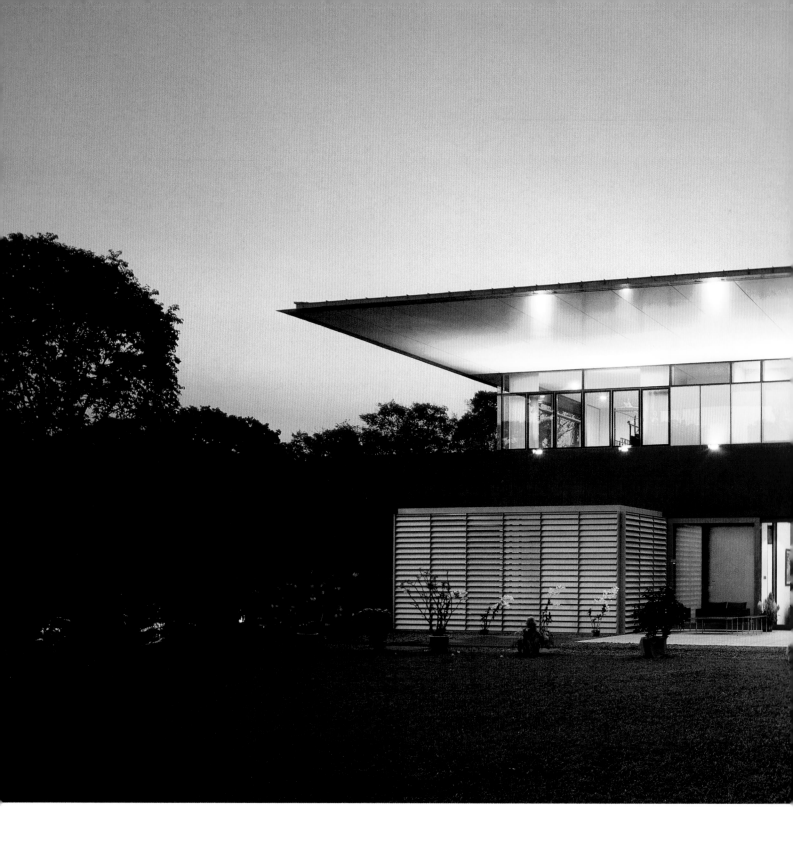

house at rochalie drive

The House at Rochalie Drive is a bold example of how the home can act as a stage for acting out the condition of modern Singapore... accommodating tradition and modernity with space for an extended family to gather together, whilst also providing privacy for parents and children.

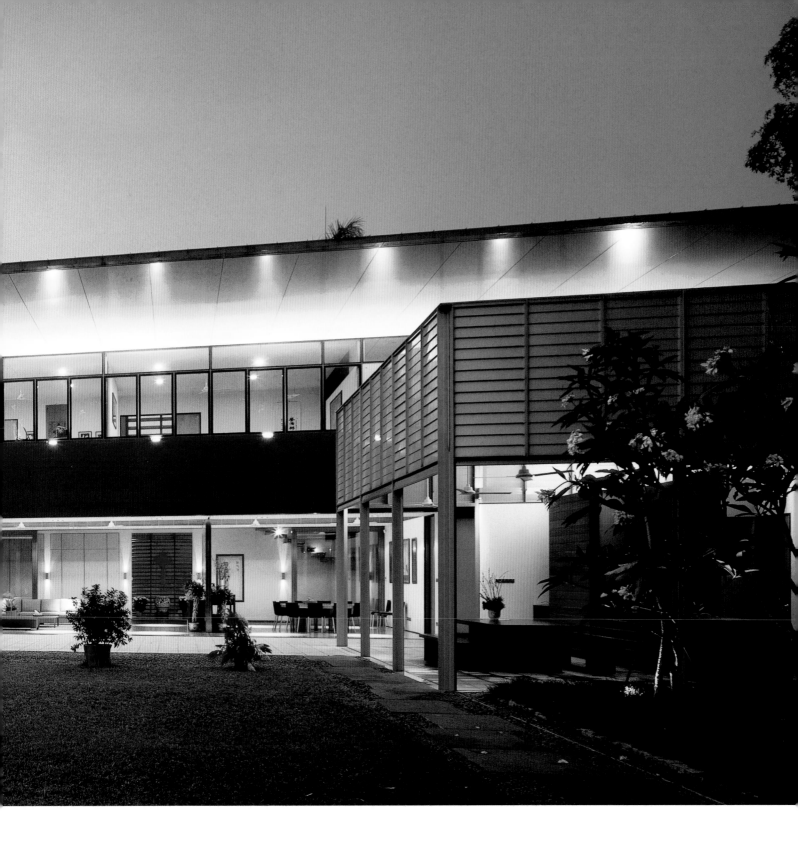

The client for this house owns a cement and concrete plant business and the extensive use of concrete celebrates this fact – in-situ concrete walls, pre-cast concrete steps and concrete pavers – and in so doing, celebrates the source of the family's prosperity. The brief was for a house which could accommodate and entertain large numbers of guests, and for a house which would be impressive, but also have a domestic feel and remain discreet and modest. This seeming paradox, however, is immediately overcome by the approach and arrival experience. From the street, the house gives little away… its front a series of receding planes beginning with a

Above As requested, the architects combined the intimacy of a home with the expansiveness of a meeting place for the extended family, as private spaces dissolve into grand public spaces.

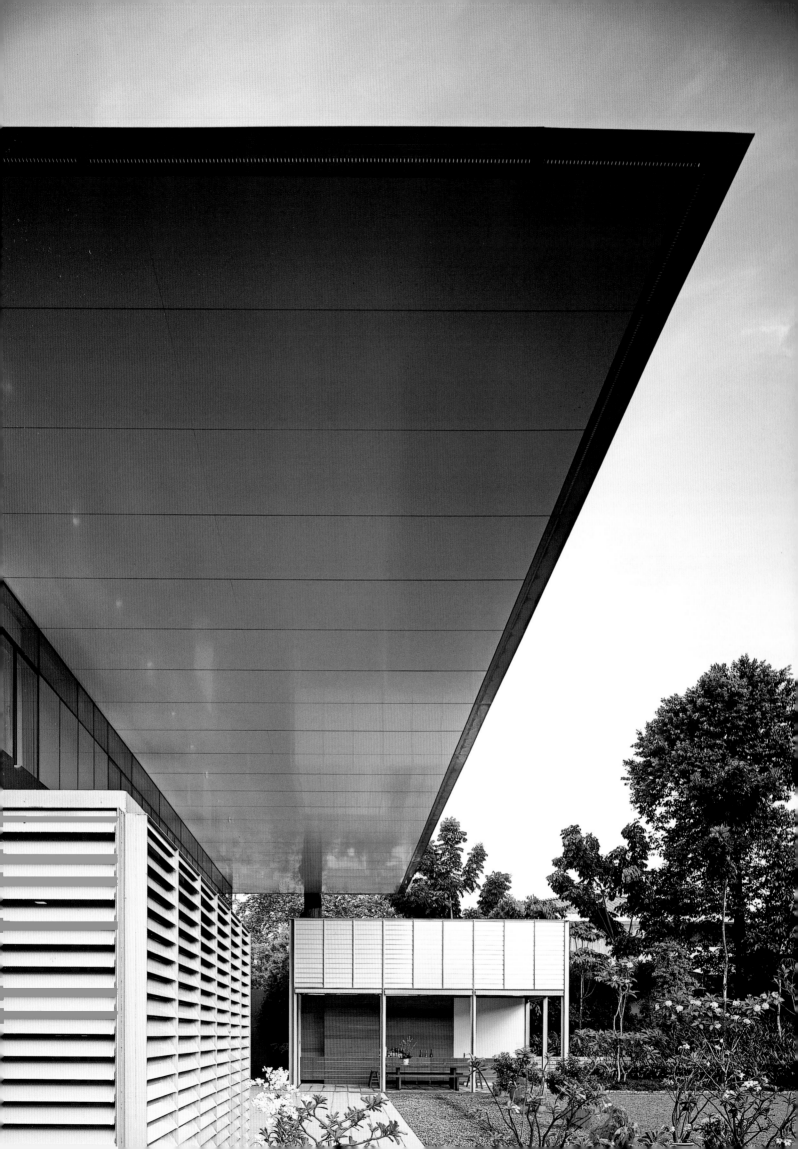

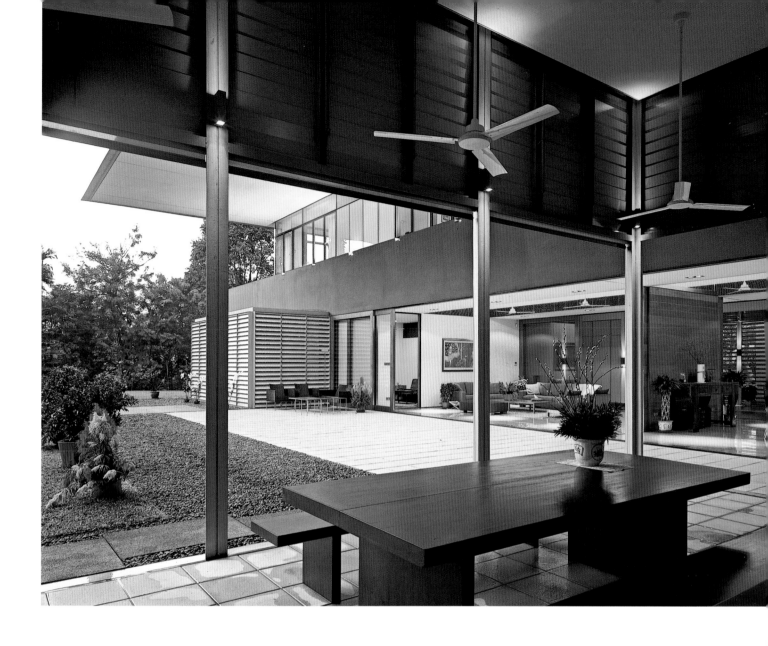

Left A massive knife-edged overhang protects the broad terrace leading from the living and dining areas. The entertainment pavilion sits at the end of this grand vista.

Above Looking back from the entertainment pavilion to the terrace and ground floor living areas, which open up to a large expanse of lawn.

Site plan

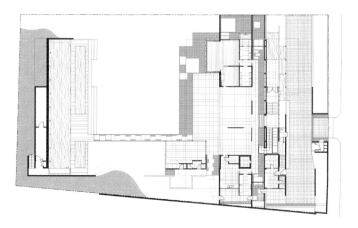

striated concrete block wall, then a white concrete wall, followed by two more planes of louvred sunshading. The arrival sequence begins with the *porte cochère* and a timber bridge over a fish pond, through two massive timber doors into an entrance foyer which reveals two regal spaces leading directly out to the expansive rear garden. These living and entertaining spaces have enormous timber-framed glass sliding doors leading on to a broad terrace protected by massive overhangs. Forming an L-shape with this main pavilion is a small entertaining pavilion with a bar, beyond which is the swimming pool and the outer edge of the garden. Effectively, the house is a large verandah. Extensive use of glass, operable aluminium louvres and open air spaces such as the courtyard off the master bedroom create a close connection between the inside and the outside, drawing light and air into the house.

Although the house has a grand appearance, the architects point out that this is not achieved by the use of expensive materials – it uses predominantly concrete, plaster and glass - but rather through spatial manipulation and sublime through views.

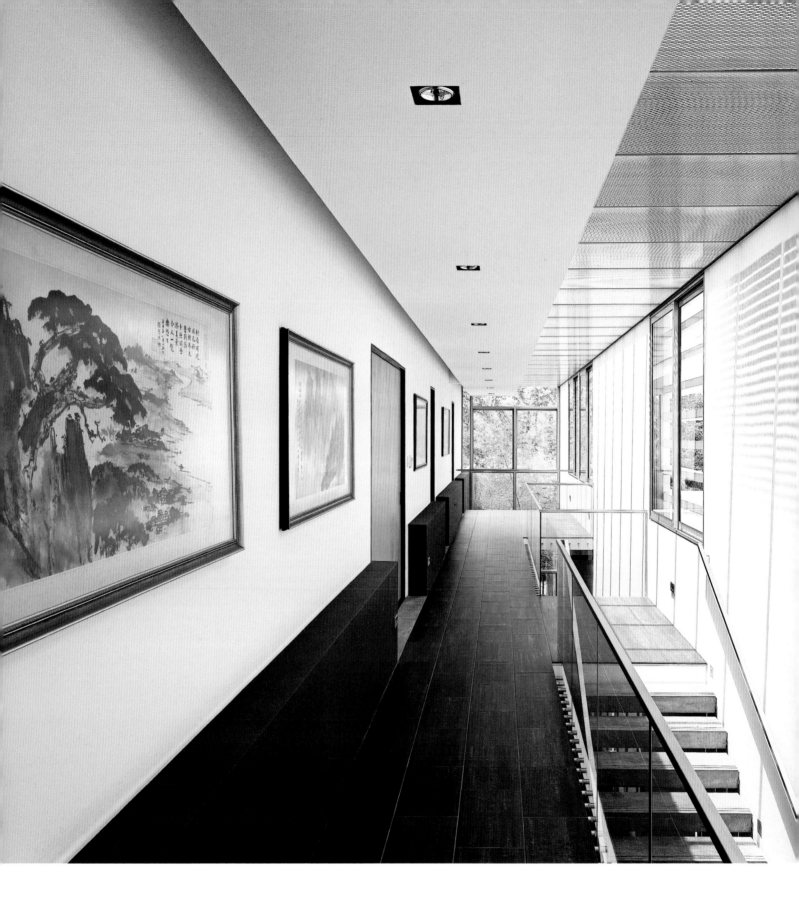

Section

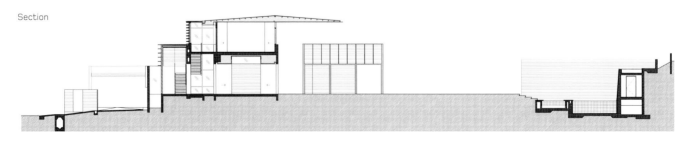

Left The upper level gallery is reached by a highly transparent flight of stairs and enjoys a generous setback, enabling artworks to be displayed away from direct light. The steel mesh screen on the northern wall creates mesmeric ever-changing sunlit patterns.

Below The internal corridors and stairways constitute a highly vertical and linear transitional zone between the street entry and the open living areas.

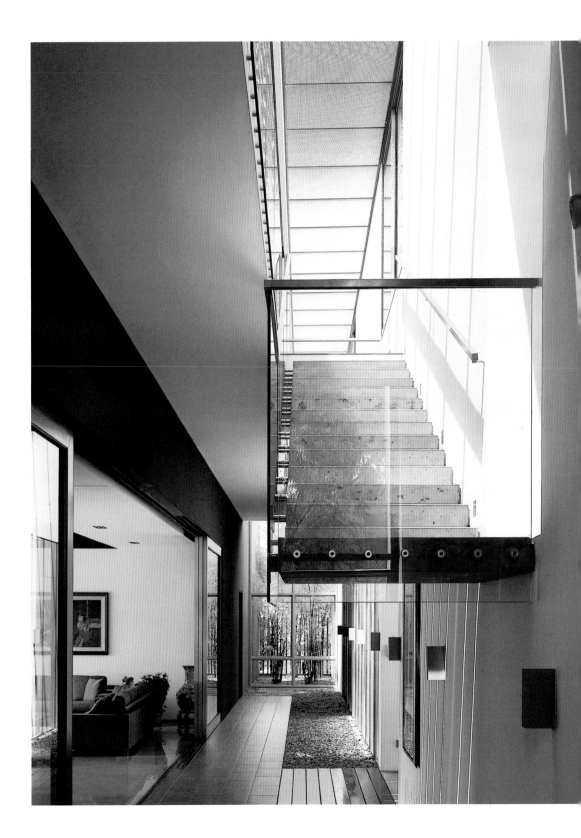

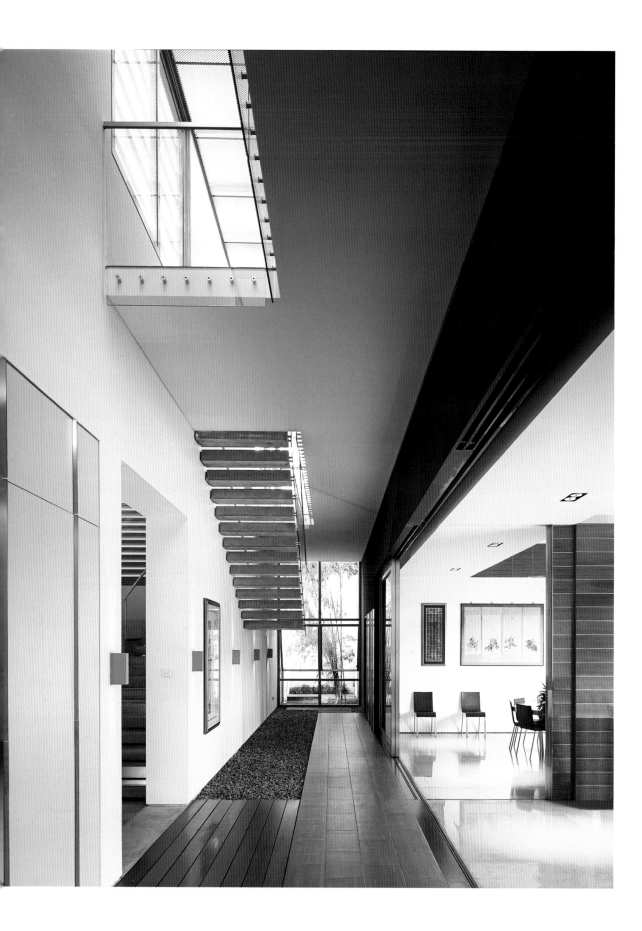

Above The transitional spaces leading to the living areas at right can be clearly seen in this view along the ground floor corridor, which is lit from above by the exposed stairway. The entry vestibule is through the door to the left.

Right The street front of the house appears as a series of receding planes, which gradually become more penetrable through the use of louvres.

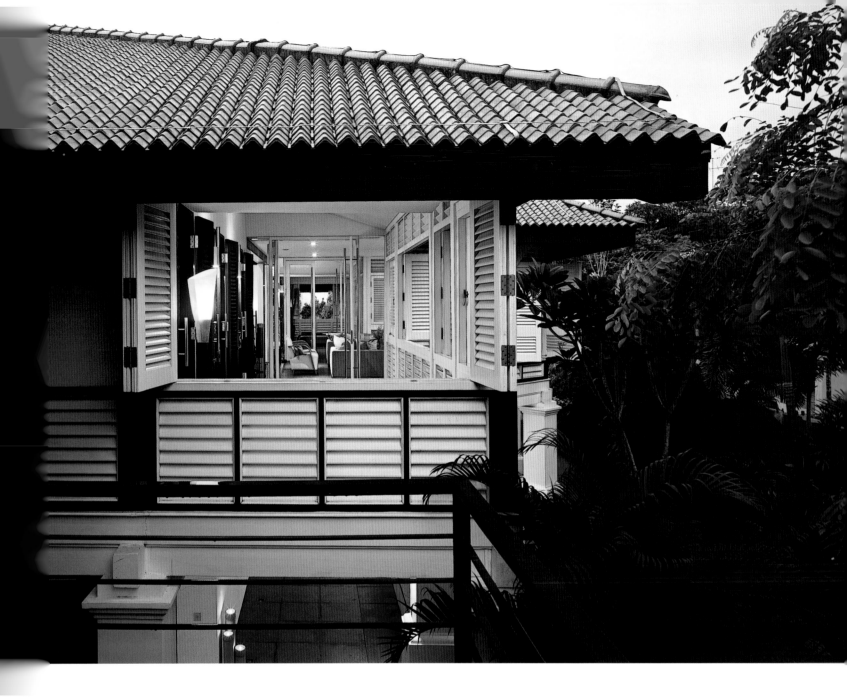

Above Looking back from the deck of the new kitchen wing into the verandah of the original Black and White house. Evenings spent on a verandah with the shutters thrown open endure as the epitome of tropical lifestyle.

Right The dining room is an elegant blend of the traditional and the contemporary, which includes a modern interpretation of shutter doors to the verandah.

Section

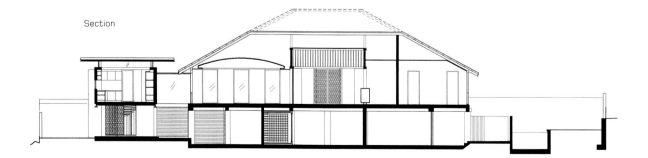

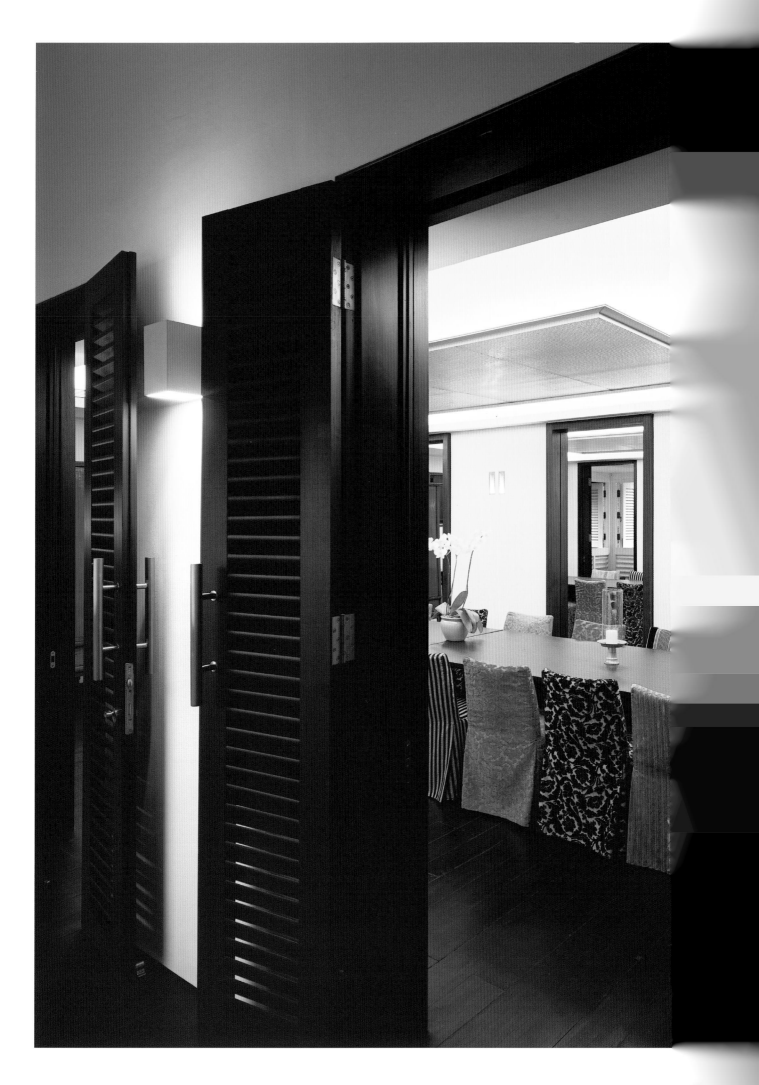

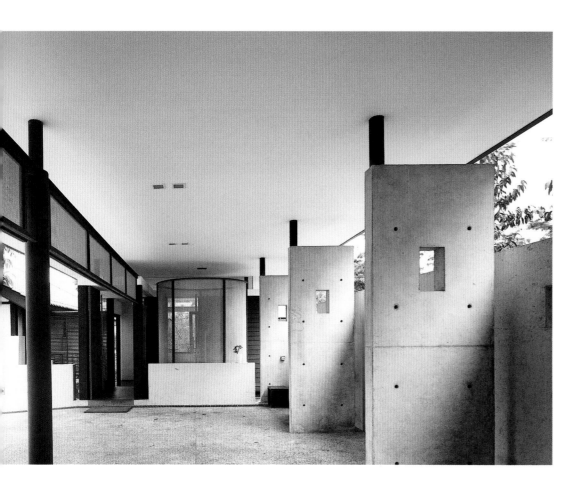

Left The new kitchen wing provides an alternative entry to the house from the new carport, which asserts a defiant modernity on the margins of colonial-era splendour.

Below Connecting the swimming pool level with the new kitchen wing, the architect boldly inserted a spiral staircase enclosed in a delicate mesh skin.

Right The entry to the Black and White house has been transformed with a subtle shimmering layer of metallic screens.

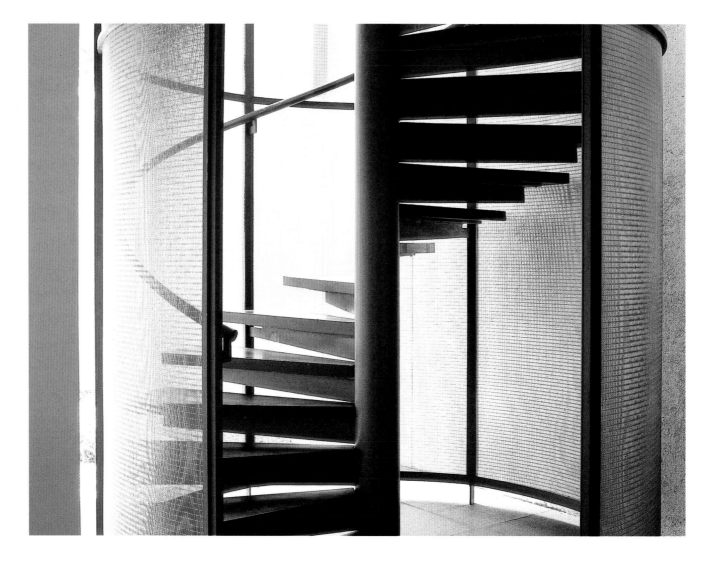

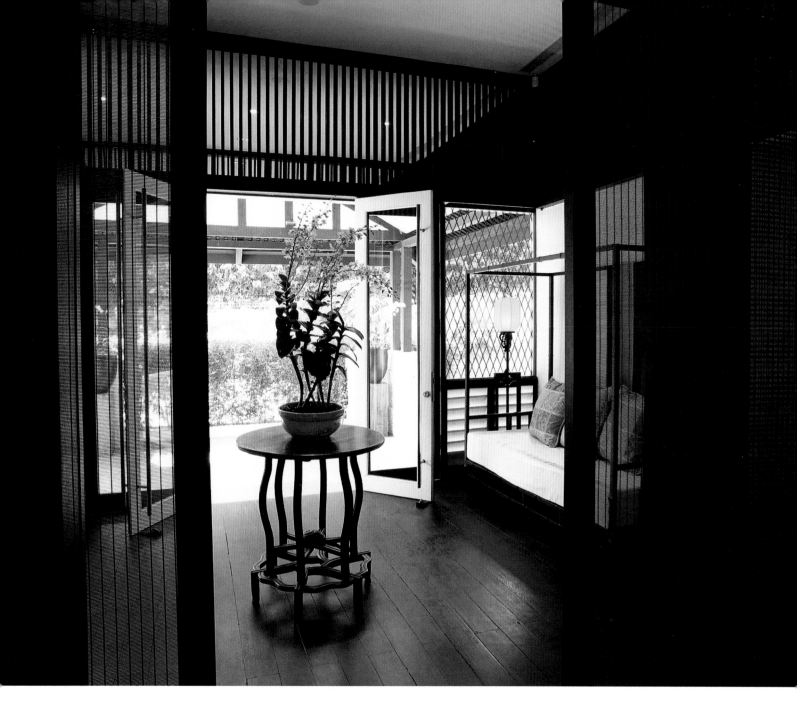

tion with judiciously introduced modern elements, including an unapologetically modern kitchen addition connected to the original building by a bridge with glazed walls and views down to a water garden below. There are now two entry points: the modern one through the new carport and kitchen; and the traditional one through a *porte cochère* into a vestibule, which is separated from the expansive living area beyond by highly refined metal mesh sliding doors. The creation of internal prospect is masterful: the original free-flowing spaces are further enhanced by the creation of flexible internal vistas, with moments of enticement as alternative routes through the house are revealed. Replete with internal prospect, the house also offers refuge (the bedrooms are kept very private, allowing the house to be used for large-scale entertainment) as well as external prospect, with generous views to the garden

and pool and cross-views between the new kitchen wing and the original house.

An intriguing extended external prospect further develops the conversation between old and new… from the verandah and sitting room, there is a clear view of the western façade of another SCDA house (completed in 2004). This house is a highly abstract, inward-looking building which seemingly makes no concession to its cultural or climatic context. In contrast to the traditional climatic mediators of floating, lightweight forms with wide eaves and direct, open connections to the outside, this house seals itself off from the outside and offers mere fragments of penetration to the inside. The conversation between the two houses becomes a specific frame of reference as to what makes the most appropriate contemporary Singaporean house.

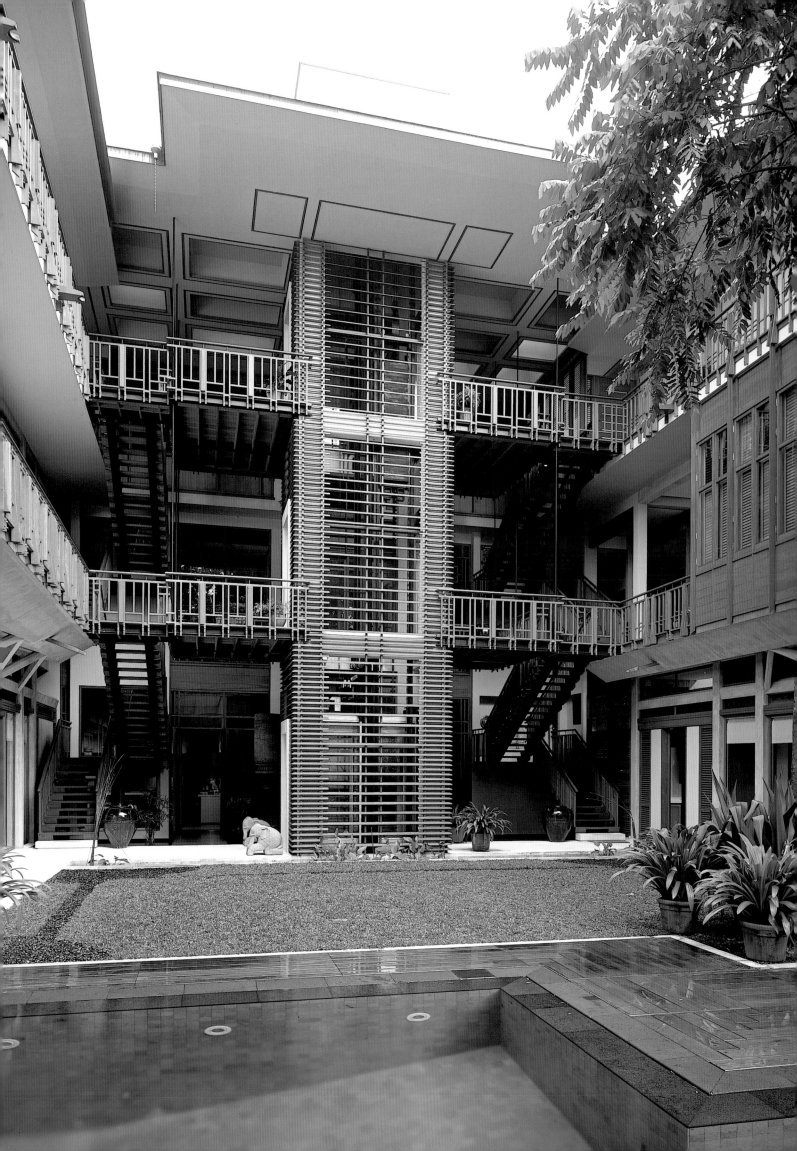

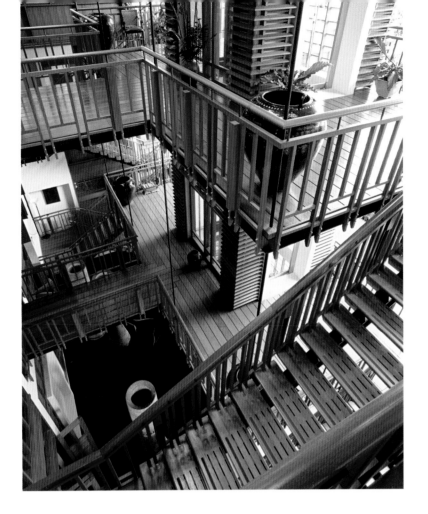

Opposite The central lift core rises from the garden as a timber pagoda, the fulcrum around which the entire house pivots. Entry from the street is at the top level, with the slope of the site falling dramatically to the garden below

Right An atrium, framed by the virtuoso timber joinery of the lift core and stairways, descends to a reflection pool at the garden level.

timber joinery house

To pass through the entry hall of this house is to step into the set of some fantastic and exotic film... nothing prepares one for the instantaneous drama of John Heah's vertiginous composition of forms and textures projecting out, over and around a lush and precipitous site. It embodies all the principles of architectural pleasure... prospect, refuge, enticement, peril and complex order.

While the transition from a discreet public entry to a rich private interior is not uncommon, in the case of the Timber Joinery House it is breath-taking. The street wall has high horizontal slots, offering glimpses of the entry court and the bland concrete-rendered façade of the house, which is interrupted by a double timber-slatted door. This disguises the fact that the house sits on a high ridge, so that on entering the house there is an explosion of space as the C-shaped building opens up with a celebration of influences and materials over three levels (entry is at the top level), looking on to a magical garden below and rooftop gardens above.

The architect designed the Four Seasons Sayan Hotel in Bali and comments that, like the Four Seasons, this house is a celebration of the new, but using traditional elements such as air chimneys to vent the basement, cross-ventilation, and skylights inspired by the Topkapi Palace in Istanbul. The

TIMBER JOINERY HOUSE

ARCHITECT JOHN HEAH

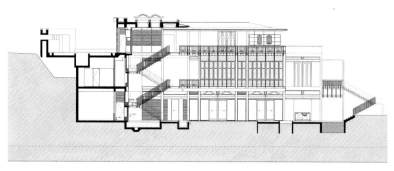

Section

extensive use of timber is contrasted against the beautiful exposed lightweight vaulted concrete trusses, which owe more to arched Romanesque buildings than to indigenous Southeast Asian structures.

Although the wrap-around timber verandahs immediately suggest traditional Asian dwellings, they are equally reminiscent of the enclosed verandahs that provide privacy for bedrooms in many other parts of the world. In this case, however, the wooden shutters of the bedroom corridors also provide natural ventilation even when it is raining… they were directly inspired by an old colonial house in Penang (now a hotel called the Cheong Fatt See Mansion).

The C-shaped plan pivots around a glazed lift core screened with timber battens, contributing to an overall filigree effect generated by the rich tapestry of timber elements. This, in turn, contrasts with a varied palette of Indonesian stones. The rooftop gardens are visually connected to the ground level garden and pool by raised water gardens and by a stepped column, which receives water run-off from the roof to become a vertical water feature.

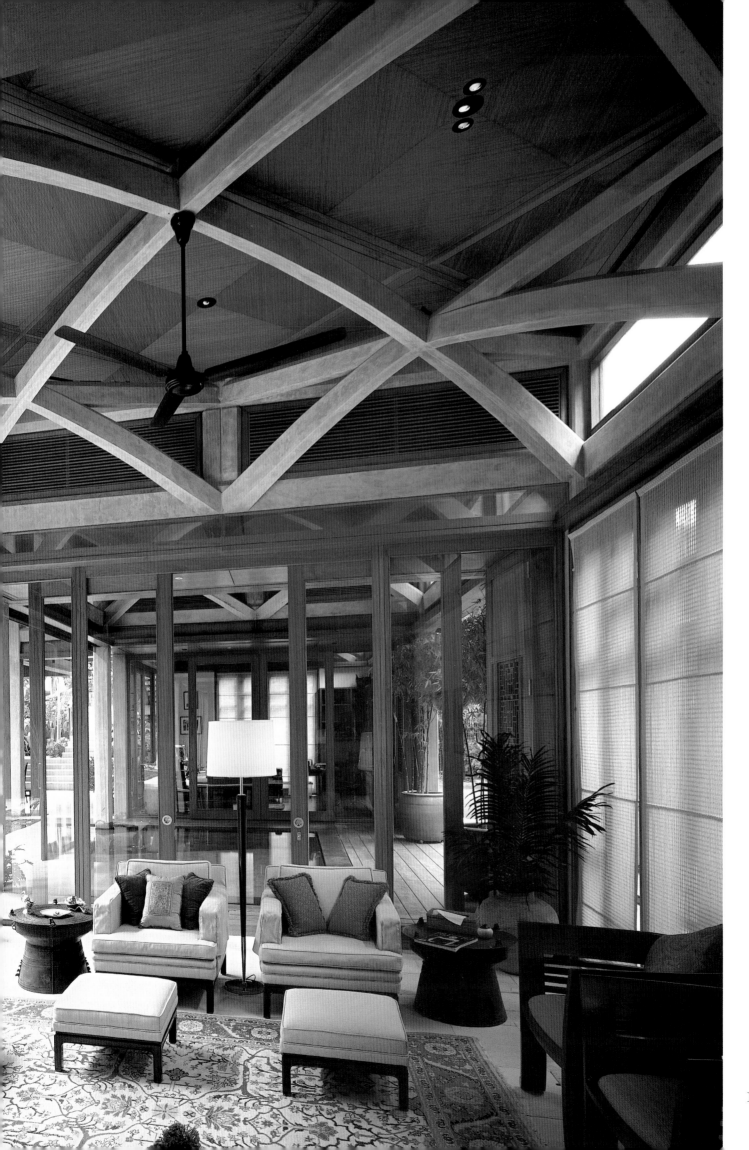

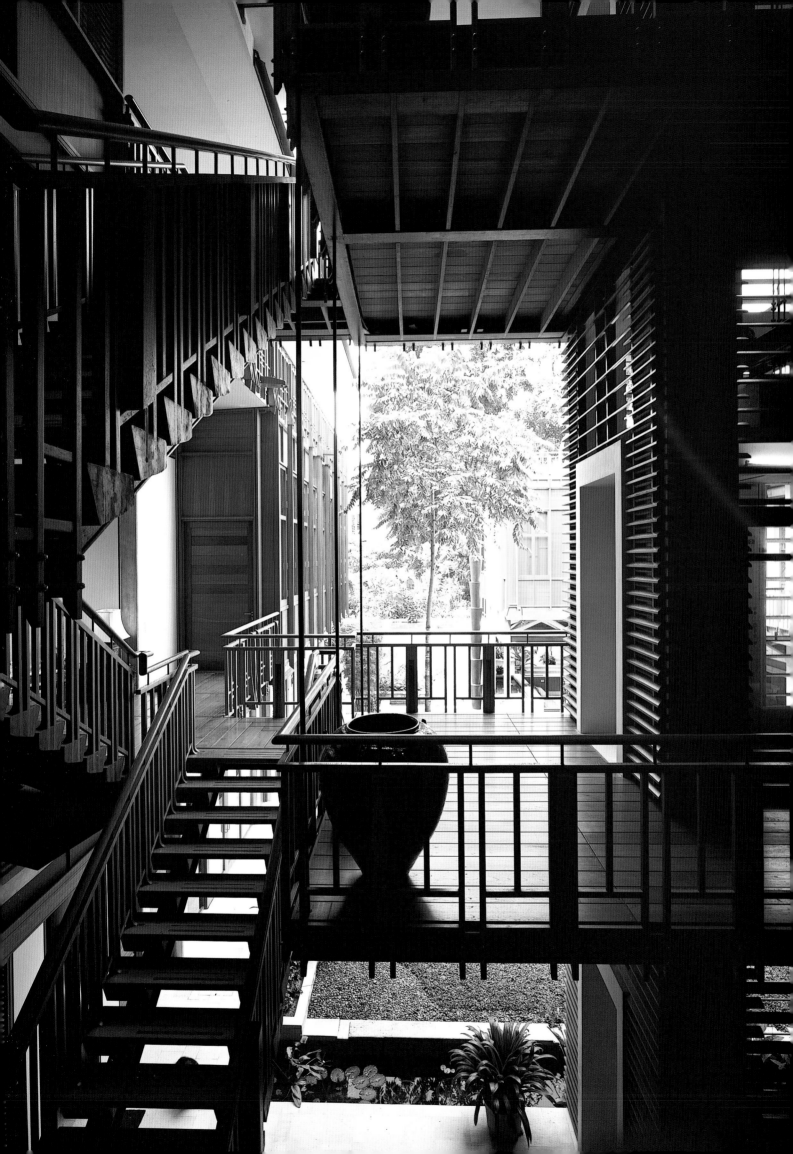

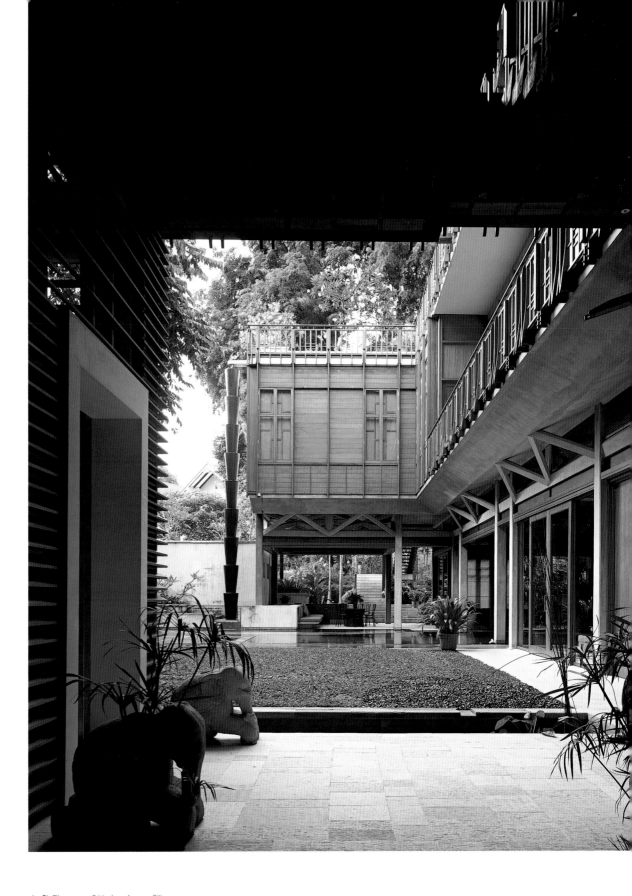

Left The use of timber has a filigree effect, lending the house great tactility and sensuality. This view looks from the mid-level of the atrium to the garden.

Above Emerging from the lift at the garden level, one experiences a completely different sense of perspective and scale. The bedroom wing, seen across the garden, can be completely closed off by paneled shutters.

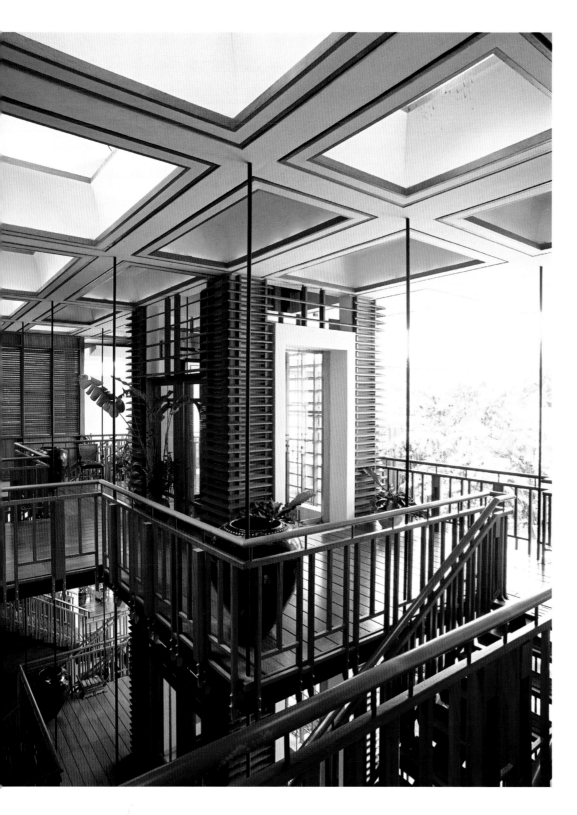

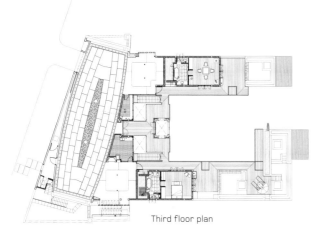

Third floor plan

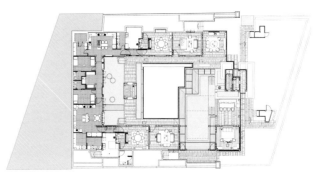

Ground floor plan

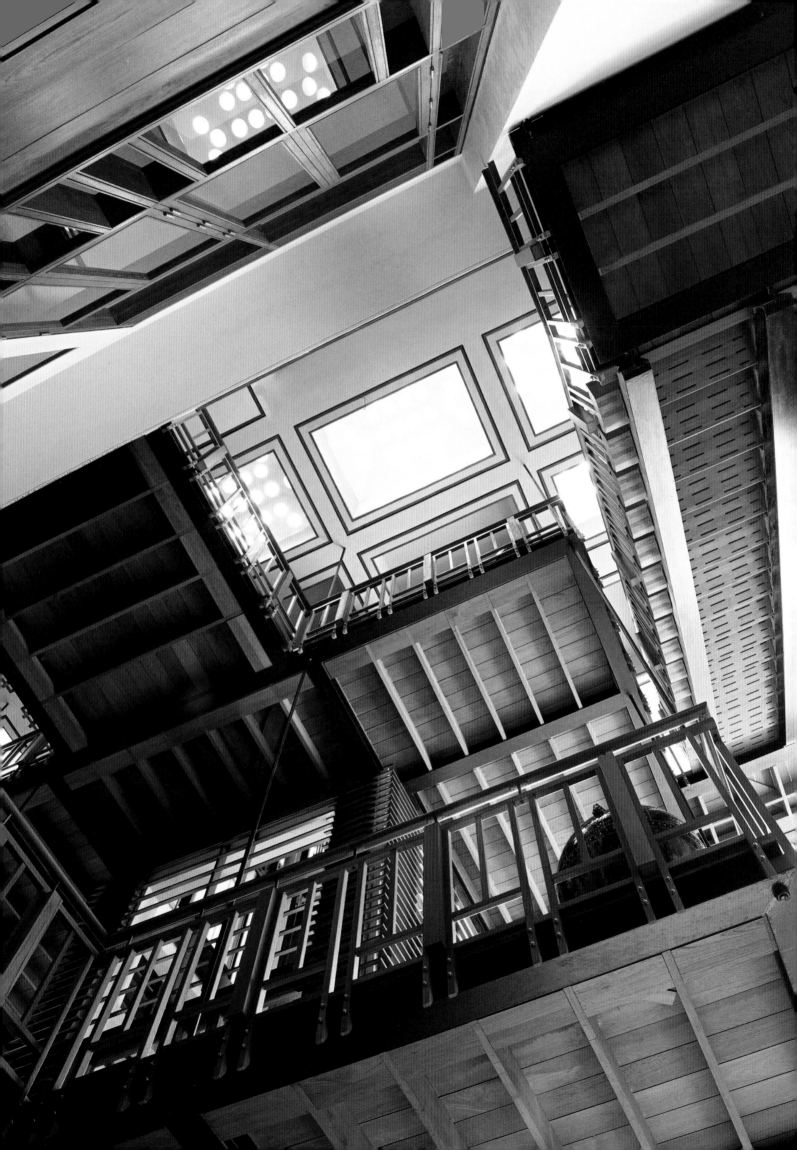

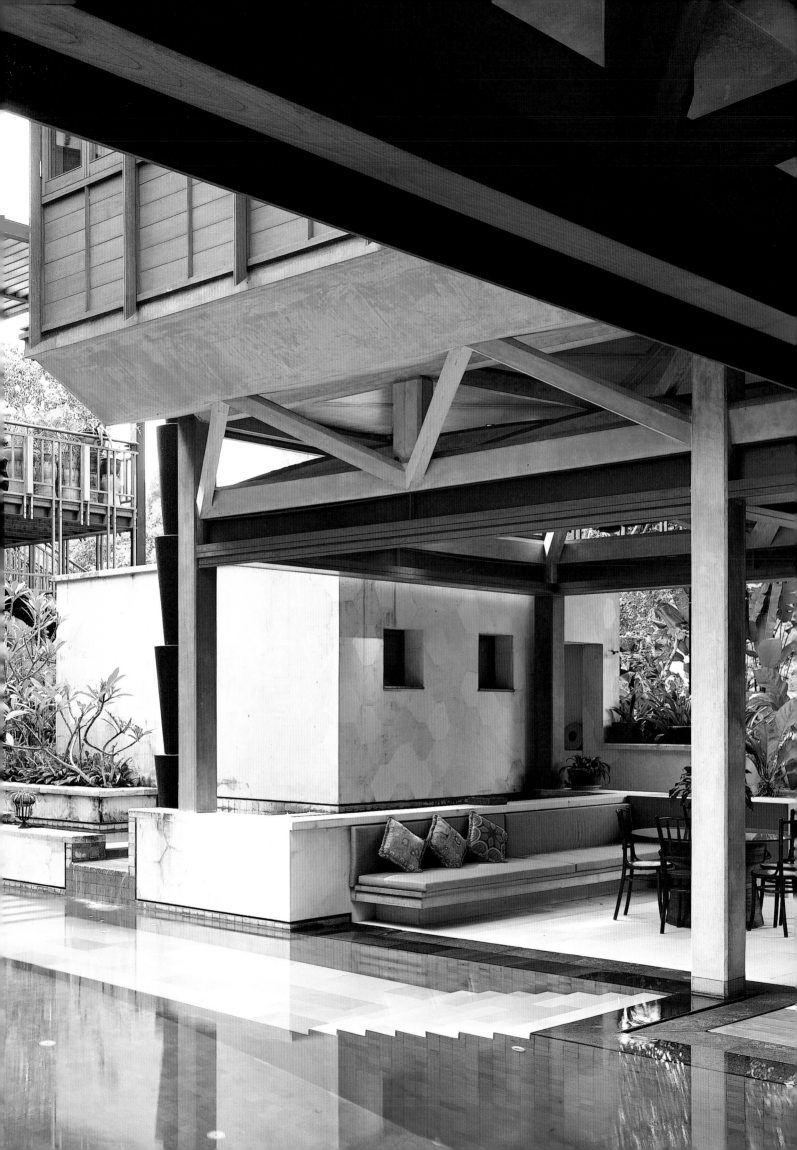

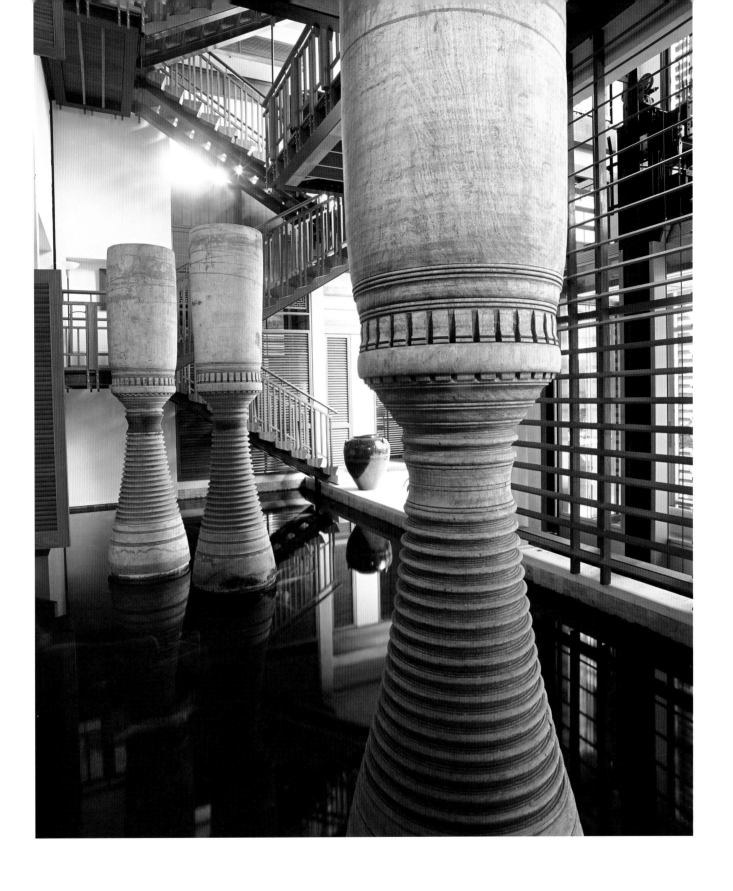

Left An informal dining area completely open to the garden links the house to a traditional tropical way of life. The elegant rib-like concrete framework lends a light-weight touch, relieving the heavy proportions of the timberwork above.

Above The reflection pond at the base of the atrium maintains the theme of tropical Asian living touched by a ceremonial mood. The giant timber tribal drums were shipped in from Borneo.

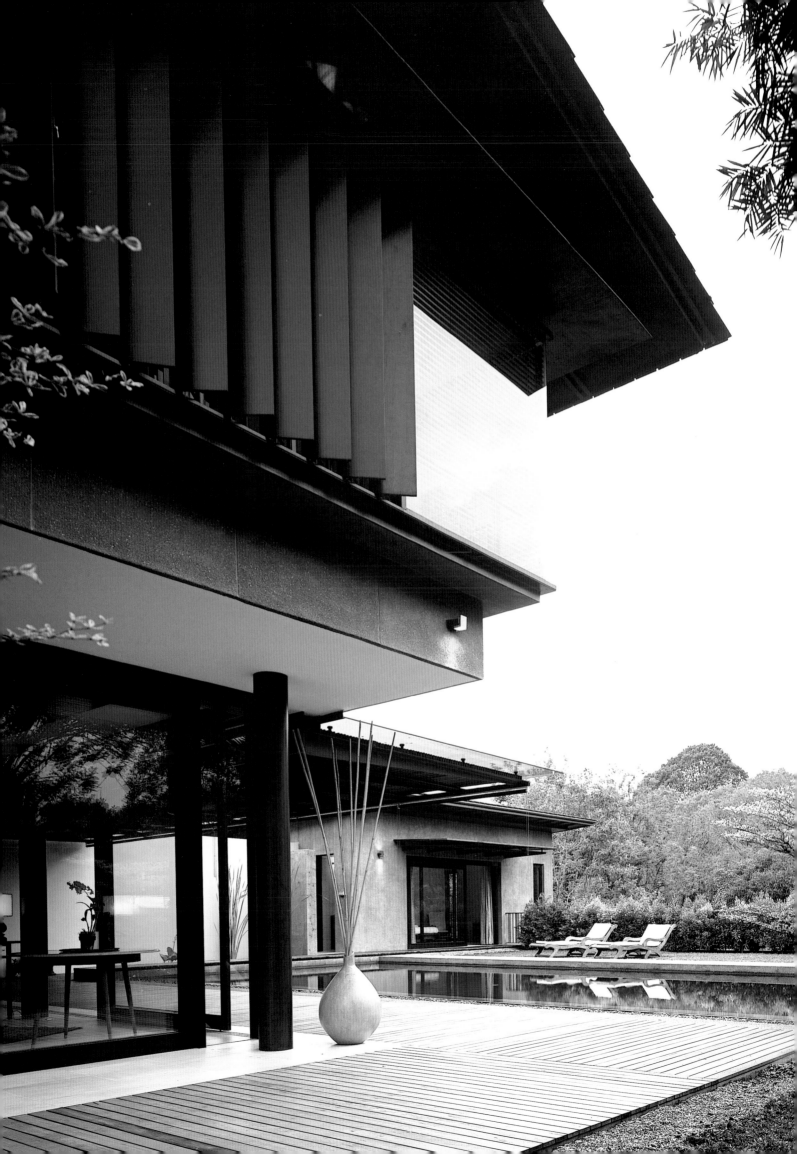

linden drive house

A unique and ingenious exercise in the enjoyment of complete privacy, whilst employing just the minimum of enclosure... the Linden Drive House is set back on a platform at the top of a two-tiered site set high above the road. The result is the easy informality of bungalow living without any strong sense of urban concentration.

Opposite A view from the northern garden over the entertainment deck to the guest pavilion beyond the pool. From its elevated position, the house 'borrows' the tree-scape of the park across the road.

Right The transparency of the living and dining area enables the dissolution of the form of the house, to create a perfect fusion with the garden.

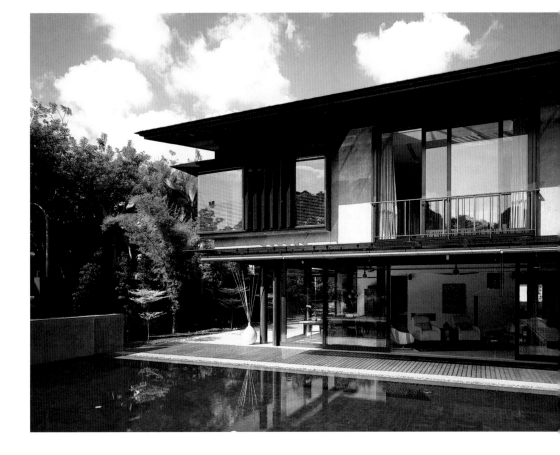

LINDEN DRIVE HOUSE

SINGAPORE

ARCHITECT IP:LI DESIGN

A flowing open-planned interior looks out across a terrace, a wide reflection pool and an expansive lawn to embrace, not the road or neighbouring houses, but the trees of a park and an uninterrupted skyline. It is a solution which owes its success to the dialogue between architect and client, and between the architect and the 'givens' of the site. Although the house does not need to screen itself from public view, it still provides a ceremonial transition from the public to the private domain in the form of a steep, canopied stairway leading up to the entry level and framed on one side by a timber screen and columns on the other. A large timber door then opens on to the key organizing element of the house, a central stairway to the upper level, enclosed on all sides, but with vertical and horizontal slots offering glimpses and containing hidden lighting. The suspended timber batten stairway is lit from above, with the sunlight filtered through a timber and steel grid.

Bottom The family room on the second floor looks into the central light-filled atrium space through a glazed wall. The core of this house is a robust contemporary adaptation of the lightwell of the Singapore shophouse.

Below and right The central atrium, containing a suspended stairway, is the heart of the house with sunlight cascading down from a timber and steel grid in the roof.

There is a hint of the Katsura Temple in the way the main level of the house zig-zags its way around to the rear of the site, with each space seamlessly flowing into the next. In fact, the journey actually begins with the guest pavilion, which is set diagonally across the pool from the main house. Clad in a distinctive Shanghai plaster, it has its own entrance from the stairway, but can also be accessed from the main house by a timber bridge, which separates the swimming pool from a fishpond. The guest pavilion is completely private with its own view on to the pool garden, but retaining a clear sense of connection with the rest of the house.

A low-maintenance Japanese garden reinforces the ceremonial mood, as do the subtly processional circular columns. Otherwise, the close connection between the inside of the house and the landscape is tropical in inspiration, with large, custom-made timber-framed sliding glass doors opening up the living area to the garden on both

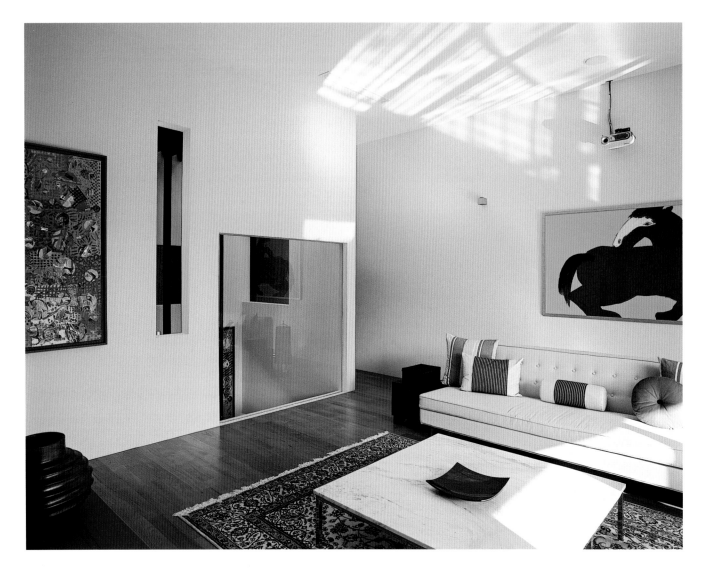

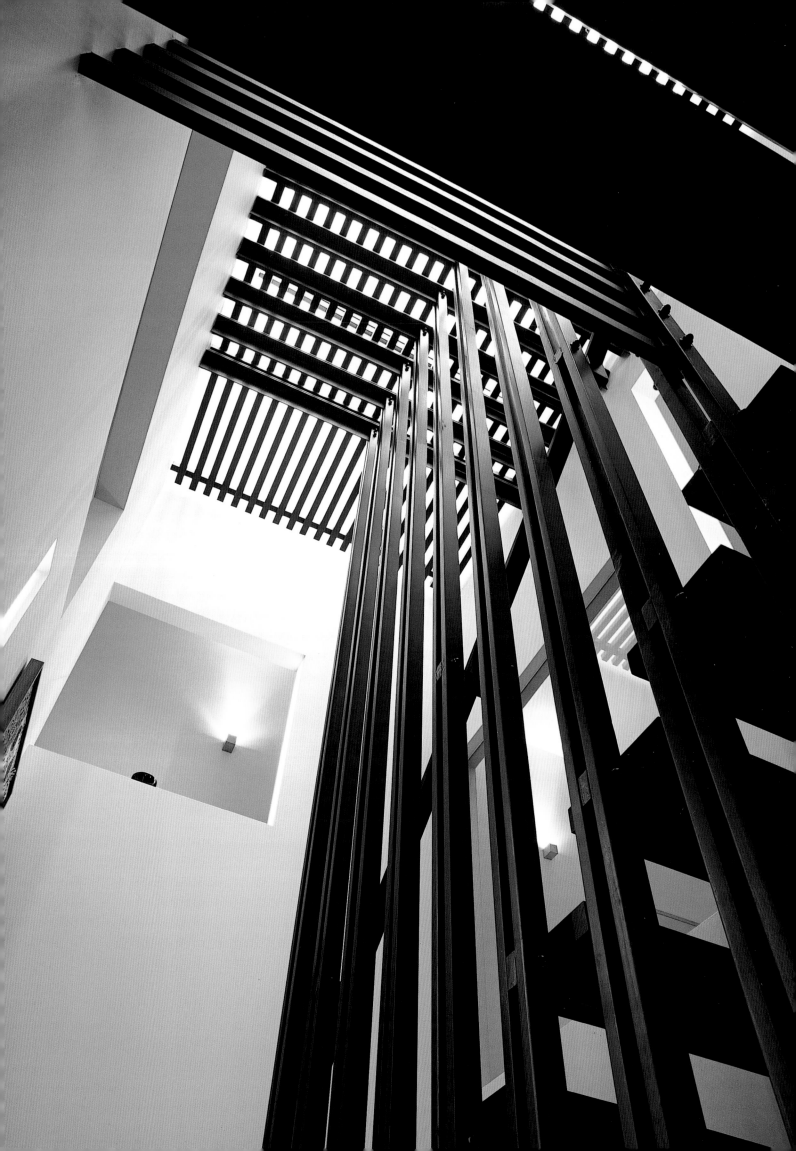

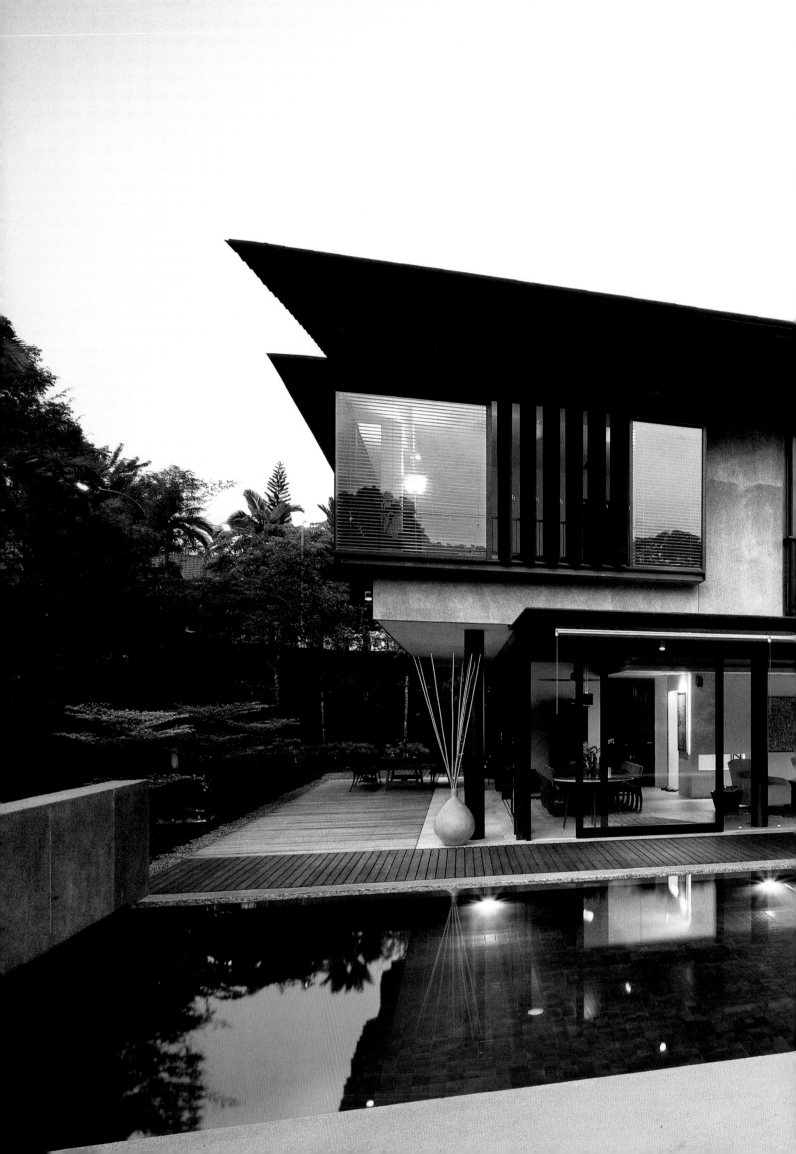

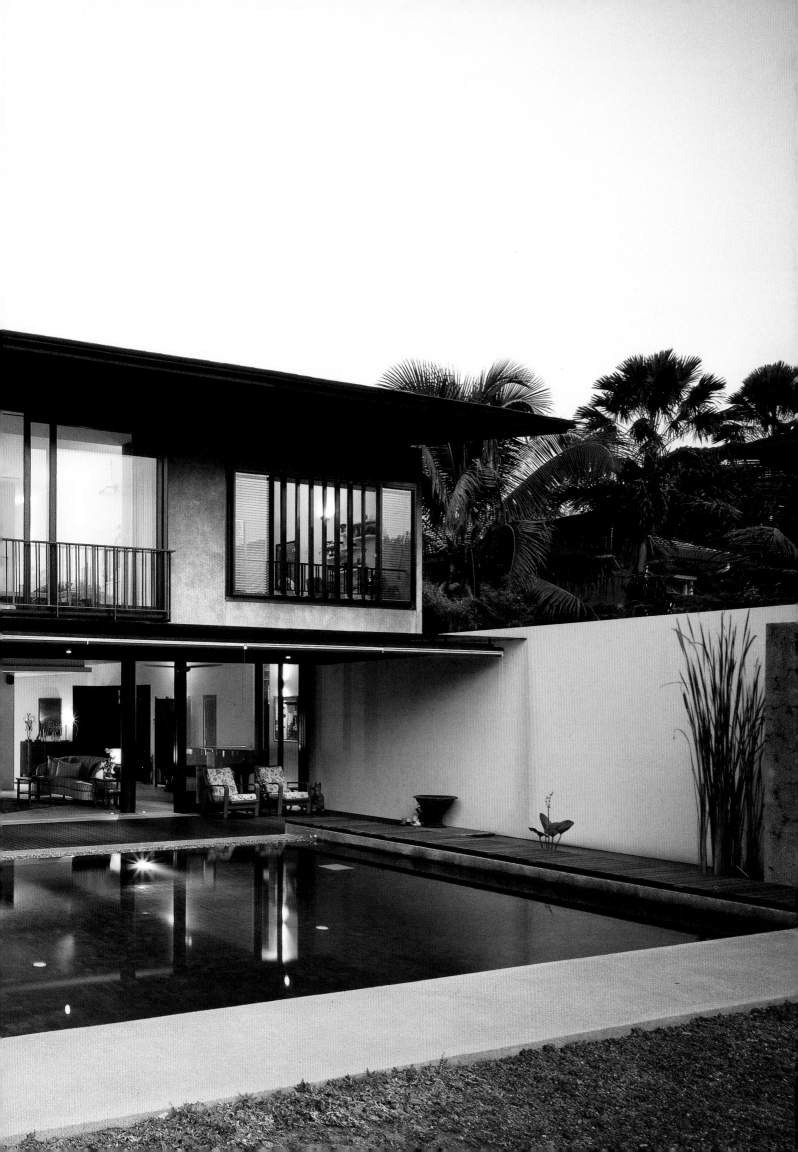

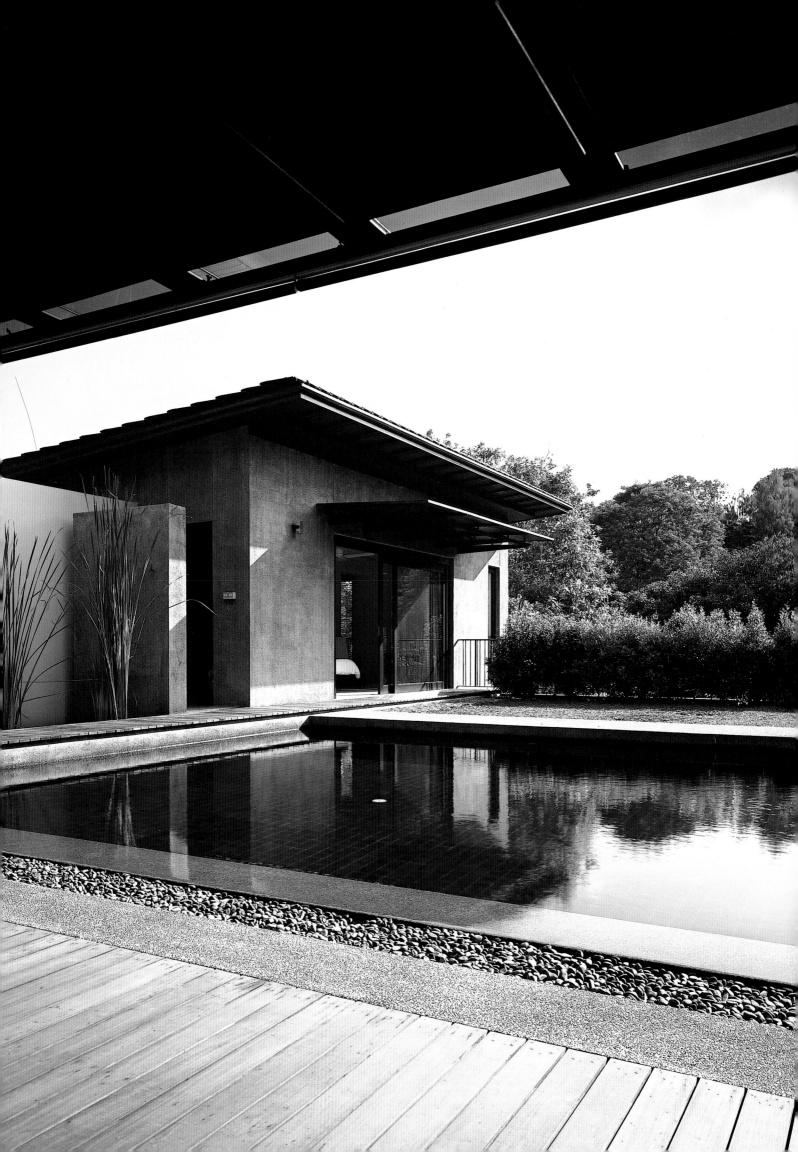

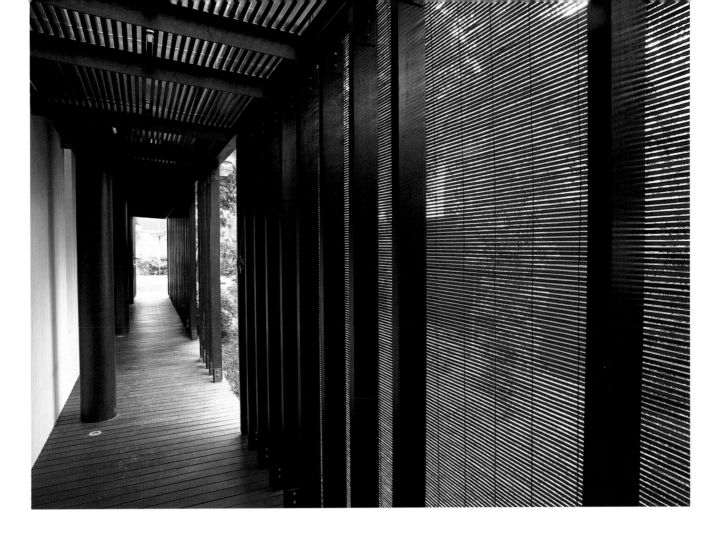

Previous pages The landscaping elements of walls, garden and water combine to generate a pervading spirit of tranquility and privacy, without any sense of enclosure.

Left The guest pavilion is completely private, yet still a part of the complex. It is reached by crossing a timber walkway, which rises just above water level between the swimming pool and the fishpond.

Above A ceremonial stairway leads up from the street entry, and its timber screens and columns introduce a Japanese mood which is continued in the gardens.

sides. Overhangs protect the timber decking, which wraps around the outside, with an additional canopy over the outdoor eating area. The main house has five bedrooms on the upper level, as well as an additional guest suite on the ground floor. The children's bedrooms are separated from the master bedroom by a family room organized around the central stairwell. The master bedroom occupies the north western corner of the building and features traditional latch-and-hook wooden pivot windows. The house has a distinctive brown on white palette… the joinery, the exterior timber cladding and the steel columns are brown, while the garden walls are painted in a slightly different tone of brown. The effect makes the columns and walls less obtrusive, emphasizing the marriage of the house with the garden.

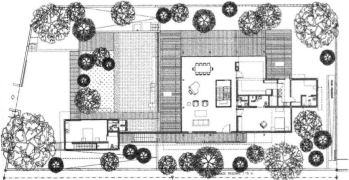

Site plan

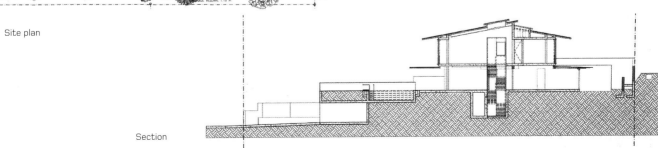

Section

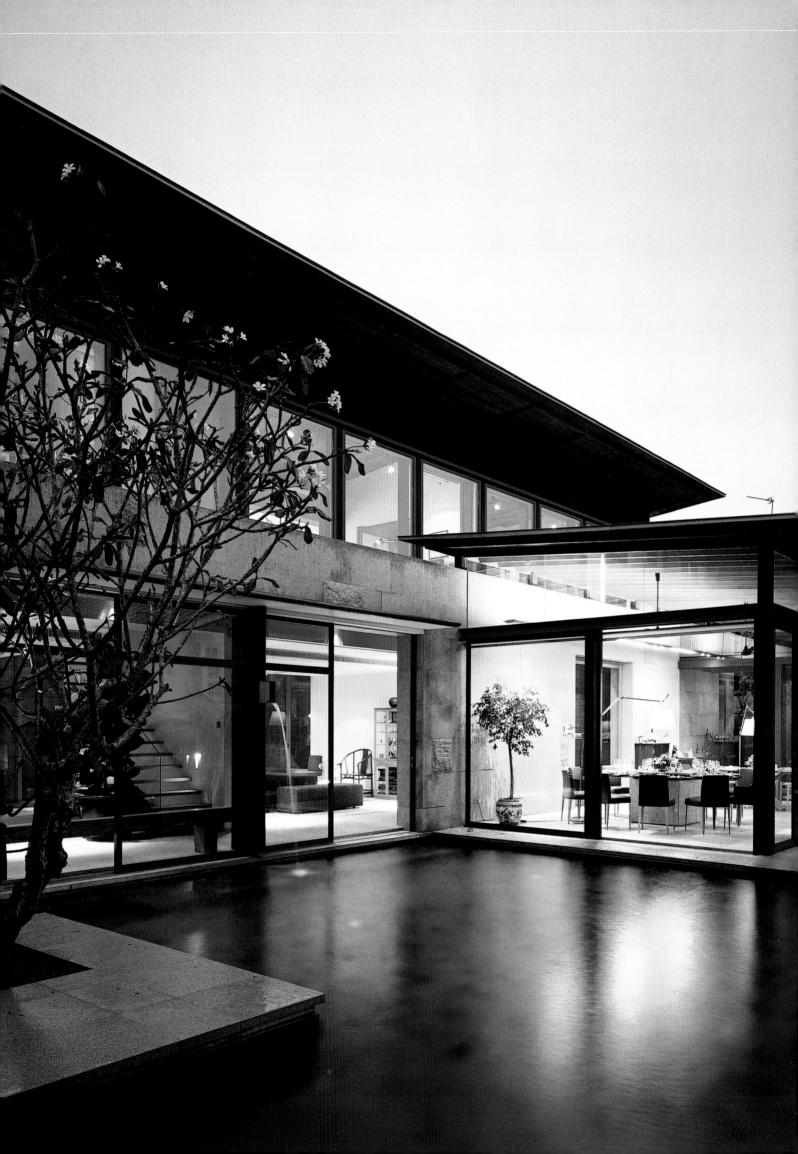

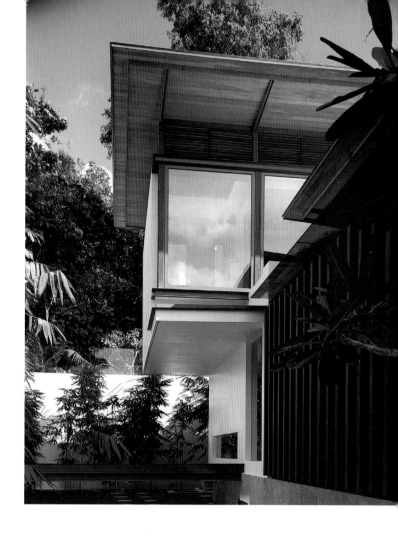

Left The wonderful and sublimely calm ambience of this house derives particularly from the manner in which the pavilions appear to float above the still surface of the reflection pool.

Right Each of the three pavilions has its own 'mono-roof', which floats free of the house to bring a sense of lightness and easy equilibrium.

caldecott house

Transparency, simplicity, light penetration and the use of water are typical of the work of Ernesto Bedmar... and these are strategies are strongly present in the Caldecott House. As with all of Bedmar's bungalows, this house enjoys a light-filled tranquility and a simplicity of living, which comes from a balance between the vernacular and the modern, which Bedmar says is "the key to a home".

The house sits at the end of a cul-de-sac, occupying a long and narrow site. It is positioned between the client's former house and a Chinese cemetery sitting 4 metres above the rear of the house. Cultural sensitivity required the house to be screened from the cemetery, and this was achieved by building a high rough-hewn granite retaining wall. By creating a fish pond along the length of the wall and the house, abundant light is drawn into the house, which is helped by the simple plan of the house... basically three pavilions forming a U-shape around an extensive reflection pond. The main pavilion is just one room deep, with an arcade running the length of the house, connecting a rumpus room, a large living area, a kitchen and a powder room. The arcade, lit through a skylight modulated by timber battens, links the fishpond, the living room, the external terrace and the reflection pond.

CALDECOTT HOUSE

SINGAPORE

ARCHITECT BEDMAR & SHI

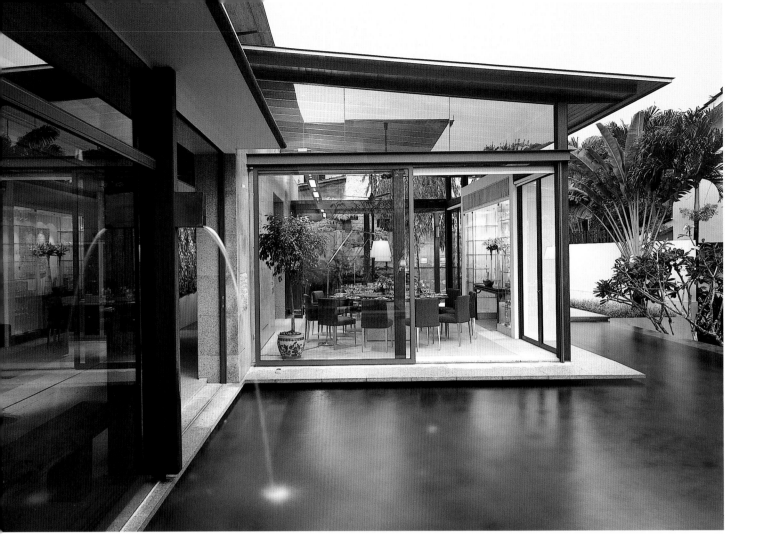

Above Broad eaves, highlight windows and fully glazed walls give the dining pavilion an ethereal quality as it floats above the reflection pool.

Right Looking across the pool, the luxuriant vegetation of the neighbouring property is 'borrowed' to maintain privacy.

The other two pavilions appear to float at either end of the reflection pond. Closest to the entry is the guest pavilion, a sublime space, which opens up completely to the pool, looking past a granite stone pier with a mature frangipani tree to the fully glazed dining pavilion opposite. The interior walls of the main pavilion utilize polished granite to contrast with the texture of the retaining wall. Access to the upstairs bedrooms is by a central stairway, where the return has a vertical slot window providing a framed glimpse of the cemetery... a reserved acknowledgement of the house's cultural context.

Transparency, light and lightness are also created by the roof forms: three separate mono-roofs 'float' above highlight windows, eliminating any sense of the roofs 'pressing down' on the building. That the house is able to enjoy so much privacy without any sense of enclosure is also due to the fact that the house is able to 'borrow' the established garden of the client's former house, which shares an edge with the pool area.

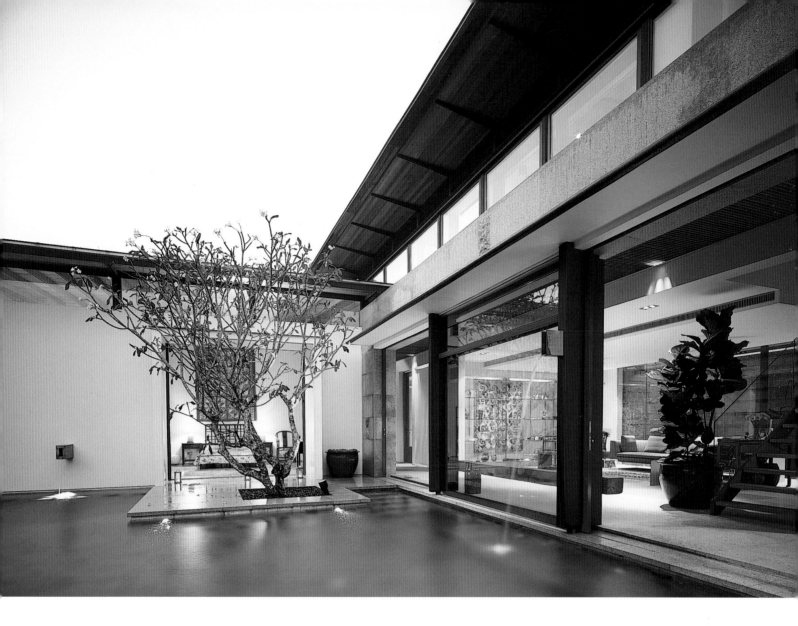

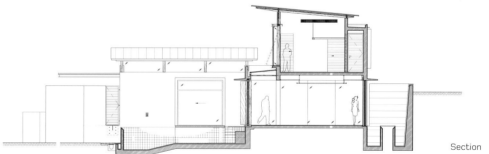

Section

Above Looking from the dining pavilion over the pool to the entry reveals an ensemble of beautiful tranquil moments, including a graceful water-spout and a single frangipani tree apparently growing out of the water.

Right The rough-hewn granite retaining wall offers enclosure and visual richness, while the glazed wall between the house and the long fish-pond draws light into the living area.

Following pages With the house glowing at twilight, this view across the water to the fully transparent living room epitomizes Ernesto Bedmar's unique ability to create extended moments of pure tranquility.

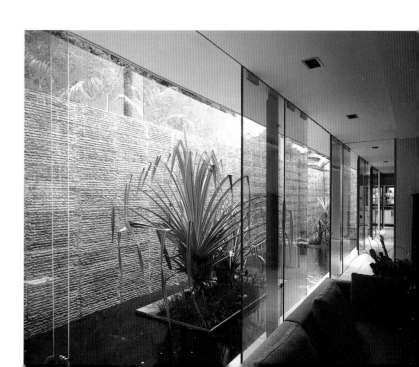

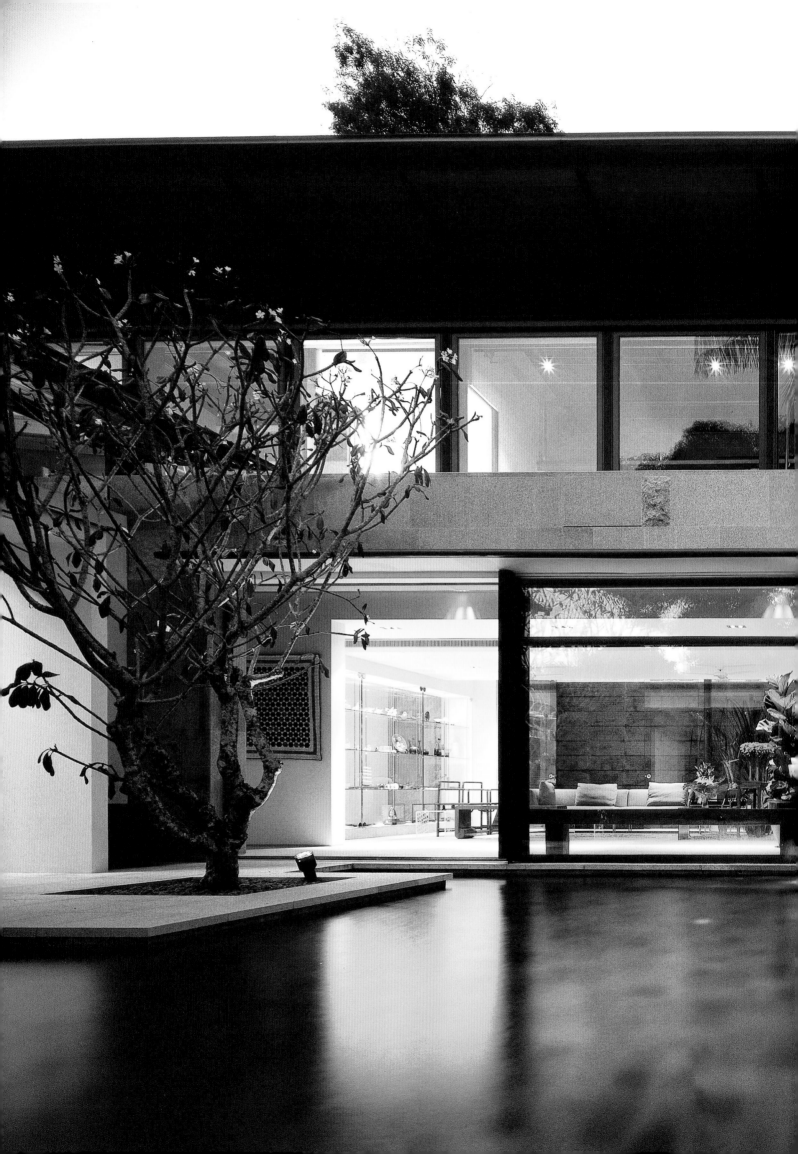

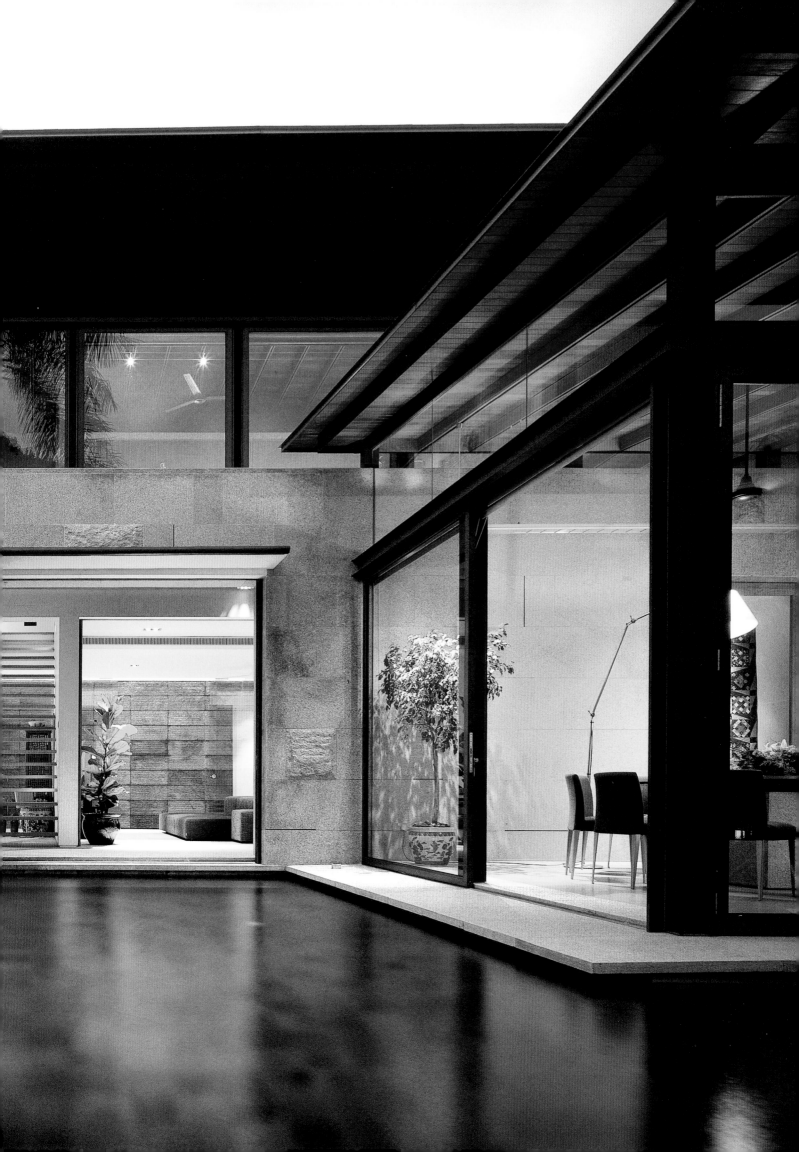

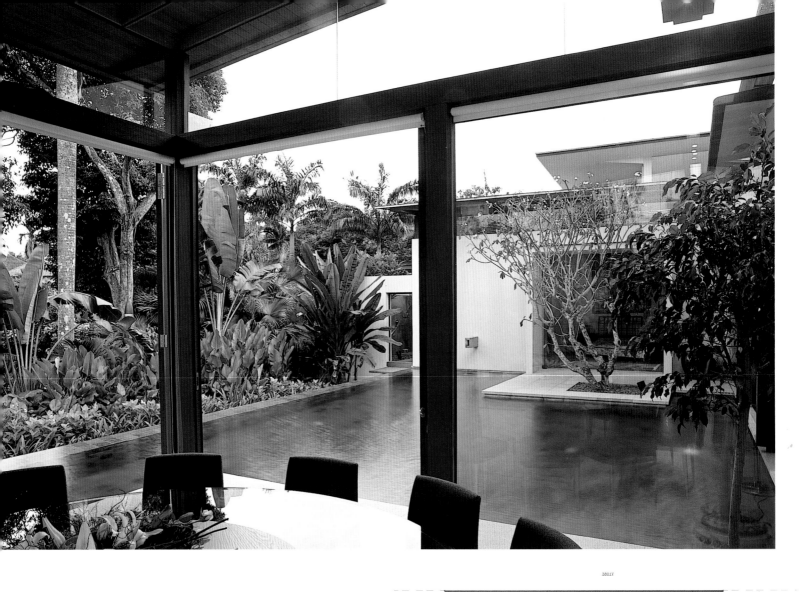

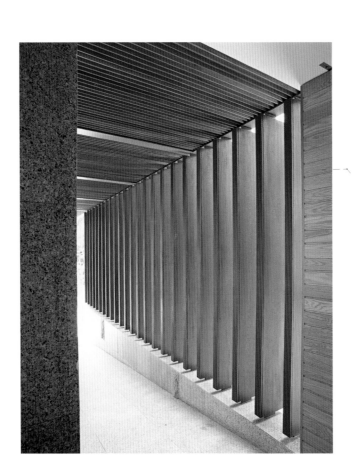

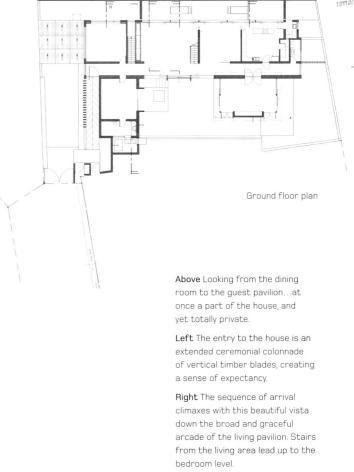

Ground floor plan

Above Looking from the dining room to the guest pavilion...at once a part of the house, and yet totally private.

Left The entry to the house is an extended ceremonial colonnade of vertical timber blades, creating a sense of expectancy.

Right The sequence of arrival climaxes with this beautiful vista down the broad and graceful arcade of the living pavilion. Stairs from the living area lead up to the bedroom level.

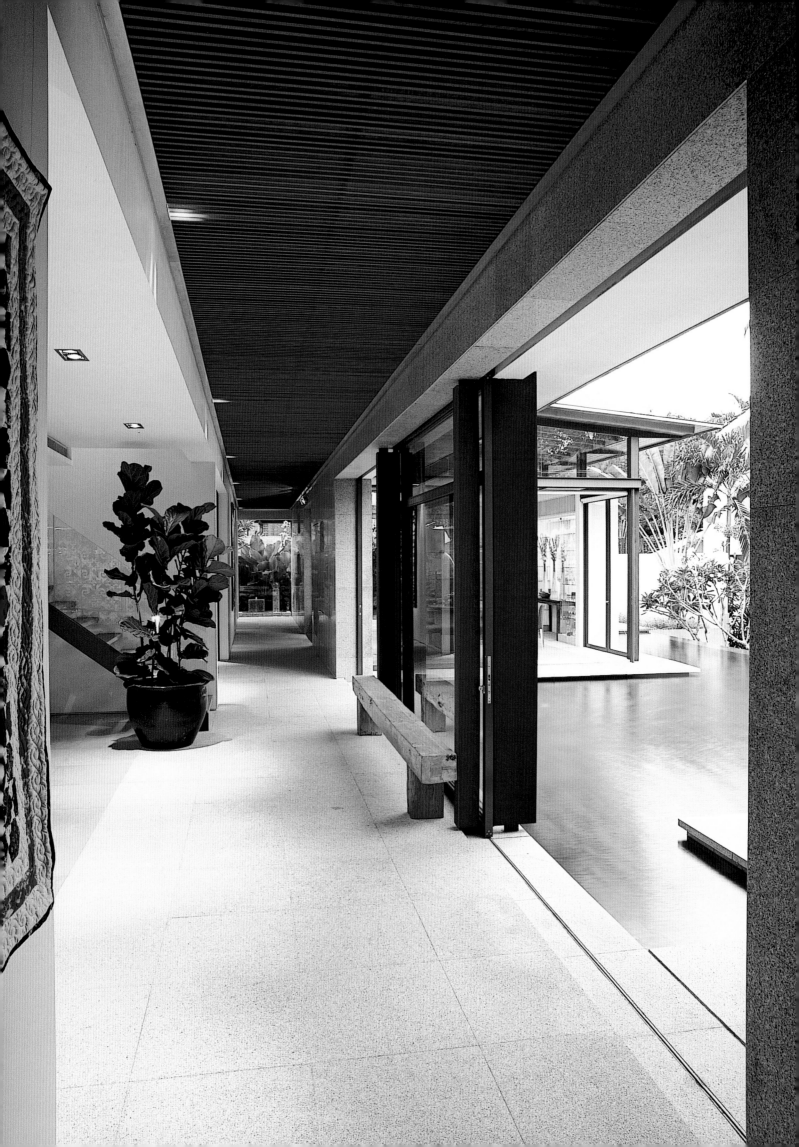

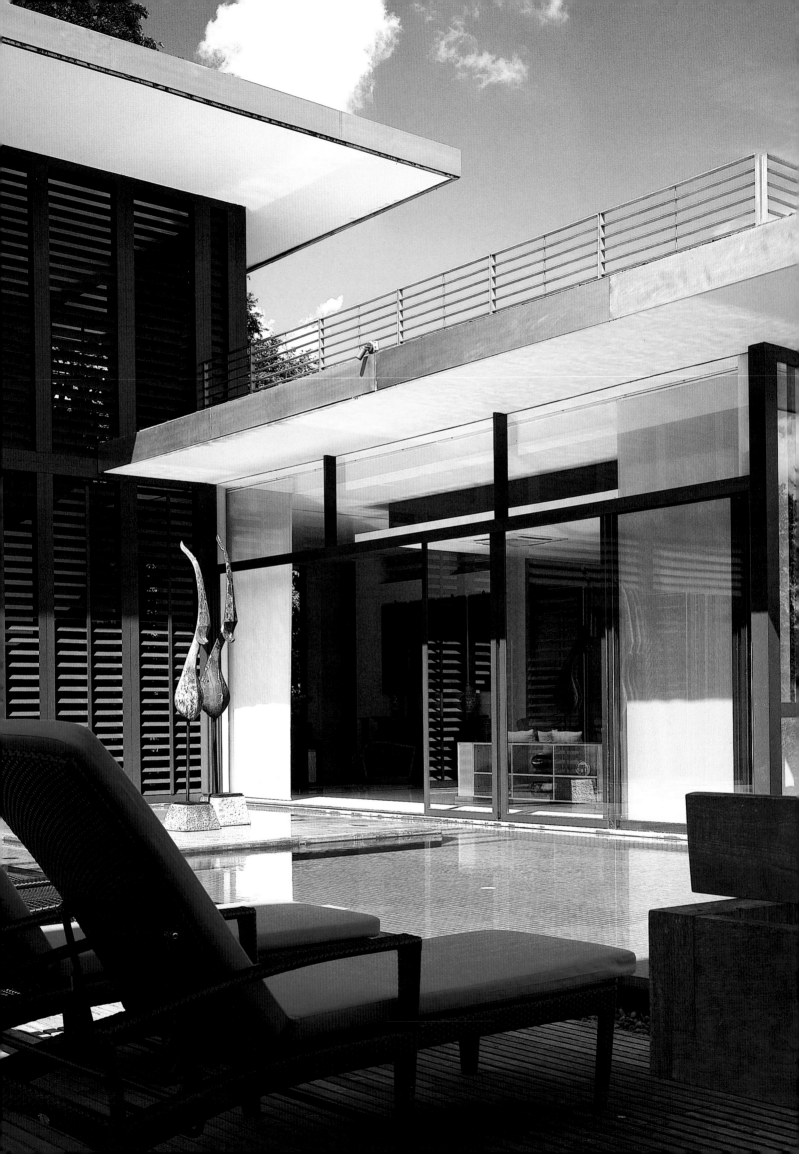

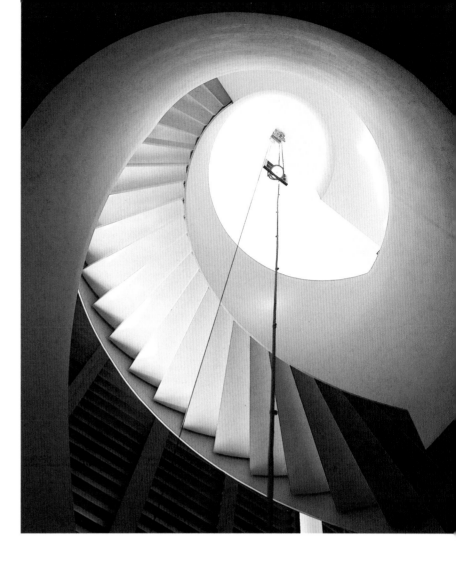

Left A view across the communal poolside area to the parents' dining pavilion shows a beautiful modernist composition of intersecting planes, punctuated by a wall of aluminium louvres, which hint at a more traditional domestic architecture.

Right The parents' house is entered at the lower street level, and the visitor ascends to the house via an elaborate spiral staircase.

coronation road west houses

This mini-village, or compound, has to be one of the clearest expressions (in built form) of the contemporary extended family in Singapore. It holds the family together through a shared site and a number of communal areas... but at the same time it allows complete independence, privacy and the opportunity for an individual lifestyle.

The 'compound' is actually a cluster of three houses on a site of nearly 4,000 square metres, which had been sub-divided by the original owner. It exemplifies a very common challenge in contemporary Asian domestic architecture, reflecting as it does the rapid economic and social changes of the last twenty-five years. This challenge results from the need to accommodate two apparently contradictory forces – the continuing strength of the extended family, and the growing trend towards individuality – within a single dwelling. In this case, the architect chose not to try to resolve the problem in a single building, but decided to create a compound in which the individual family houses could have separate identities, but also enjoy communality through the linking landscape, the reflection ponds and the swimming pool. Separation has been enhanced by rationalizing the sloping site into two terraces. Similarly, the buildings are staggered to

CORONATION ROAD WEST HOUSES

SINGAPORE

ARCHITECT CSYA

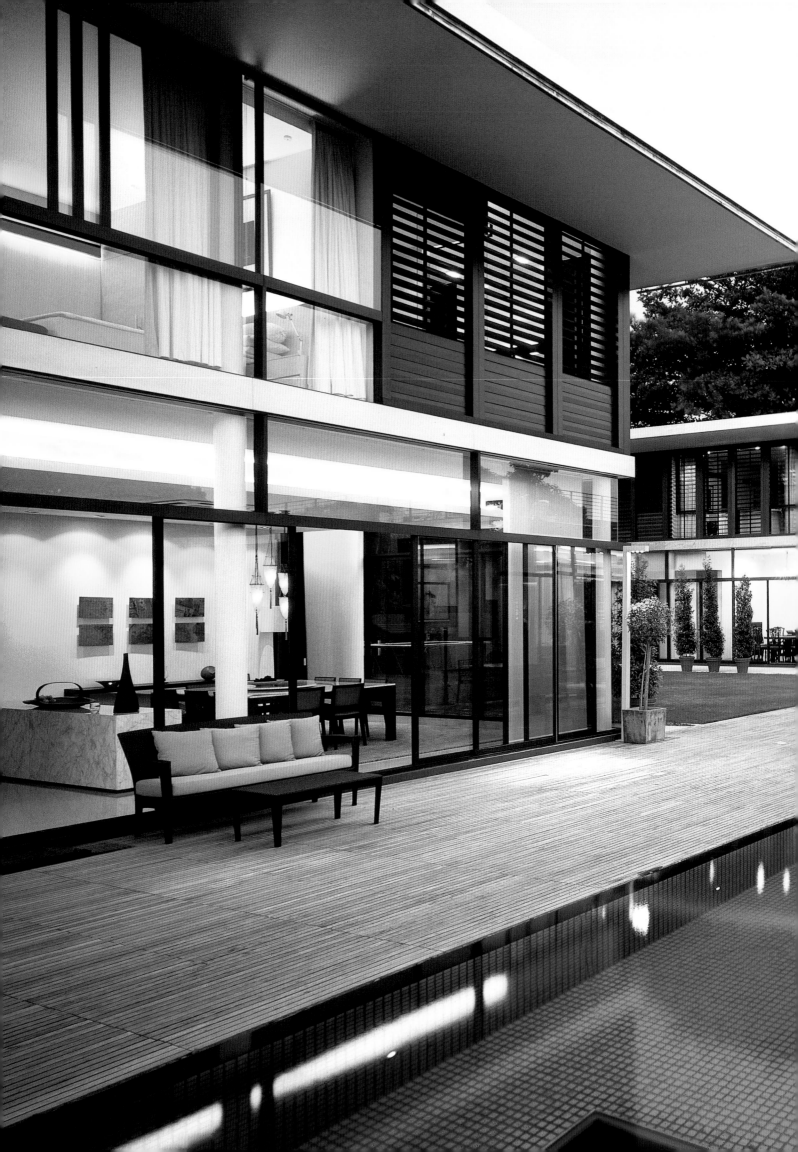

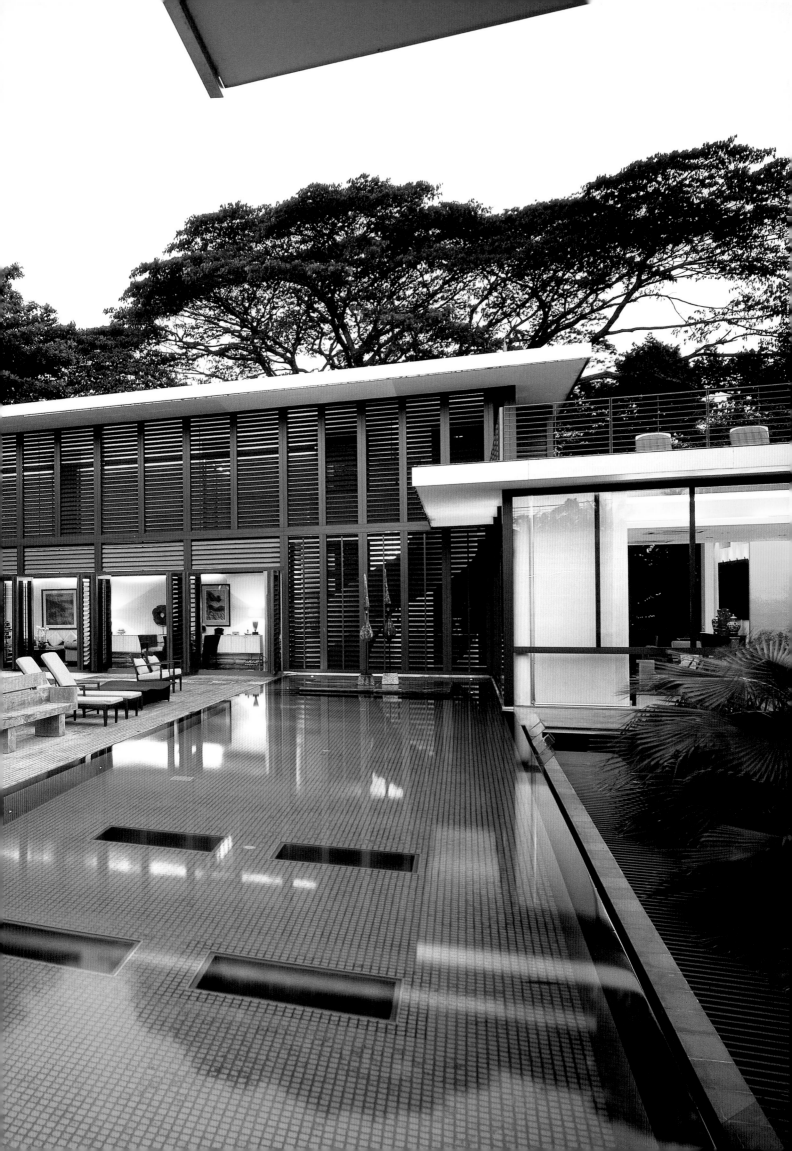

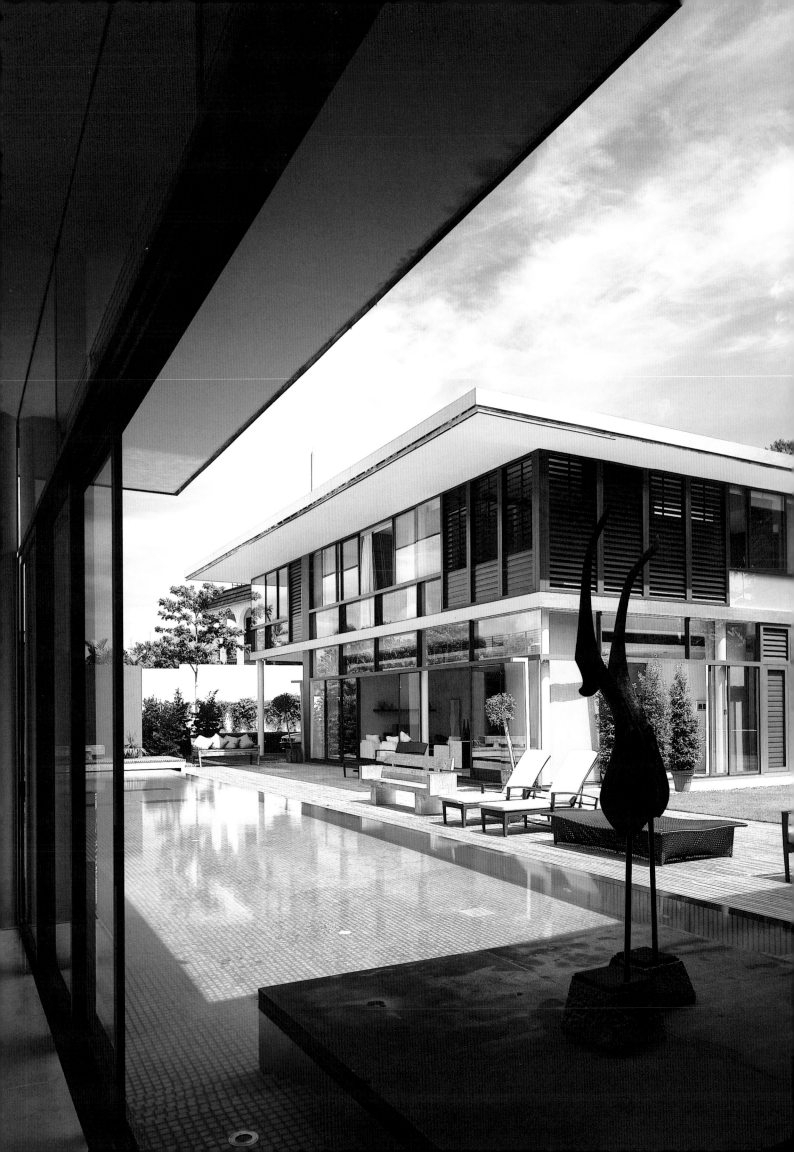

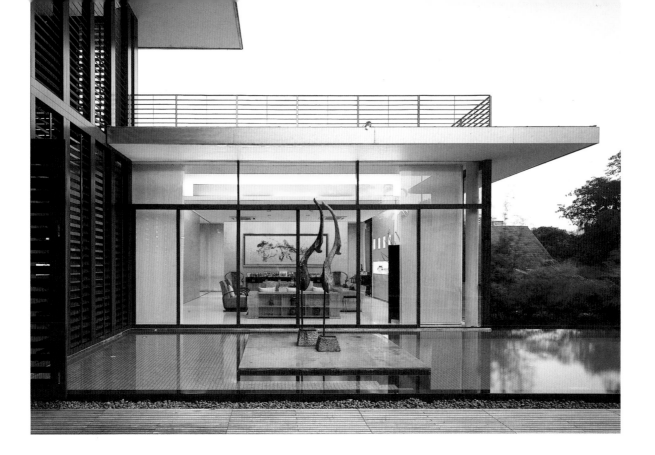

create view corridors and enhance privacy. Yet these strategies also create an over-riding sense of cohesion, supporting the impression of a shared urban space.

The smaller plot is occupied by the parents' house, which straddles the fall of the site with a *porte cochère* formed by the extruded formal living and dining pavilion supported on *pilotis*: this links with the two-level residential pavilion on the upper terrace. The larger plot is occupied by the son's house on the lower terrace, and the daughter's house on the upper terrace, with a basement looking out to the lower terrace.

The landscaping elements delineate the three areas of the compound, but without the need for physical barriers. The notion of a compound implies traditional villages, which are often clustered around a river course. Here the river course is suggested by the sequence of reflecting pools and the 45 metre swimming pool. The latter, with its broad, open joint timber deck, links the buildings on the upper terrace, but also links to the lower terrace: terminating as a cascade down into the reflecting pool at the entrance of the parents' house. Vertical connection is also promoted by the light drawn down into pebble courtyard of the lower terrace through the open deck.

As with the connecting water features and the timber deck, operable aluminium louvres on the façades overlooking the communal courtyard and swimming pool hint at traditional houses, and so amplify the feeling of compound living. Each house also has a directly accessible rooftop garden for private recreation. Traditional motifs are set in conversation with explicitly modern elements, such as the rectilinear forms of the buildings, the flat roof eaves and the flat modular façades, with full-height panels of either aluminium frame and glass, operable aluminium louvres, translucent marble, or opaque pre-cast hollow core concrete.

Previous pages On the upper level, the swimming pool and extended timber deck create a vast communal area. The lower level of the house is illuminated by glass panels in the bottom of the pool.

Left The central pavilion sits to the west of the swimming pool. This view is from the parents' house to the north.

Top The dining room of the parent's house is visually connected to the communal area, but gently set apart by a reflection pond with its central sculpture.

Above A view from the southern house looks to the parents' house, with the western pavilion to the left. The levels of the 'compound' are clearly shown, with the communal swimming area set above a private courtyard.

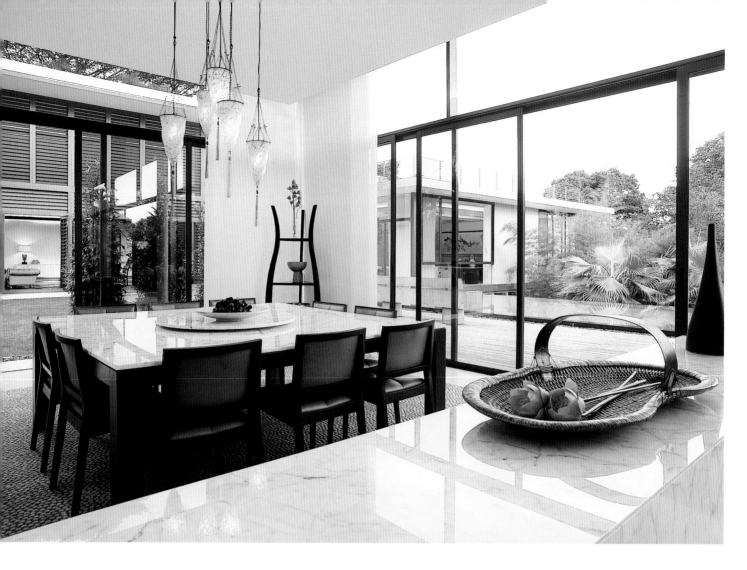

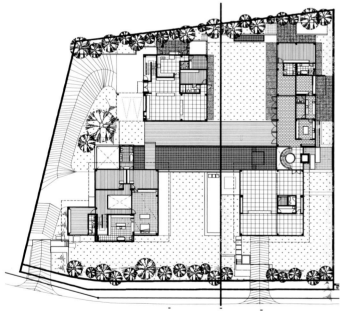

Site plan

Above The dining and living areas of the western house look out to the common areas. Each house is always visually connected to the others, but the landscaping, differing levels and the orientation of the buildings create a sense of separateness without the need for physical barriers.

Right The southern house has a dramatic double-height central space, which is bathed in sunshine from a huge skylight. The bedrooms are located on the upper poolside level, with living areas on the ground floor.

Section

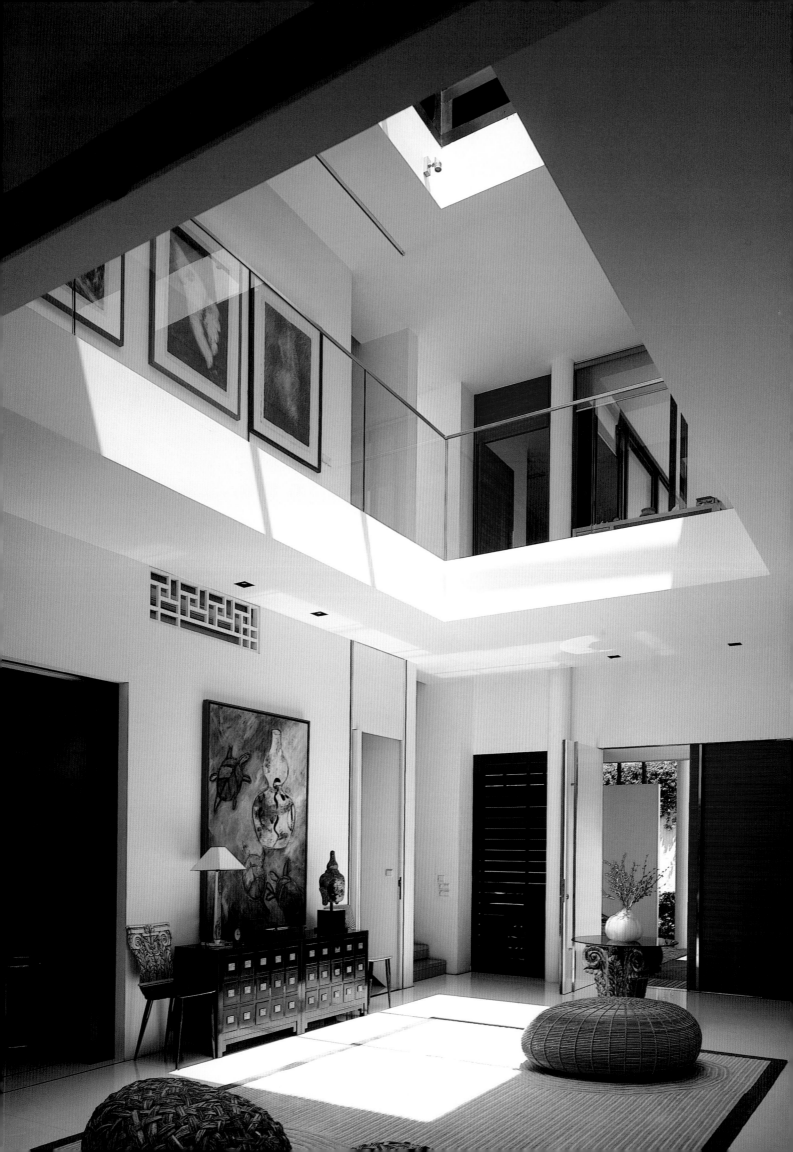

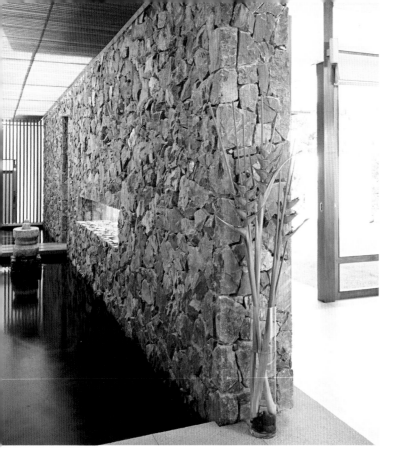

Left When seen from inside the house, the massive granite wall appears to be the outer containing wall of the inner sanctum. It also acts as a robust decorative feature, with a horizontal slot window providing a glimpse of the outside world.

Right The street façade of the house hints at the architectural pleasures contained within. A discreet entry is through a ceremonial timber door.

sadeesh house

A sublime exercise in prospect and refuge, the Sadeesh House is a sanctuary whose cross-views and fragments of views, and whose internal journeys and varieties of domestic spaces create a world within a world. It is a house meant to be lived in... its textures are meant to be felt, and its sanctuary experienced, as a form of transcendental stillness and harmony.

SADEESH HOUSE

SUBANG JAYA, MALAYSIA

ARCHITECT BEDMAR & SHI

The prospect it offers is threefold: it looks out on to its own garden courtyard; it offers views over the pool to the distant Damansara Valley; and it provides an internal vista of effortlessly flowing spaces. The house is a harmony of contrasting materials and textures within a union of garden and interiors. Structure seems to dissolve into pure spatial experience, lit by a calming modulated light which appears to have no source, but simply suffuses through the house.

Traditionally, the journey from the hectic world outside into the sanctuary of the home involves transitional spaces. So it is here with a large ceremonial timber door, which opens on to a loggia marked out by a series of timber columns, and to a free-flowing garden courtyard defined by the U-shaped house made up of three pavilions. The single-storey entry pavilion also houses the guest

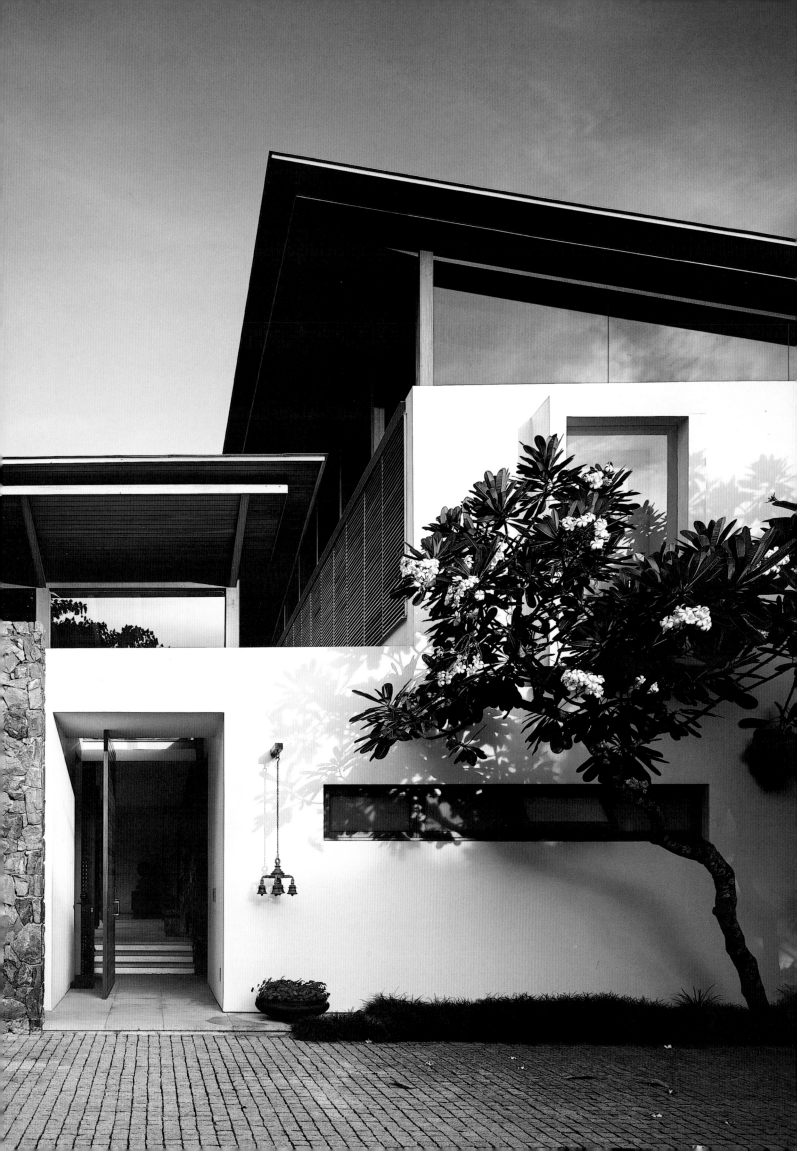

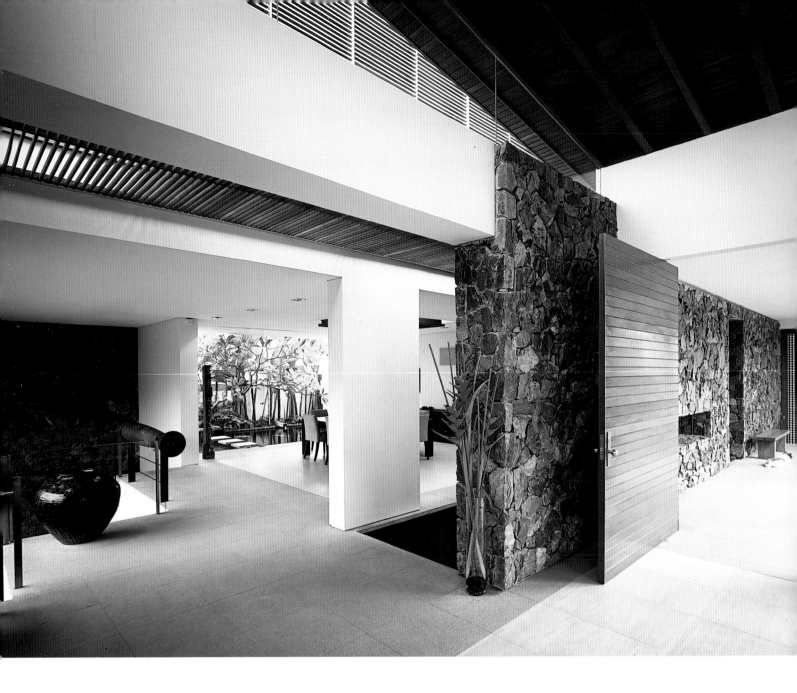

Above The dining and living areas flow seamlessly together, pivoting around the end of the granite 'rubble' wall and the internal reflection pond.

Right and opposite The gentle calm of the large open dining room is established by the transition from the garden and verandah, where a timber bridge spans the internal reflection pond. The columns are patterned with shadows from the battened skylight.

Following pages A view across the grassed courtyard shows the single floor living pavilion to the left. The larger two storey pavilion contains the bedrooms on the second floor, with the kitchen and dining room at ground level.

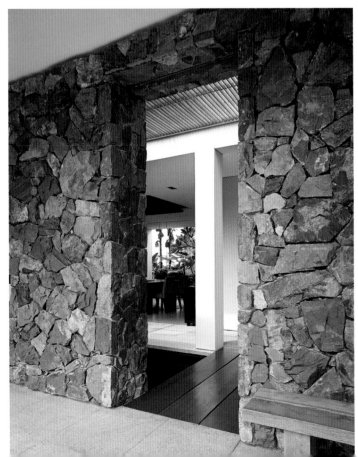

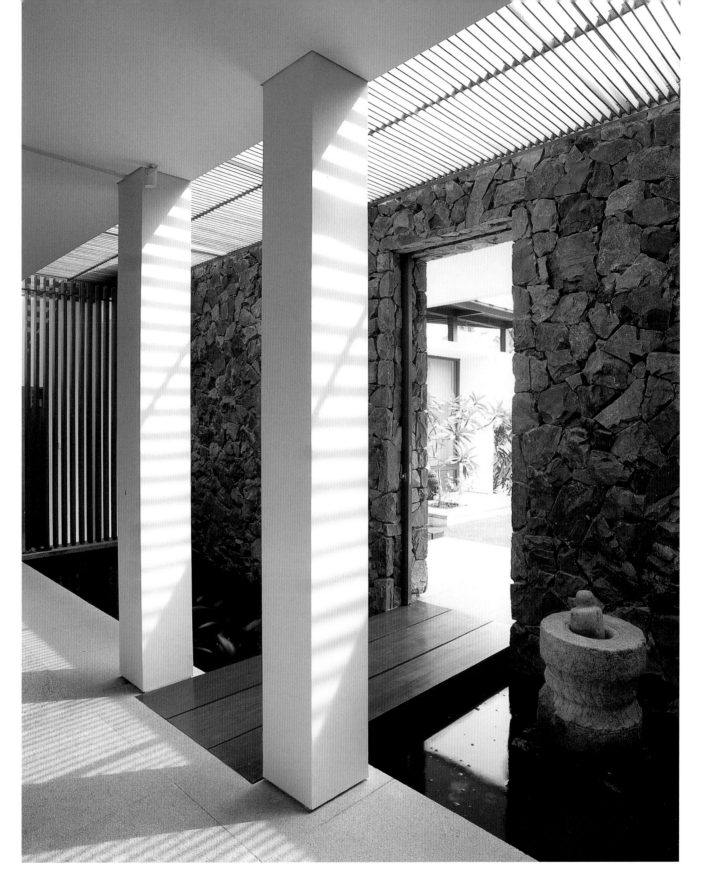

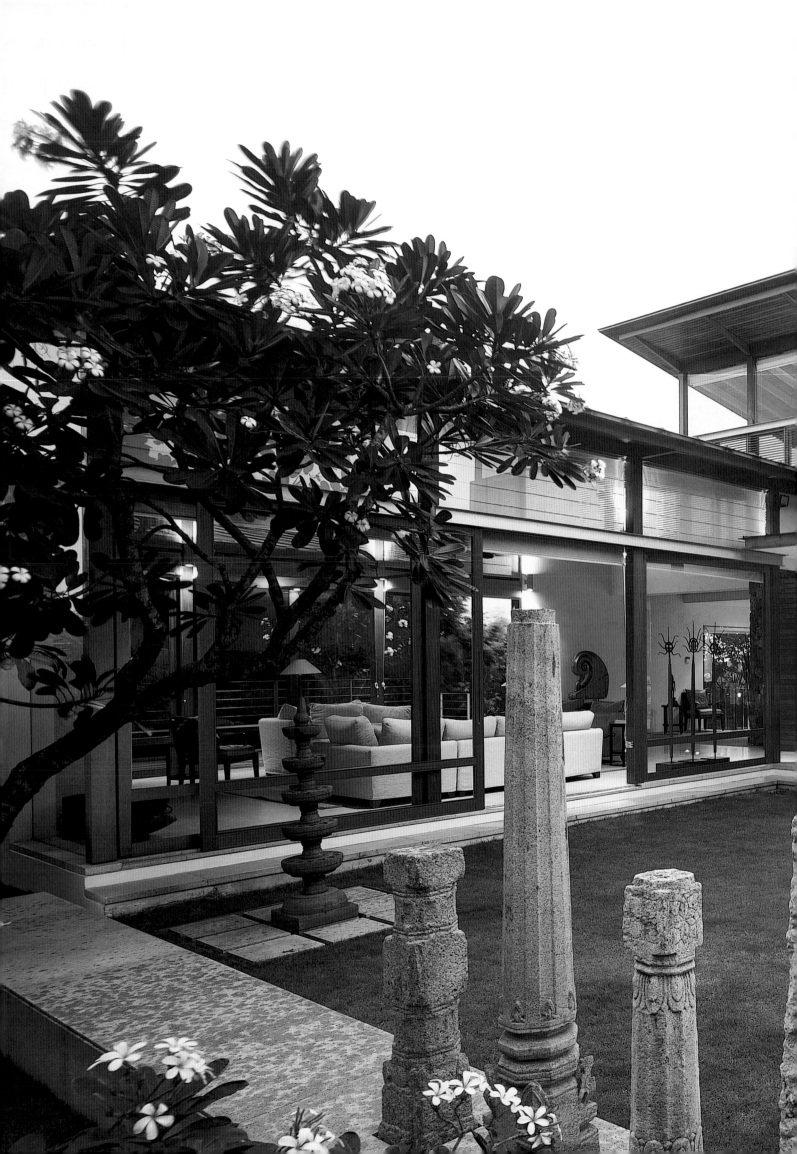

Left Discreetly placed ornamental artefacts remain one of the pleasures of traditional tropical living.

Below The swimming pool is a world within a world, set beneath the entry level at the bottom of a grand stairway.

Right The grassed courtyard is a place of contemplation, enclosed by the three pavilions. The smaller white-walled guest pavilion plays a deferential role to the two larger transparent pavilions.

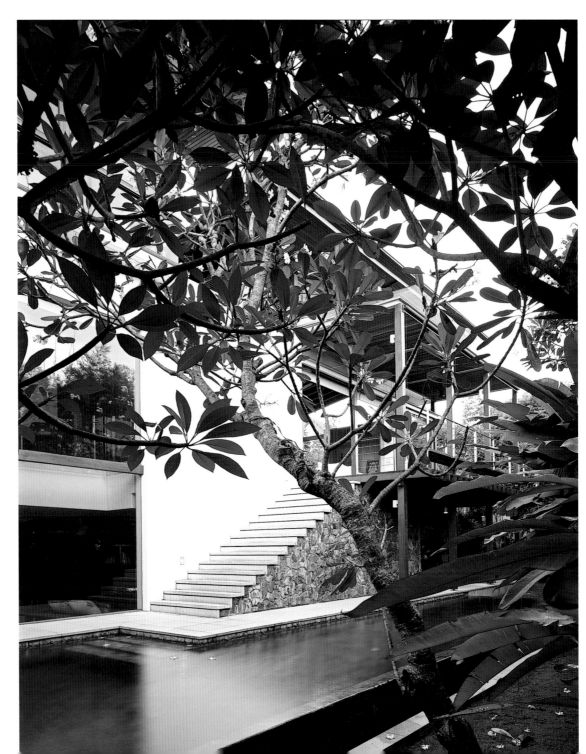

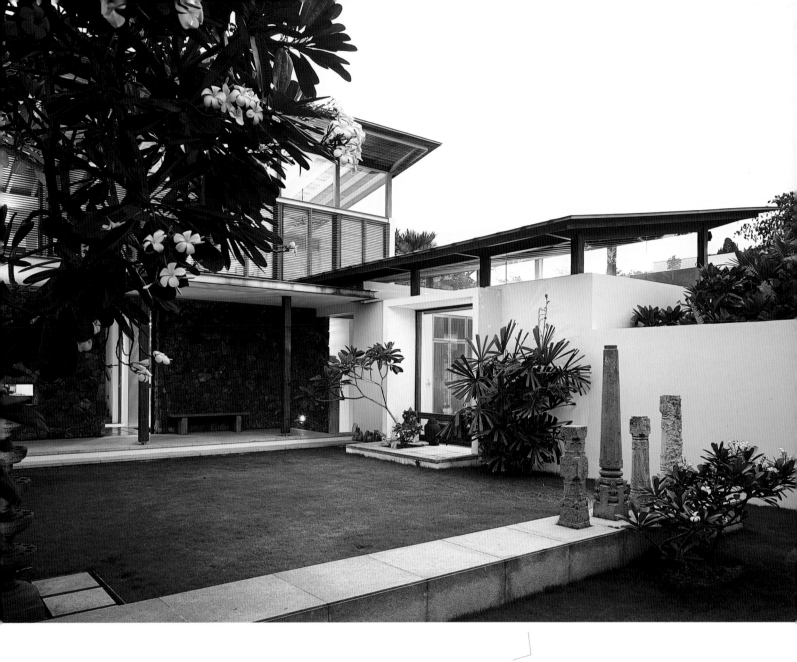

room, and opposite is the double-height, fully glazed living pavilion, which opens on to both the interior garden and the pool. The central two-storey pavilion contains the dining area, linked seamlessly on the entry side to the kitchen, and to the eastern living pavilion. The bedrooms and family room are on the level above. The transition to the restrained sensuality of the interior is extended by a timber entry walkway leading to a beautiful rough-hewn, effectively free-standing, granite rubble wall with a low, horizontal slot window. This walkway passes over a bridge, which spans a moat lit from above, the banded sunlight washing down through a timber screen.

Internally, the wall can be appreciated both as a sculptural object with a Zen-like stillness and beauty, and as an organizing element which articulates the transition between the dining area and the living pavilion. The eastern living pavilion continues the ceremonial journey through the house with tall, timber-framed sliding glass doors opening on to the garden on one side and on the other to a timber deck overlooking the pool.

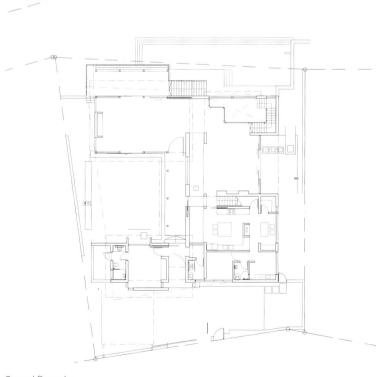

Ground floor plan

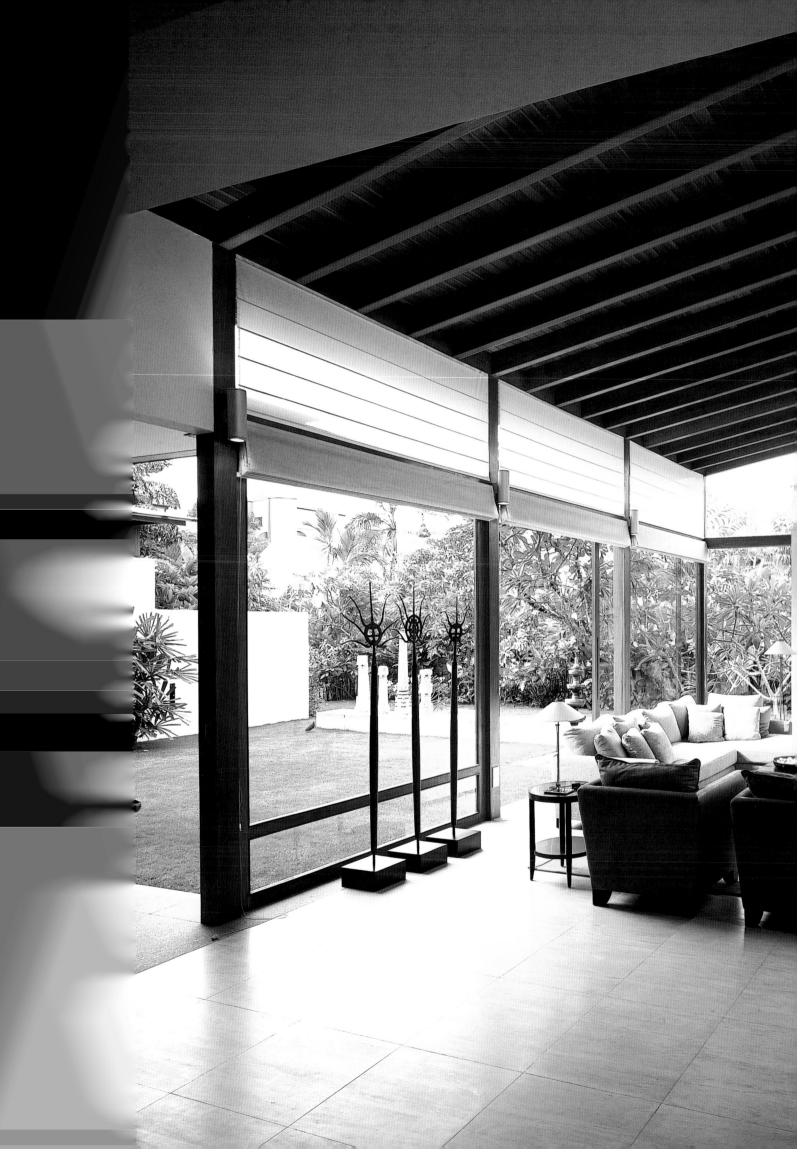

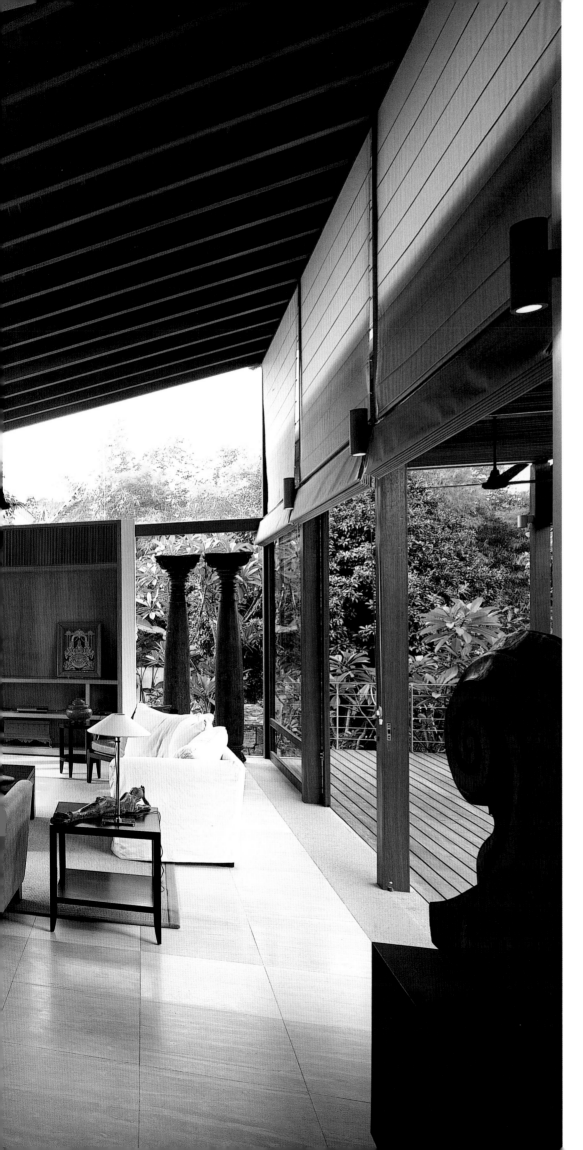

The soaring space of the living pavilion opens to the courtyard garden on one side, and to a timber deck above the pool on the other.

sundridge park house

The architects jokingly refer to the Sundridge Park House as "a racing car on stilts"... a riposte to the futuristic dynamics of the house's surging form, which turns the house inside out, and to the array of internal and external circular supporting columns. Exemplified by a pivotal curved glass brick wall with overtones of art deco, this house represents a playful exploration of the origins of modernist architecture.

SUNDRIDGE PARK HOUSE

SINGAPORE

ARCHITECT AAMER TAHER

From the street, the house appears as a horizontal brown timber box contained within a floating shell, whose undersides are faceted, giving the impression that the house is dynamically opening up to the street. But this orthogonal profile is anchored by a central curved element, which continues all the way up the front elevation, and this form is repeated inside the house by a curved glass brick wall. This penetrates up through the entire height of the building, starting as a curved wall just inside the ground floor entry, then continuing as a curved segment for the shower recess in a second floor bathroom, and terminating as a curved garden bed enclosure for the jacuzzi on the roof terrace. The curvilinear motif is repeated down the side of the house from the secondary

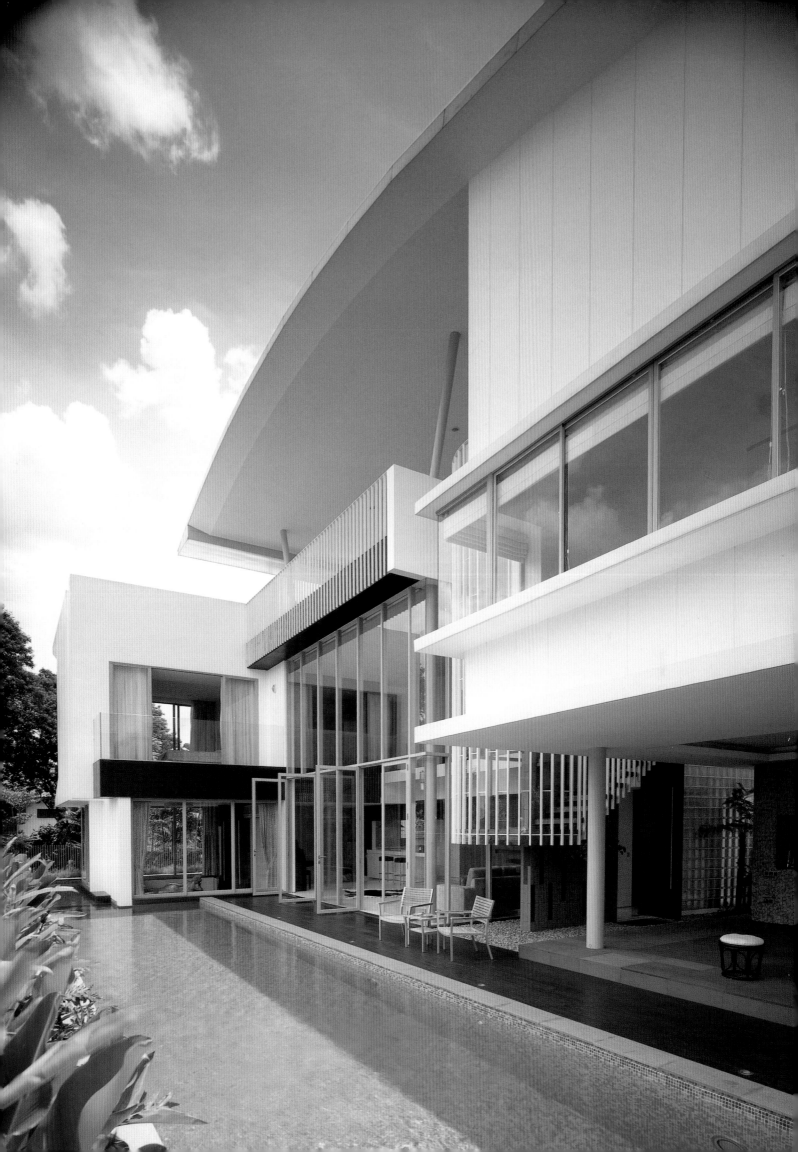

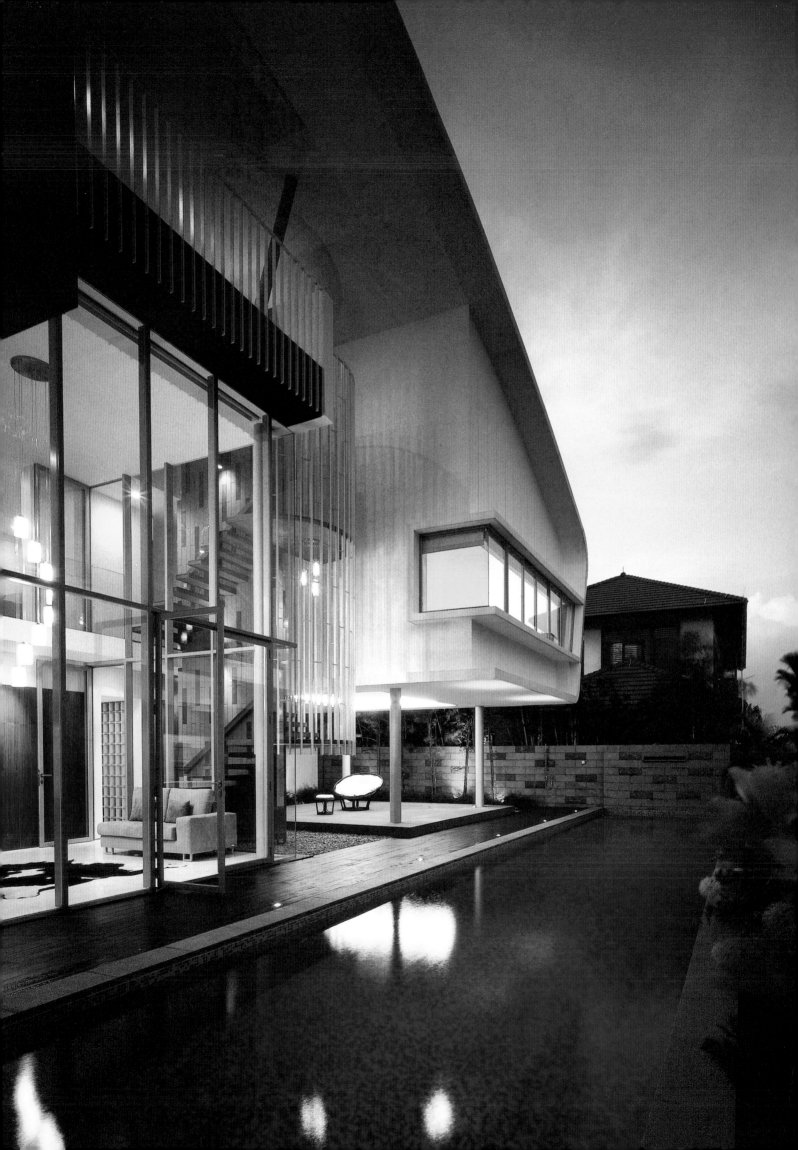

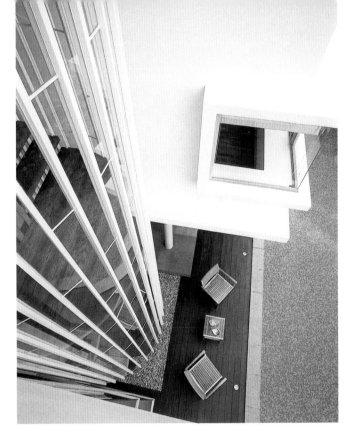

Left The delicate mullions of the central tubular stairwell contrast with other more rectilinear forms.

Below The contrasting architectural forms are complemented by the use of contrasting materials, such as the timber detailing of the ground floor bar area.

Opposite The house is a daring composition of curved and rectilinear forms where the curved elements, such as the central stairway atrium, act as pivots for different sections of the structure.

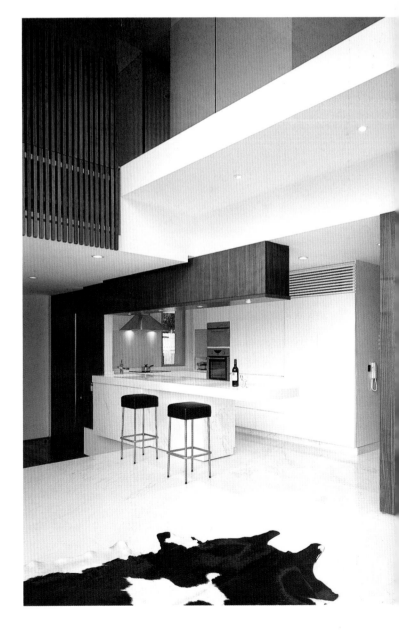

entry… responding to the irregular site, it curves its way to an open tropical pavilion next to the pool. The motif is continued in the elevation of the house with the floor, walls and roof forming one continuous element, which curves its way from the back and culminates in an overhang above the roof terrace.

A breezeway separates the open pavilion from the main house. Here the corner of the house is a translucent curved glass brick wall, which is also expressed internally. On the ground floor, the shower recess in the guest bedroom *en suite* is a double-height curved atrium, leaving an open space at the top between the wall and the glass ceiling. On the second floor, this wall becomes the internal wall of the family room. From here, through a large picture window, the curve of the building is reversed by a sunscreen also acting as a privacy screen.

Site plan

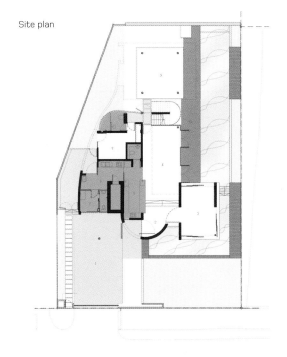

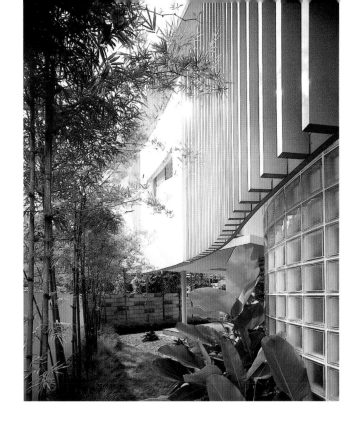

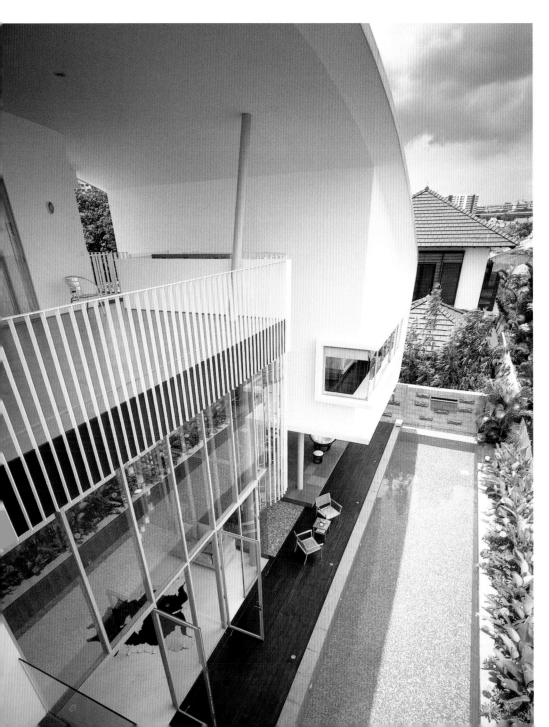

Above The side entry follows a curving wall of glass bricks through to an outdoor entertainment area, which is sheltered by the cantilevered rear bedroom.

Left The curve motif of the house is highlighted by the shell-like rear roof form, which surges up to shelter the rooftop entertainment area.

Right As the main volume of the house is set back allowing for an open air bathroom at the core of the building, the curves of the northern elevation act as an independent decorative feature.

Right below The western street-facing elevation is an orthogonal timber box—a deceptive façade, masking the surging curves of the house to its rear.

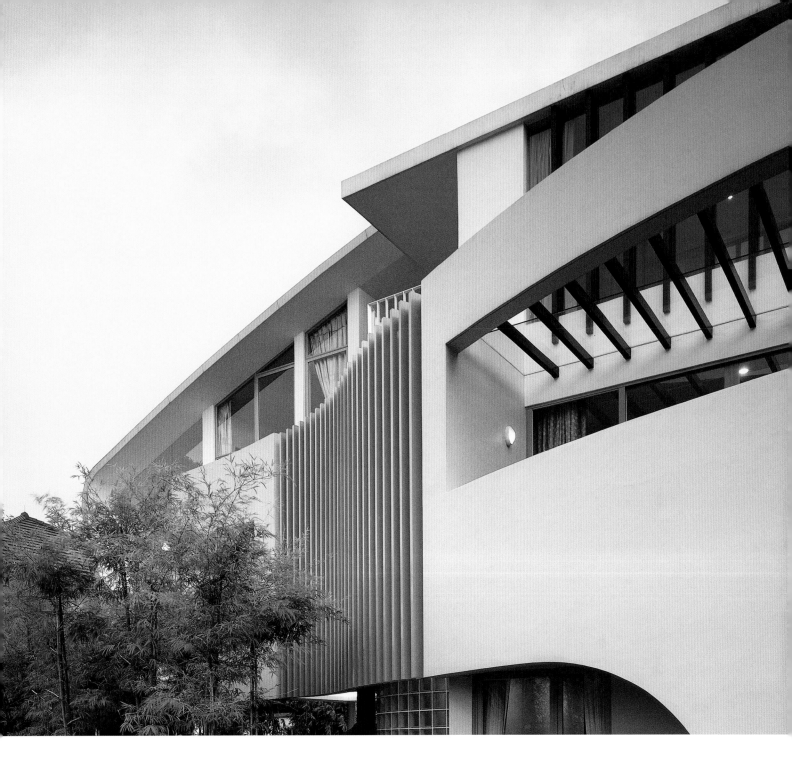

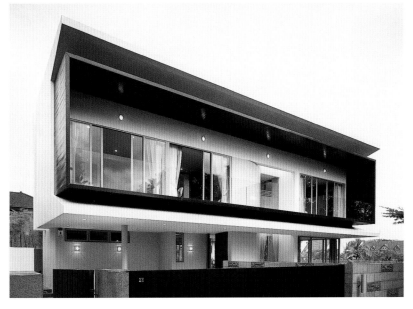

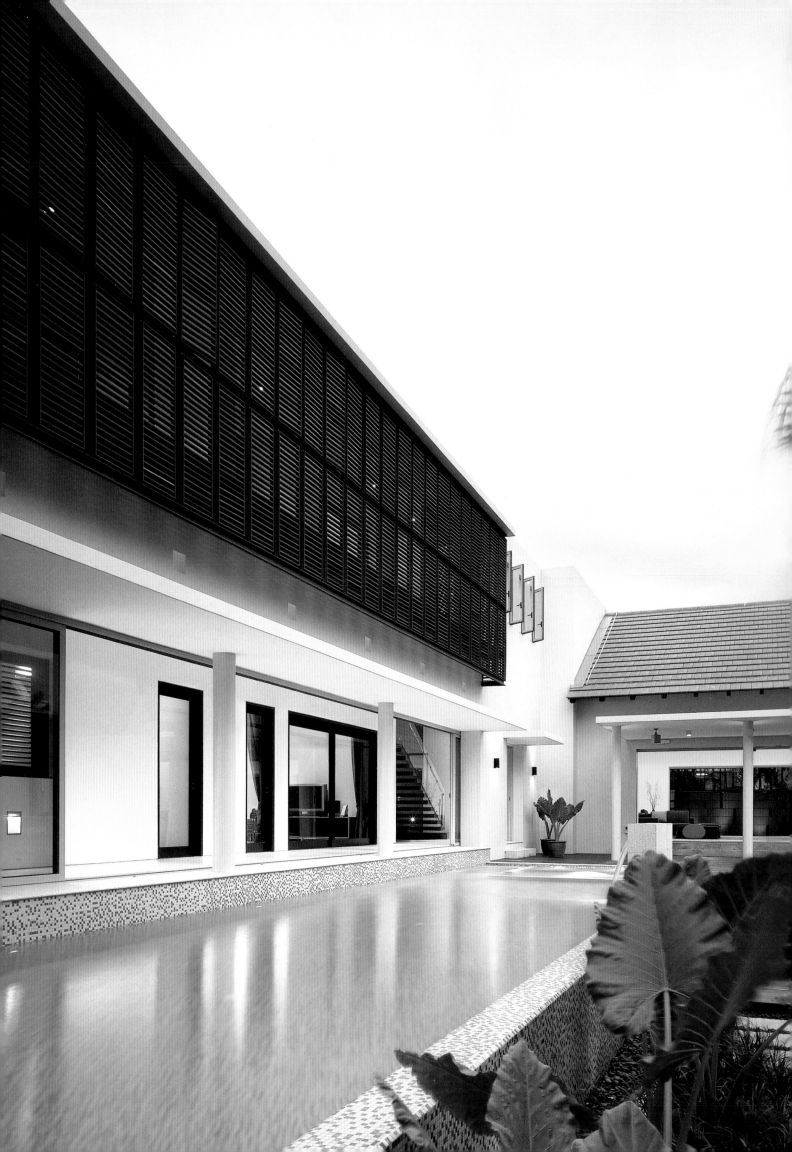

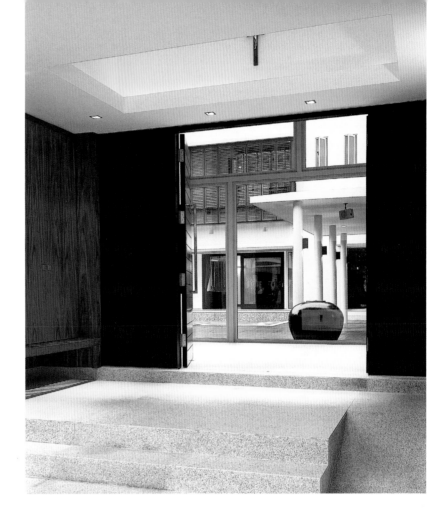

Left A graceful harmony of differing materials reflects the architect's intention to provide a house of spiritual communion. This view shows the bedroom pavilion on the left.

Right Entry to the house is through a portal and into a glazed vestibule, a sequence of arrival appropriately charged with ritual.

chang house

Less a temple and more a church... this almost monumental house is primarily a communal place of worship. Although it does offer privacy and sanctuary, these appear secondary to providing a meeting ground for large numbers of people who share the same spiritual values.

A program combining domestic intimacy with large-scale public spaces is not only unusual, but seemingly contradictory. Nevertheless, the Chang House does just this through adroit planning, which separates the public and the private conceptually while integrating them into a sequence of free-flowing spaces. The architect comments that "99% of our houses are not showpieces" and it is impressive that, despite the size of the public areas in this house, it still manages to emanate a disarming modesty. This is partly due to the way the pavilions are scaled in relation to the expansive central outdoor timber deck and partly to nature of the client, a devout Roman Catholic who wanted the house to able to accommodate large gatherings of people for social and ecclesiastical purposes.

Described by the architect as "contemporary tropical" with "a constant engagement with light, air and water", the

CHANG HOUSE

SINGAPORE

ARCHITECT RICHARD HO

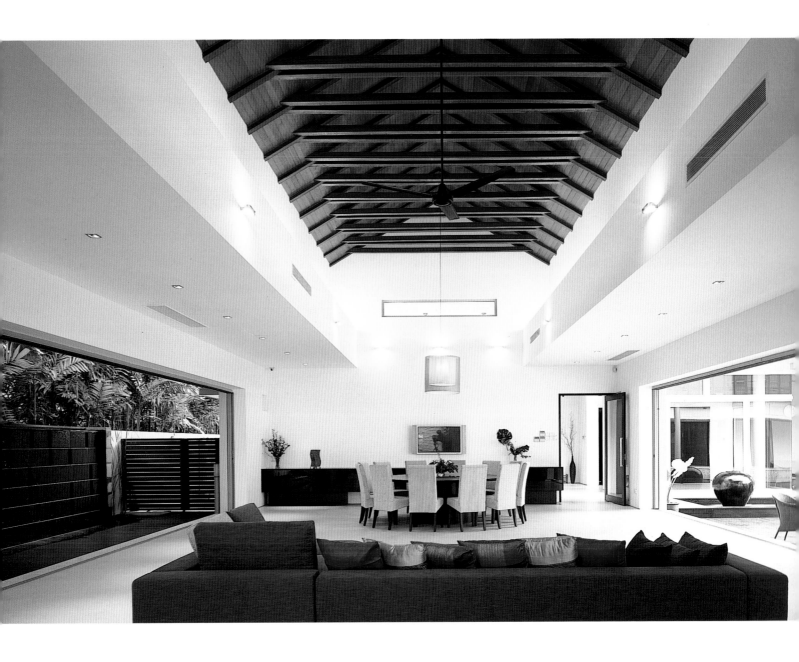

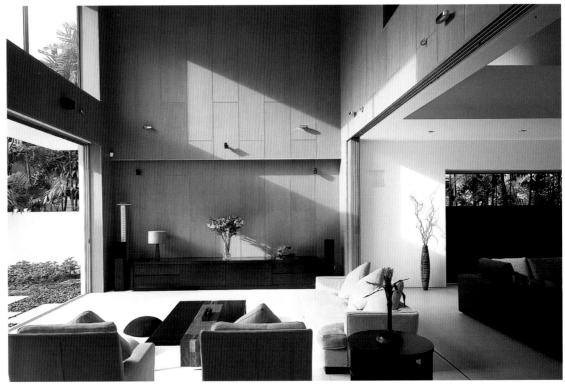

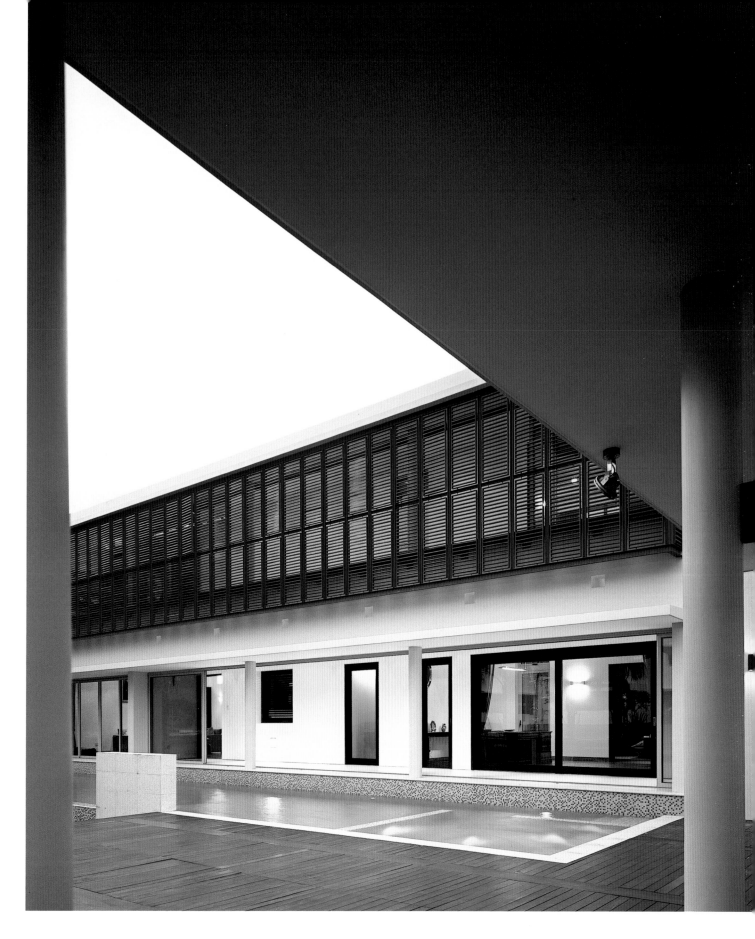

Left above The high pitched timber ceiling of the dining room and ceremonial space is a reconnection with traditional natural materials. Full-width sliding glass doors link this huge room to the gardens outside.

Left below The double-height family room can be closed off from the rest of the house by large sliding timber doors, creating intimacy adjacent to the grand central ceremonial hall.

Above The bedroom pavilion viewed from the portico outside the central dining and ceremonial pavilion. An expansive timber deck encloses and floats above the pool.

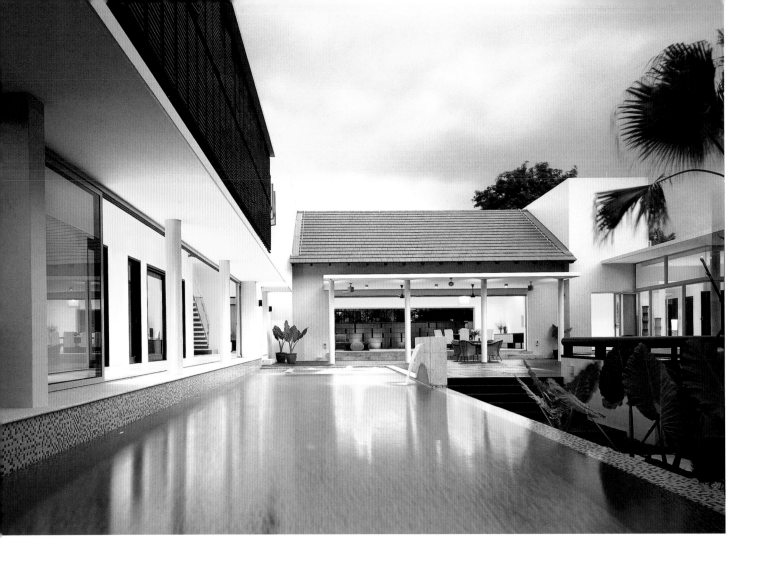

Above The pool, the gardens and the timber deck combine to provide a calm and contemplative environment.

Right above Timber detailing, such as this crafted balustrade, lends warmth and texture to the concrete and glass structure of the house.

Right below The bedroom pavilion glows like a lantern through a timber screen, overlooking the large timber deck used for accommodating large crowds on ceremonial occasions.

West elevation

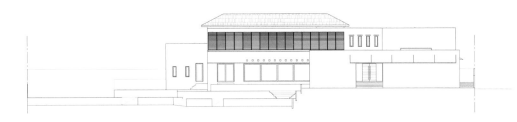

North elevation

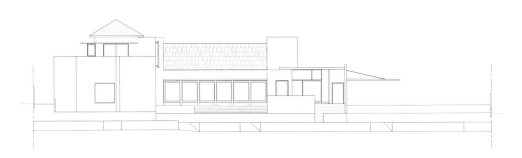

house appears very discreet and unassuming on approach from the street. Entry is through a glazed box looking past a water garden to reveal the huge public timber deck and the two-storey residential pavilion on the other side. Joining these two elements is a single-storey pavilion, which can be completely opened up to the full width of the deck. This long rectangular space is used for large meetings and has a high, pitched timber ceiling with hidden lighting suggestive of a traditional church. It extends out to an enclosed garden court whose visual focus is a statue of the Virgin Mary. The end section of the interior space can be closed off by sliding timber doors, which creates a more intimate family room.

Although the public areas are downstairs, the family bedrooms are also downstairs, linked on the pool side by a glazed corridor, and internally by a garden courtyard which draws natural light into the interior. As with the downstairs rooms, all the upstairs rooms have two openings: either to the pool side and a long louvred gallery, or the other way on to a rooftop garden terrace. The guest room is extensive, containing an *en suite* with a spa and a sitting room looking on to the rooftop terrace.

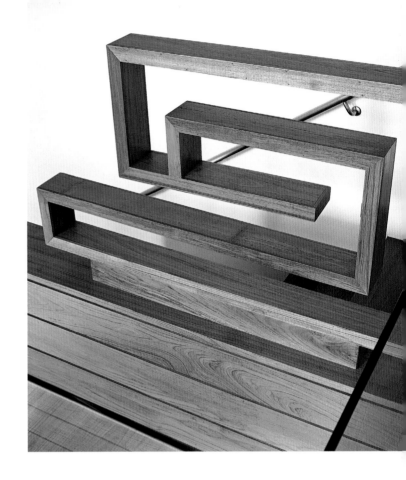

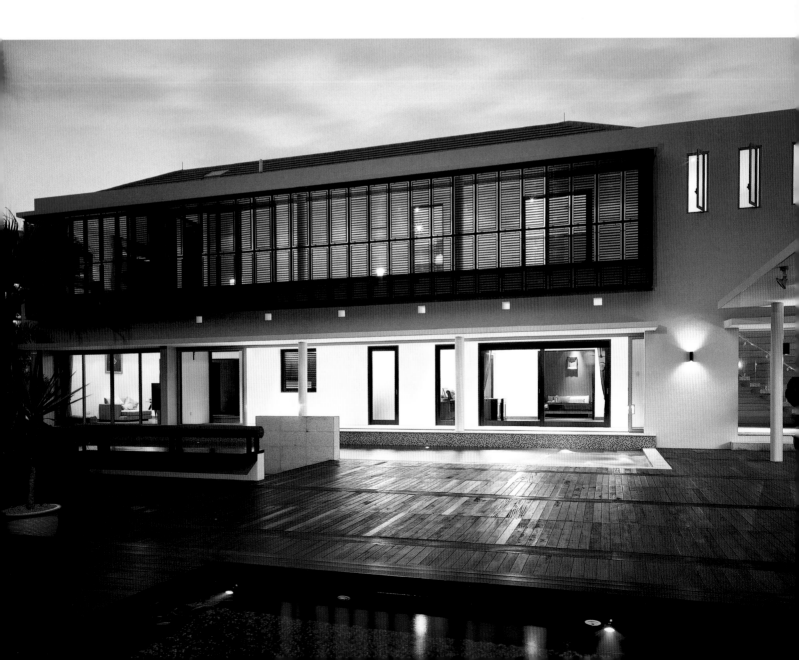

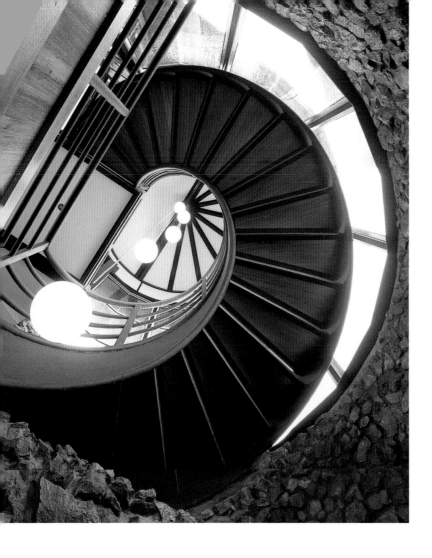

Left A spiral staircase thrusts up through the heart of the house to the eyrie-like study at the top.

Right The double-height living room has sensational views during the day, while at night the raised brim overhang allows full appreciation of the night sky. The fantastic landscape of islands and mountains surrounding Kota Kinabalu can be seen in the distance.

Following pages The house is a joyously complex assembly of forms and competing spaces. Its asymmetrical roofline deliberately complements the tree-line of the forest.

sinurambi

Set on a mountain spur, surrounded by untouched jungle and with glorious views over valleys to the South China Sea and Mount Kinabalu... this house lives in perfect harmony with its environment.

SINURAMBI

KOTA KINABALU, SABAH, MALAYSIA

ARCHITECT FAHSHING

Close rapport between architect and client enabled the Sinurambi House ('jungle hut' in the local Kadazan language) to become a clear expression of the architect's concept of 'growing' a house rather than building one. The idea comes from the traditional house, which not only grows organically out of the changing needs of its inhabitants, but also out of its physical and climatic context. Hence, the Sinurambi House grows out of the contours of its site – 1,000 feet above sea level – and blends in with the surrounding jungle. Its roofline remains below the tree line, and the roof form itself suggests a tree.

The house integrates with the environment through a series of physical and visual connections, and the extensively glazed living areas are oriented towards views of the sea and the mountain. The glazed, double-height volume of

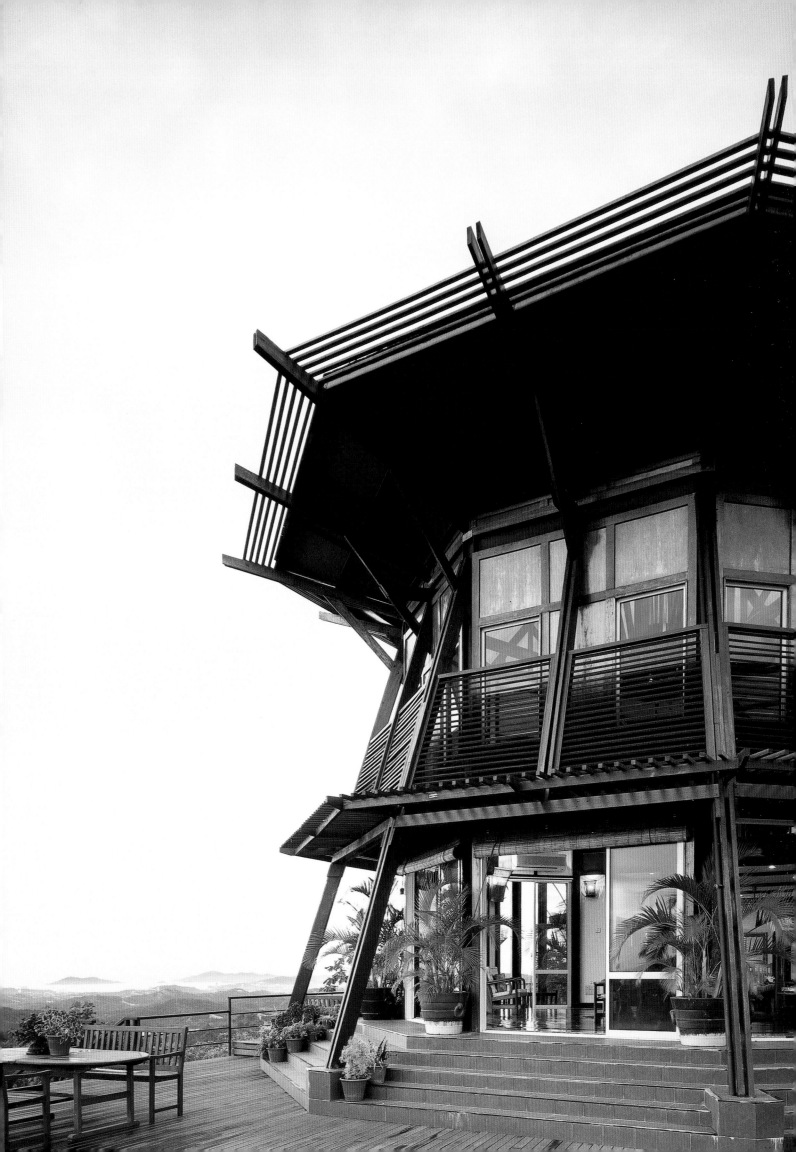

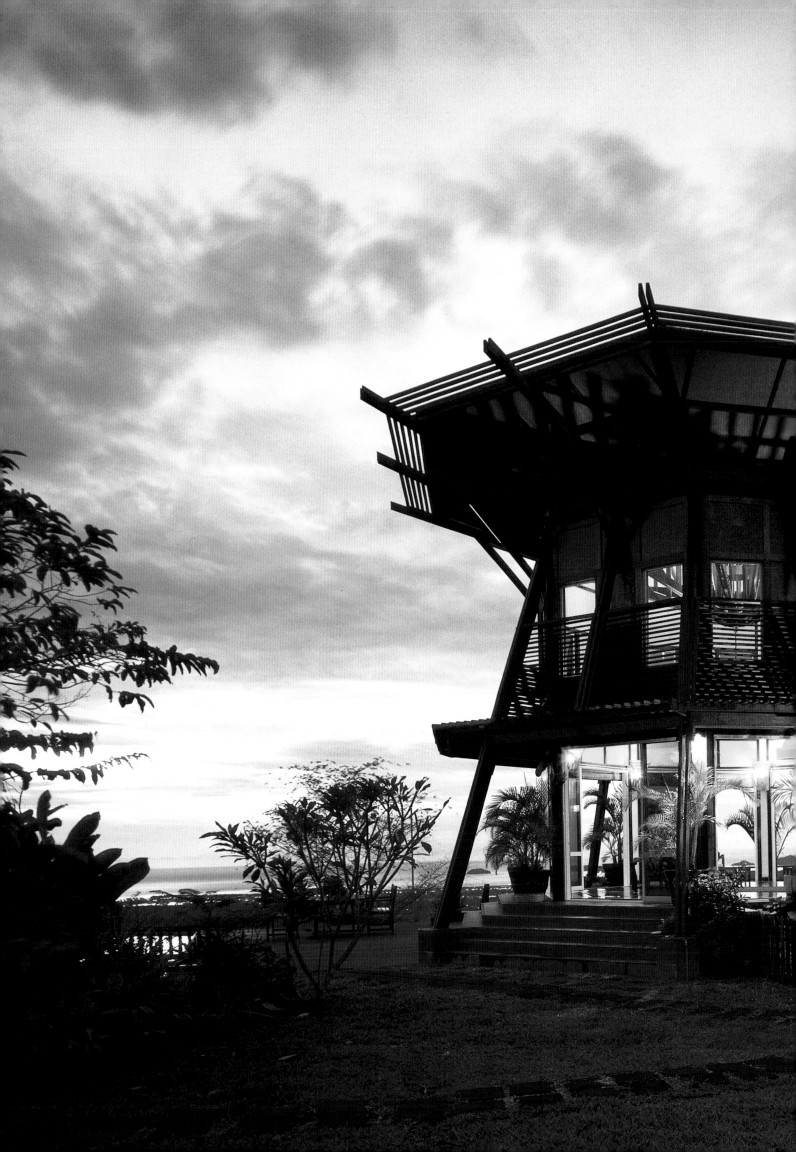

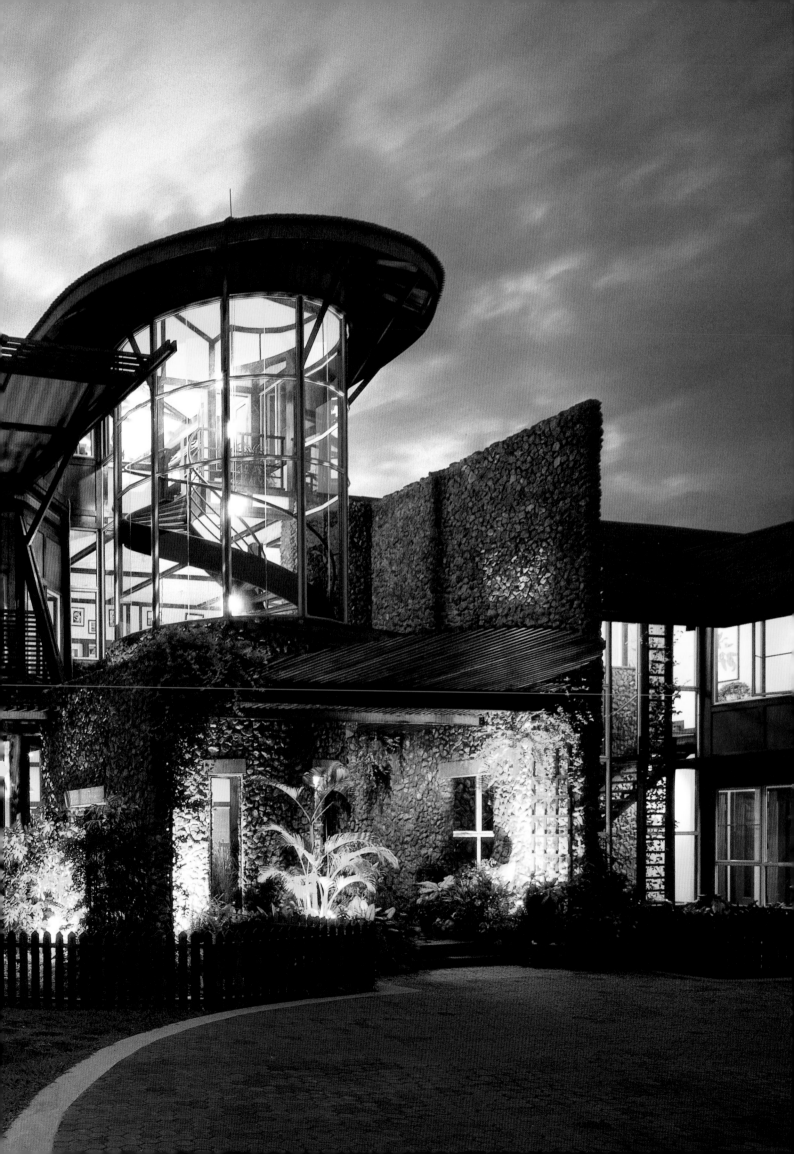

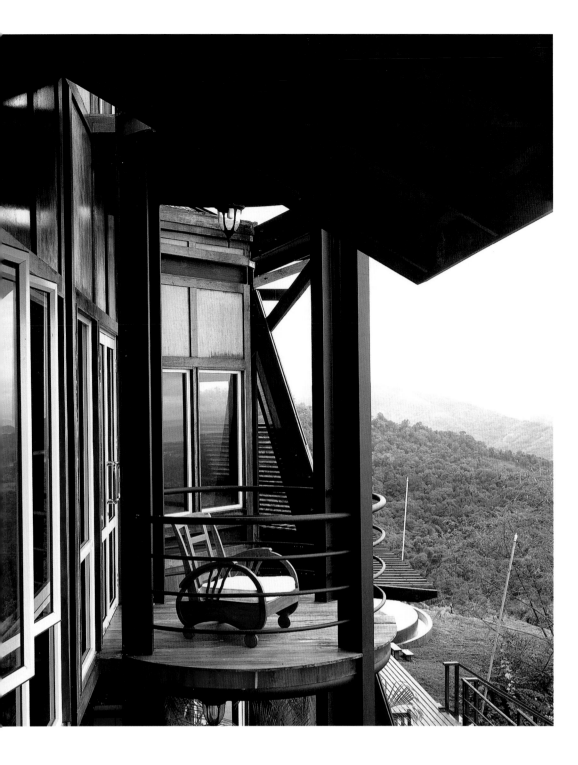

Left Second floor balconies on the western façade are private spaces for respite and for quiet contemplation of the views out to the South China Sea.

Right The house grows out of the forest and the mountain topography, in partnership with nature rather than in competition.

the living room embraces the surrounding landscape, and the timber flooring extends out to the swimming pool, creating a direct link between inside and outside. The living room sits under a canopy of extended eaves whose fan-shaped trusses were inspired by the bamboo baskets woven by the local people. Similarly, the exposed bracing of the trusses was inspired by the form of an open flower. The eaves are pitched upwards to allow generous views of the night sky from the living room, whose pavilion-like character reinforces the sense of connection with nature.

This connection with nature is literally emphasized by the horizontal and vertical trellises attached to the house,

providing nesting opportunities for birds and support for climbing plants. Interior and exterior rubble walls are made from local sandstone, further integrating the house with its location. The overall asymmetry of the house is a response to the asymmetry of nature, just as the use of natural materials emphasises its organic nature. While the house is thoroughly integrated, both metaphorically and literally, into its environment, it is also a place from which the environment can be observed… exemplified by the glazed central spiral stairway leading up to the study, which provides a succession of varied views to the surrounding landscape.

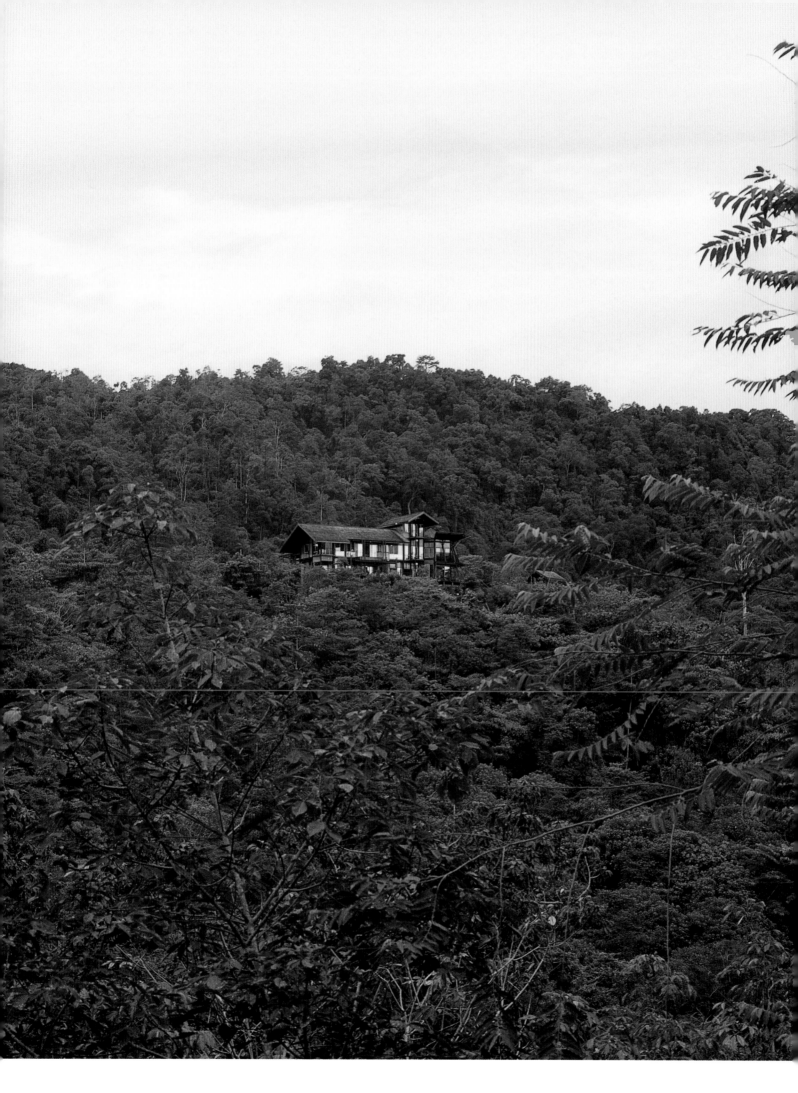

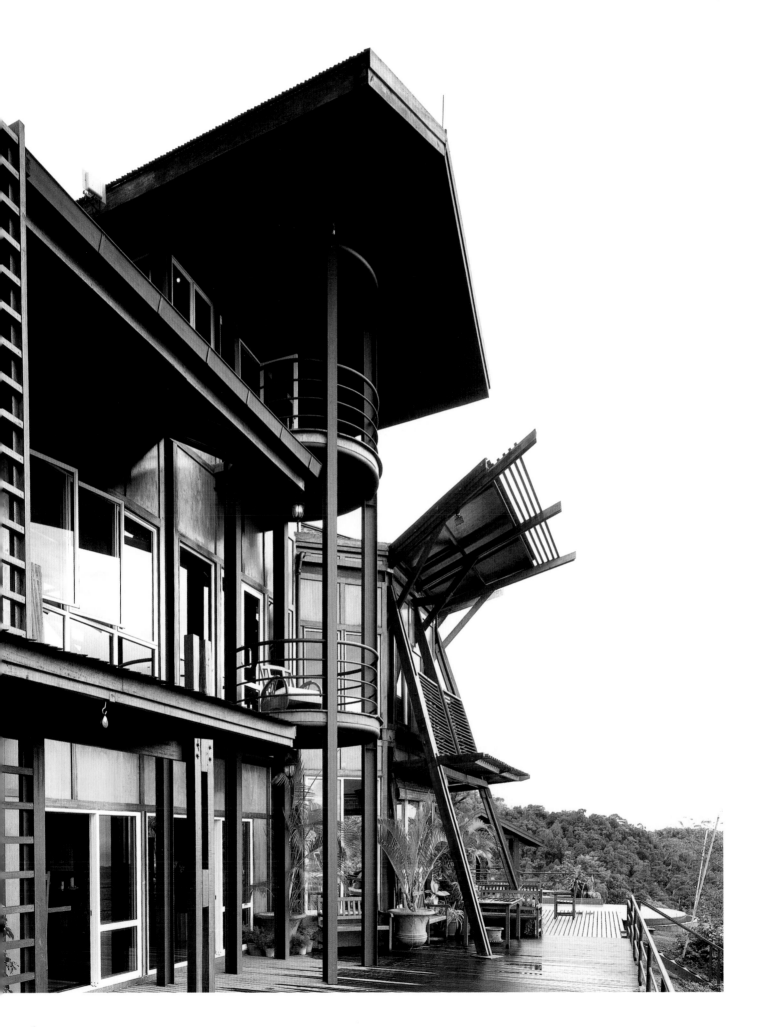

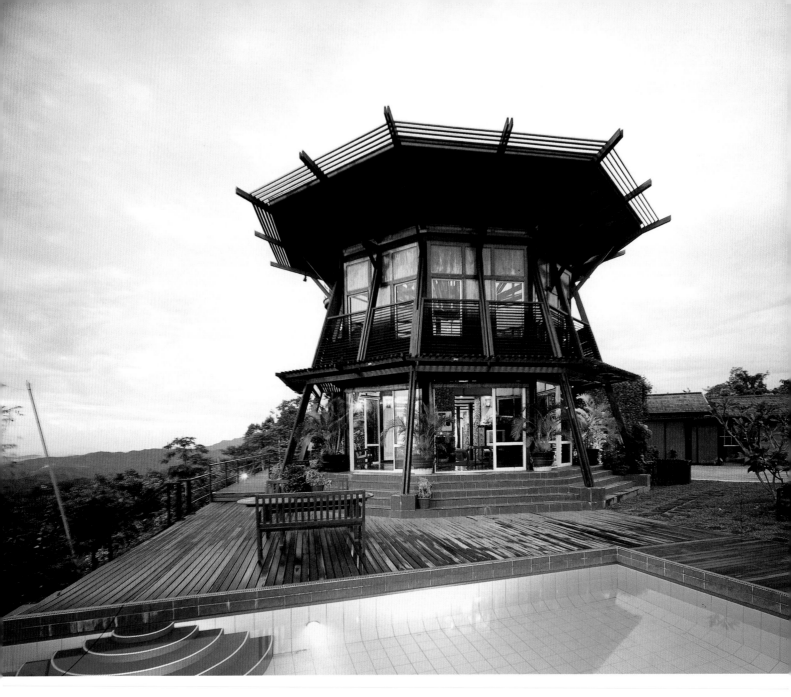

Left The western façade shows an exuberant architectural touch, far removed from most rationalized contemporary house design. This house responds to its location in a personal, fundamental manner.

Above The architect describes the living room as a space under a canopy, whose fan shape was inspired by local bamboo basket weaving.

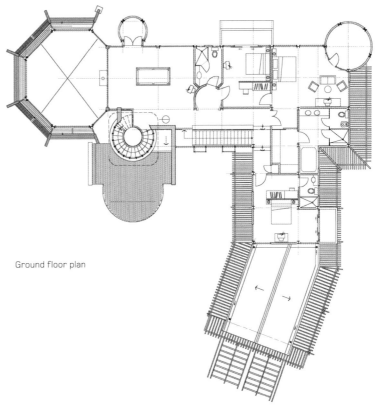

Ground floor plan

Right Seen from the street entry, the horizontal planes of the floating roofs form an interplay with delicately patterned concrete screens, which are in turn partially screened by delicate ash trees.

Below The entry demonstrates the contrast between the natural and the manufactured, the rough and the smooth, the delicate and the emphatic, which continues throughout the house.

safari roof house

SAFARI ROOF HOUSE

KUALA LUMPUR, MALAYSIA

ARCHITECT KEVIN LOW

The Safari Roof House shimmers on an escarpment above a beautifully wooded golf course. The seemingly contradictory elements of the house hold together in delicate tension, with the roof floating free in a gesture of salutation above an intriguing counterpoint... rough and polished concrete is set off against the slender ash trees and pebbles of the central garden.

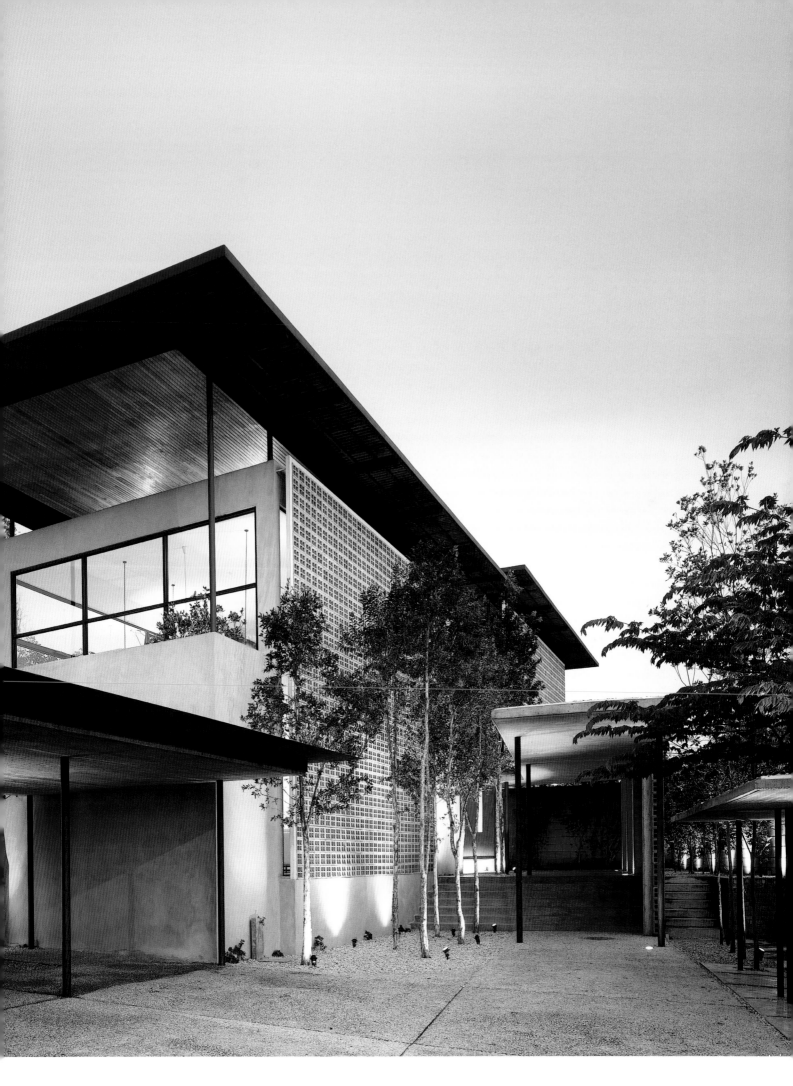

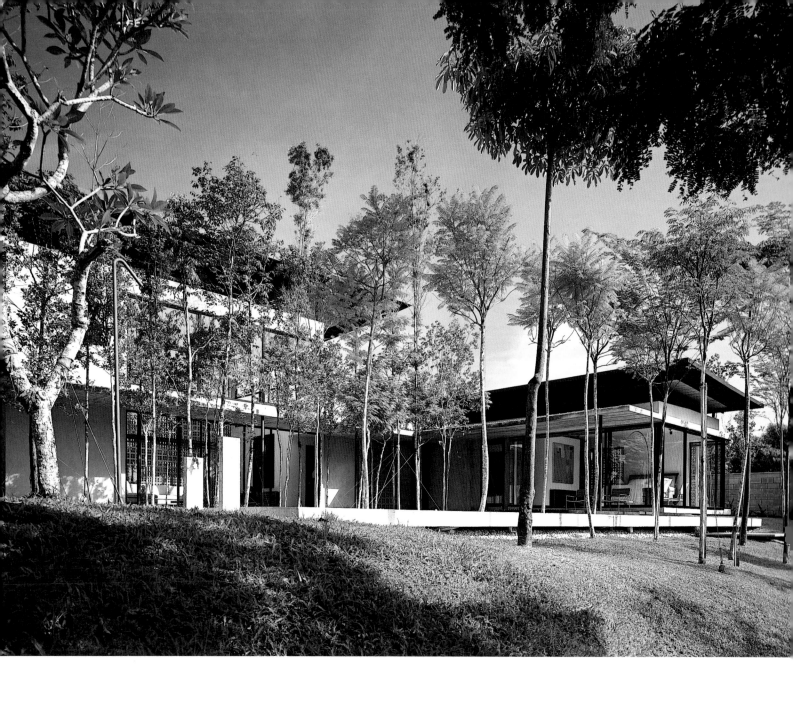

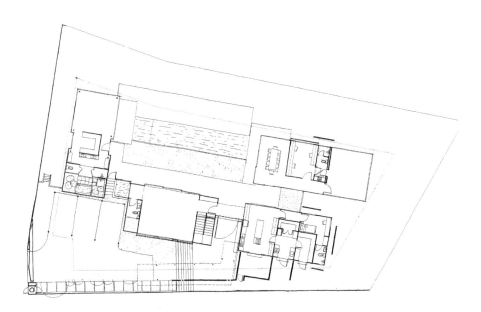

Above Rising from a gently falling lawn, a stand of ash trees provides a delicate garden landscape, without screening the house off from its view.

Right The concrete-screened walkway leading to the house culminates in a powerful steel portal, which frames both the garden and the landscape beyond.

The Safari Roof House shimmers on an escarpment above a beautifully wooded golf course. The seemingly contradictory elements of the house hold together in delicate tension, with the roof floating free in a gesture of salutation above an intriguing counterpoint… rough and polished concrete is set off against the slender ash trees and pebbles of the central garden.

This house represents another stage in Kevin Low's on-going exploration of the garden house… where house, garden and borrowed landscape form a unity. It is not so much a sculpture in the landscape as a series of spaces, which, like the landscape and its central garden of ash trees, are planned to age and evolve.

The house takes its name from a version of the Land Rover, which had an extra roof to reduce heat penetration in hot climates. The three detached, corrugated, bituminous roofs of this house function in the same way, deflecting heat from the roof below and creating a space

for a natural flow of air. Natural climate control is just one of a number of issues addressed by the architect who is committed to maximizing the use of local materials and "an architecture of economy", not meaning an affordable architecture as such, but an architecture which eschews ostentation and unnecessary expense.

From the street, the house presents as a composition of patterned concrete screens and white rendered concrete, with the extended roofs floating apparently free of the building itself. The approach from the carport is along a concrete screened walkway to a massive painted steel gate, which, when it opens, becomes a ceremonial entry framing the garden and the landscape beyond. Once inside, the house unfolds with a double-height living pavilion and guest room pavilion on the left, and the bedroom pavilions on the right. The pavilions are linked by a colonnade of slender steel columns, which supports a concrete canopy. The concrete walkway defines an aggre-

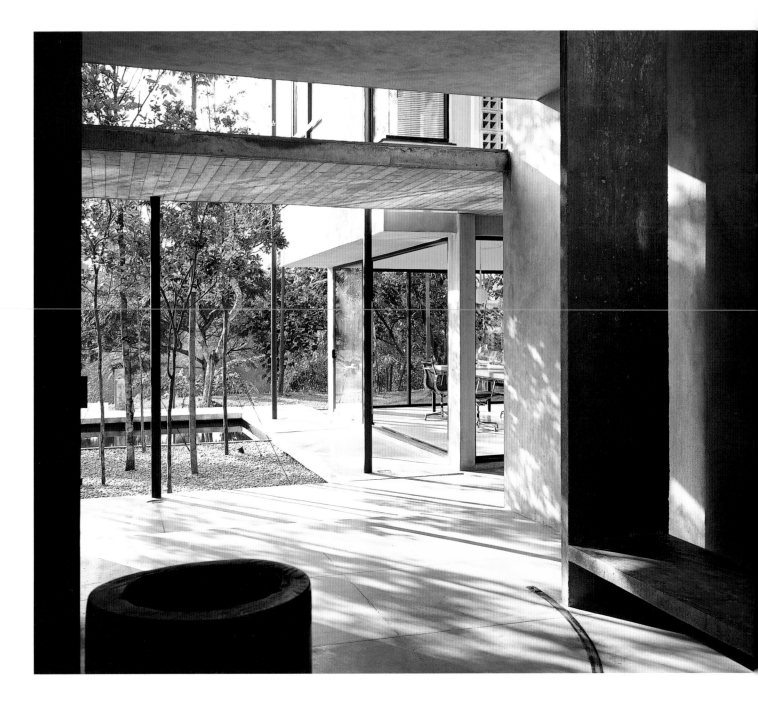

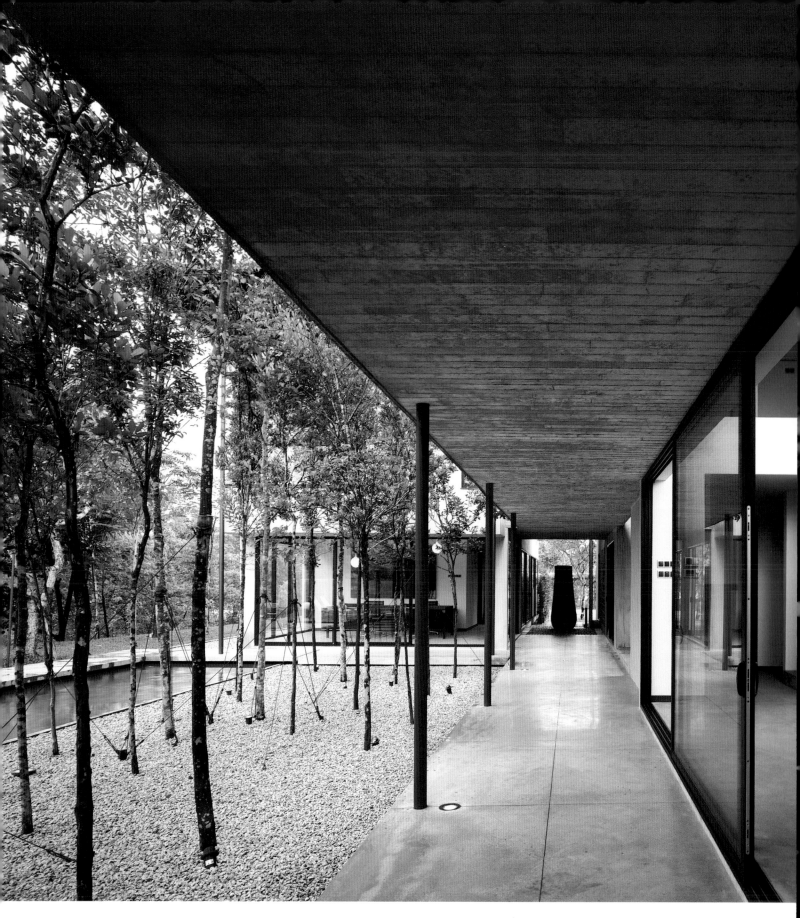

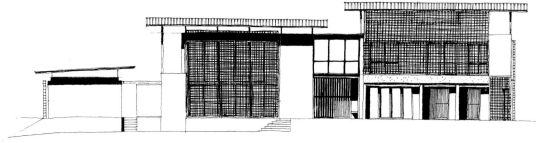

Left A colonnade runs between the central living pavilion and the pool area, leading to the main bedroom pavilions and the dining room. The slender metal poles blend delightfully with the similarly slim saplings surrounding the pool.

Below As seen in this view of the entry, the house is an almost musical composition of horizontal and vertical geometric forms.

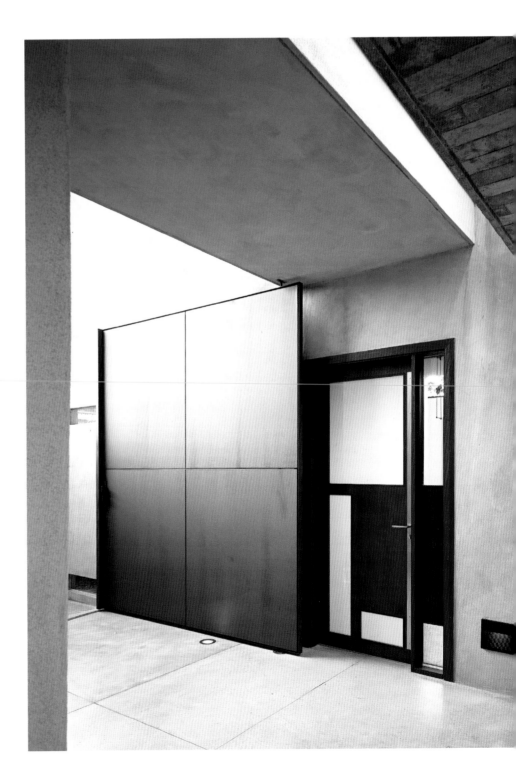

Below Looking down from the master bedroom, the smooth plane of the pool contrasts with the pebble garden on one side and the concrete and timber deck on the other. The guest pavilion sits at the end of the pool.

Right A massive swinging steel gate is a climax to the delayed entry sequence, which comes via the L-shaped concrete roofed walkway.

Opposite The central living area is a grand double-height space backed by a breathing concrete screen, which becomes a decorative wall and creates sunlit patterns through the room in the afternoon.

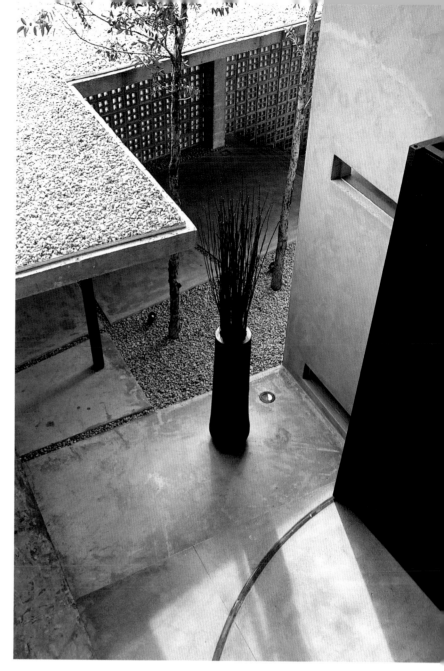

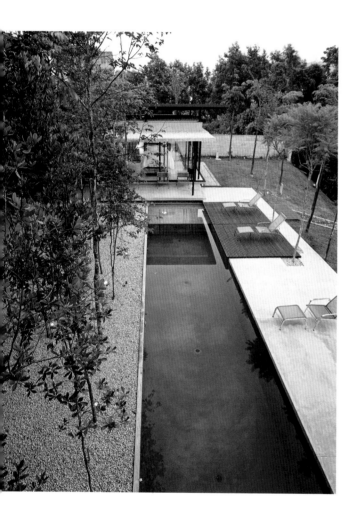

gate garden of tall, slender ash trees and extends all the way around the swimming pool.

The house is a virtuoso celebration of different concrete finishes, held in counterpoint against the timber deck of the pool, the timber lining of the underside of the roofs and the timber joinery. It is also an exercise in composing different concrete elements and in refinement of finish. The house side edge of the pool, for example, is flush with the level of the ash tree garden, so that the pool seems to slot delicately beneath the rendered concrete walkway.

Extensive glazing creates a close connection between inside and outside, but the outside is also drawn into the interiors, especially in the bathroom areas. In the guest bathroom, the bath is sunk into a bed of river stone pebbles and much of the wet area is exposed to the open air. Orientation of the house and the use of screens also assist in the climate control, with the house facing the morning sun and protected from the afternoon sun by patterned concrete screens.

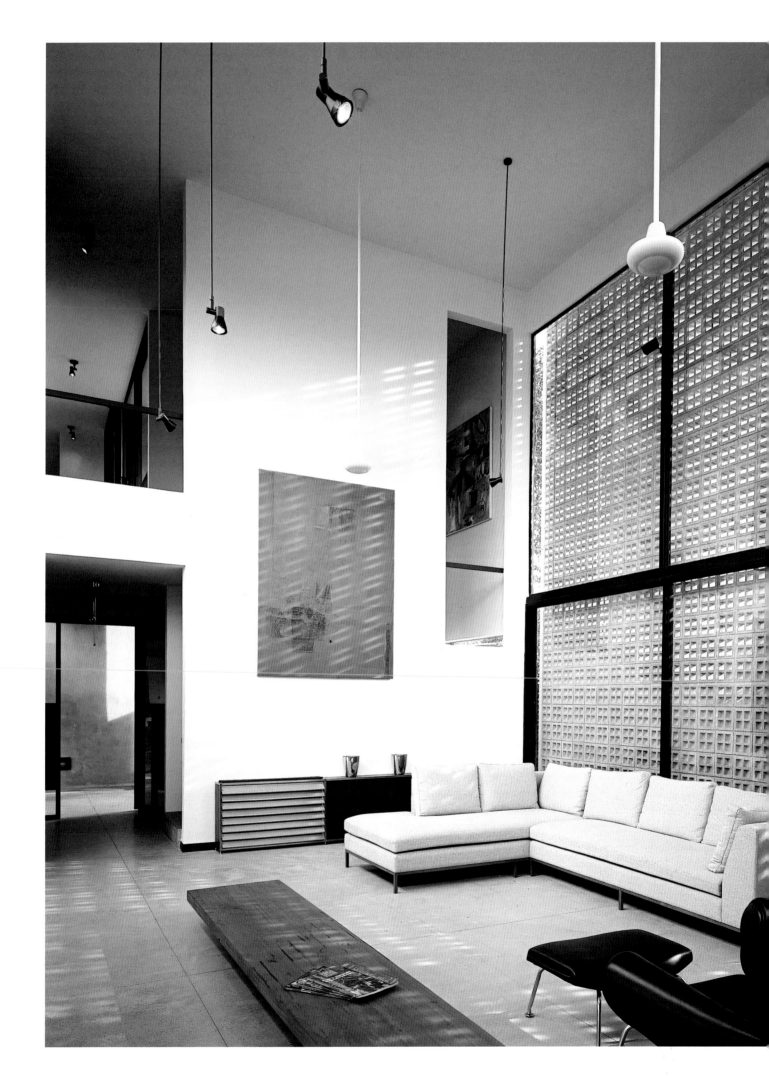

67 tempinis satu

Here in suburban Kuala Lumpur... the house and the garden are one. The house seems to have only as many walls as are strictly necessary to support the roof, while the garden constantly spills over into the interior, a playful mix of the natural and the ingenious reincarnation of everyday objects.

67 TEMPINIS SATU

KUALA LUMPUR, MALAYSIA

ARCHITECT SEKSAN DESIGN

The Bangsar Studio House is an ongoing experiment, a house which will never really be finished: it constantly evolves, forever open to re-configuration and new uses. Although conceived of as a house, it has never actually been used for domestic purposes, and is now Ng Sek San's studio where he works primarily as a landscape architect. And, in many ways, this studio is more a landscape than a house.

On the western side, it is elevated above a busy road and is entered through a garden court, with brick walls for protection against the noise and visual distraction of the street below. The house is open at both ends and along the northern side with a sitting area, two bathroom and toilet areas (also open to the outside) and a glazed office space. The ground level is a continuous open plan, which ends with a fishpond and a secondary entry point to the east. This was the original entry, as the building was formerly a semi-detached house in a suburban precinct. The house can still be entered from this street through a carport (roofed by plantings) and past a faceted brick wall. The architect gutted

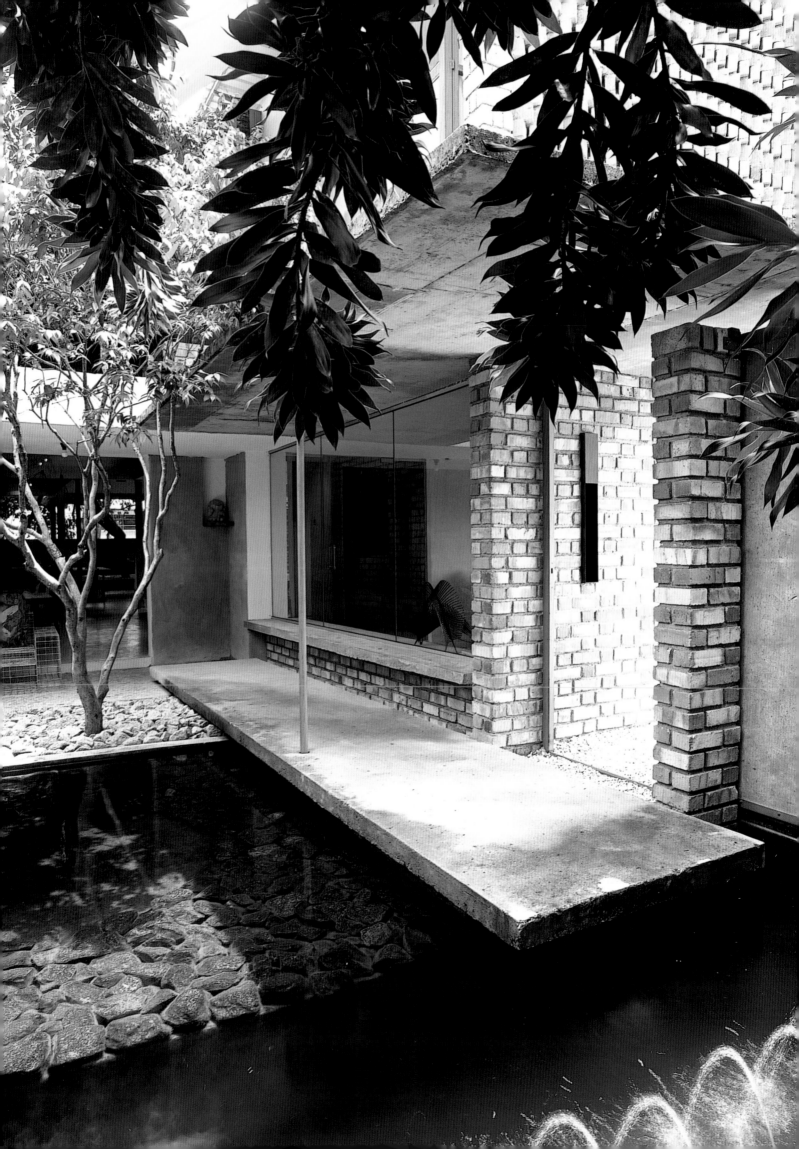

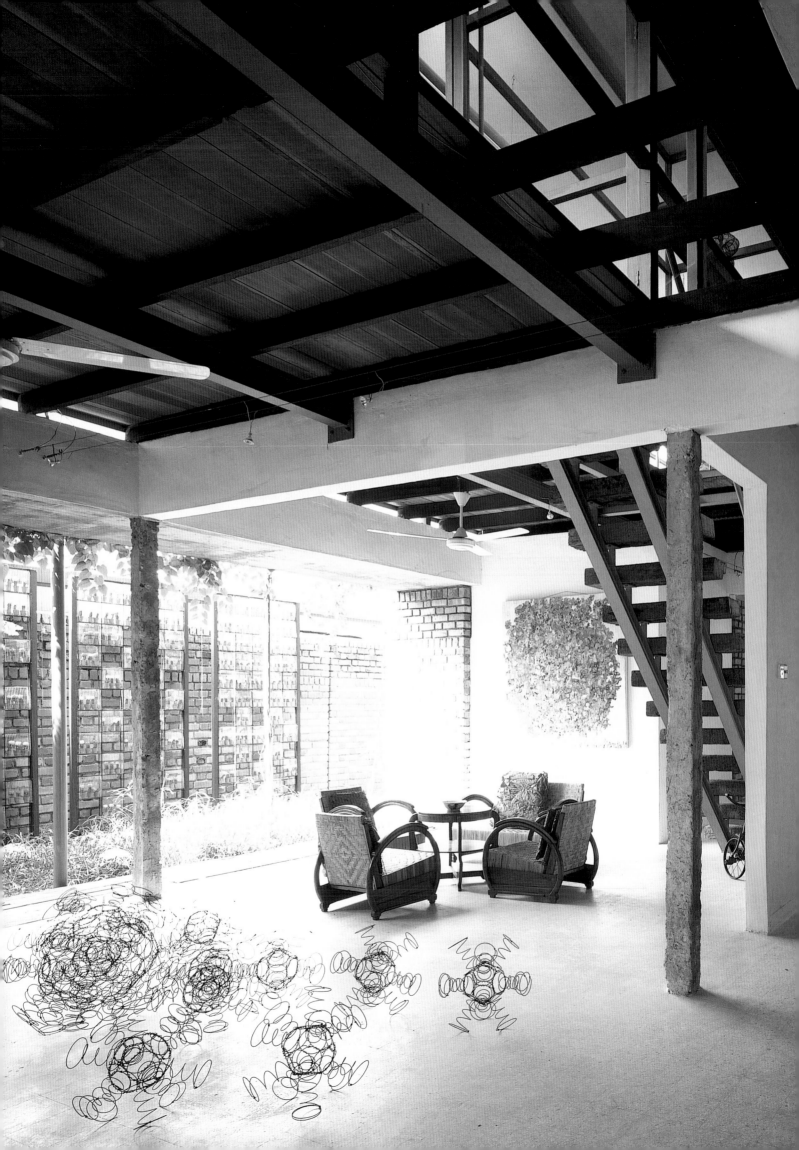

A free-flowing downstairs space serves as gallery and living room, providing a rich visual palette of art-works, pockets of garden, industrial materials and exposed structure.

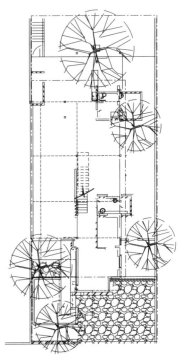

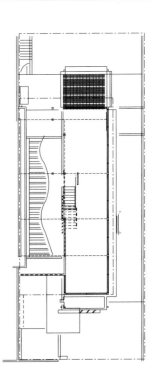

Left The art works engage in a dialogue with the building, with the artifice of art in conversation with the contrivance of architectural structure. The concrete columns of the original bungalow have been retained in a 'distressed' condition.

Above The diverse palette of materials and the counterpointed planes of patterns, which characterize this house, are signaled at the entry from the car park.

the original house and removed one of the two pitched roofs, but retained the original timber structure. The second storey, a long rectangular glazed studio space, is lightweight, thus reducing the load on the existing structure.

The conversion was inspired by the traditional Malay village timber house whose living areas are raised up above the ground, leaving the ground floor as an extension of the garden. This supports the architect's emphasis on 'poor' and 'slow' architecture… architecture which is not indulgent, which uses local materials or re-cycles materials and which allows itself time to evolve through use. Here the original concrete roof tiles have been re-cycled into a textured wall at the entrance, re-cycled railway sleepers are used for the stair treads, the original terrazzo tiling remains as flooring

(with a newly inserted section of dark grey terrazzo for contrast), only local clay bricks are used and other materials are simple everyday materials such as granite rubble (for the garden in the rear courtyard), limestone chips, concrete, wire, glass and steel. Even some of the ubiquitous artworks have an improvisatory feel, for example the steel mesh frames on the brick walls, which house miniature cacti to form a decorative wall feature.

The house also experiments in the use of plantings as an architectural element, especially for climate control. The roofing of the carport is one example, and another is the vinery running along the side, which will eventually grow over the roof and form a second skin to help cool the house.

Left The enclosed entry courtyard gives respite from the heat with a small splashing adjustable fountain, which can be enjoyed from a concrete armchair.

Below The doorway to the open-air downstairs bathroom is clearly signposted. The bathroom fittings continue the industrial mood, and the toilet is a small concession to privacy in the otherwise completely open house.

Right The architect's delight in art, landscape and structure harmonizes in the entry composition of planes, patterns and textures. The contrasting patterns of locally-made faceted bricks are visually stimulating, and hint at traditional structures and fabrics.

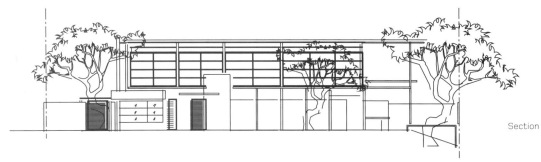

Section

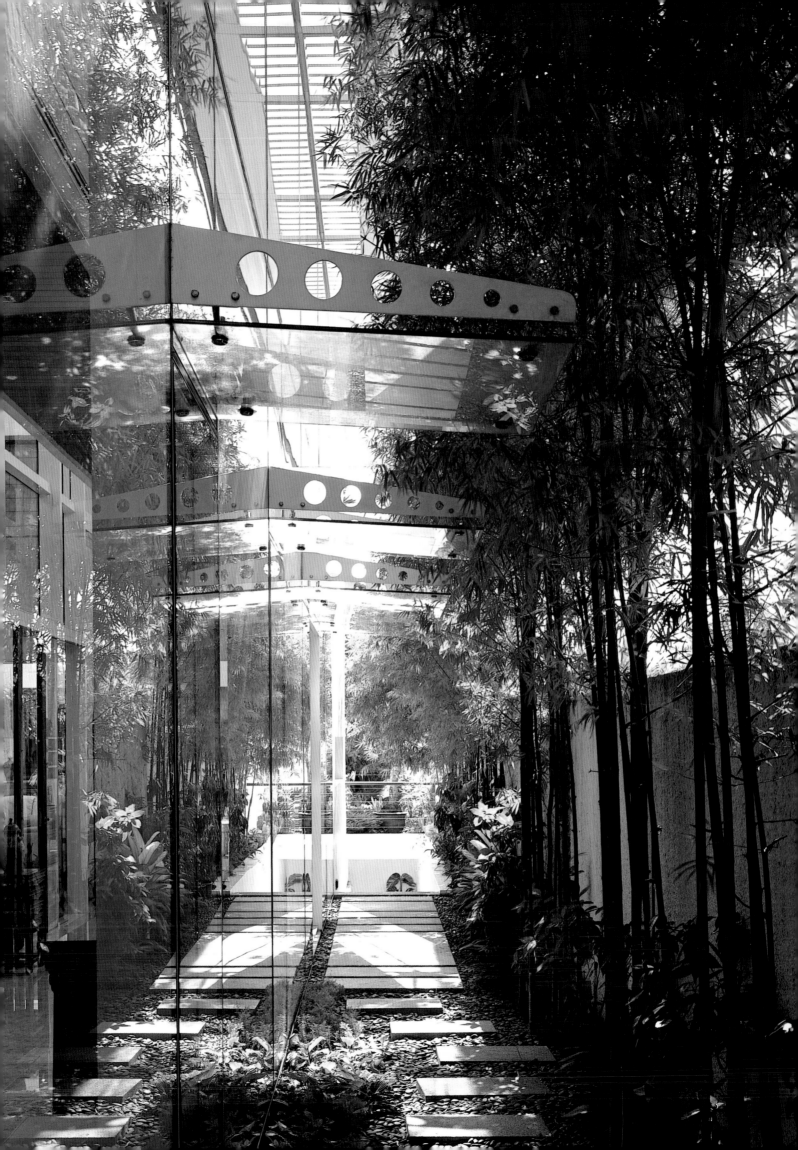

Left Dappled light bathes
a side path of stepping stones,
where the glass walls of the
ground floor dematerialize,
creating a perfect fusion of
garden and interior.

Right The robust massing of the
street façade gives no hint of the
light-filled verdant world beyond.

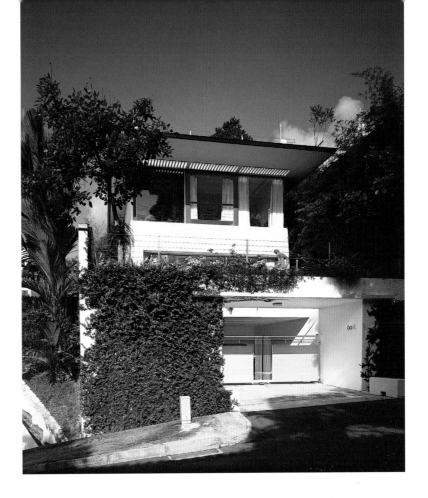

jalan ampang houses

The Jalan Ampang Houses are an imaginative resolution of two problems presented to the architect… maximizing space on a very constrained site without any sense of confinement, and optimizing the amount of available natural light. The completed houses are highly transparent and, as a result, they enjoy a wonderful fusion of house and garden

These two houses form a mirror image of one another. Elevated high above a steeply climbing road, they are approached along a side path of pavers and river stones bounded on one side by the fully glazed façade of the house and, for the higher of the two houses, by a masonry retaining wall which gives complete privacy from the neighbour, but restricts the amount of natural light. Entry is approximately half way down the path, which continues on to the rear of the house and the kitchen. The overhang of the second floor, along with a series of glass canopies, provides shelter for the entry sequence. The organization of the house is a clever counterpoint of laterally sequenced spaces and vertically stacked spaces, with high levels of transparency in both plan and elevation, which compensate for restricted light on the two side elevations.

The series of spaces on the entry level is linked by a wide corridor, which doubles as a gallery running the

JALAN AMPANG HOUSES

SINGAPORE

ARCHITECT GUZ ARCHITECTS

Previous pages Just as sunlight is drawn down into the innermost parts of the house… the land-scaping climbs upwards, culminating in the rooftop gardens.

Below The ground floor and upper level galleries joining the two wings of the house are brief, fully glazed interruptions to the luxuriant vegetation. The theme of transparency is also present in vertical spaces such as the stairway linking all the levels of the house.

Bottom and opposite The rooftop lap pool emerges from the shade of the overhanging roof garden… a spectacular cantilevered presence in the leafy suburban context.

length of the fully-glazed side wall. The series begins with the living area at the front of the house, which is separated from the rest of the house by a central garden courtyard open to the sky. The dining room opens on to this court from the other side, and both the living and the dining spaces open up completely to this central court through floor-to-ceiling sliding glass doors, making the garden a continuation of the inside space. This compensates for the fact that the nature of the site does not permit any other garden area, except at the rear and on the roof. Beyond the dining room is a timber staircase thrusting up through the core of the house, with a powder room and the kitchen beyond that, opening on to the rear garden with a fish-pond, a stone wall and a canopy of trees, which although handsome, filters out a lot of natural light.

The sequence is repeated on the next level, where the connecting corridor is replaced by a timber bridge linking the bedrooms, and running the length of what is effectively a glass atrium. On the top level there is another bedroom and a sitting room, which lead directly on to the pool terrace. The pool forms an L-shape, following the side elevation and then turning around the front edge of the building. From the pool and terrace there are views down into the garden courtyard below.

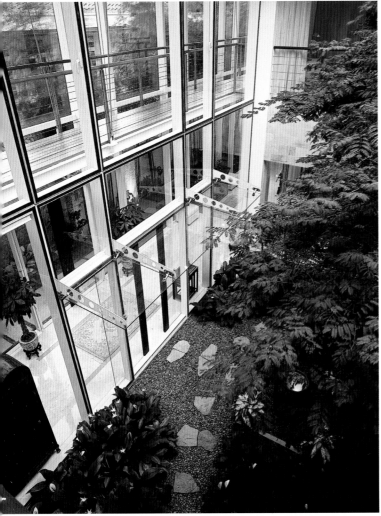

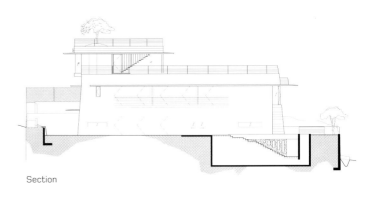

Section

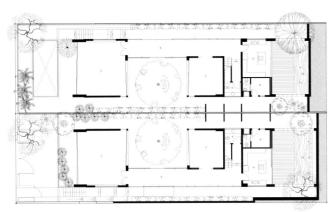

Site plan

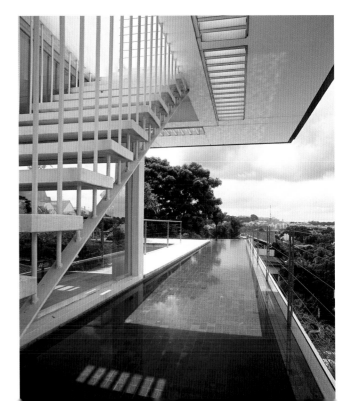

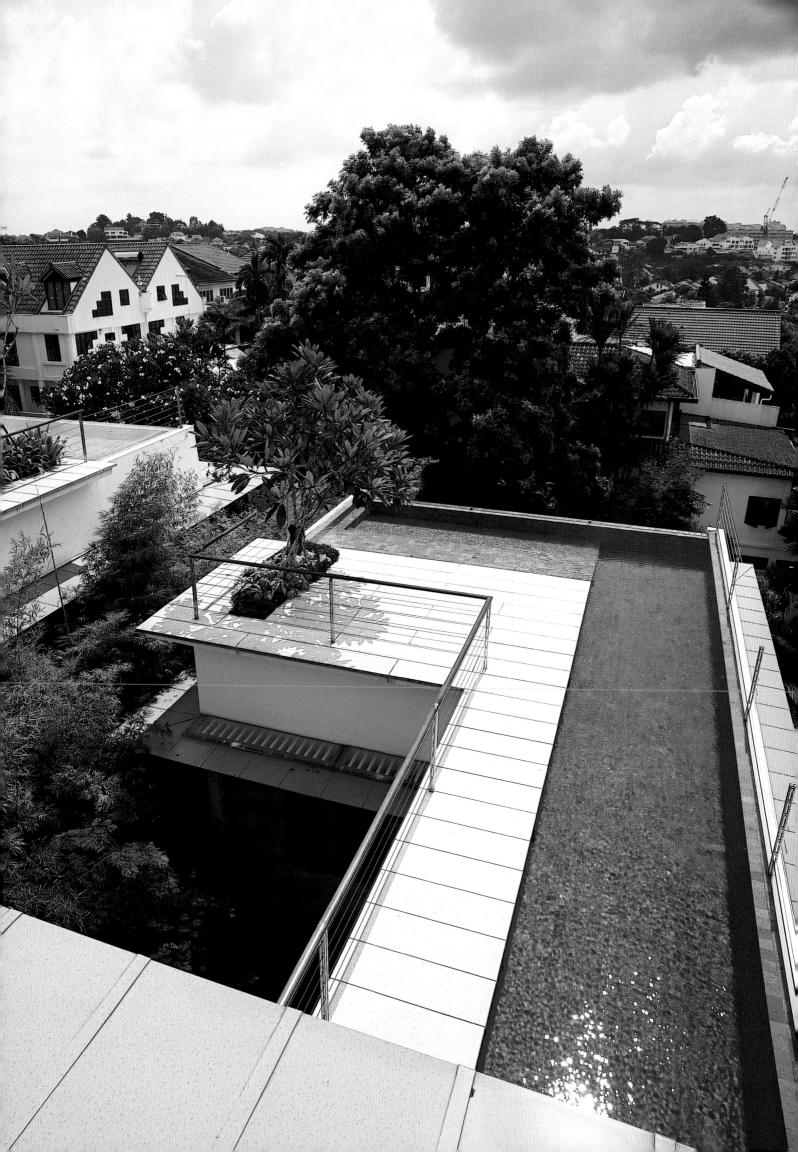

wooi residence

Most houses start from the ground up, but the Wooi Residence explodes from the top down... its magnificent fan-shaped, high-pitched roof generating a wealth of varied spatial experiences.

WOOI RESIDENCE

SHAH ALAM, SELANGOR, MALAYSIA

ARCHITECT LOK WOOI

The houses architects design for themselves are always fascinating, but the Wooi Residence it is especially exciting because it is like a never-ending story. It is a house which never ceases to reveal something else, both in the way spaces ceaselessly unfold from one another, and for the rich palette of detail offered by its exceptional craftsmanship.

The form of the house is a dynamic consequence of the soaring zinc-titanium roof, which opens like a heraldic umbrella, braced by a massive central timber column. The struts that angle out from this spine to support the roof reinforce the impression of a giant umbrella that has been suddenly and vigorously opened up, in a gesture which generates the energetic, free-flowing plan of the house. The house is centred on the entry-level family room, a cathedral-like space with views over a courtyard sheltered by the fan of the roof. A spatial explosion is repeated in

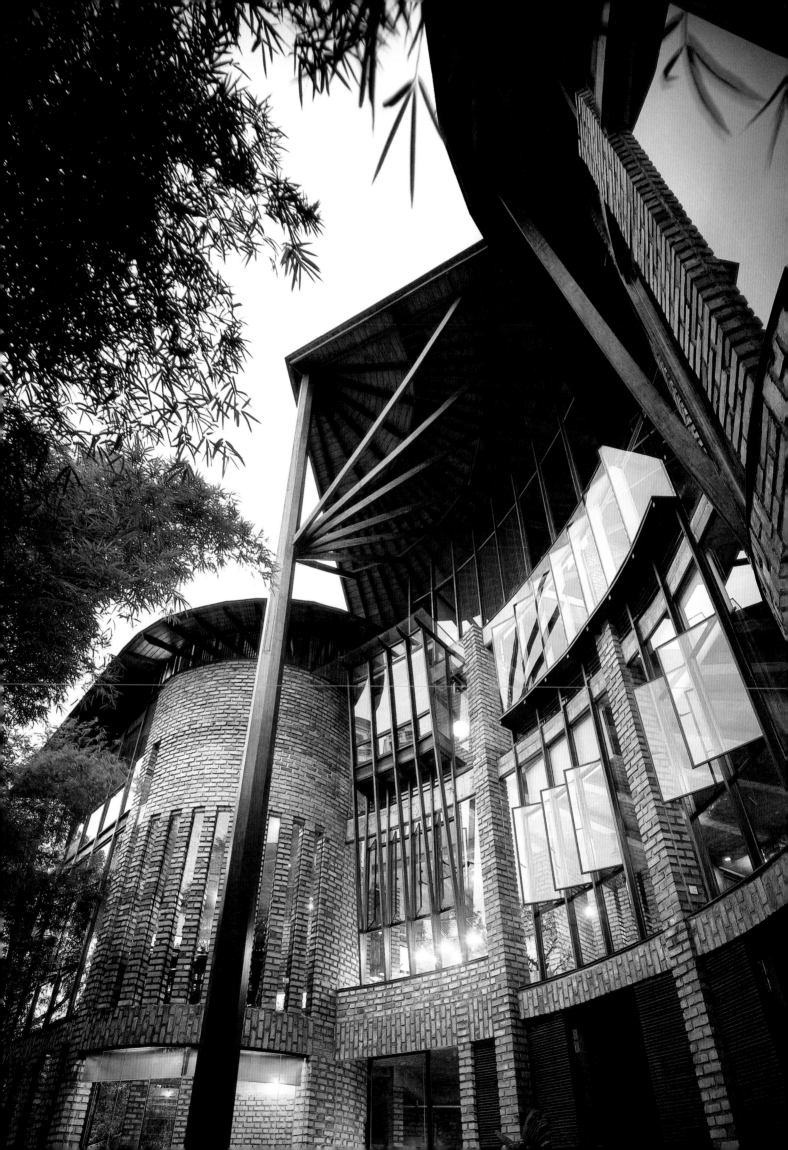

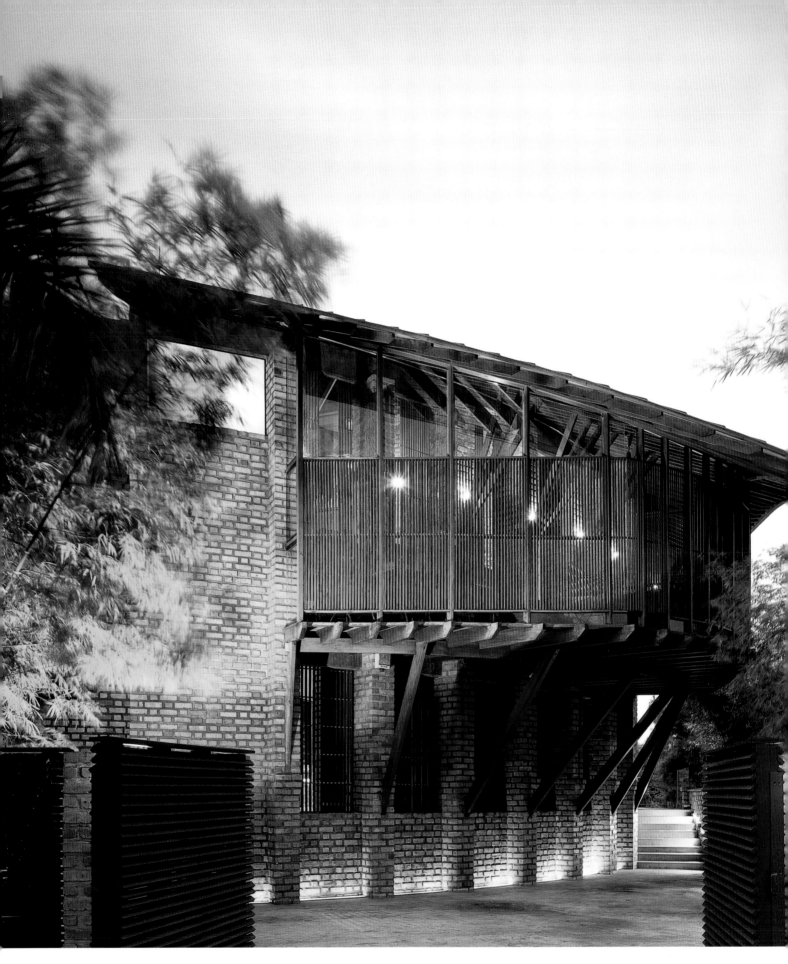

Above Cars are parked beneath the cantilevered fan-shaped study, and visitors proceed to the entrance through a ceremonial series of brick piers and angled timber struts.

Right above Exuberant juxtapositions of materials and forms abound... fair-faced brick walls, hinting at earlier building technologies, meet elegantly modernist framed windows.

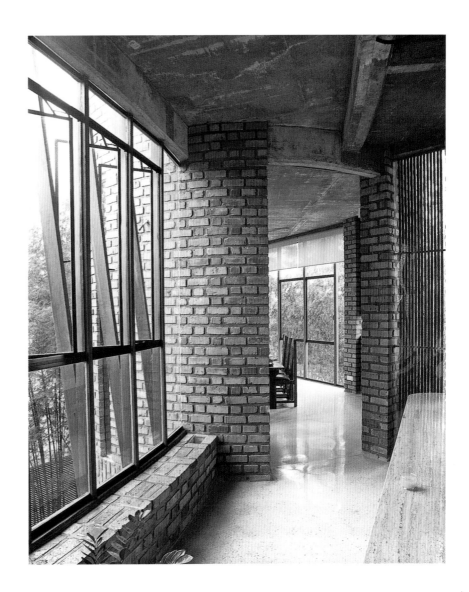

Right The house is replete with unexpected junctions of curved and straight walls, providing intriguing glimpses to the world outside or to the rooms beyond.

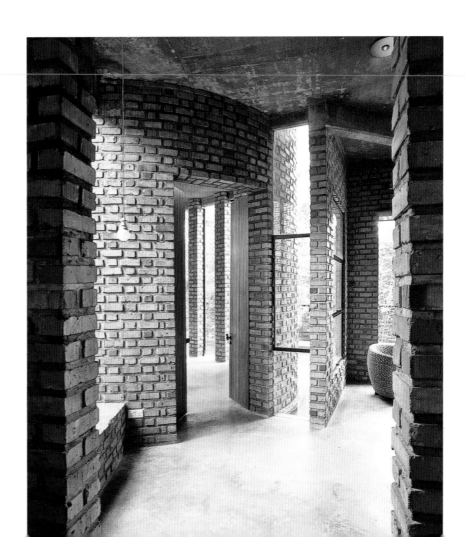

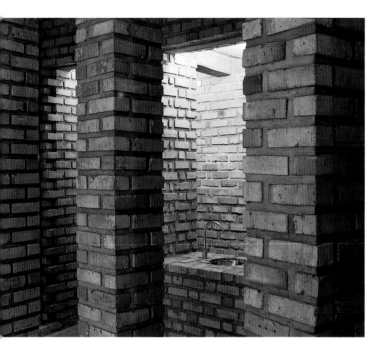

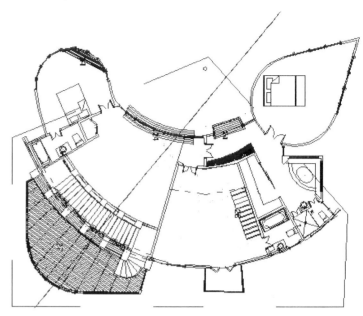

First floor plan

Above Another surprise is seen with the discovery of a small bathroom set into a brick grotto.

Right The finger-like detailing of the timber stairs is complemented by a delicate timber batten screen.

Opposite The soaring rounded brick elevations of the house combine with a dense screen of bamboo to make the courtyard a private place of contemplation.

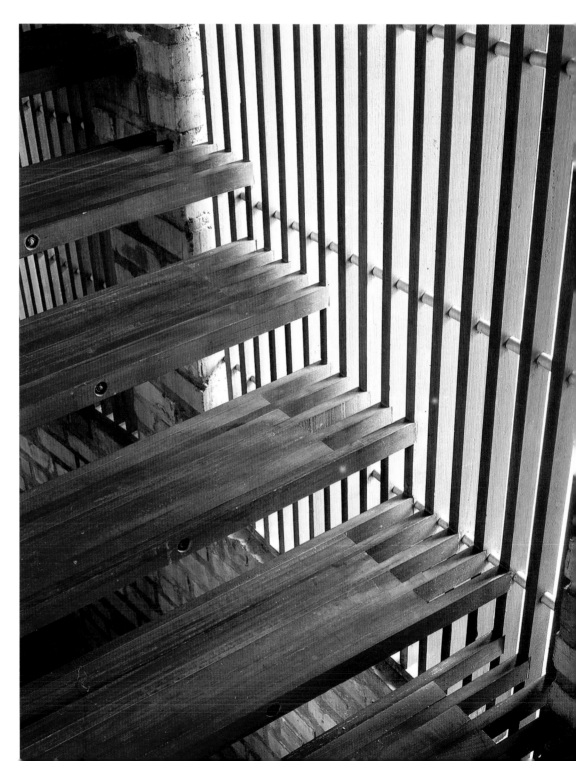

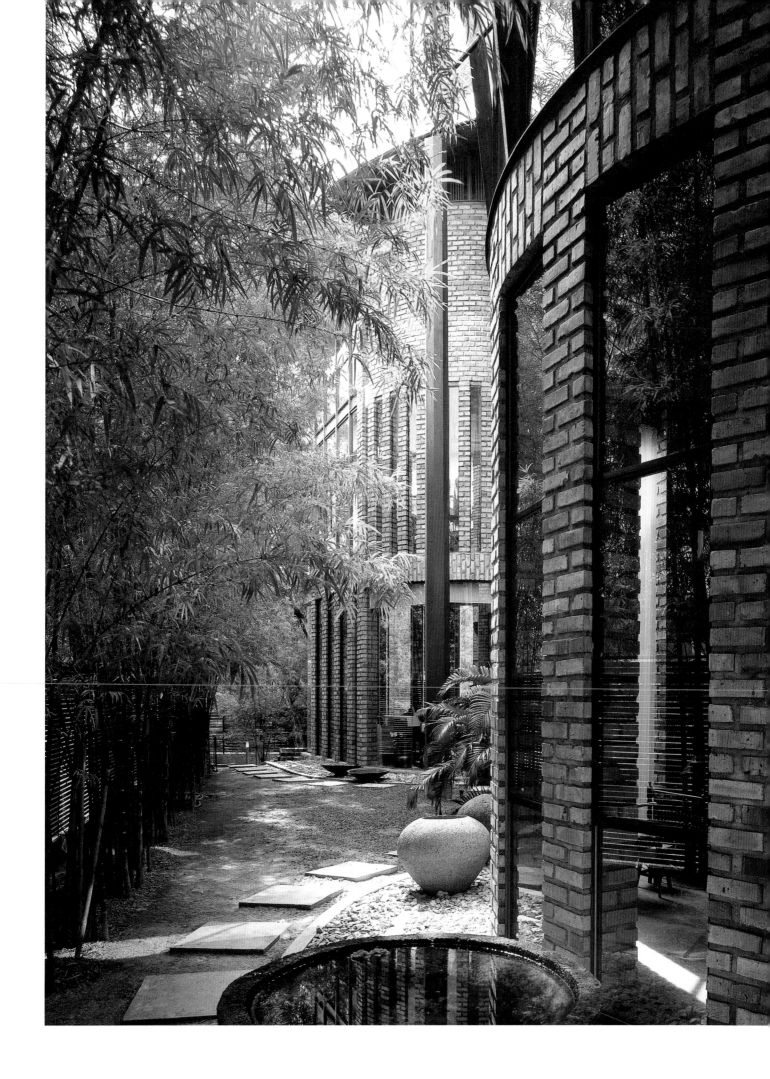

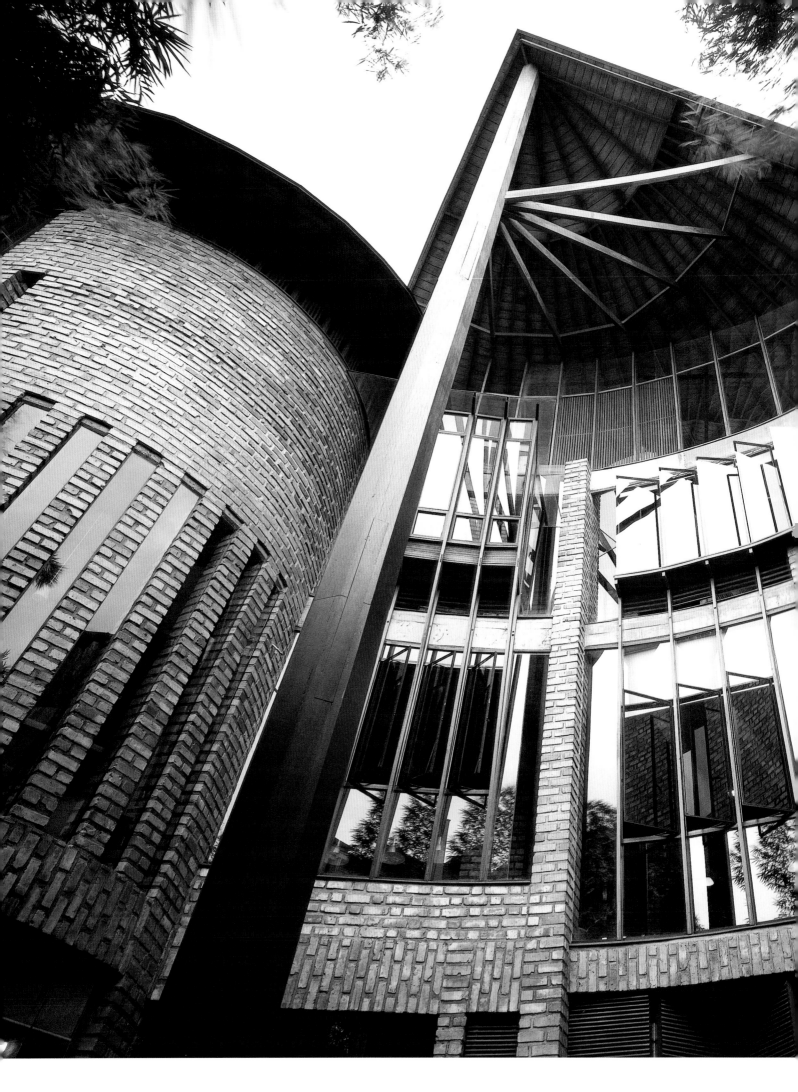

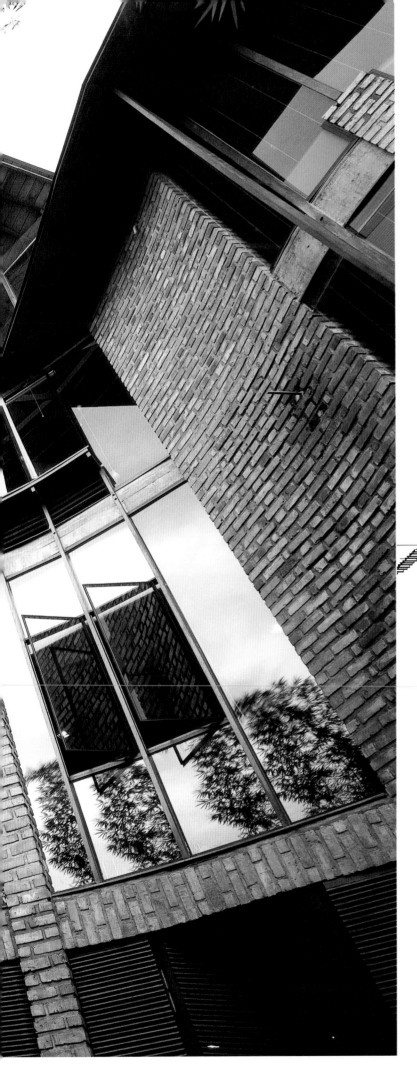

A massive timber column simultaneously pins the house to the ground and supports the soaring umbrella roof. The grandiloquence of Wooi's external forms and internal volumes generate their own sense of limitless space.

Section

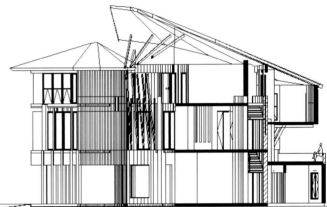

the master bedroom, where the leaf-like detailing of a splendid pitched timber ceiling is lit by clerestory windows.

The surging roof is expressed in the plan of the house, which is an endlessly flowing sequence of spaces. The counterpoint of curved walls and asymmetric straight walls creates unexpected glimpses of spaces beyond spaces, framed views of the outside landscape and the infrastructure required for a high degree of natural ventilation.

Just as there is a rich interaction of forms, so there is also an equally intriguing conversation between materials. This is conducted without any surface ornamentation. Instead, the materials – timber, fair-faced brick walls and off-form concrete – are allowed to be themselves. Nonetheless, the refined timber detailing of the ceilings, doors, joinery and staircases, and the considered brickwork is set against an almost industrial rawness to amplify the richly textured experience of moving through the house. The achievement of the architect in this house is to sustain a balance of dynamic juxtapositions, which seem to be in equilibrium despite having been generated by the 'big bang' of the roof profile.

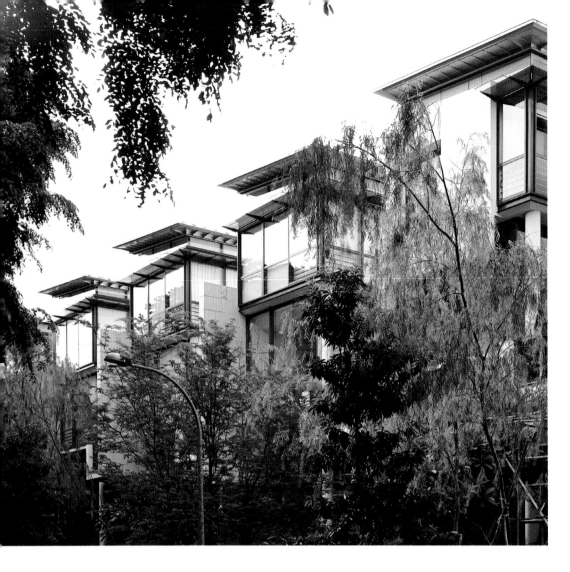

trevose 12

The genius of the Trevose 12 Townhouses is to re-invent the traditional shophouse, and challenged by the site and by regulatory constraints, the architects have made a virtue of necessity. Where the traditional shophouse was dark, these townhouses are filled with light... and where once there was a sense of uncomfortable enclosure, these townhouses thrust out from the hill in an exciting and gratifying occupation of space.

TREVOSE 12

SINGAPORE

ARCHITECT BEDMAR & SHI

The twelve townhouses represent a new typology in multi-residential development in Singapore - the strata bungalow – and they were also among the first to depart from a vernacular expression. Set in a quiet, tree-lined street, the site is 130x30 metres and constrained by the steep fall of the hill. Originally, there were three bungalows on the site, elevated high above the road, and the authorities required that the townhouses be positioned on the original plat-form. This raised the issue of access, and other issues concerned with common amenities and space. These were resolved by applying the horizontal shophouse typology to the townhouses. The units are just six metres wide with a four metre garden area on the side leading to the pool, although technically these are common areas making up for

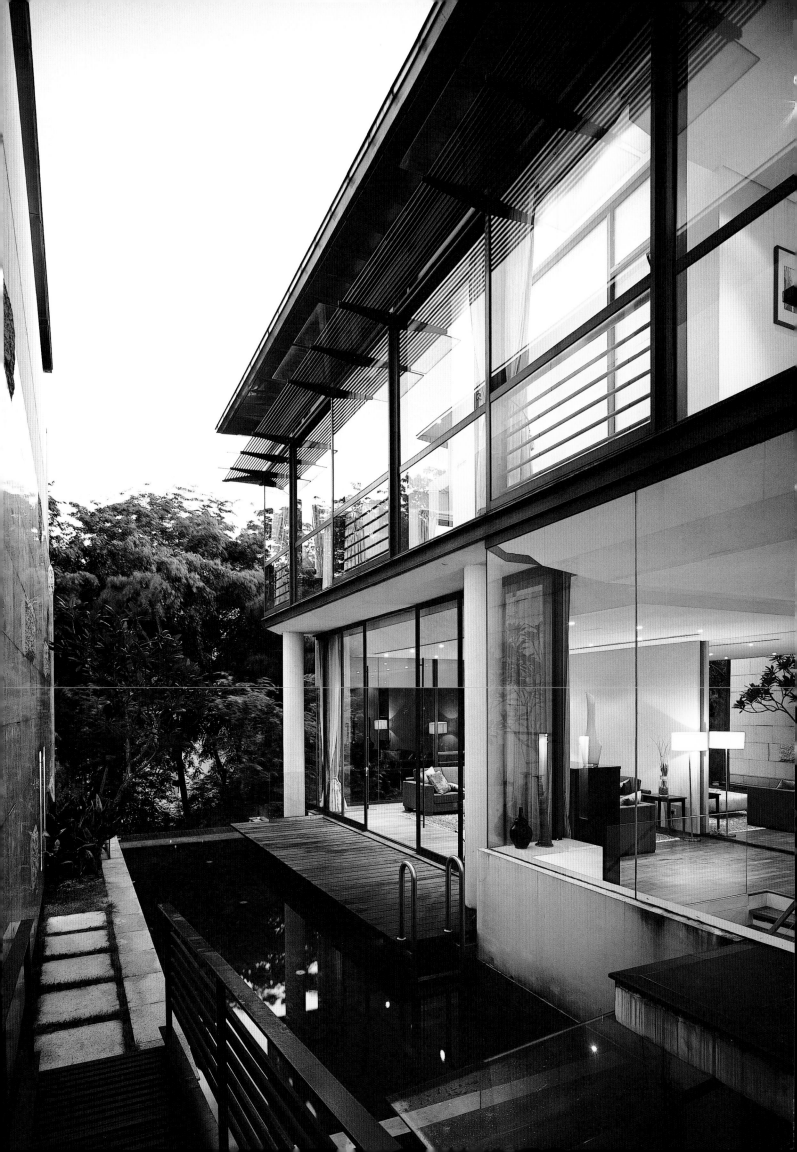

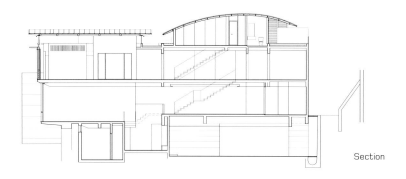

Section

the lack of green space along the rear of the complex.

Resolving these issues has also resulted in surely one of the beautiful multi-residential car parks to be seen anywhere. Due to the regulatory constraints, the car park had to be at street level: so, unlike other developments, it is not a secondary entry, but the primary entry. The car park has beautifully landscaped bays, which use water as a connecting element flowing from the swimming pools above, down granite-block water walls to garden ponds, creating a soothing acoustic. The setback of seven metres also led the architect to another solution, which utilized otherwise unusable space over the steep slope of the site… each unit has its own swimming pool with a glass end, which cantilevers out beyond the building line. At the opposite end, an infinity edge allows the water to spill down

Above left The water features in the car park initiate a beautiful entry sequence to the apartments, as well as providing a soothing acoustic ambience.

Above right The completely transparent living rooms borrow the luxuriant foliage of the trees in Trevose Crescent, and open out to the meditative calm of the pool in the garden courtyard.

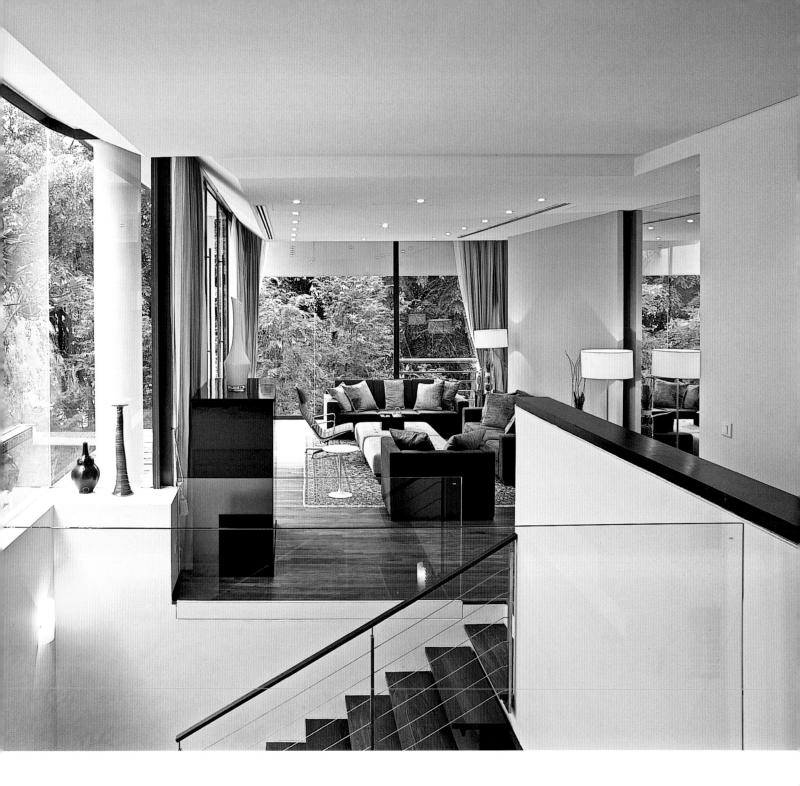

Right Seen from the bedroom above, a timber deck floats out over the water... adding to the visual ambiguity created by the glass-fronted, cantilevered pool.

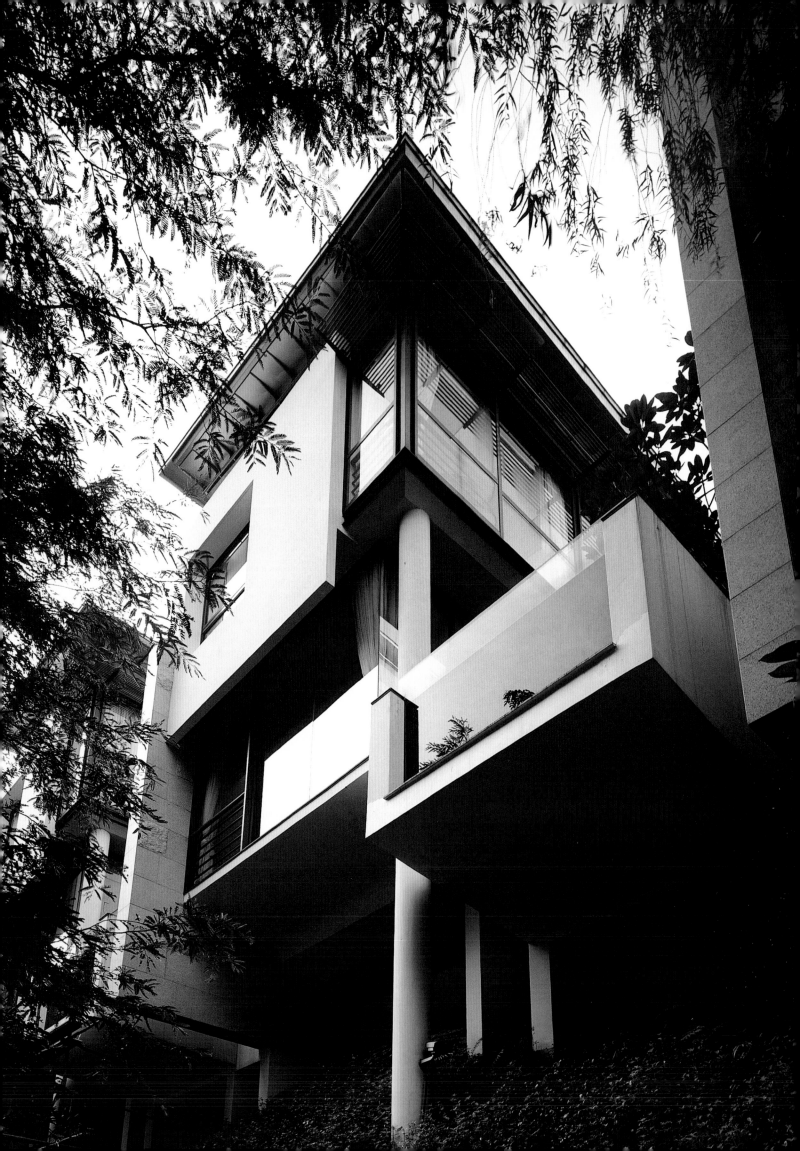

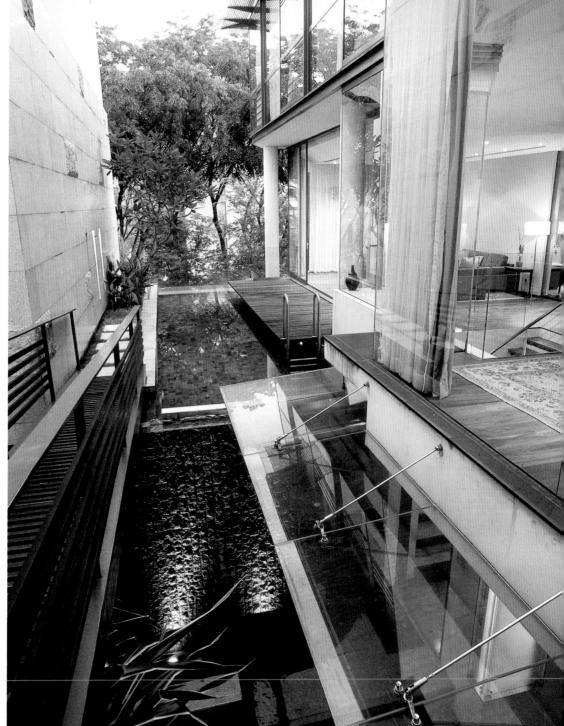

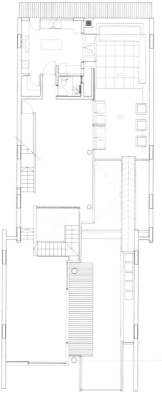

Apartment plan

the granite wall into the car park ponds. Blade walls prevent cross-views and ensure privacy. As a result of the steep site and the regulatory constraints, the ground floor sits very high above the road. As with a shophouse, the main functional spaces form a linear sequence along this level, with the master bedrooms overlooking the street. An attic level with a curved roof contains a sitting room and bathroom.

The floating roof forms and the high level of transparency - resulting from the glass and steel profile of the complex - combine with the porosity generated by the interstitial spaces with their projecting glass swimming pools. The result is a cluster housing project unique for its transparency, and for the way it integrates effortlessly with that Singaporean rarity… an elevated site.

Opposite The glass front walls of the cantilevered pools provide a dramatic sensation for the swimmer, whilst breaking down the mass of the townhouse complex when seen from the street.

Above Gardens and feature walls are washed with overflow from the swimming pools above, creating a wonderful sense of arrival and belying the fact that entry to the units is through the car park.

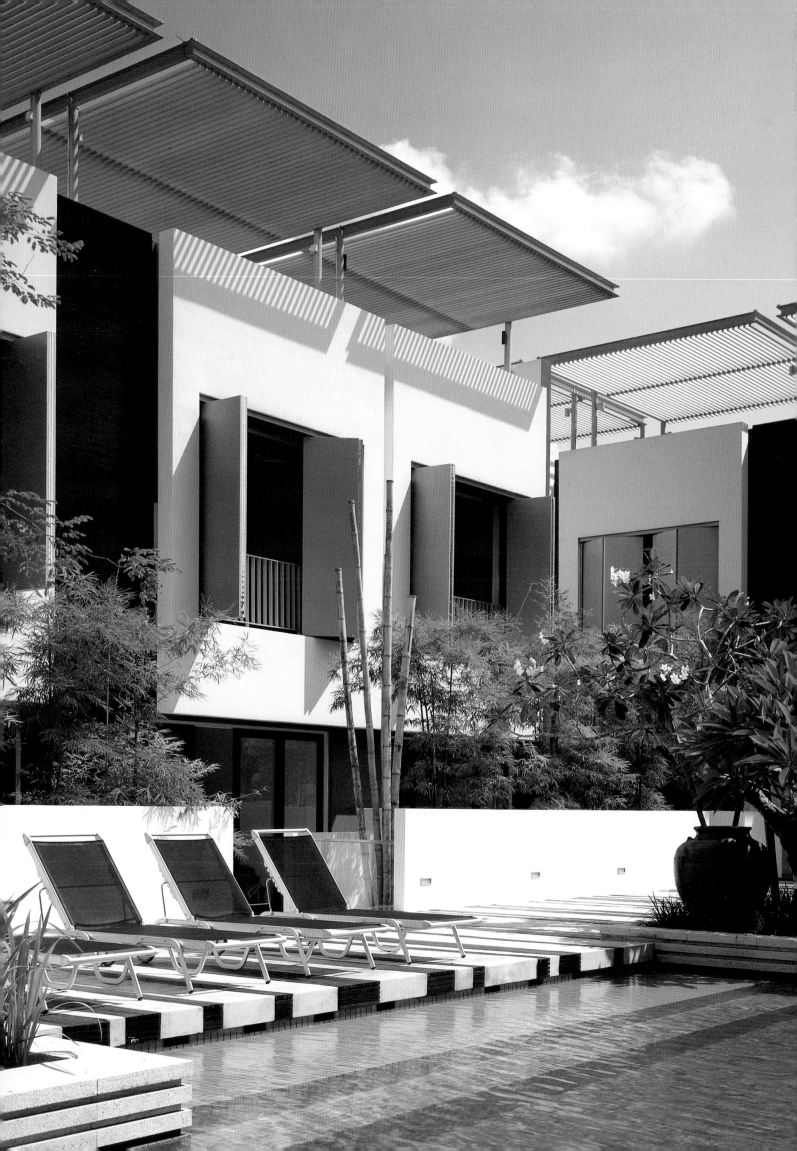

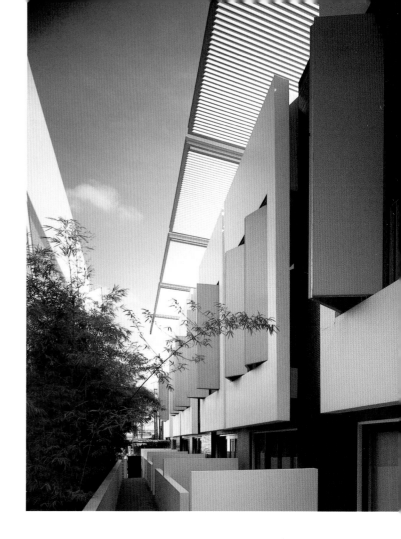

Left The pool area is completely enclosed, surrounded by the contemporary rear elevations of the remodeled shophouses. The successful ambience of this complex results from the harmony between the deferential modern additions and the crafted intricacy of the original shophouses.

Right A narrow walkway runs between the rear elevations of the two wings of shophouses. An ethereal architecture has been created by the battened sunshades and folding metal louvres of the modern additions.

sandalwood

The layering of history takes on new meaning with this beautifully scaled apartment complex... a direct, yet subtle, combination of tradition and modernity. Set in the historic Joo Chiat district on Singapore's East Coast, Sandalwood combines a new five storey condominium with 16 heritage shophouses dating from the early 20th century.

The shophouses and the new apartment block form an L-shape which encloses an elaborately landscaped, semi-private common garden with a 25 metre swimming pool. The façades of the shophouses have been meticulously restored to maintain their historical character. At the rear, however, they have been refurbished to complement the contemporary architectural language of the apartment block. The shophouse interiors have been extensively altered to create spacious common areas on the ground floor, lit by a central lightwell above a shallow reflection pool, which is only deep enough to cool one's feet. Bedrooms and bathrooms are on the upper levels, with a spiral stair leading to a rooftop terrace.

The historical layerings are echoed in the apartment block, not in an obvious way, but through elegant planning. The block consists of 23 two-bedroom units - all

SANDALWOOD

SINGAPORE

ARCHITECT SCDA

Left The eclectic neo-Classical Straits Chinese architecture of 1920s Singapore featured such decorative touches as ornate Malay fretwork and garlanded reliefs of tropical scenes. The Joo Chiat and Koon Seng Road precinct retains some of the most splendid examples of Straits-style shophouses, in varying states of preservation.

Below The swimming pool area is an oasis of repose and elegance in a neighborhood characterized by noise, colour and street-life.

Right Looking down from the apartment block to the pool area and the two shophouse wings. The pitched red-tiled roofs of the original shophouses mark the boundaries of the complex.

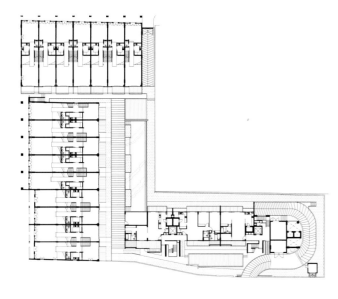

Site plan

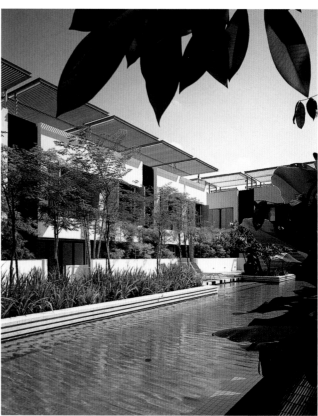

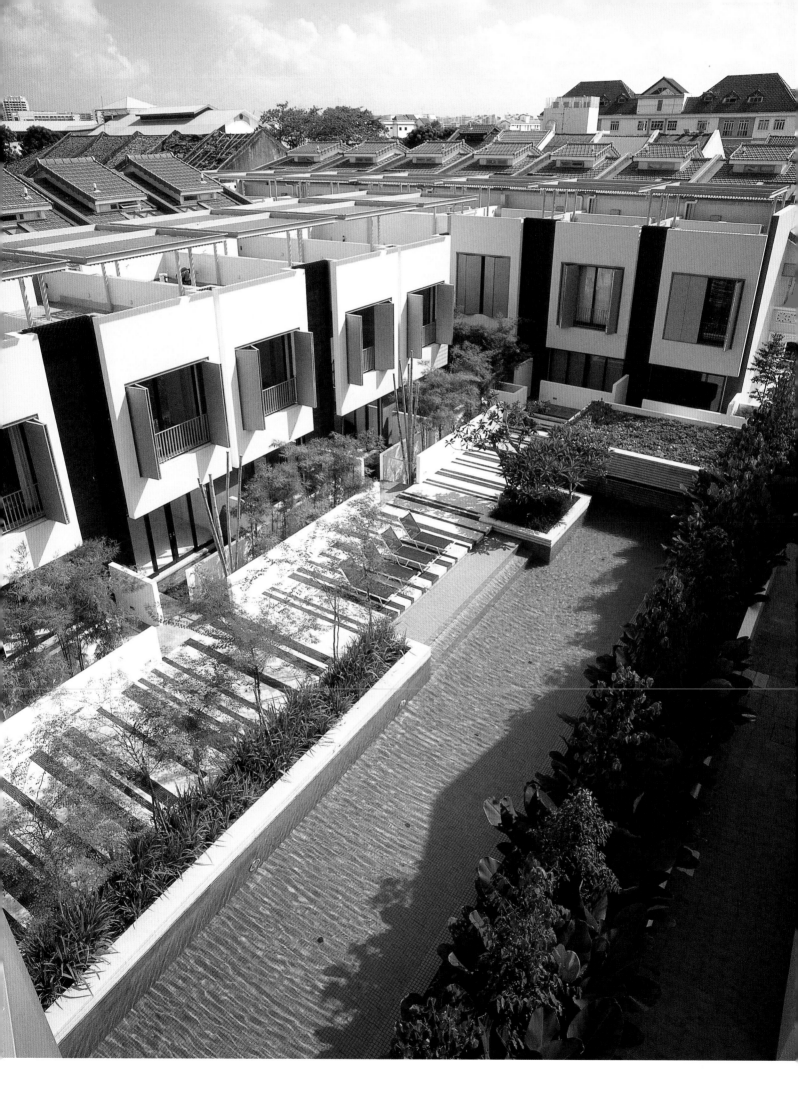

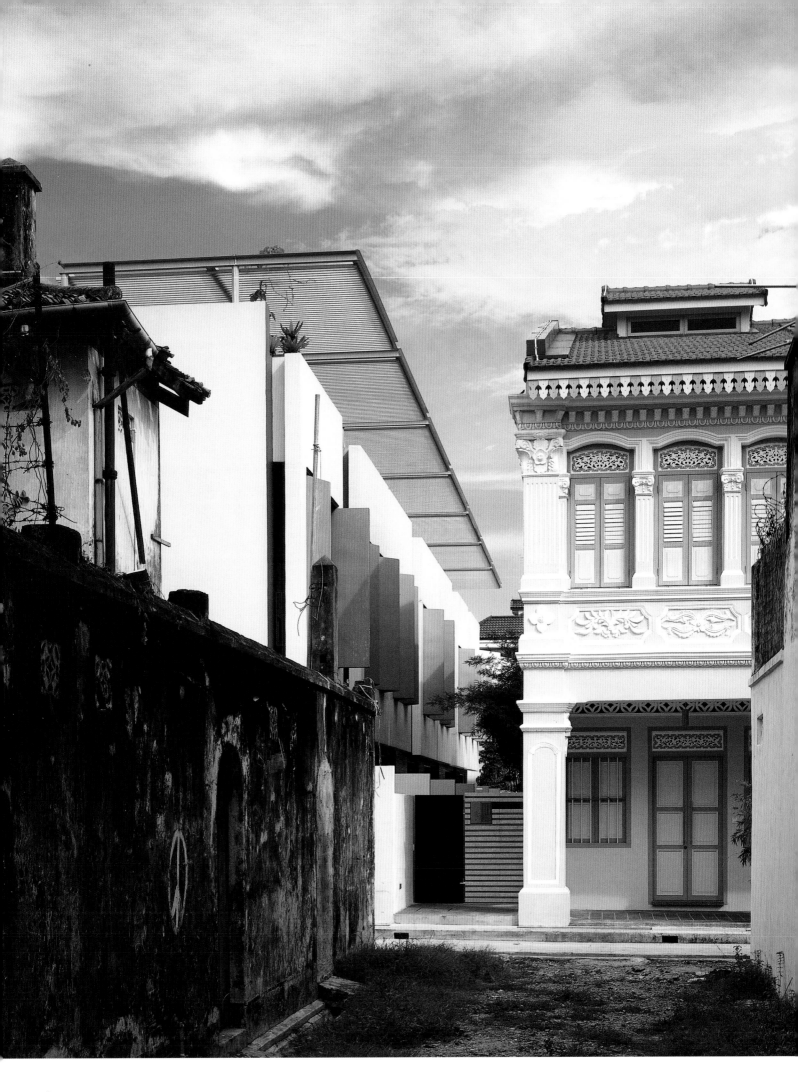

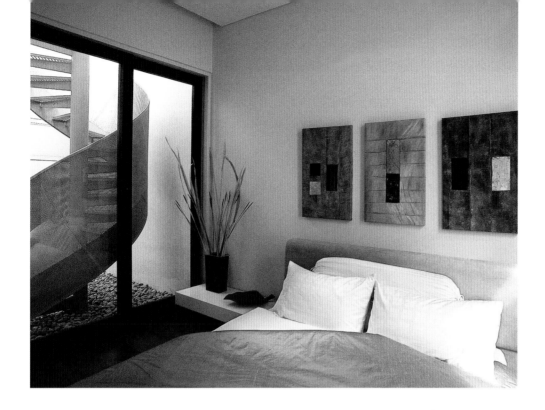

Opposite A view along a laneway running from Koon Seng Road to Sandalwood. The contemporary additions to the rear of the shop-houses on Tembeling Road can be seen to the left, while the restored frontages of Sandalwood's western wing are to the right.

Left A bedroom in a restored shop-house with a spiral stair leading to the rooftop terrace.

Below A view of the ground floor living area in a restored shophouse, looking to the street entry. The stairway leads to bedroom levels above, while sunlight falls through the lightwell to the right.

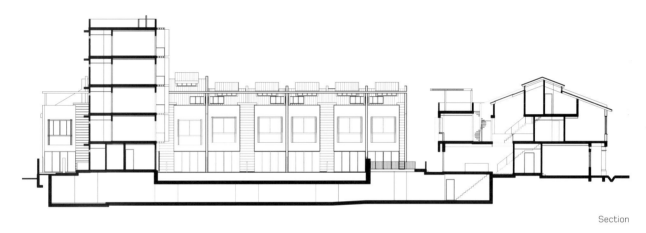

Section

open plan – with five different types on each floor. The top floor penthouses have rooftop terraces. The apartments are organised around two vertical circulation and service cores, and each unit has three layers of enclosure. Firstly, a generous 'stroll terrace' creates an interface between the façade and the open plan living areas with floor-to-ceiling glass sliding doors. The open metal grill of the terrace then draws attention to the vertical layering of the building, allows a flow of light and air, and generates a mood of transparency and lightness. The façade is further layered by zinc titanium panels for sunshading, which contrast beautifully with the elegant timber screens concealing the service cores.

tanglin residences

The Tanglin Residences look more like an elegant estate than a multi-residential complex... a lot to do with the fact that it is close by, but tucked away from, the bustle of the Orchard Road area. This elegance also results from an intriguing mix of residential types and the easy way with which the buildings respond to the sinuous sloping site.

TANGLIN RESIDENCES

SINGAPORE

ARCHITECT W ARCHITECTS

This condominium development of ten townhouses and thirty-three apartments is just off a busy shopping precinct, but enjoys surprising peace and privacy. It is a shallow, extended site, which follows the snake-like form of the road whose gentle slope ends at a cul-de-sac, the entry point for the development. The plan of the complex creates a far more interesting narrative than that which is usually the case with consolidated multi-residential blocks. The changing typology from townhouse to apartment gives added richness to this narrative, which gains interest at those points where the building line changes direction, emphasizing the theme of volumetric expression that shapes the overall character of the development.

Volumetric expression is set against linear elements, such as sunshading and roof eaves, to set up an intricate

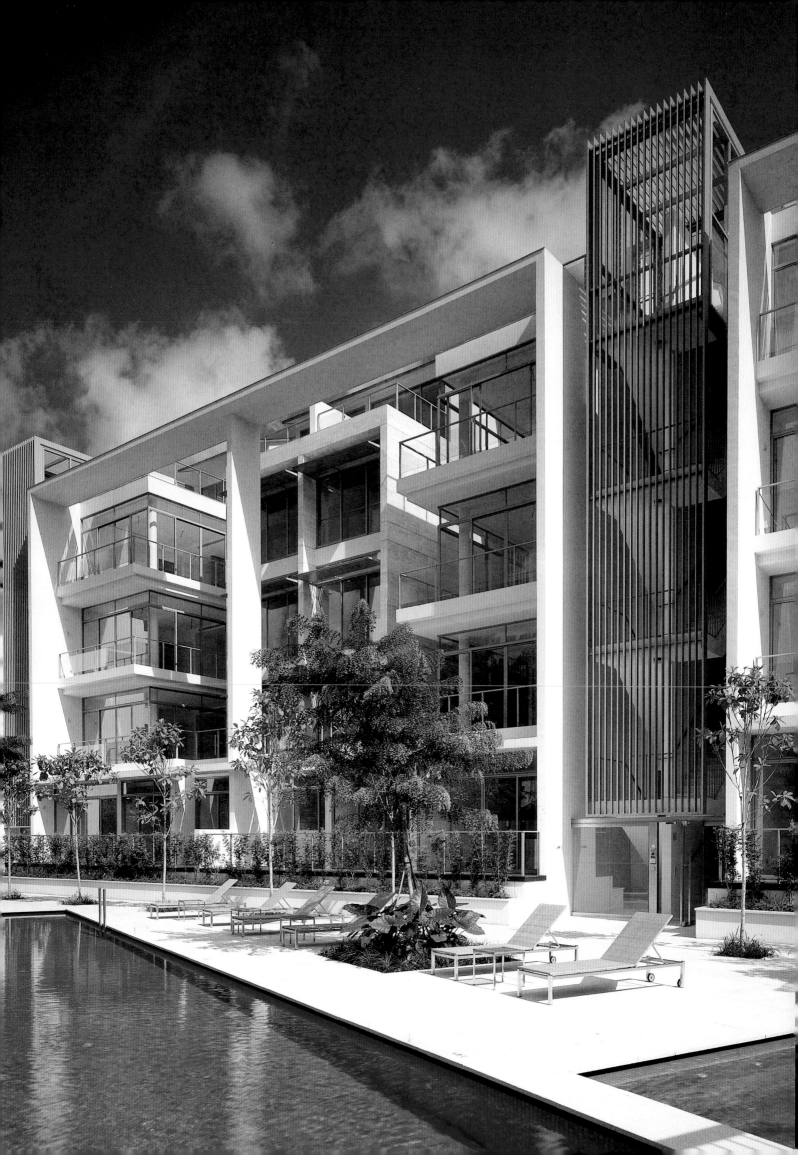

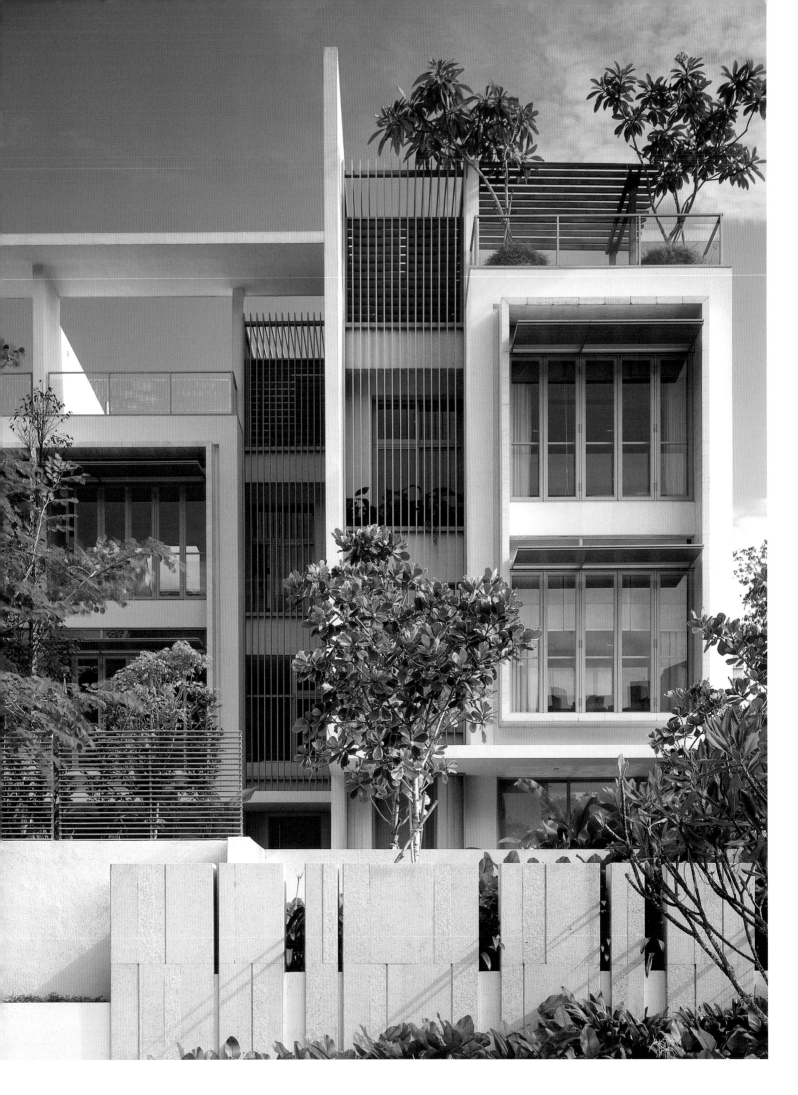

Opposite Seen from the street, the townhouses present themselves as resolved compositions of frames and cubes... internally they are experienced as self-contained worlds.

Left The air-well is a feature of both the apartments and the townhouses and, as in a traditional shophouse, draws in light and air.

Below The bedrooms exemplify the strategy of drawing in generous natural light while preserving privacy.

rhythm, which takes on even greater complexity when set in counterpoint against the sinuous progression of the road. The volumetric expression is particularly evident in the townhouses, whose bedroom elevations are, in the words of the architect, "grouped and expressed as a cube, and set within the envelope of planes". Where the townhouses give the impression of a dynamic progression, the apartments seem to be held in a state of tension, framed by their eaves and screens.

Just as a piece of contrapuntal music is an exercise in simultaneous connection and separation, the vertical and horizontal elements of the Tanglin Residences, when set against the curve of the road and the angled feature wall of stone and plants at the entry, engender a series of conceptual oppositions. The units are at once connected, yet separated... they expose themselves, yet they reserve a lot of privacy, and they form a shallow curving band, yet possess a powerful three-dimensional quality, enhanced by a staggered profile, which also adds to the privacy of the individual units.

As a result, the townhouses give the impression of being more like terrace houses with their own plot of land, rather than elements within a consolidated development. This impression is reinforced by the entry from the private parking lots in the basement through an entry hall.

The houses are accessed by a dynamic staircase to the ground level, which has views out to the lush landscaping. On this level, the living area is divided from the dining area by an air well, open to the sky. This triple-height air well draws in light to the whole unit, conjuring up memories of the traditional shophouse. The air well device is also used in the apartments, creating an inward, contemplative mood without loss of views to the outside. In this way, the architects have addressed a brief which called for privacy and intimacy, whilst providing light and space.

Section

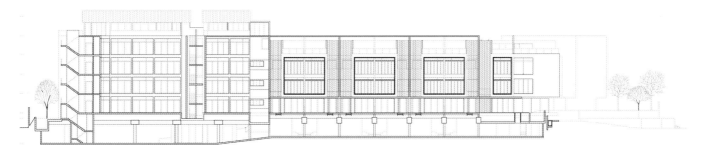

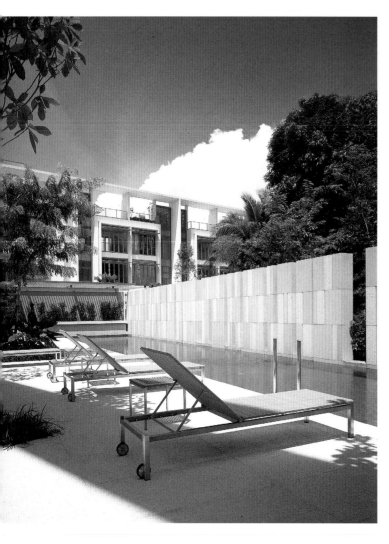

Floor plan

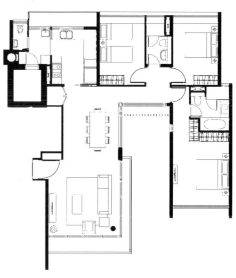

Left A feature wall of vertical stone blocks shields the swimming pool area from the ramp to the basement car park. The architect has responded to the geometric peculiarities of the site by producing axial tensions, such as the angle of the swimming pool and terrace.

Following pages The bedroom elevations of the townhouses are "grouped and expressed within a cube, and set within the envelope of planes."

Below The swimming pool and communal area enjoy a heightened sense of privilege and privacy as a result of carefully considered landscape elements, which reflect the relentlessly orthogonal composition of the apartments and townhouses.

Right The townhouse wing derives privacy from the landscaping and gardens, which create a buffer zone between the building and the communal pathways.

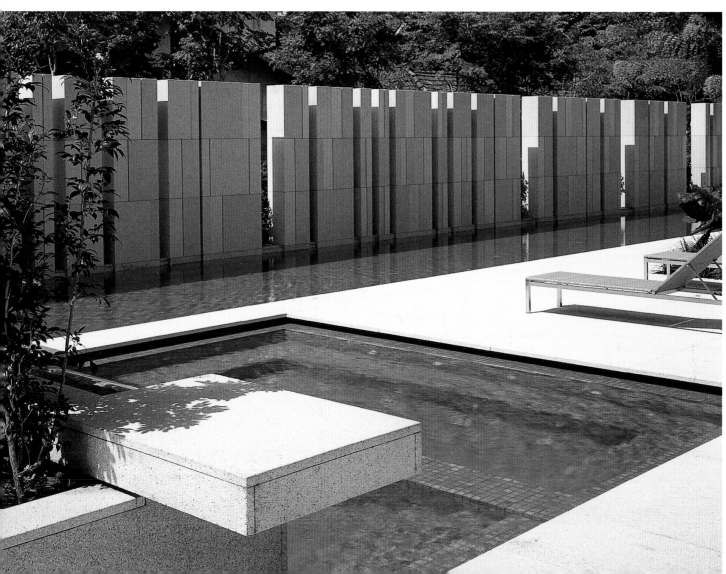

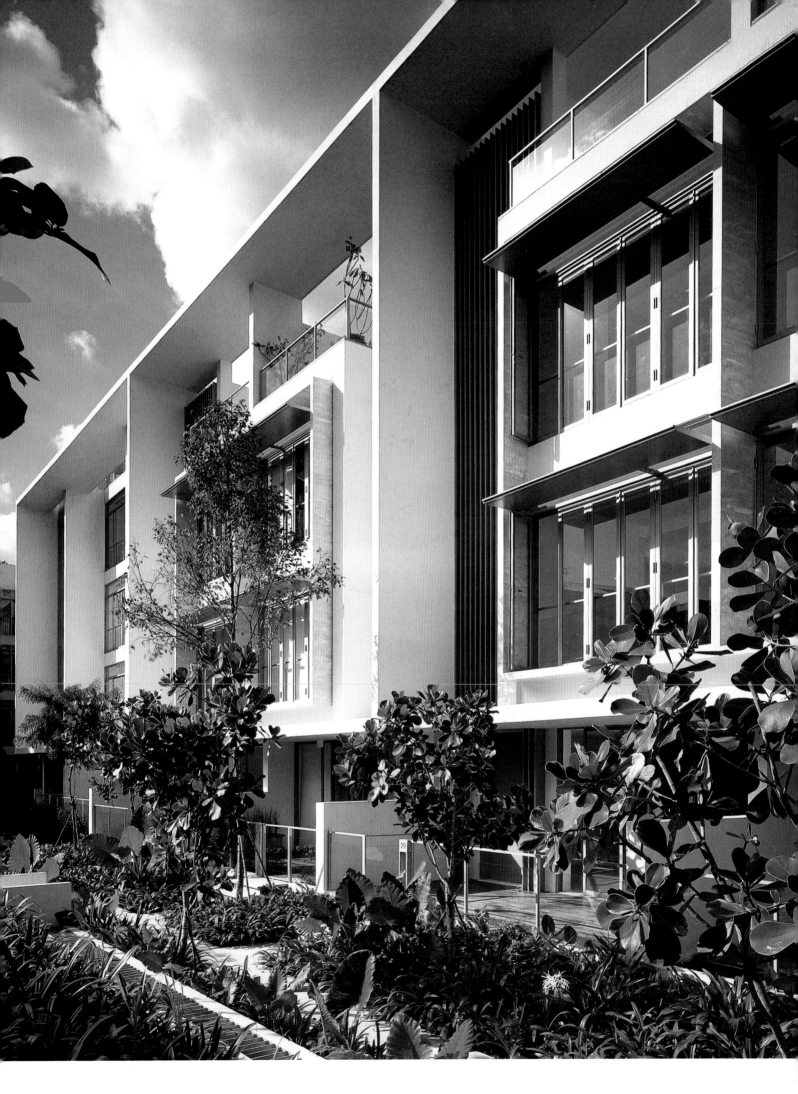

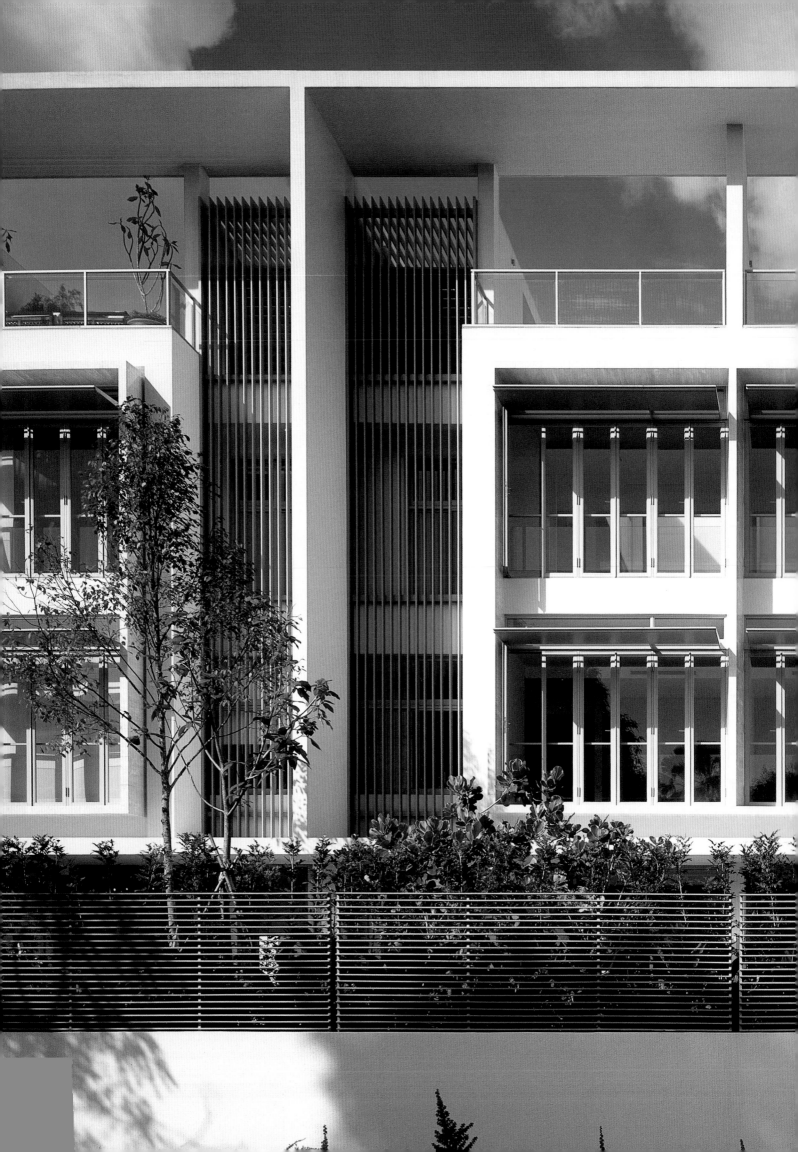

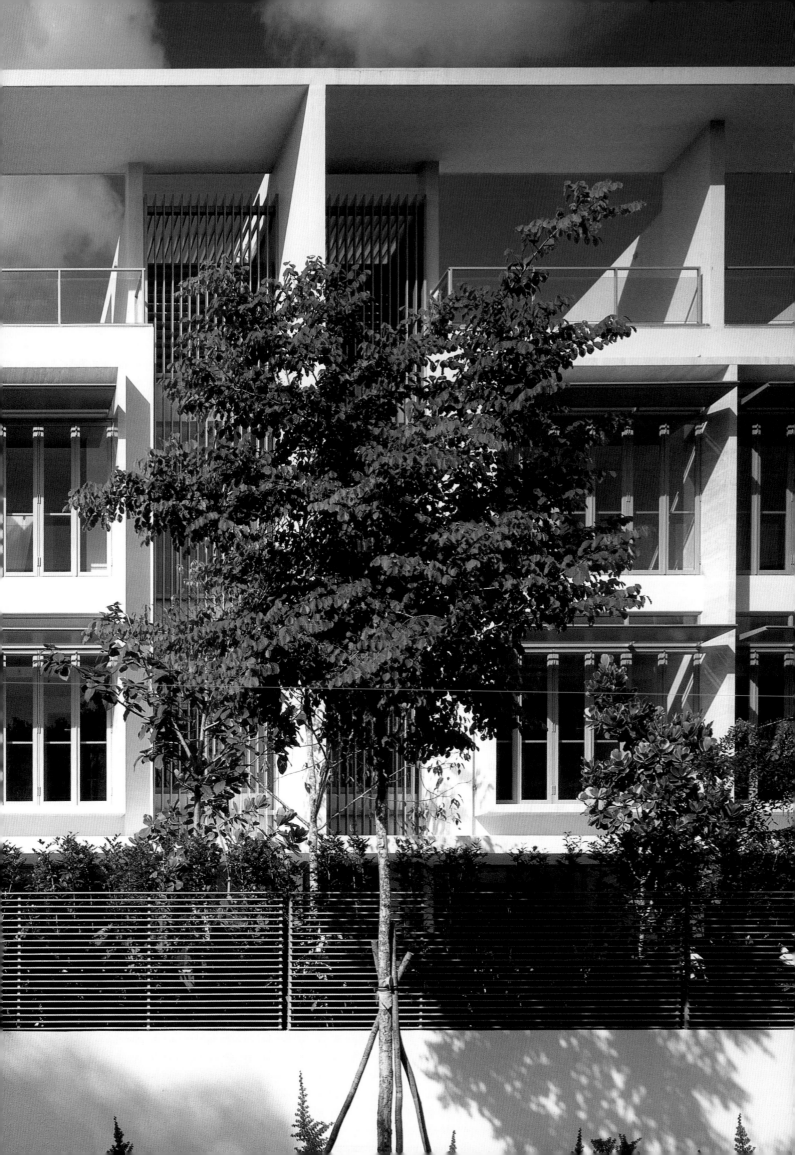

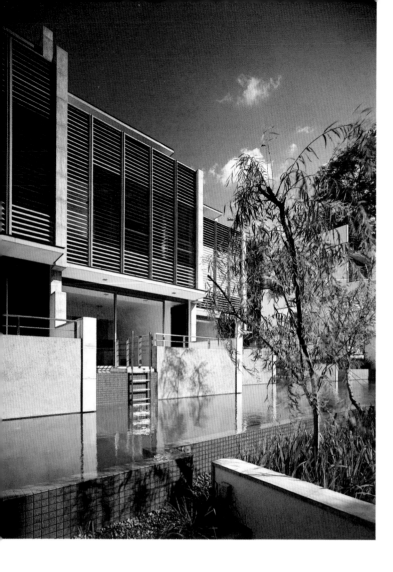

gilstead brooks

The magic of Gilstead Brooks is conjured up in the image of a village wrapped in the fragrance and colour of a tropical garden... cooled, calmed and connected by a languorous brook. The residents enjoy the privacy of individual homes with all the reassurance of a community.

The site for this cluster housing project of 28 townhouses (including two semi-detached houses) had previously been home to two bungalows, so it was a restricted in size and the Urban Redevelopment Authority required that the existing levels be maintained. This involved stepping down from street level. WOHA Architects turned this to advantage when they developed the concept of a village occupying the slopes down to a meandering brook. The brook here makes up most of the common area – a series of connected ponds culminating in an expansive swimming pool: a visual rather than a physical sharing of space. All the townhouses look out through their own gardens to the 'brook', while four of the units, together with the two

GILSTEAD BROOKS

SINGAPORE

ARCHITECT WOHA

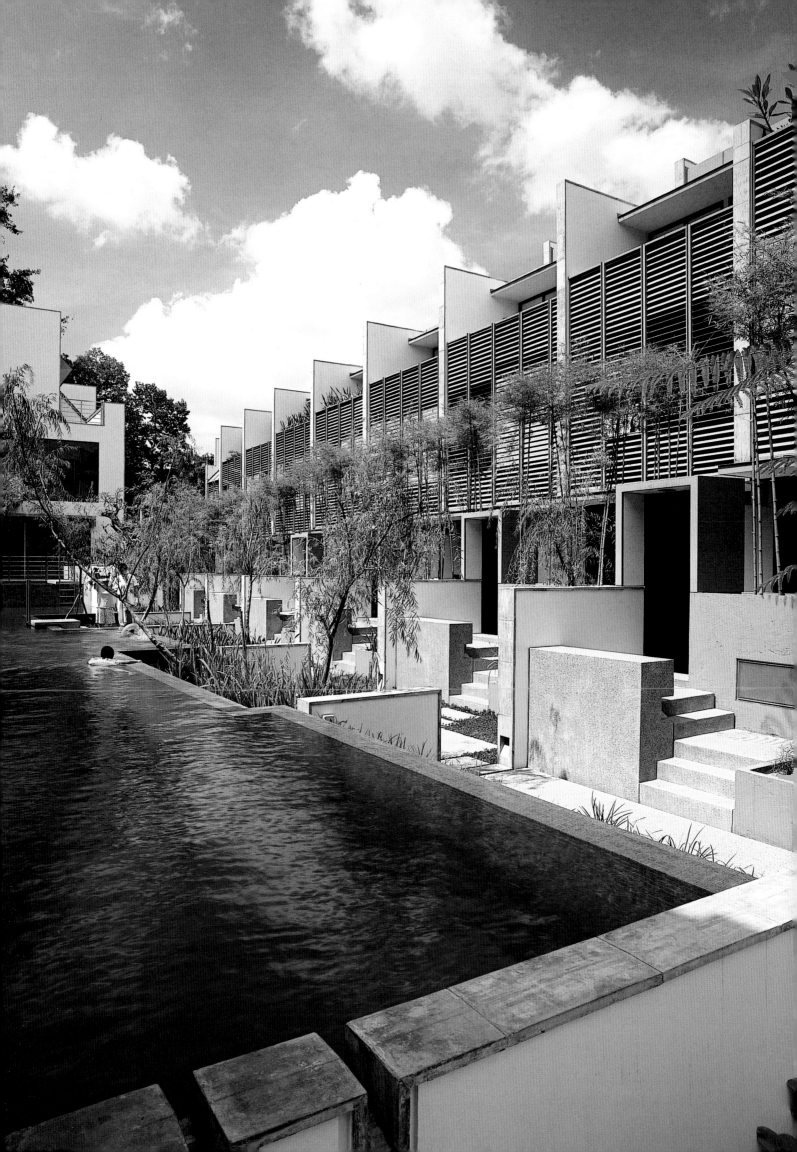

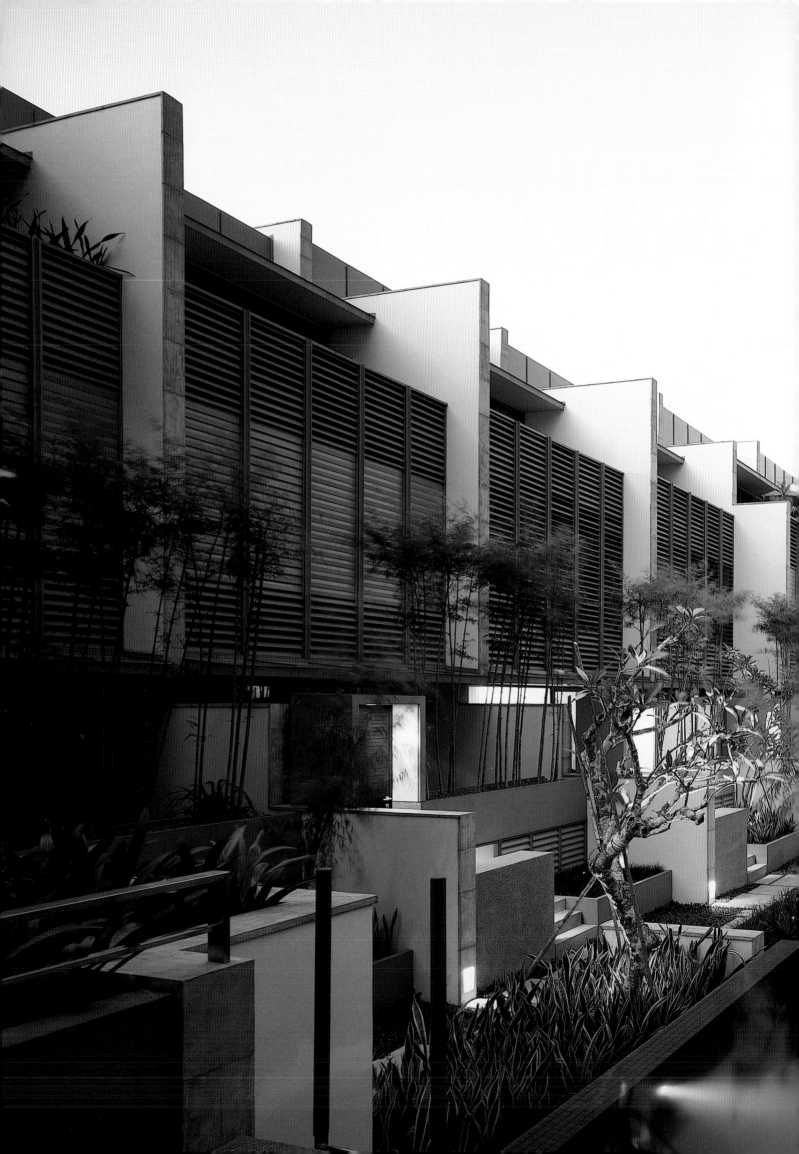

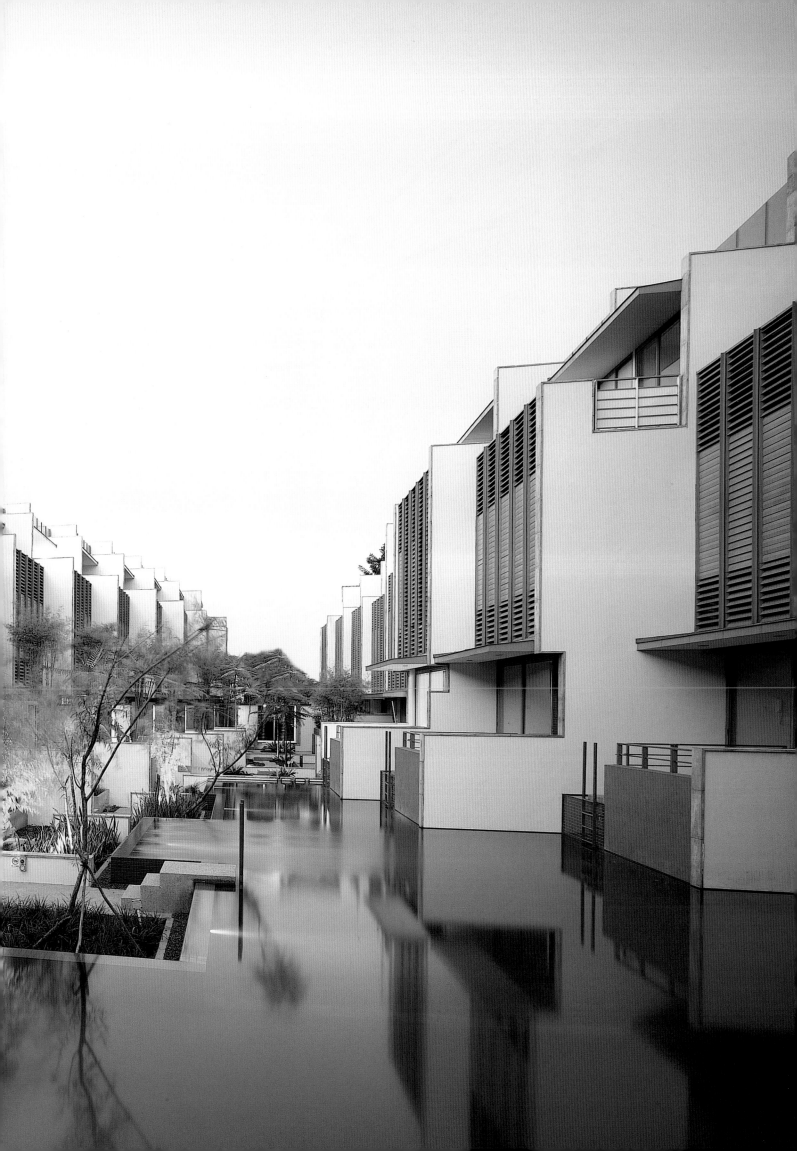

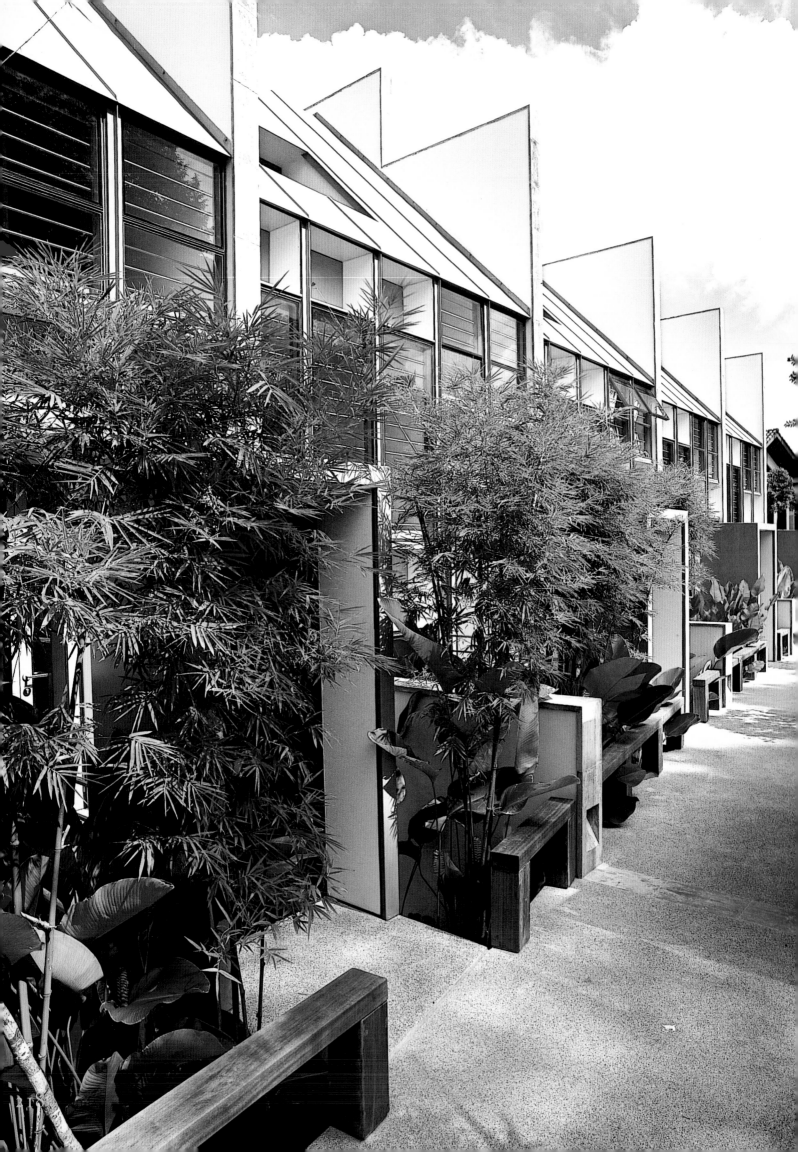

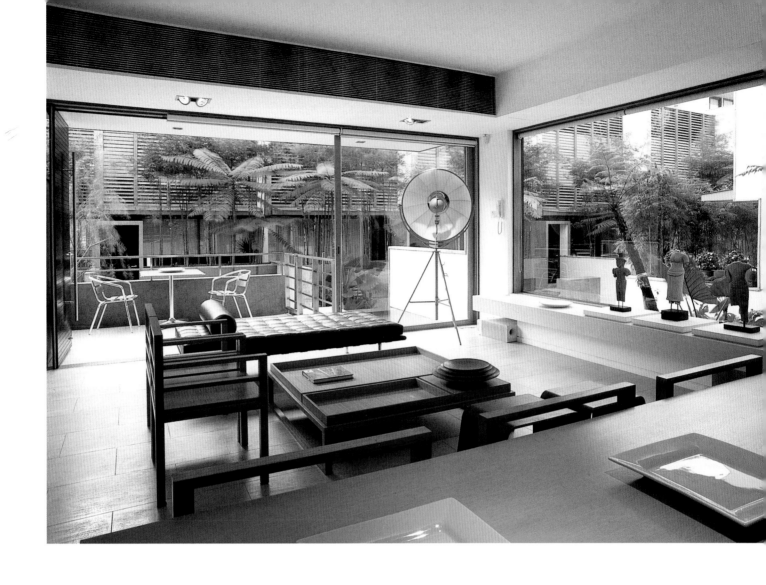

Previous pages The languid pool and the garden beds conjure up the image of a gently meandering stream passing through a village.

Left The condominium is screened from the street by a path of bamboo. The blade walls give privacy to each apartment, and a sense of individuality… a real town house.

Above To be inside looking out is to be in an elevated river house, a part of the river, with glimpses of neighboring homes through the trees.

Site plan

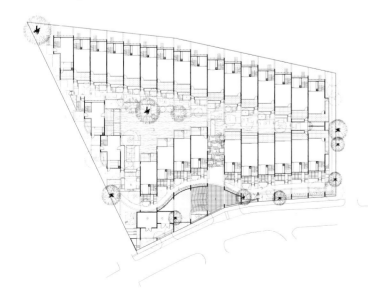

semi-detached houses, have direct access to the pool from their own terraces. Centralizing the common area helped to make full use of the available land, just as exploiting the stepped site profile enabled the architects to maximize density while staying within local height restrictions.

Conceptually, the architects divided the irregular (but basically linear) site into strips that 'slip and slide' alongside each other, suggesting the kind of randomness expressed by the organic development of a riverside village. As well as simulating the meandering of a stream, the stepped elevation and various water areas hint at rice terraces. The result is a peaceful oasis with visual variety and a sense of space which belies the actual size of the development.

Each apartment consists of four levels, including a basement. A gridded fence maintains connection with the street, with each apartment set back behind its own garden. Entry is through a freestanding portal and across a bridge which spans the basement level garden below. The steeply pitched roofs contain an attic space, and lead on to a small terrace where blade walls ensure privacy. This elevation hints at the mansard roof apartments common in Europe… introducing a sense of urbanity to contrast with the rural mood of the internal landscape.

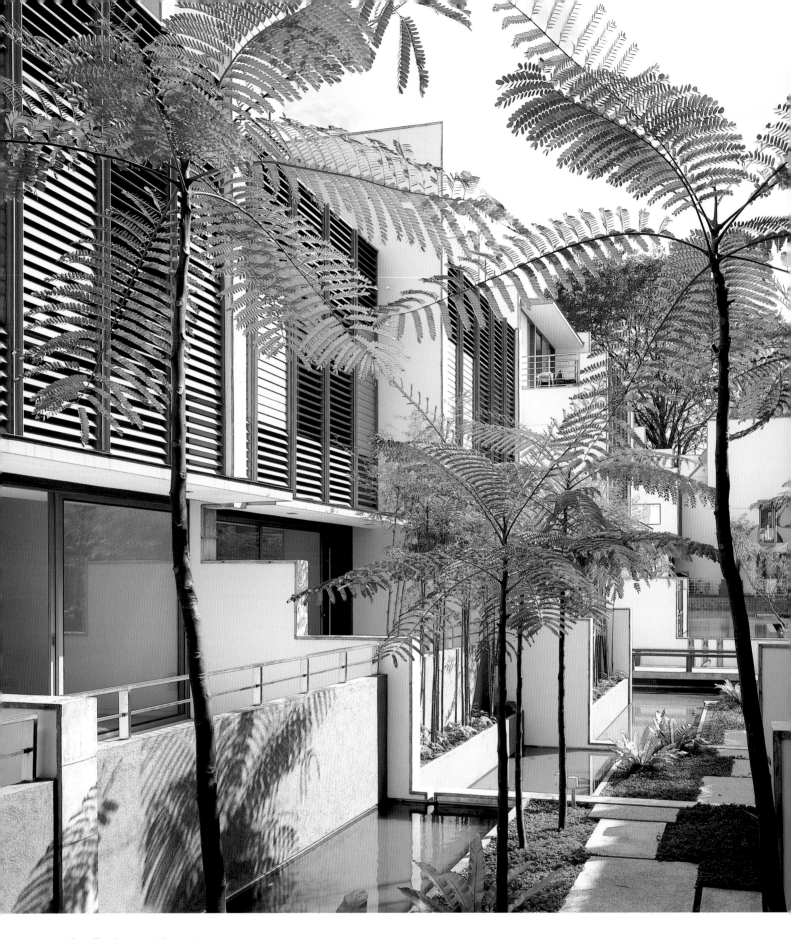

Above The close proximity creates a sense of community, but louvred screens, blade walls and landscaping also ensure privacy. The lush foliage provides a wonderful contrast to the restrained architectural palette.

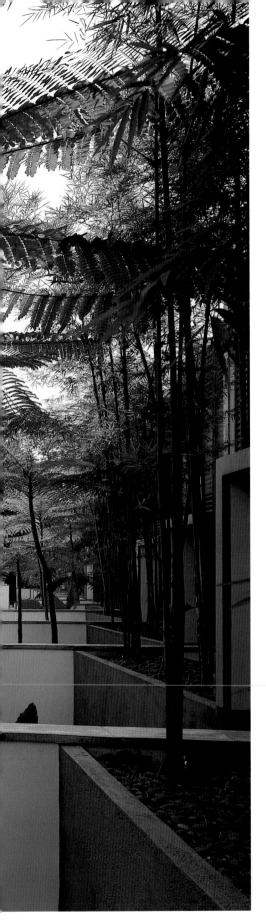

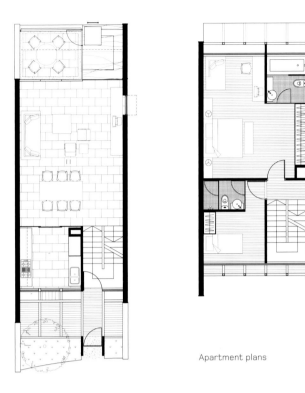

Apartment plans

Above Seen from within the apartments, the shifting levels and staggered pathways of the garden landscape create constant visual variety.

the architects

Guz Architects
3 Jalan Kelabu Asap
Singapore 278199
Tel: + (65) 6476 6110
Fax: + (65) 6476 1229

WOHA
175 Telok Ayer Street
Singapore 068623
Tel: + (65) 6423 4555
Fax: + (65) 6423 4666

BEDMaR & SHi PTE LTD
12a Keong Saik Road
Singapore 089119
Tel: + (65) 62277117
Fax: + (65) 62277695

RichardHO Architects
691 East Coast Road
Singapore 459057
Tel: + (65) 6446 4811
Fax: + (65) 6446 4822

Aamer Taher Design Studio
25 Jalan Kuning
Singapore 278170
Tel: + (65) 6476 6441
Fax: + (65) 6476 6442

Chan Sau Yan Associates
CSYA Studio Pte Ltd
No. 5 Keong Saik Road
Singapore 089113
Tel : + (65) 6324 3128
Fax : + (65) 6324 3138

WOW Architects
30 Hill Street, #01-04
Singapore 179360
Tel: + (65) 6333 3312
Fax: + (65) 6333 3350

Ip:Li Design
27 Mt Faber Road #05-13
Mt Faber Lodge
Singapore 099200
Tel: + (65) 6274 4830
Fax: + (65) 6274 4830

Seksan Design
Landscape Architecture &
Planning
67 Jalan Tempinis Satu
Lucky Garden, Bangsar
59100 Kuala Lumpur
Malaysia
Tel: + (603) 2282 4611
Fax: + (603) 2282 0366

K2LD Architects
136 Bukit Timah Road
Singapore 299838
Tel: + (65) 6738 7277
Fax: + (65) 6738 7677

SCDA Architects Pte Ltd
10 Teck Lim Road
Singapore 088386
Tel: + (65) 6324 5458
Fax: + (65) 6324 5450

Kevin Mark Low
smallprojects
Kuala Lumpur
Tel: + (6012) 200 1800
Fax: + (603) 2282 2861
www.small-projects.com
lsd@pd.jaring.my

Heah & Co Thames Wharf Studios
Rainville Road
London W6 9HA
England,UK
Tel: + (44) 20 7385 9109
Fax: + (44) 20 7385 5395

HB Design
179 River Valley Road
River Valley Building
#04-07/08
Singapore 179033
Tel: + (65) 6476 1323
Fax: + (65) 6475 2373

Fahshing Architect
Lot 16-2,Blk B,
Damai Point, Luyang
88300 Kota Kinabalu
Sabah
Malaysia
Tel: + (60) 88 269018
 + (60) 88 269019
Fax: + (60) 88 238160

W Architects Pte
179 River Valley Road #05-06
Singapore 179033
Tel: + (65) 6235 3113
Fax: + (65) 6733 3366

Wooi Architect
45-3A, Level 3 OG Business
Park, Jalan Taman
Tan Yew Lai,
58200 Kuala Lumpur
Malaysia
Tel: + (603) 7782 5518
Tel: + (603) 5192 9082

the tuttle story

"Books To Span The East And West"
Many people are surprised to learn that the world's largest publisher of books on Asia had its humble beginnings in the tiny American state of Vermont. The company's founder, Charles Tuttle, belonged to a New England family steeped in publishing.

Immediately after WW II, Tuttle served in Tokyo under General Douglas MacArthur and was tasked with reviving the Japanese publishing industry. He later founded the Charles E. Tuttle Publishing Company, which thrives today as one of the world's leading independent publishers.

Though a westerner, Tuttle was hugely instrumental in bringing a knowledge of Japan and Asia to a world hungry for information about the East. By the time of his death in 1993, Tuttle had published over 6,000 books on Asian culture, history and art—a legacy honoured by the Japanese emperor with the "Order of the Sacred Treasure," the highest tribute Japan can bestow upon a non-Japanese.

With a backlist of 1,500 titles, Tuttle Publishing is more active today than at any time in its past—inspired by Charles Tuttle's core mission to publish fine books to span the East and West and provide a greater understanding of each.